THE PHOTOGRAPHIC ART MARKET

[Vol. 1]

PETER H. FALK

INTERNATIONAL·INC

New York, New York

Printed in the United States of America

Library of Congress Catalog
Card Number: 81-68613
ISBN 0-940926-00-8

Illustrations by Mark Tansey 1981

Printed by Science Press

Acknowledgments

I would like to extend my sincere
thanks to the photography department
heads of Christie's, Phillips', Sotheby's,
and Swann's auction houses for their
continued cooperation in providing us
with important statistical information.
My thanks also go to the many dealers
and collectors who have continued to
share their personal views on the
photography market with us.

I am also grateful to the many people
who helped produce this book
including Charles Rizzuto and Marc
Leeds for their expert assistance in
editing the text; Jody Seide, our
computer systems analyst, for design-
ing and managing the computer
program for our Auction Price Results
section; and Art Director Patrick
Vitacco and his staff at Leeds
Communications for their intelligent
artistic direction and design
of the book; and Yancey Perkinson for
her concentrated efforts in coordinating
the production of this book.

In particular, special thanks go to my
partner, Don Leeds, whose boundless
creative spirit and practical problem-
solving combine to be a continual
source of inspiration.

Peter H. Falk

For further information on future
Falk-Leeds publications and
periodicals, simply call or write us at:
521 West 23rd Street
New York, New York 10011
Tel: 212-620-3196

CONTENTS

v

The purpose of this report is to survey the economic development of the photography market during the past decade in order to give prospective investors an overview on the current status of collecting. It will also provide projections for the course of the photography market during the 1980's.

Making predictions in the photography market or, for that matter, in any area of the fine arts, can be as difficult as forecasting the seesaw pattern of recession and recovery in the economy as a whole. Nevertheless, it is hoped that this analysis will shed light on critical market indicators that many collectors, investors, and dealers may be unaware of and which may be of help in their decision-making process.

Investment in art and genuine appreciation of quality in fine art are not of necessity the irreconcilable opposites they may seem to be. Indeed most of the world's leading art collectors have successfully merged the two in the process of building important collections. While these collectors are usually viewed as individuals who "acquire fine art" rather than "invest in a tangible," their ultimate success owes a great deal to a very subtle and refined acquisition and marketing strategy. Consequently, successful collectors usually possess a voracious appetite for information on every aspect—historical, critical, and economic — of their field. Yet, until now, a comprehensive overview of the photography market has never been attempted. Bearing in mind that there are really only about ten years of collecting activity to monitor, the lack of any market analysis to date is not surprising.

At present, collectors of photography have several useful primers to which they can turn. The best are Richard Blodgett's *Photographs: A Collector's Guide* (1979) and a study by Lee Witkin and Barbara London entitled *The Photograph Collector's Guide* (1979). *The Photographic Art Market* has specifically avoided repeating any information that could easily be obtained from these other sources. Rather it is based on the assumption that readers are already involved in collecting and possess the incentive and interest to make use of histories of photography and scholarly monographs on specific photographers to answer questions regarding history or aesthetic theory.

The latter half of the past decade saw increasing public attention turn to the fine arts as a viable alternative form of tangible investment. In the hope of raising the level of expertise of collectors, several symposia entitled "Investing and Collecting in Photography" were organized in the spring of 1980 in New York and Toronto. The inclusion of the word "investing" in the title represents

a serious effort to attract the attention of a new breed of art buyer, the "collector – investor." Many of those who attended, however, were sorely disappointed to find that very little concrete information was provided concerning the more subtle investment aspects of collecting photographs.

This same complaint has been voiced to me by many people, from the smallest collectors up to the chief executives of large United States corporations. These are individuals who, I might add, can be faulted for neither their understanding of art history and their appreciation of quality in the fine arts nor their reputation as frank, "hard-nosed," conservative businessmen and women. One such businessman is the Chairman of the Bank of America, the world's largest bank. We met last spring to discuss corporate involvement in the fine arts. It struck me that his concern about both the economic and qualitative sides of collecting applies to all collectors, regardless of the size of their financial commitment:

> The investment in or patronage of photographic art by corporations is in an early stage and rather limited in scope...You as an active participant no doubt can help to inform interested parties by providing market data and aesthetic judgment.

Bearing in mind that market data is always influenced and conditioned by aesthetic judgment, a fact reconfirmed by many such intelligent inquiries, I set out to draw together years of accumulated statistics and expertise in order to formulate the present analysis.

This report, while centered mainly on a market analysis, will stress that there is no substitute for a knowledge of art history in order to appreciate true artistic merit. Collectors owe it to themselves to benefit from the methodology and seriousness of approach that art history can provide. Therefore, if I were to emphasize the importance of any single section of this report, it would be the Selection Criteria. Only with an understanding of such criteria can a collector hope to assemble a collection of real significance. Appreciation in value may then follow as a happy result but only after a true appreciation of quality.

Peter H. Falk
Spring 1981

An Introduction to Fine Art Photography | CHAPTER 1

Historically, art has been the means through which society expresses itself. The form that this expression takes is constantly changing. With the advance of civilization, the tools of expression available to the artist have become technically more sophisticated. Cave art, for example, was created with tools that by today's standards seem rather unsophisticated; yet they were the only tools that the culture of the time could provide. Medieval art shared with cave art a vital connection with religious imagery and practice. The medieval artist, however, had at his disposal more advanced tools than the cave artist had and created what to our eyes seems like a more refined work of art. Society advances, the technology available to the artist advances, and with these tools the quality of expression, hopefully, advances as well.

An Appraisal of Photography within Art History

Since the invention of photography was announced by Daguerre in 1839, the question "Is photography art?" has been a fiercely debated one. On the surface, photography may appear a merely mechanical medium. Camera, lenses, film, developing solutions, and enlarger are mechanical and chemical elements that to some make up an impersonal process quite different from the artistic process involved in painting, drawing, or sculpture.

But in that same year, 1839, the French painter Paul Delaroche declared, "From today, painting is dead." Twenty years later, at the revered Exhibition of Fine Arts in Paris, photography finally won the long battle for the right to be exhibited as "art" beside painting.

In the 1880's Peter Henry Emerson's influential writings emphasized photography's independence as an artistic medium whose aesthetics should not be confused with those of painting. The greatest of all promoters of photography as fine art was Alfred Stieglitz who, from the 1890's until his death in 1946, devoted his life to setting to rest the old question regarding the validity of photography as art. Perhaps the most powerful and lasting influence on the course of photographic art has been the commitment—just since the early 1970's—of the major art museums in the United States and Europe to photography.

Photography As Art

Museum Collections and Exhibitions

Certainly there was some museum interest in photography before the 1970's. Stieglitz, for example, donated his massive personal collection to the Metropolitan Museum of Art in the early 1930's. It is interesting to note, however, that it was not until 1978 that this museum chose to publish a book to accompany a major photographic exhibition there.

Of the museums in the United States, the Museum of Modern Art is photography's oldest proponent: it purchased its first photograph (by Walker Evans) in 1930, mounted the historic first survey exhibition of the history of photography in 1937, and established an independent Department of Photography in 1940. By the 1970's many of the major museums in the United States and Europe had formed their own photography departments to conserve and exhibit their growing collections. Also during the 1970's, colleges and universities began instituting and increasing existing offerings of courses in fine art photography and the history of photographic art.

In addition to constituting fine photography collections, museums actively exhibited their acquisitions thereby establishing a firm foundation for acceptance within the museum-going public. The enormous and continuous professional commitment to scholarly research, acquisition, public exhibitions, and publications throughout the 1970's set the stage for what should prove to be an extremely far-reaching public exposure in the 1980's.

Museums, long society's most conservative collectors and promoters of art, have expressed their unequivocal confirmation that photography is a fine art. They had accepted photographs within their sacrosanct premises well before the visible market of the 1970's, a decade in which photography struggled to establish an elite identity within the broad fine arts market. Indeed, no other medium within art history took so long to gain acceptance by the art-collecting public. There are really only ten years of active collecting to analyze for market growth. Even as late as the mid–1970's the photography market was still in its infancy. Despite record dollar volumes at the auctions and in the galleries, the real growth in photography collecting has just begun.

Photography Yesterday and Today

Not since the fifteenth century, when Gutenberg refined the printing press, has a medium had as profound and lasting an impact on our culture as photography has. Now, at age 140, it clearly takes its place as just one of many media available to society for artistic expression. Born at the peak of the Industrial Revolution,

photography has always possessed many strictly utilitarian purposes. Its artistic uses, however, have also been present right from the start. Like other artistic media, photography serves the dual purposes of expression and communication; but the fact remains that only an artist can create art and only the quality of the artistic expression can give a work true value. (See "Acquisition Strategy" for extensive comments on image quality.)

In his landmark work on the graphic arts, *Prints and Their Creators: A World History*, Carl Zigrosser states:

> It has been said that photography could not be an art medium because all its operations are mechanical. All print mediums have mechanical elements, which the artist has learned to manipulate and control. There are enough variations in the steps of the photographic process to give the artist a wide repertory of expressive devices: lighting and arrangement of materials, changes of focus, variations in development and printing, including solarization. There is no logical reason, then, why a photograph cannot be a work of art if it is made by a conscious artist. (p. 6)

Zigrosser points out that only an artist can create art and that only a master can make important and lasting contributions by virtue of his mastery of his chosen medium.

Statements of two master photographers of the twentieth century also speak to this view of a master's seriousness and commitment to his medium. In *The Print*, (p. 6) Ansel Adams writes:

> We may draw an analogy with music. The composer entertains a musical idea. He sets it down in conventional musical notation. When he performs it, he may, although respecting the score, inject personal expressive interpretations on the basic patterns of the notes. So it is in expressive photography: the concept of the photograph precedes the operation of the camera. Exposure and development of the negative follow technical patterns selected to achieve the qualities desired in the final print, and the print itself is somewhat of an interpretation, a performance of the photographic idea.

In Witkin and London's *The Photograph Collector's Guide*, (p. 10) photographer W. Eugene Smith is quoted as saying:

> There is nothing in photography I hate more than printing. The care I give the prints and the agony I go through in making them make it a most unpleasant but necessary task. Because of the time it consumes, I could never flood the market with my prints. I make my own prints because no language or communication allows me, or anyone else, to tell another person the very subtle balances of print quality only I can register. Anyone else's print of my negative is a rough approximation, even with the best of printmakers. I struggled all my life to come back from assignments and make my own prints.

The great art collectors, including museums, are not interested in owning anything but the works of true artists. Unfortunately the price of an excellent work by an Old Master or Impressionist is now far beyond the financial capabilities of any one collector. Usually syndicates must be formed in order to purchase a single painting of great value. Thus the ability to form a comprehensive collection of paintings and sculptures by great artists is sadly gone forever.

This is not the case in photography, however, and suddenly in the 1970's, collectors began to realize that the possibility of owning examples of each master photographer's work was within their grasp. At first relatively few collectors actually took advantage of the situation. Quietly and cautiously, it was the museums that first began to acquire significant photographic collections.

Throughout the decade it was the growing realization that the demand (and potential future demand) for important vintage prints far outstripped the supply that kept the photography market expanding (sometimes erratically) during its formative period. The next section will provide an historical examination of this market, essential background information for understanding our Acquisition Strategy and Selection Criteria.

The Fine Art Photography Market: An Overview

In the spring of 1977 the author placed an advertisement in art magazines in the United States and Europe. The advertisement featured a famous photographic portrait of Albert Einstein and bore the headline: "The Truth about Vintage Photographs." In essence its aim was to describe the wide gap that then existed between prices actually realized at auction and the high price structure that most galleries were imposing. In order to promote an elite status that would give fine art photography a valid economic footing, dealers had created and were supporting a price structure at auction and at galleries that would command the respect of the public. This need was indicative of an immature market struggling to attain high price status prematurely, before establishing the support of a wide base of collectors. Thus there was a real danger of creating a "false bottom" to the market.

It was in 1975 that Sotheby's, the world's largest fine art auction house, began to schedule regular fall and spring photography sales in New York and London. This commitment was partly responsible for the increased publicity photography investing began to receive from the financial, popular, and art presses. Equally important was the growing number of exhibitions being mounted by influential museums such as the Museum of Modern Art, The Metropolitan Museum of Art, and other important public and university museums in the country's largest cities.

 The 1975–76 auction season witnessed a great influx of speculative investment capital into the photography market—the first stage of the post-recessionary boom that would lift photography collecting out of infancy into adolescence. Typically, this adolescent behaved erratically and it was this tendency that prompted the advertisement described above. It was predicated on the assumption that the intelligent collector–investor, armed with the knowledge and reliable advice of an expert, could form an important and valuable collection at very reasonable prices.

 For the next two years prices leveled off. The collector who bought and

A History of the Photography Market since 1970

First Major Auctions

sold at auction during this period would have been fortunate to break even. One who bought at gallery retail prices and sold at auction would certainly have taken a loss. But along with the risks, this stagnant market situation presented some extraordinary opportunities as well.

In the fall of 1979 the photography market experienced its second and more spectacular jump. A wave of new collector–investors spurred a flurry of record-breaking prices at auction, many driven unrealistically high. In fact a full half of the winning bids at Sotheby's registered at least 20 per cent above the highest pre-sale estimates.

Many dealers were suprised by the high bidding. They had not anticipated that the number of bidders from the private sector had grown from such a small group in the mid–1970's to an influential new force in the current market. As is curious but not unusual in the art market, this new wave of collecting public had calculated that the time was right to buy. After all, they reasoned, the world's second and third largest fine art auction houses, Christie's and Phillips respectively, had opened elaborate new auction rooms in New York just a year earlier. Each had its own staff of photography experts and had realized that the market leader, Sotheby's, was breaking in on the ground floor of a very promising, if not yet fully developed, segment of the art market.

These trends are illustrated in Table 6. One of the logical concerns in examining the 1979–80 figures in Table 6 is that the influx of speculative capital may have left the market "overbought" in the fall of 1979, a situation in which vigorous buying leaves prices too high.

Recent Trends: The Two-tiered Market

In the auctions of spring 1980, collectors were indeed left with an overbought market. Overoptimistic (and perhaps a bit greedy) about the auction market's ability to absorb a great quantity of material, the three biggest auction houses (Sotheby's, Christie's, and Phillips) had released catalogues listing a total of 3,600 lots, to be sold within two weeks of each other. This flood simply could not be absorbed especially since many of the consignors, basing their expectations on the success of the fall 1979 auctions, had set their reserves (the price *under* which the lot will not be sold by the auctioneer) unrealistically high. At Christie's, delays in catalogue production and mailing were partly responsible for the weakness in their special sale of Ansel Adams prints. Yet a record number of prints was sold in New York that spring for a total of over $1.5 million—far more than the combined totals for the entire preceding 1978–79 auction

year. Furthermore, many records were set for individual photographers and historic periods; for example, Christie's world record price of $36,000 (plus 10 per cent buyer's premium) for a single photographic image.

The most important single development since the spring of 1980 has been the market's advance, in logical progression, to its second major stage of maturation: a two-tiered structure. The finest works offered did indeed bring in record prices but prints of secondary or tertiary importance, some of these by the most famous photographers, either brought disappointingly low prices or failed to sell at all. Clearly the lesson to be learned was that the market should not jump ahead of its collector base and that what was needed was an expansion of its all-important "exchange" segment. (The term "exchange" throughout this study refers to all sales: auction, gallery retail, intra-trade wholesale, as well as trading between dealers.) The process of "separating out," price-wise, the most important prints of the highest quality repeated itself in the 1980–81 auction season. The subsequent leveling in Table 6 reflects this second major plateau which occurred despite many individual prices of record proportion.

The Growth Potential of the Photography Market: Three Factors

In order to arrive eventually at a comprehensive overview of the growth potential of the photography market, it will be useful first to consider three key factors: photography auctions in relation to all art and antiques sold at auctions; photography auctions in relation to the photography market's total exchange; and auction sales of all art and antiques in relation to the total exchange of all art and antiques.

Photography Auctions in Relation to All Art and Antiques Sold at Auction

The growth in the photography market can be seen by measuring the ratio of all photography auction sales to the auction sales of *all* art and antiques. According to figures released by the nation's twelve largest fine art and antique auction firms, the total of auction sales of all art and antiques in 1979–80 was over $434 million, up from $267 million the previous season.* For this same period the auction sales of all photographs totaled about $5 million. This figure, based on statistics from Sotheby's (New York and Los Angeles), Christie's, Phillips (New York and Toronto), Swann (New York), and other smaller houses selling photographs represents just over 1 per cent of the total 1979–80 art and antique auction volume. This 1 per cent, however, represents a doubling of photography's

*1980-81 figures not released as this book went to press.

share of the market just one year earlier. Clearly this ability to double its share of a total auction market, that is itself expanding, is a very positive sign of growth.

In forthcoming seasons photography's share of the total art and antique auction market should continue to increase gradually before leveling off at about 3 per cent by the end of the current decade. In other words it is expected that photographs will appreciate at a rate higher than that of the other fine arts and will continue to demand a higher relative share within both the auction market and the general exchange.

Photography Auctions in Relation to the Photography Market's Total Exchange

It is very important to note that while auction prices have traditionally been regarded as a barometer of market strength, the cumulative auction sales represent only a small percentage of the photography market's annual exchange. Statistics from Sotheby's, Christie's, Phillips, Swann, and other smaller houses show that in the 1979–80 season photography auctions represented about 20 per cent of the total photography market exchange of an estimated $25 million. In the future, as the photography market expands, its total exchange will rise. Accordingly, even though the dollar volume at the photography auctions will continue to increase, the percentage of auction sales volume in relation to the total exchange can be expected to decline, reflecting the rapidly growing interest of the public sector.

Also of interest are statistics printed in *The Gray Letter* (Vol. IV, No. 29; Vol. V, No. 29) which set the market exchange for *all* art and antiques in the 1979–80 season at approximately $7.8 billion, up from approximately $6.25 billion in the previous season.* Within these figures *auction* sales of all art and antiques represent about 5.5 per cent of the annual exchange. Yet photography auctions, in comparison, now claim about 20 per cent of photography's annual exchange figures. Once again, as mentioned above, the photography market can be expected to increase dramatically its collector base and its total exchange volume during the 1980's. The rate at which it does so will reflect its true market strength.

The Collecting Public

While it is important to keep an eye on auction results for prices realized on specific prints, a factor which is far more critical in the long run is actual growth in the real market base—the collecting public.

*Recently released figures from *The Gray Letter* put the total art and antiques exchange at $8.7 billion in the 1980-81 season.

On a recent lecture tour to various cities (including New York, Los Angeles, and San Francisco), the author conducted an audience poll which revealed some surprising facts. Despite the simple fact that these were lectures on collecting photography, 90 per cent of those in attendance had *never* purchased a photograph, 65 per cent had purchased other fine art and/or valid collectibles (such as paintings and graphics or stamps and coins), and 25 per cent had never purchased any fine art or collectibles. These polls indicate that the number of individuals who are actually involved in collecting photographs is very small as compared to those who are currently still gathering information and observing the market before they begin actively collecting and investing. Thus the polls confirm both the existence of a potentially huge collecting public and at the same time its need of further education in the historical and more practical aspects of collecting photography. Clearly the growth potential is enormous.

During the 1970's it was the boom in the photography market that received a great deal of publicity. But in the long term the decade will be remembered as the renaissance of scholarly research in photography. The copious output of dedicated researchers has added immeasurably to the public's understanding of and perspective on a wide range of important photographers.

Tables 4 and 5 show clearly how the market has truly broadened. By 1981 there were hundreds of collectors who would pay $5,000 for a single photograph. In 1975 there were scarcely a dozen. As the collector base continues to grow, the market should assume the classic upright pyramid structure with rare master prints of the highest quality at the top, commanding the highest prices. The price layout of the supporting levels will be determined by the critical factors to be discussed later: quality, condition, rarity, photographer status.

Market Growth on Two Levels: Photographica vs. Fine Art Photography

Any discussion of the growing popularity of collecting photographs and the expansion of the "exchange" must make mention of the two very different areas within that market: photographica and fine art photography. These are two distinctly separate collecting fields despite the fact that some observers have grouped them together.

Photographica includes: daguerrotypes, ambrotypes, tintypes, stereoviews, *cartes de visite*, cabinet cards, and antique cameras and equipment...all largely confined to the nineteenth century.

Fine art photography encompasses images made since the beginning of

photographic history. Accordingly, fine art photography can include all media within the designation "photographica" although it is most commonly associated with larger images on paper such as calotype, salt, albumen, platinum, gum, and silver prints.

The finest images in photographica are of interest for their historical importance *and* their aesthetic quality. For example, although each daguerrotype exists as a unique image, straight portraits, which are abundant, bring only $10-$20 today. But a daguerrotype of high aesthetic quality, by an anonymous daguerrotypist, can realize $500 or more. Thus the marketplace also responds to an inherent paradox: the type of medium employed is irrelevant, yet it can mean everything. It gives a photograph its unique quality of presence. At the same time the concern for aesthetic problem-solving is the catalyst necessary to create the very qualities in fine art that attracts collectors. In the finest of photographic images the relationship between the medium and the final image can be highly paradoxical.

The bulk of images within photographica are documentary in nature and collectors are therefore often motivated by historical concerns in their choices. However, the photographica images of greatest value are those whose conceptual intent involves not only this documentary side but also the investigation of real aesthetic questions.

The major market distinction between photographica and fine art photography is the type of collector each attracts. The peculiar polarity that has developed between these two branches of the market is based largely on the difference in motivation of the two groups of collectors. The market for photographica has built a strong foundation of the "little guy" collector whose love of collecting is motivated by the simple joys of discovering images of a bygone era in antique shops, flea markets, and trade fairs. Since most photographica has been widely available at relatively low cost, new collectors have found it easy to join in. It is precisely this relative ease of entering the photographica field that has been its strength. With a modest budget and armed with a special interest and a clear direction for his collecting ambition, the novice can build a fine collection.

Not surprisingly, a two-tiered market has developed within the photographica field as well. Nevertheless, the supply of images for the beginner is still abundant. In terms of volume of trade in the photographica market, the average "little guy" collector may not spend a great deal at any one antique shop or flea

market but his total yearly purchases may well add up to $500 or more. A conservative estimate sets the number of collectors of strictly photographica at 5,000. Most of this group is concentrated in the Northeastern United States.

Predicting the strength of the photography auctions has been viewed as a guessing game. In reality there are certain indicators that can provide us with some solid, reliable information on which to base investment decisions. These Photography Market Indicators are (1) Internal, (2) External, and (3) Inter-Art-Market. They are factors critical to the Acquisition and Disposition strategies outlined in the next four chapters.

The purpose of Diagram 1 is to illustrate the point that the photography market should not be viewed in a way that focuses only on Internal Indicators such as auction results and museum interest. In the past, market strength has tended to respond to significant movements in both Inter-Art-Market Indicators and External Indicators. While photography's own Internal Indicators are certainly the most influential factors to watch, it would be a mistake to view the photography market as independent of the general art market or, in still broader terms, unaffected by general economic conditions.

Internal Indicators

The most highly visible of the Internal Indicators includes the activities of the auction houses, galleries, and museums. The communications structure that interprets and presents these events to the public is of prime importance to the market exchange. Increased and enthusiastic mass-media coverage of the auctions, new gallery shows, and museum exhibitions have played a very important role in promoting the collecting of photographs. In this respect, the epicenter of the booming interest in photography has clearly been New York City. In other major U.S. cities the educational role of proper publicity is of even greater importance in building public interest. Critical reviews and articles by the art, financial, and popular presses have assisted in gradually attracting more collectors.

For investors, the auction price results are considered the most objective measure of market strength. These should be actively watched while taking into consideration the relation of the other Internal Indicators that are outlined in Diagram 1.(p.13)

External Indicators

Over the last several years the rate of inflation (as measured by the GNP deflator) has remained at 8–10 per cent. At such a rate both large and small investors have been prone to "lock in" on long-term investments that guarantee a consistently high annual return and can, at the very least, beat inflation. An investment without a guaranteed return such as a long-term investment in tangibles has usually carried the attraction of a significantly higher potential return. The key word is "potential," for all tangible investments, whether gold, real estate, stamps, paintings, or photographs, carry a substantial element of risk. Expertise, which in the realm of fine arts means an eye for quality, can go a long way to help minimize this risk.

External factors, particularly economic ones, can have a positive or negative effect on the volume of investment capital and discretionary income being channeled into fine art (including photography). For example, some speculators feel that President Reagan's tax cut will free a huge amount of investor income, a substantial portion of which may be directed into fine art investment. This influx would push the market to higher levels. Conversely, other speculators feel that a rebounding stock market, a balancing of the federal budget, and a dwindling rate of inflation would cause the art market to stagnate. To many the question of increased interest in art as investment is as simple as asking someone if he believes inflation will continue or subside.

Inter-Art-Market Indicators

In periods when the photography auctions have proved decidedly strong or weak, how many individuals have bothered to examine the outcome of concurrent auctions of modern and Old Master prints or nineteenth and early twentieth century American paintings? The correlations can be quite instructive. (See Table 7.)

The fall of 1979, for example, was a strong period for almost all of the fine arts. Sotheby's nineteenth and early twentieth century American painting sales registered a record volume of nearly $7 million, including the record for an American painting: $2.5 million for Frederic Edwin Church's "Icebergs." The following week Sotheby's, Christie's, and Phillips recorded their most successful photography sales ever.

At times, due to internal complicating factors, the Inter-Art-Market signals do not correlate. In the spring of 1980 the photography auctions showed results that were erratic: unusually weak in certain areas while very strong in others. Market leaders such as Ansel Adams and Irving Penn suffered most visibly. 12

Diagram 1

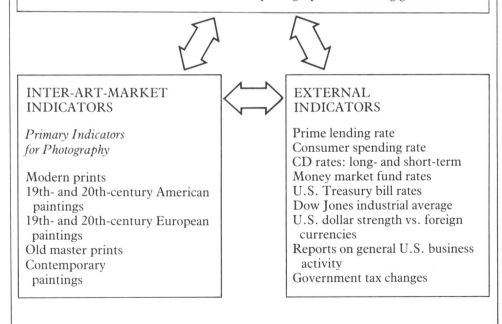

INTERNAL INDICATORS

Museums
Exhibitions: public response, number of viewers, accompanying publications
Acquisitions: direction of museum's collecting interests; private, government and corporate support activity

Auctions
Sale results: number of lots, percentage of lots sold, auction's dollar volume, price result analysis

Publicity
Art press, popular press, financial press: critical reviews and influential articles; new books
Television, radio, and other mass-media

Galleries
Exhibitons and acquisitions: public response, annual sales volume

Art Politics
Importance of relationships between galleries, auction houses, museums, critics, editors, and publishers.

Market Shift
Psychological factors contributing to changing collectors tastes

Exchange Status
Newly opened galleries; defunct galleries; museums newly beginning to collect; corporations newly beginning to collect; international market growth; photographica collecting growth

INTER-ART-MARKET INDICATORS

Primary Indicators for Photography

Modern prints
19th- and 20th-century American paintings
19th- and 20th-century European paintings
Old master prints
Contemporary paintings

EXTERNAL INDICATORS

Prime lending rate
Consumer spending rate
CD rates: long- and short-term
Money market fund rates
U.S. Treasury bill rates
Dow Jones industrial average
U.S. dollar strength vs. foreign currencies
Reports on general U.S. business activity
Government tax changes

The reasons offered to explain these results ranged from a renewed attractiveness of the stock market to the effects of the high prime lending rate. Why should the investor speculate in photographs if he could earn high interest, tax-free, in long-term government bonds? It was feared that many investors who had diversified their holdings to include tangibles were now curtailing their activity in favor of more traditional investment vehicles. In fact that spring did see net borrowings drop from a $400 billion annual rate to $230 billion (as reported in *Forbes Magazine*, April 1981).

A look at the Inter-Art-Market Indicators for the same period, however, shows this reasoning to be inaccurate. The market for nineteenth century American paintings, American Impressionists, Old Master and modern prints continued to prove particularly strong. Although the photography auction market, as a whole, had leveled off to a major plateau, photography's upper tier continued to command record prices. The decisive factor in this situation was the marked emphasis of the two-tiered market in light of a plethora of auction lots.

The important point here is that all three major indicator areas must be taken into account to gain a full and accurate market perspective. These guidelines remain useful despite the fact that Economic Indicators and Inter-Art-Market Indicators examined alone are not always totally reliable since the photography exchange is still at a relatively early stage of development.

Table 1. Annual International Photography Auctions

Auction House	Number of auctions/year	Auction House	Number of auctions/year
Christie's East, New York	2–4	Phillips, New York	2–4
Christie's, South Kensington, London	3	Phillips, London	3
California Book Auction Galleries (Los Angeles and San Francisco)	2	Phillips, Toronto	1
		Sotheby's, New York	2–4
Cornwall-Koln (Germany)	1–2	Sotheby's, Los Angeles	1
Petzold K.G. (Germany)	1–2	Sotheby's, Belgravia (London)	3–4

Houses scheduling photography sales on an irregular basis are Skinner Galleries, Boston and Harris Book Auction Gallery, Baltimore.

Table 2. Analysis of Price Results for Several Photography Auctions Prior to 1980-81

Auction House	Date	Period	Number of Lots in Sale	$1,000–$4,999		$5,000–$9,999		At Or Above $10,000		Percentage of Lots Bought In
				Number of Individual Prints Sold	Number of Groups* of Prints Sold	Number of Individual Prints Sold	Number of Groups* of Prints Sold	Number of Individual Prints Sold	Number of Groups* of Prints Sold	
Sotheby's New York	May '76	19th–20th C.	408	14	19	0	0	0	1	15
Sotheby's New York	May '78	19th–20th C.	342	21	21	0	2	0	0	18
Sotheby's New York	May '80	19th–20th C.	721	140	19	8	2	4	3	22

*"Groups" of prints refer to lots with two or more prints: usually albums, portfolios, or books with original photographs mounted within.

Table 3. Lots Sold at or Above $10,000 for the Auctions in Table 2.

Auction House	Date	Photographer	Title/Description	Price Realized
Sotheby's New York	May '76	Curtis, Edward	*The North American Indian:* complete set of 20 text vols. and 20 portfolios, 1907-1930, photogravures	$60,000
Sotheby's New York	May '80	Adams, Ansel	*Portfolio 3:* 16 silver prints, edition of 208, 1960, 8″ x 10″	$20,000
		Man Ray	"Swedish Landscape" 1925, rayograph, 9″ × 12″	$10,250
		Man Ray	"Lace and Candle" 1923, rayograph, 12″ × 9″	$10,500
		Steichen, Edward	"Eleanora Duse" negative 1903/print c. 1905, pigment print, 13″ × 11″	$13,500
		Weston, Edward	"Pepper No. 30" 1930, silver print, 9″ × 8″	$14,000
		White, Minor	*Jupiter Portfolio* negatives various dates/prints 1975, 9″ x 12″ edition of 100	$14,000
		Stieglitz: Editor	*Camera Work:* incomplete set, lacking vol. 49/50 and one Steichen photogravure	$20,000

Table 4. Analysis of Price Results: 1980-81 Photography Auction Season

Auction House	Date	Period	Number of Lots in Sale	$1,000–$4,999		$5,000–$9,999		At Or Above $10,000		Percentage of Lots Bought In
				Number of Individual Prints Sold	Number of Groups* of Prints Sold	Number of Individual Prints Sold	Number of Groups* of Prints Sold	Number of Individual Prints Sold	Number of Groups* of Prints Sold	
Phillips Toronto	Oct. '80	19th–20th C.	269	22	2	1	0	0	0	27
Sotheby's New York	Oct. '80	DeMeyer	162	44	9	3	1	1	0	2
Swann New York	Nov. '80	19th–20th C.	430	9	3	0	0	1	2	18
Christie's New York	Nov. '80	19th–20th C.	655	87	16	4	3	1	1	40
Phillips New York	Nov. '80	1920's–1930's	301	41	1	0	0	1	0	35
Phillips New York	Nov. '80	Stieglitz and Photosecession	73	12	4	2	0	1	0	36
Sotheby's New York	Nov. '80	19th–20th C.	520	142	11	8	2	3	4	16
Sotheby's Los Angeles	Feb. '81	19th–20th C.	528	73	14	4	1	1	0	11
Phillips New York	Apr. '81	1940's–1950's, Fashion	200	13	1	0	0	0	0	49
Swann New York	Apr. '81	19th–20th C.	557	5	6	0	0	0	1	12
Phillips New York	May '81	19th–20th C.	345	16	3	0	0	0	0	37
Christie's New York	May '81	19th–20th C.	217	75	5	13	8	5	2	26
Sotheby's New York	May '81	19th–20th C.	599	110	17	11	2	1	1	16

*"Groups" of prints refers to lots containing two or more prints; usually albums, portfolios, or books with original photographs mounted on the pages.

Table 5. Photographs Sold at or Above $10,000 for the Auctions in Table 4.

Auction House	Date	Photographer	Title/Description	Price Realized
Sotheby's New York	Oct. '80	DeMeyer, Baron	"Nijinsky, Le Spectre de la Rose," 1910, platinum, 13″ × 10″	$12,500
Swann New York	Nov. '80	Stieglitz: Editor	*Camera Work:* 1903-1917; vols. 1–50 plus 3 special vols. (complete)	$42,000
		Gardner, Alexander	*Sketchbook Of The Civil War:* 100 albumen prints, 1866	$12,500
		Steichen, Edward	"Lotus, Mt. Kisco, N.Y." silver print, 10″ × 8″ negative 1915/print c. 1931	$10,500
Christie's New York	Nov. '80	Eastman, Seth	"Seth Eastman on Dighton Rock" 1853, daguerreotype, half-plate	$12,000
		Watkins, Carleton	*Views of Thurlow Lodge* c. 1874: 60 mammoth albumen prints in 2 volumes	$75,000
Phillips New York	Nov. '80	Moholy-Nagy, Lazlo	"Photogram" c. 1922, silver print, 36″ × 25″	$13,000
Phillips New York	Nov. '80	Stieglitz, Alfred	"Icy Night, New York" c. 1897, 5″ × 6″	$12,500
Sotheby's New York	Nov. '80	Adams, Ansel	"Mary Austin": 12 silver prints, edition of 108, 1930	$12,000
		Brancusi, Constantin	"Golden Bird" c. 1920, silver print, 9″ × 6″	$13,500
		Curtis, Edward	*The North American Indian:* complete set of 20 text vols. and 20 portfolios, 1907-1930, photogravures	$73,000
		Penn Irving	"Two Guedras" neg. 1971/print 1978, platinum, edition of 40, 21″ × 17″	$10,000
		Weston, Edward	"Female Nude" 1925, platinum, 6″ × 7″	$16,000
		White, Clarence	Portfolio of 9 silver prints, c. 1902-1912, approx. 10″ × 8″	$24,000
		White, Minor	*Jupiter Portfolio,* negatives various dates/prints 1975; 9″ × 12″, edition of 100	$14,000

continued ...

Table 5. Photographs Sold at or Above $10,000 for the Auctions in Table 4. *continued ...*

Auction House	Date	Photographer	Title/Description	Price Realized
Sotheby's Los Angeles	Feb. '81	Weston, Edward	"Sand Dunes" 1936, silver print	$10,500
Swann New York	Apr. '81	Moran, John (attributed to)	27 albumen prints from the Darien Exhibition, c. 1874; each 10″ × 9″	$12,000
Christie's New York	May '81	Stieglitz: Editor	*Camera Work:* 1903-1917, vols. 1–50 plus 3 special vols. (complete)	$30,000
		Emerson, P.H.	*Life and Landscape of the Norfolk Broads*, 1886. 40 platinum prints, ranging in size from 5″ × 9″ to 11″ × 9″	$24,000
		Le Blondel, A.	"Post-mortem" daguerreotype c. 1849, half-plate	$15,000
		Outerbridge, Paul	"Roses and Clouds" c. 1937, carbro print, 15″ × 12″	$12,000
		Outerbridge, Paul	"Seated Nude" c. 1937, carbro print, 16″ × 12″	$10,000
		Weston, Edward	"Tina Modotti, Mexico" 1924, silver print, 9″ × 7″	$13,000
		Weston, Edward	"Nude" 1934, silver print, 4″ × 5″	$10,000
Sotheby's New York	May '81	Stieglitz: Editor	*Camera Work:* 1903-1917, vols. 1–50 plus 3 special vols. (complete)	$23,000
		Weston, Edward	"Nude on Sand" 1936, silver print, 8″ × 10″	$12,500

Table 6. Annual Sales Volume at the Four Major Photography Auction Houses (in thousands of dollars)

Auction House	1975–76	1976–77	1977–78	1978–79	1979–80	1980–81
Sotheby's New York Los Angeles	$400	$510	$394	$467	$2,300	$2,157
Christie's New York	No Sales	No Sales	No Sales	$407	$1,444	$1,020
Phillips New York Toronto	No Sales	No Sales	No Sales	$325*	$ 537	$ 500
Swann New York	$200	$200	$250	$450†	$ 275	$ 257

Note: The dollar figures apply to photography auctions in North America and do not include London auctions.

* Includes two auctions conducted by Argus. Ltd., a photography auction firm acquired by Phillips in 1979.
† Includes $198,000 for two albums of one hundred mammoth prints by Carleton Watkins sold at a Swann rare book sale. Swann reports that its annual photography sales volume should be qualified upward about 10% due to the fact that it does sell photography books and albums (original photographs mounted within) at its rare book sales.

Table 7. Photography Auctions Compared With Other Fine Art Auctions at Sotheby's New York (in thousands of dollars)

Sotheby's Department	1976–77	1977–78	1978–79	1979–80	1980–81
American paintings	3,770	7,800	8,860	15,710	* 23,000 +
Old Master paintings	1,990	4,180	4,640	5,430	* 9,600 +
Contemporary paintings	2,220	2,870	1,560	5,250	* 4,200 +
Prints (Old Master and modern)	2,020	2,500	5,160	10,550	* 10,000 +
Photographs	510	394	467	2,300	2,157
All departments	79,000	112,000	147,000	247,800	* 250,000 +

Note: All sales figures do not include *unsold* lots or the *10% buyer's premium*.

* Our estimated figures, projected from Sotheby's recorded sales for the fall (Sept.-Dec.) season. At the time of our printing Sotheby's had not tabulated their complete season's sales.

Table 8. Photography Galleries, Museums, and Other Exhibition Spaces in the U.S.

State	No. of Museums	No. of Galleries
AL	2	0
AZ	4	1
AK	1	0
CA	23	29
CO	4	2
CT	5	6
DE	2	2
DC	13	5
FL	5	2
GA	2	4
ID	0	1
IL	6	8
IN	3	1
IA	0	1
KS	2	0
KY	2	0
LA	2	2
ME	4	3
MD	2	2
MA	17	14
MI	5	4
MN	5	4
MO	5	2
NE	3	0
NH	1	0
NJ	3	2
NM	2	4
NY	27	52
NC	3	1
OH	8	5
OR	3	2
PA	7	6
RI	1	1
SC	1	1
TN	4	0
TX	9	5
UT	1	0
VA	2	2
WA	3	3
WI	1	3
Total	192	180

Table 9. Foreign Photography Galleries, Museums, and Other Exhibition Spaces

Country	No. of Museums	No. of Galleries and/or Exhibition Spaces
Australia	4	6
Austria	2	2
Belgium	5	9
Brazil	2	4
Canada	19	1
Czechoslovakia	1	31
Denmark	3	0
Finland	2	2
France	17	0
Germany	15	18
Great Britain	37	16
Israel	1	33
Italy	1	1
Japan	1	7
Mexico	1	3
Netherlands	2	1
New Zealand	8	2
Norway	1	1
Peru	0	1
Poland	1	1
Portugal	1	1
Republic of South Africa	1	0
Spain	0	3
Sweden	2	2
Switzerland	1	10
Venezuela	1	1
Yugoslavia	0	2
Total	129	156

Museums listed are those actively collecting photographs and maintaining a permanent collection.

Galleries listed specialize exclusively in photography or it makes up a significant amount of their exhibitions for sale. These numbers do not include private dealers. The Association of International Photography Dealers currently estimates that there are over 600 gallery and private dealers worldwide.

Exhibition spaces are non-profit organizations with gallery space devoted to photography.

Table 10. A Partial Auction Record for Prints by Julia Margaret Cameron

Auction House	Date	Title and Size	Price Realized
Sotheby's Belgravia	Oct. 1975	(a mixed offering)	$300–$800 each
Sotheby's New York	May 1976	Tennyson, 12″ × 10″ The Maid of Athens, 11″ × 9″ The Rosebud Garden, 13″ × 11″	$850 $475 $1,200
Sotheby's New York	Feb. 1977	Vivien and Merlin, 13″ × 11″	$600
Christie's New York	Oct. 1979	Florence, 14″ × 10″	$1,200
Phillips Toronto	Oct. 1979	Sir Henry Taylor as King David, 11″ × 9″	$2,200 (Can.)
Phillips New York	Nov. 1979	The Dirty Monk (Tennyson)	$2,600
Swann New York	Oct. 1979	Sir Henry Taylor, 13″ × 11″	$3,400
Christie's New York	May 1980	Joseph Joachim, 12″ × 10″	$1,000
Christie's New York	Nov. 1980	Rebecca, 14″ × 11″ The Sun-tipped Sybil, 14″ × 11″	$3,800 $1,900
Phillips Toronto	Oct. 1980	Thomas Carlyle, 13″ × 10″	$6,000 (Can.)
Sotheby's Belgravia	Mar. 1981	Mrs. Herbert Duckworth	$12,430
Phillips New York	May 1981	Thomas Carlyle, 12″ × 10″	$1,800
Christie's New York	May 1981	Daphne, 14″ × 11″ The Dream, 12″ × 10″	$3,000 $2,600
Sotheby's New York	May 1981	Portrait of a Young Girl, 13″ × 10″	$500

Note: Print quality and physical condition are primary price determinants for Cameron's photographs. The examples listed above serve to illustrate the wide discrepancy in prices that commonly occurs with a nineteenth-century master's works within a rising market.

CHAPTER 3 | Acquisition Strategy

It is possible to trace a cyclical pattern of development: the pre–1975 plateau, the 1976 boom, the 1977–79 plateau, the fall 1979 boom, and the current plateau. These developmental cycles are actually subcycles of a general upward trend. While it is difficult to predict these subcycles, their occurrence not only makes sense but can serve as an indicator for anticipating future moves.

We predict that for the next eighteen to twenty-four months the photography market will continue to level off in terms of auctions but its base exchange will continue to grow. New price records will again be set at auction as the two-tiered market asserts itself ever more strongly. We believe that the three major auction houses will respond to this trend by holding smaller special sales of high quality master prints. The number of novice collectors with a spending ceiling of $500 should continue to grow and their demands will be accommodated by the general auctions of nineteenth and twentieth century photographs as well as by the galleries.

While on this plateau, the photography market will again reveal some extraordinary buying opportunities in the private sector, just as it did in the 1977-79 period. At the same time, such publications as *The Wall Street Journal*, *The New York Times*, and *ARTnews* may continue their focus on the more glamorous aspects of the market during this period: the new price records beings set at auction in the upper tier. (See Table 5.)

As described in the following section, *quality* is the single most important factor in determining the value of *all* fine art including rare photographs. It is the criterion used by museums in choosing master prints by major photographers for their collections, and the criterion used by auction houses in selecting images to be included in the future special sales limited to master prints.

An Analysis of Selection Criteria

The prudent management of art investment requires a strict definition of the criteria upon which the Acquisition Strategy is based. In photography, as in all of the fine arts, the single most important factor is the expert recognition of

quality. The five sections below focus on the critical points that, when combined, serve as a prudent guide in making the actual selections of works for a portfolio.

Aesthetic Quality
Scholarly Consensus

In all of the fine arts, lasting investment value has historically been linked to the objective recognition of true artistic excellence. Taste for works of art has undergone as much change as western culture itself. Just within this century, we have witnessed the development of movements such as Surrealism and Abstract Expressionism which seemed at odds with the aesthetic standards of the previous generations. Yet today we look back, better able to judge in retrospect the proper place of all of these movements within the history of art. Accordingly, a great weight is entrusted to scholarly consensus.

As mentioned earlier, the past decade will be remembered for the profusion of scholarly research on the history of photography. Every museum curator of photography in this country and abroad has seriously researched and written about particular periods or specific photographers. The copious output of monographs, books, articles and the exhibitons that they have accompanied, have further reinforced the prominent place of many photographers in art history. And the proliferation of these publications and exhibitions has had a direct positive influence on the economics of the photography market. (See the section on Photography Market Indicators in Chapter 2.)

Subject Matter

For the individual collector–investor, subject matter can be a personal aesthetic judgment. Taste and the "psychic income" derived therefrom, including the pride of ownership, are strong motivating factors. An important quality that distinguishes the best dealers is the ability to make aesthetic choices that rise above the tides of fashion and that correlate with both the principles of scholarly consensus and a lasting demand by sophisticated collectors. The preference of a fine dealer may not always appeal to every collector. This interaction, however, may prove a valuable learning process for the deeply committed collector. Of course, in the end, the collector's decision should be his or her own if a collection of truly personal distinction is to be formed.

Technical Quality

Even though a number of different images within a master's life's work may be important, the technical quality of each print will affect its value, espe-

cially among connoisseurs. If the printing quality is poor, with weak tonal ranges as compared to known excellent examples, the print's value will be reduced.

Physical Condition

There are four basic sources of damage to works of art on paper. Drawings, engravings, etchings, pastels, photographs, and watercolors are all equally susceptible. Photographs that have survived the ravages of time in mint or excellent condition are quite rare.

Chemical

Many nineteenth and early twentieth century prints were mounted on highly acidic paper boards which over time can cause fading or yellowing of the image. Framed photographs were commonly separated from their wood backing by only a thin layer of newspaper, resulting often in a chemical wood burn in the print. Even in prints made today, improper darkroom developing and washing leaves harmful chemical residues that can cause fading or staining, or give the print surface a rough texture. Other chemical damage can result from fingerprints, grease stains, and water spots, all of which can cause emulsion pitting.

Environmental

Changes in temperature and humidity can have a damaging effect on photographs. Extreme humidity can cause the surface emulsion of a print to blister off its paper base. Extreme dryness can cause prints to become brittle or curled.

Biological

Certain environmental conditions can also give rise to the growth of a common paper mould called "foxing." These small brownish spots can spread rapidly. Professional conservators have had mixed success in efforts to remove them. Nineteenth and early twentieth century photographs can also be victims of insect pests of the bookworm type which cause holes and pitting.

Mechanical

Perhaps the single greatest source of damage to photographs is human mishandling. Man has inadvertently created rarity by destroying numerous important photographs. Scratches, tears, and holes have lowered the market value of many otherwise valuable prints. Many of these imperfections are the result of carelessness.

24

Foxing, fading, yellowing, bromidization, stains, scratches and tears can all affect the true value of a print. Conservation and restoration of works of art on paper involves highly sophisticated scientific techniques which, in the case of photography, are complicated by the chemical nature of the medium. The field of photographic restoration is risky and highly specialized and is still in its infancy. Emphasis must therefore be placed on conservation (proper matting, storage, and display conditions).

The ability to recognize true rarity, which can legitimately enhance the value of a print, requires a thorough historical knowledge and access to key information contributed by leading researchers and museum curators.

 Many prospective collector–investors are concerned that there may exist hundreds of prints made from the same photographic negative. This notion has been proven erroneous and today's serious collectors, both private and institutional, are well aware of this fact. Still, many new collectors raise the question, "How many are there?"

 While in theory an unlimited number of prints could be made from one photographic negative, in actuality it was rare (prior to 1970) that a master photographer made more than approximately ten prints from a single negative except in the rare case of the publication of a special limited edition set. (Limited editions were first issued in the 1970's as a marketing mechanism in response to the growing number of collectors.)

 As shown in Graph 1, there was little economic incentive to make large quantities of prints before the 1970's. The artistic habits of the master photographers also account for the limitations in quantity. After laboring for hours or even days in the darkroom on a single negative, most serious art photographers disliked returning to the same negative and focused, instead, on creating new works.

Another important element of the Acquisition Strategy is the need to concentrate upon vintage prints known to exist in relatively small numbers. A word of caution, however: the fact that an edition is small does not in and of itself enhance the value of a particular print from that edition. Again, the other selection criteria must be taken into account. A vintage print is one that was made by the photographer himself (or by an assistant directly under his

supervision) close to the time at which the negative was taken. Correct physical identification of the vintage print, combined with its provenance, ensures authenticity.

There are cases, almost entirely involving living and contemporary masters, in which, due to advances in papers, chemicals, and other darkroom variables, a later print may be preferred over the vintage one. In this situation the evaluation of the work becomes largely qualitative and will be based more heavily on the other Selection Criteria.

Photographer Status

As with the other arts, scholarly consensus has singled out those photographers who are true masters, the seminal creative forces of the medium who are actively sought after by the world's leading photographic art dealers and museum curators.

The importance of a photographer's role as a genuine creative force and the significance of his contribution to the art of photography are major criteria. This is particularly true when evaluating the quality of the work relative to photographs by other artists working in a similar mode during the same period, or to works by a more important predecessor. These criteria are also most crucial when assessing the quality and importance of a certain print in relation to the photographer's whole life's work.

As an example, let us look at Francis Frith, the great British photographer of scenes in the Middle East. Frith was undoubtedly the largest publisher of photographs in the nineteenth century. Many of his smaller views of Sinai, Palestine, Egypt, and the Holy Land, dating from the late 1850's, have survived in varying condition. Most of them are rather small (approximately 6″ x 9″) and their aesthetic quality is generally not high, except for a small percentage of fine key images. The collector's attention should be focused rather on the most valuable of his works, the mammoth-plate (approximately 15″ x 19″) albumen prints of Egypt. Clearly it would have been a mistake to choose a Frith print for one's portfolio based solely upon the superb physical condition and a merely acceptable aesthetic quality. Here, as in all cases, the comprehensive selection process must involve applying all five criteria in order to assure the most prudent purchase.

While the history of the photography market is relatively short, the decade of the 1970's affords us enough time and distance to be able to see patterns of price activity for certain masters. As we enter the 1980's, it becomes increasingly important to monitor actively the course of photographic print returns at auction in the United States and Europe. The selections suggested in this study will also be based on this principle of supply and demand. Each photographer must have established an auction record (wholesale value) and a gallery record (retail value) which are easily verifiable by independent appraisals, exhibition price lists (where available), and actual price results at auction. This type of information is not always available in every case and is sometimes too incomplete to be useful. But dealers watch auction history as closely and instinctively as a serious stock market investor would watch the Dow Jones Industrials. Such information can be useful as an indicator but should certainly not form the sole basis for decision-making. The final purchase decision must take into account all five Selection Criteria discussed above as well as the market indicators.

Market History

1. *1970:* Sotheby Parke Bernet's landmark Strober Sale, considered by many as the birth of the photography market.

2. *1970–1975:* Photography collecting begins to receive increasing attention from the popular and financial press. Collector interest grows gradually. Photography galleries begin to open across the country.

3. *1974:* Recession sparks increase in investor interest in rare photographs as a desirable alternative investment.

4. *1975:* Sotheby Parke Bernet, recognizing the potential for the photography market, begins to actively solicit photography consignments and for the first time schedules regular spring and fall auctions to meet the growing demand.

5. *1976:* Photography market experiences its first strong influx of investor interest as evidenced by firm auction bidding.

6. *Fall 1977–spring 1979:* Photography market reaches a plateau period during which auction activity is inconsistent. Dealers begin to establish realistic price ranges.

7. *1978:* Christie's and Phillips establish their auction firms in New York. Recognizing the potential for growth in the photography market, they follow Sotheby Parke Bernet's lead, scheduling regular spring and fall photography sales. Sotheby Parke Bernet expands its role, forming a photography department at its Los Angeles division.

8. *Fall 1979:* Photography market experiences its second major influx of investor interest, far greater than that of 1976. Prices are driven high as numerous records are shattered at auction. Phillips expands, holding the first successful photography sale in Canada (Toronto). Most significant positive development: the greatly increased number of private collector–investors entering the market.

9. *Spring 1980–spring 1981:* Auction market reaches its second major plateau period similar to that of 1977–1979, with one major difference: the advent of a two-tiered market. As collectors become more sophisticated and the supply of rare high quality prints declines, the two-tiered market further imposes itself.

Graph 1. Composite Auction Sales Volume of the Four Major Photography Auction Houses (see Table 6)

Numbers indicate significant developments in the photography market over the past decade.

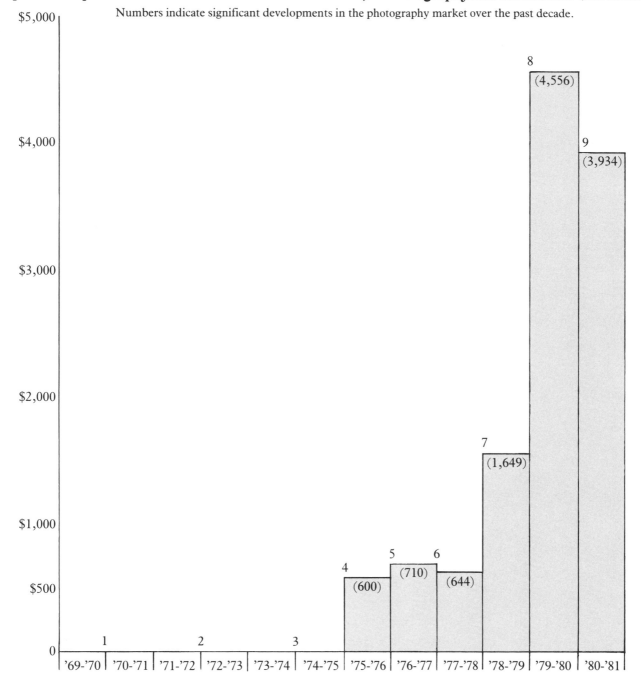

The Falk-Leeds Photography Grading System

There can never be a perfect grading system for any fine art. Other valid collectibles such as stamps and coins can be subjected to a battery of objective or quantitative tests but these collectibles are not fine art. The qualitative judgments made in appraising fine art are of necessity subjective and personal in many ways. For this very reason, the most important of the Selection Criteria discussed in this chapter—quality—is also, understandably, the most difficult to grade in a way that will be universally agreed upon. In the same way, it is difficult to assign a grade to the importance of the photographer relative to other photographic artists. Rarity, on the other hand, is somewhat easier to measure. Physical condition is probably the easiest for an expert to grade since it is the most open to objective analysis.

Throughout this text we have repeatedly referred to the value of scholarly consensus in the decision-making process. While this grading system is not meant to dictate taste, it does assume that a consensus of opinion on a specific photograph under examination could be reached by a group of qualified experts. In addition, it is intended that this grading system contain enough flexibility so that it can be used by anyone, whether collector, dealer, or museum curator. Surely one might argue that, based on personal tastes and standards, an infinite number of grades could be assigned to a particular print under examination. In reality, grades for specific prints *can* be narrowed down to a fairly short range.

Though photography may be viewed by many as the most democratic medium of the fine arts, it is under the same dictatorship that rules all of the fine arts: quality. Therefore, real value will be derived from this grading system only after comparison of one's own grades for a specific print with the grades of other qualified persons for the same print. In short, it is hoped that a natural side effect of this grading system will be the encouragement of communication between collectors, dealers, and museum curators.

The purpose of this grading system is simple in that it hopes to give any buyer of photographs extra assistance in the decision-making process leading up to a purchase. It should be used only by those with a thorough grasp of all aspects of the Acquisition Strategy.

Section 1: Aesthetic Quality

Score	Rating	Description
11	Masterpiece	One of a small number of images in the history of photography that scholarly consensus considers an example of ultimate creative achievement in the art of photography
7	Primary image	Held in the highest regard as a great photographic image and highly sought after by leading museum curators, dealers, and noted collectors
		Among the very best images representing the master's mature style and also important within the history of photography
		Well known within academic and photography market communities
4	Secondary image	Not as important as the primary image in terms of the history of photography but possibly a primary image in terms of the photographer's life's work
		Good representative example of the photographer's mature style even if not one of his greatest images
		Lacks a wide interest or appeal due to subject matter or is of less than perfect technical print quality which holds this particular print back from rating as a primary image
2	Tertiary image	Basically an image of lower quality
		Possibly a work from an earlier formative or immature period of development or from a later period of declining creativity
		Image experimental in nature or atypical in relation to the photographer's more accomplished work
		Work that the photographer may not hold in high regard or would not want exhibited but is, nevertheless, on the market
0	Poor	Lacking any creative spirit
		Dull, commonplace, or obviously imitative

Qualifying Factors

Technical printing quality: Does the print reflect the photographer's ultimate intentions in terms of technical darkroom control? Tonal range, contrast, and other qualities of the fine print can be very important.

Size: Depending on the period, photographer, and particular image, size can be very imporant.

Score: Neutral (0), ± 0.5, or ± 1.0

31

Section 2: Physical Condition

Score	Rating	Description
5	M = Mint to Extremely Fine	Outstanding: the finest condition; superb
4	E = Very fine to fine	Choice condition
		Satisfies the requirements of particular collectors
		Very few slight surface scratches, unobtrusive indentations, visible only under careful examination in a raking light
		No yellowing or fading—a rich print
3	G = Very good to good	Generally pleasing appearance but with a larger number of slight surface defects
		Slight but limited bromidization (halo effect) at edges but not detracting from primary image area
		Any yellowing or fading very slight in comparison with prints in fine condition
2	F = Fair	Surface defects directly visible
		Image showing increased fading or yellowing
		Previous small tears either repaired or still apparent
		Signs of staining or improper washing
		Light foxing of limited spread but affecting image area
		Wider band of bromidization affecting image area
		Obvious creases or emulsion loss
		Paper becoming brittle
0–1	P = Poor to unacceptable	Heavier surface defects
		Scratches and marring highly visible
		Tears
		Extensive yellowing, staining, and/or foxing present
		Obvious fading
		Paper very brittle
		Surface emulsion lifting or flaking

Qualifying Factors

In some cases a print may be in excellent or mint condition yet show a number of small white or black spots or hairs in the image. These are problems associated with the negative. White spots or hairs are caused by dust on the negative while it is being printed. A scratch in the negative will print as a thin white line.

Black spots or hairs are usually the result of dust on the negative while the exposure is being made. Black dots, commonly called "pinholes," can often be attributed to improper darkroom processing.

In many cases the photographer chose to apply special pigments (such as "Spotone") to these spots by hand. Experts can effectively cover up these specks and imperfections, but if these pigments are not carefully applied, the spots will still stand out. Such carelessness will lower the condition grade. If white spots are so prominent that they detract from the image's aesthetic quality, the grade may once again suffer.

Score: Neutral (0), -0.5, or -1.0

Section 3: Rarity

Score	Rating	Description
5	Unique	One of a kind or scholarly evidence suggesting probability that this print is unique (for example: if five vintage prints of a certain image are known to exist and four of these are in permanent museum collections, the remaining print would score 5 points)
4	Rare	One of approximately twenty or less known to exist on the market (outside permanent museum collections)
3	Uncommon	More than approximately twenty but less than approximately 100 (these prints occasionally appear at auction)
2	Available	More than approximately 100 but less than approximately 400 (these prints may appear at auction)
1	Common	More than approximately 400 (includes prints that are "made-to-order" and are generally known to exist in large numbers)
		Commonly available through galleries

Qualifying Factors

Historical importance: An image can receive a higher grade if it is important in terms of political history, ethnographic history, the history of exploration, the history of science and invention, or the history of art and photography.

Score: Neutral (0), +0.5, or +1.0

Section 4: Photographer Status

Score	Rating	Description
5	Greatest masters	The top 30
4	Masters	The top 100
3	Important	The top 200
2	Potential	The top 300
1	Formative	Includes many young contemporaries, unknowns, and anonymous photographers

Qualifying Factors

Score may be raised in the case of an anonymous photographer whose work is of high quality but who has not yet been researched, identified, or rediscovered. This may also be the case with undiscovered photographers from the nineteenth and twentieth centuries and young contemporaries who show promise.

Printer: The issue of vintage vs. non-vintage prints again points out the importance of authentication. Did the photographer who made the negative also make the print? It is important to point out that throughout the nineteenth and twentieth centuries some master photographers did not make their own prints but assigned this task to assistants working directly under their supervision. Brady, Kertesz, and Cartier-Bresson are examples of masters who worked in this way. Today's masters often employ master printers with whom they work closely. Therefore each print must be judged individually.

Signature: Handsigning of photographs is largely a twentieth-century practice but it is quite common to see many prints by masters unsigned. A signature can enhance value.

Score: Neutral (0), or ± 0.5

With the exception of Aesthetic Quality, each category uses a simple 1 to 5 incremental grading system. Since Aesthetic Quality is such an important and influential factor, its scoring system is based on a 0 to 11 geometric progression. This system was chosen after extensive experimentation with alternative systems and after careful consideration of as many grading factors as possible. Within grading categories a certain amount of flexibility has been provided in the Qualifying Factors which can raise or lower the category grade by as much as a point or half a point.

As mentioned above, the system is designed to be used to grade specific prints after thorough examination. Each photograph is rated separately in each of the four categories: Aesthetic Quality, Physical Condition, Rarity, and Photographer Status. Each rating should also take into account any positive or negative Qualifying Factors. After a grade has been determined for each category, turn to the Scoring Index to find out how that particular print has rated as a whole.

In the case of a low score, it is important to review each grading category to identify which factors created the low score. If all categories scored low, the indication is that the print should be closely re-examined or rejected.

A rare image of high aesthetic quality in excellent condition but made by an anonymous photographer could rate a low grade simply because of a low rating in the Photographer Status category. In this case the prospective buyer would consider other Qualifying Factors and then return to the Aesthetic Quality category before making the final decision. At this point the price of the print may also play a decisive role.

Finally, as the science of image restoration advances and achieves a higher success rate, certain prints that scored high in all categories except Physical Condition have the potential to rate higher in overall standing.

How the Grading System Works

35

Scoring Index

Total Score	Description
20 and above	Undoubtedly an important image Highest probability that this is an excellent choice
17–19	Could be an excellent choice but check each category grade again before making any final decision: are all categories rated fairly high or is only one category very low?
14–16	Exercise caution: weigh all grading factors again Was there one area in which the print received a very low score or are all of the categories generally graded in the medium to low range? Perhaps not the best choice if you are intent on owning work by this photographer
13 and under	It should be noted that the work of many contemporary and anonymous photographers will fall into this category. The final purchase decision will depend on the opinion of the buyer. Note, however, that if the print in question is the work of a well-known photographer, it should probably be avoided.

Selecting for the Portfolio

Portfolio Selections 1

The selection suggestions which appear in this chapter are based upon only one of the Selection Criteria: Photographer Status. It is essential to note that even for the few masters to be covered here, it is possible that a considerable number of individual prints by these masters could score low on the grading system proposed in the last chapter. For this reason the potential buyer must consult *all* of the Selection Criteria before making his decision.

Basically the strategy for Portfolio Selections I is to concentrate on a smaller number of master photographers (approximately sixty are listed) whose works have generally ranked high in all of the Selection Criteria. Those photographers marked with an asterisk are ones whose work is especially recommended for closer examination. In addition, certain photographers have been omitted not because they are unimportant but because their works are extremely rare and seldom available for purchase.

There are certainly many more important and potentially important photographers than are listed here. In *The Magic Image*, Sir Cecil Beaton and Gail Buckland selected 209 masters for discussion. In *Looking at Photographs*, John Szarkowski, Head Curator of Photography at the Museum of Modern Art, illustrated and discussed 101 masters selected from the museum's massive permanent collection. *The Photograph Collector's Guide* by London and Witkin includes 234 illustrated biographical profiles on photographers whom the authors consider to be the medium's most important masters.

Young Contemporaries

In all of the fine arts, works by young contemporaries are the most speculative. This area should be approached only by the collector who is buying for aesthetic reasons and remains unconcerned with liquidity restrictions. The market for works by young contemporary photographers has been growing, however, and should not be overlooked. The largest gallery currently dealing exclusively in contemporary photographers, Light Gallery (New York), recorded sales of $1.75 million last year.

Due to the highly speculative nature of collecting young contemporaries as investment, they have been omitted from this selection study.

Older Contemporaries

Most conspicuous by their absence is a group of well-known, older living contemporaries, omitted despite the fact that they are actively sought by collectors and have appeared fairly consistently at auction over the past five years. (See Auction Price Results.) This group includes such respected photographers as Richard Avedon, Bill Brandt, Harry Callahan, Paul Caponigro, Duane Michals, Lisette Model, Barbara Morgan, Eliot Porter, Arthur Rothstein, Aaron Siskind, Frederick Sommer, George Tice and others. These photographers have produced some remarkably fine work which the serious collector should consider. They have been omitted here because it is felt that sufficient time has not elapsed to allow placing their work in clear perspective for a conservative acquisition plan.

For the works of certain older contemporaries (those produced about four decades ago), collectors will be given a clearer perspective, one which owes less to the promotional efforts of galleries during the past decade. To avoid any conflict of interest and to keep this market analysis as objective as possible, most living photographers have been excluded. Surely many photographers will continue to be newly promoted or "rediscovered," but a clear historical and marketing perspective can come only with time.

**Portfolio Selections 2:
A Brief Survey
of Undervalued Areas**

It would be impossible to list here every photographer over the past 140 years whose output merits attention. For the sake of brevity, we will focus upon those photographers whom we consider underrated and whose best works can be expected to increase tremendously in value during the 1980's.

Photographica

In the unique images such as daguerreotypes and ambrotypes, look for occupational genre, outdoor scenes, and images of unusual subject matter. Straight portraiture is most abundant and is of little value unless the subject is an important personality. The same advice applies to *cartes-de-visite* and cabinet cards of which millions were mass-produced. (Abraham Lincoln and the American Indian are among the most sought after American subjects.)

The new collector would do best to concentrate on stereo views. Most of the great nineteenth century photographers famous for their large landscape views also set up a stereo camera wherever they were shooting. As a result, the new collector can buy fine works at a fraction of the cost of the large prints by such greats as Carleton Watkins, John Moran, Timothy O'Sullivan, John

Portfolio Selections 1

Nineteenth-Century Masters

Period	Photographer
Formative	Important daguerreotypes
Civil War	Barnard, George N.
	Brady, Mathew B.
	Gardner, Alexander
	O'Sullivan, T. H.
American West	* Curtis, Edward S.
	* Muybridge, Eadweard
	* O'Sullivan, T. H.
	* Watkins, Carleton E.
Early British	* Cameron, Julia Margaret
	Carroll, Lewis
	Emerson, Peter Henry
	Fenton, Roger
	Hill & Adamson
	Sutcliffe, Frank M.
	Talbot, W. H. Fox
Early French	Bayard, Hippolyte
	Bisson Frères
	* LeGray, Gustave
	LeSecq, Henri
	* Nadar
	Negre, Charles
Middle East	DuCamp, Maxime
	Fenton, Roger
	* Frith, Francis
	Salzman, August
Far East	Beato, Felice
	Miller, M.
	Thomson, John

Twentieth-Century Masters

Period	Photographer
Turn Of The Century and Photosecession	* Atget, Eugene
	Demachy, Robert
	Genthe, Arnold
	Hine, Lewis
	Kasebier, Gertrude
	Schutze, Eva Watson
	* Steichen, Edward
	* Stieglitz, Alfred
	White, Clarence
Teens, 1920's and 1930's	Abbott, Berenice
	Brassai
	* Cartier-Bresson, Henri
	Cunningham, Imogen
	* Evans, Walker
	Kertesz, Andre
	* Man Ray
	Moholy-Nagy, Lazlo
	Sander, August
	* Sheeler, Charles
	* Steichen, Edward
	* Stieglitz, Alfred
	* Strand, Paul
	Sudek, Josef
	* Weston, Edward
1940's to 1970's	* Adams, Ansel
	Arbus, Diane
	Bullock, Wynn
	* Frank, Robert
	Penn, Irving
	* Smith, W. Eugene
	White, Minor

Hillers, and William Bell, to mention only a few of the most sought after names. Many of the views which cost 25 cents five years ago may now cost $5–$10. (Many are still worth only 25 cents!) Excellent views by Watkins and Moran are now selling in the $50–$75 range and still climbing.

(Photographica, in particular the daguerreotype, has been only briefly covered in the Portfolio Selection listings. A thorough analysis of the photographica market will appear in a subsequent report.)

Nineteenth-Century American

Works from the first fifty years of photography in America are without a doubt the most undervalued segment of the market today. The collector should look for large format albumen prints of the collodian wetplate era: 1850's to 1870's. Some of the names are now well-publicized: Carleton Watkins, William H. Jackson, Mathew Brady, and Alexander Gardner. However, try to find good landscapes by George Barnard, T.H. O'Sullivan, John Hillers, A.J. Russell, William Bell, and William Bradford (Dunmore and Critcherson.) These men produced some of the finest work of the nineteenth century. It is by and large greatly undervalued. George Barnard, for example, was not simply a documentary photographer who recorded General Sherman's destructive southern campaign. He possessed a very sophisticated vision and has been called "the poet of the Civil War."

William Notman was Canada's most prominent photographer, Alexander Henderson probably its most overlooked. Both men produced some excellent landscape views in the 1860's and these prints remain greatly undervalued today. Also of interest are Notman's unusual studio recreations of hunting and trapping scenes which date from the same period.

Watch for the best platinum prints of American Indians by Frank A. Rinehart, Karl Moon, Adam C. Vroman, and Edward Curtis. These prints constitute an important and often moving record of Native American civilization; moreover, their value should increase. The ubiquitous photogravures by Edward Curtis should be carefully authenticated since later reprints from original plates are common. As with most prints, a key factor in authentication is the type of paper used.

Nineteenth-Century Foreign

Fine calotype and salt prints by well-known masters are extremely rare, which accounts for the prices. Talbot, Hill and Adamson, Le Secq, Marville, Negre, Le Gray, DuCamp, Bayard and Baldus are all names to watch for.

The 1850's to the 1870's provide us with a second generation of great regional and travel photographers who mastered the difficult wetplate process, producing some fine albumen studies: MacPherson, Sommer, and Ponti in Italy; Laurent and Clifford in Spain; the Bisson Frères, Neurdein, Ferrier, and Quinet in France; Frith, Beato, Bonfils, Bedford, and Fenton in the Middle East; Bourne, Beato, and Thompson in the Far East. Some of these men were also successful publishers of volumes of portfolios which quenched the Victorian era's thirst for glimpses of exotic lands. In this country one is most likely to find such European photographs mounted in travel albums.

With all nineteenth century images *condition* is a key determining factor. Avoid photographs that have been improperly mounted because often the chemicals used in old glues have caused yellowing and staining damage. Paper is particularly susceptible to the ravages of time and many prints show up torn, scuffed, and creased. Remember that the name of a great photographer, however attractive, will not rectify these problems. Therefore avoid the many prints by notable photographers that are faded or in poor condition.

Turn-of-the-Century

One of the finest and most permanent of photographic media, reigning from the 1880's until World War I, was the platinum print. Peter Henry Emerson, often referred to as the father of the pictorialist aesthetic, produced some magnificent platinum prints that are now rare. The later photosecessionists also mastered the subtleties of platinum and various gum bichromate processes. Their original prints are also rare, but Alfred Stieglitz's publication, *Camera Work*, featured many excellent reproductions of their works in photogravure form. Issues containing works by Stieglitz, Steichen, and Strand are the most in demand. Excellent buys can still be had, however, on a number of the lesser known photosecessionists in gravure, platinum, or silver print form.

The Twentieth Century

Our own century presents a wide variety of photographers for consideration. Collectors would do well to take a close look at the original work of the photographers of the German Bauhaus and the New Bauhaus movements in America in the late 1930's and early 1940's. Prints from before 1930 which paralleled or anticipated original development in Constructivism or Surrealism should also gain in stature during the coming decade. Of course owning an original Weston, Strand, Stieglitz, or Steichen is considered by many collectors to be like owning a piece of the Holy Grail! Nonetheless, collectors would do well to explore the

monumental contributions made by such underappreciated giants as Minor White and Walker Evans.

Many of the best photographers also held commercial illustration jobs at various points in their careers. The fact that a certain fashion or industrial photograph or commercial portrait was executed by a very fine photographer does not automatically make this work a worthwhile investment or justify a high price. Certainly there are works of value in this category but, in general, their merits should be weighed very carefully. In a short time we may well see a flood of commercial photographs pour out of the files of the old magazine publishers and stock news photo companies.

Another topic that has continued to cause heated debate is that of the limited edition portfolio. The commercial concept of the limited edition portfolio was most successfully implemented by the Parisian art dealer Vollard in the early part of this century. Vollard's purpose was to substantiate pricing by creating rarity. Some dealers feel that this concept is a useful sales tool while others contend that it places unnecessary limitations on the photographer who could never "pull" an entire edition at once. Most photographers are unwilling to destroy their negatives upon completion of the edition. In many cases vintage prints are rare or non-existent, and therefore some collectors see later prints by the photographer or his assistant as the only realistic way to own the work of a prominent photographer.

Utmost caution should be exercised when considering posthumous editions. Reject those meaningless portfolios that have been cranked out by amateur printers carelessly and with little thought. In some cases certain vintage examples of a deceased photographer's work may be so rare and of such importance that a legitimate and well-planned portfolio by a master printer thoroughly familiar with the photographer's original intentions, can be of real value. But while some posthumous prints have been actively traded in the market, the novice collector would do well to concentrate mainly on vintage prints.

Preliminary Appraisal of One Master Photographer: Julia Margaret Cameron (1815-1879)

Historical Significance

Julia Margaret Cameron photographed the most illustrious men and women of the Victorian Age. Her portraits are among the most sought after works of the nineteenth century. The editor's foreword to *Julia Margaret Cameron* describes them as follows:

Startling in their originality and intensity, they reveal the very mind and soul of the in-

42

dividuals who sat before her camera. Rarely in the history of art has so much vitality and spirit been brought to portraiture.

Helmut Gernsheim, most noted as author of the text often referred to as the Bible of the field, *The History of Photography*, wrote the first monograph on Cameron in 1948. Since then Cameron's works have become an essential element of the photography collection of every major art museum.

Gernsheim accurately summarized the surge in interest in purchasing fine art photographs such as Cameron's:

Market Analysis

The demand for prints by the old masters of photography—virtually unsaleable in the auction rooms ten years ago—is greater than the supply. Britain felt the need to impose export restrictions to stop the drain of her photographic heritage across the Atlantic. The discovery of photography as a potential article of commerce for an undeveloped market led to the establishment of photographic galleries and dealers attracting the investor with the result that prices for photographs have risen faster than that of gold! In this photo-rush the work of Julia Margaret Cameron, in my opinion the greatest portrait photographer of the past century, inevitably experienced an unprecedented boom. (*Julia Margaret Cameron*, p. 9)

As expected, important works by Cameron in excellent condition have rarely appeared at auction since 1976. Images of importance in very good to excellent condition that brought from $400 to $800 at auction in 1975 can be expected to realize from $3,000 to $6,000 in 1981-82. Superb images can be expected to bring from $6,000 to $10,000 or more in 1981-82. Images of secondary importance but in good to excellent condition, or primary images in poorer condition, have generally hovered in the $800 to $1,200 range since 1977.

The key point to remember here is that auction prices are not always the most accurate gauge for measuring liquidity and market strength. Print *quality* and *condition* are the primary determinants of value. Their primacy is often what accounts for a wide difference in prices between two vintage prints made from the same negative.

This author thought it would be helpful to list a few of Cameron's images that he would consider highly for inclusion in a hypothetical portfolio. The examples are divided into two categories: the Pre-Raphaelite studies and portraiture of Victorian notables. The subjects noted below are but a few representing an important volume of her life's work that should be closely studied. Illustrations for these subjects can be found in the following publications:

Portfolio Selections

1. Gernsheim, Helmut. *Julia Margaret Cameron*. Millerton, N.Y. Aperture, 1975
2. Ovenden, Graham. *A Victorian Album*. New York: DaCapo Press, 1975

Portraiture of Victorian notables:
Sir Henry Taylor, 1867 (1, p.103)
Thomas Carlyle, 1867 (1, p.117)
Sir John Herschel, 1867 (1, p.121)
Lord Alfred Tennyson, 1867
 (1, p.142)
Sir Henry Taylor (2, p.19)

Pre-Raphaelite studies:
Mrs. Herbert Duckworth, 1867
 (1, p.149)
Alice Liddell, 1872 (1, p.158)
The Kiss of Peace, 1869 (1, p.167)
The Dirty Monk (Tennyson)
 (2, p.118)

Note: See Table 10, p.21: A partial auction record of prints by Julia Margaret Cameron

Disposition Strategy

Asophisticated disposition strategy usually involves establishing the art-work's provenance which, simply defined, is the lineage of ownership of the work. Yet in the art market, provenance can do more than just supply a history of past ownership. It is a kind of pedigree that substantiates the authenticity of the work and may increase its value. The large fine art auction houses have found that items sold from well-known collections or estates attract more active bidding and bring higher prices than the same items placed on sale with no provenance listing in the catalogue.

The reasons for wishing to liquidate a work of art or an entire collection are almost as numerous as the collectors themselves or their individual motivations for putting together a collection in the first place. In general, from the investment point of view, a reasonable holding period is from three to five years. One study in the modern print market has shown that optimum returns are achieved after a fifteen-year period. (See the study by Robert E. Penn in the fall 1980 issue of *The Journal of Portfolio Management*.)

Liquidity

Whatever the holding period and the reasons for liquidation, there are basically five possible avenues to pursue: auction, galleries, dealers, private collectors, and donation.

Auction

Pros: The print receives a great amount of public exposure through catalogue illustrations and the pre-sale exhibition period, thus attracting more potential buyers. Heated competition can drive prices high. Usually a higher price can be obtained at auction than with a forced liquidation sale to a dealer.

Cons: The work may sell at a very low price, near its established reserve. (The "reserve" is the price, agreed upon between the auction house and the seller, under which the work will not be sold.) Often, if a work fails to reach its reserve and is subsequently "bought-in," its credibility in the marketplace will be tainted, making it even harder to sell to a dealer.

Checkpoints: Does the sale date fit your financial needs? What is the house's commission percentage? (Most are now 10 percent of the sale.) Does the seller incur any extra fees for insurance against loss or damage? Will there be an illustration charge? Are the auction price estimates and the reserve bid realistic? (Reserves are usually set at 60 per cent of the low estimate.)

Dealer: Outright Purchase

Pros: Immediate payment, privately and discreetly handled.

Cons: In a forced liquidation one may have to accept a price at or below a low auction estimate. Negotiations may be difficult depending on the individual approach of both buyer and seller. It is best to work from a familiarity with the particular dealer's reputation. Also, overexposure of a print to too many dealers could risk its becoming "tainted" as can occur with a print that fails to sell at auction.

Gallery Consignment

Pros: Far better terms can often be arranged with a dealer since such an agreement involves no capital investment on his or her part. Commissions can be negotiated and will for the most part depend on the value and desirability of the print. Usually they range from 20 to 40 per cent. Since photographs are priced relatively low as compared to fine paintings, for example, the commission rate has tended to stay closer to 40 per cent. Generally this rate decreases as the value of the work increases.

Cons: There is no telling how long it will be before the item is sold. The seller could wait anywhere from a few days to a full year.

Checkpoints: Is there a written agreement concerning the dealer's percentage commission and a consignment termination date? Is the dealer fully insured against theft and damage? Are there any other related sales charges?

Collector: Private Purchase

Pros: Generally the highest price one can obtain is through a private sale to another collector.

Cons: This route may demand a great deal of personal time and effort. It is a realistic course only if one knows many other collectors who are potential buyers for a particular work. Advertising tends to attract only dealer inquiries.

Pros: Works of art that have appreciated in value can possibly have significant tax benefits if:
1. donated to a qualified non-profit institution such as a museum;
2. passed to one's heirs through a trust or as tax-free gifts;
3. purchased by a Pension and Profit-sharing Plan

Cons: The Internal Revenue Service is continually re-examining and revising its rulings on charitable and investment deductions. Proceed only with the advice of one's accountant and attorney.

Donation: Possible Tax Advantages

Adams, Ansel. *Basic Photo Series: The Print.* New York: 1948-1956.

Beaton, Cecil, and Gail Buckland. *The Magic Image: The Genius of Photography From 1838 to the Present Day.* Boston: Little Brown, 1975.

Blodgett, Richard. *Photographs: A Collector's Guide.* New York: Ballantine, 1979.

Eder, Joseph. *The History of Photography.* New York: Columbia University, 1945.

Gernsheim, Helmut. *The History of Photography: From The Earliest Use of the Camera Obscura in the Eleventh Century Up to 1914.* New York: McGraw Hill, 1969.

Julia Margaret Cameron. Millerton, N.Y.: Aperture, 1975.

Green, Jonathan. *Camera Work: A Critical Anthology.* Millerton, N.Y.: Aperture, 1973.

Naef, Weston. *The Collection Of Alfred Stieglitz: Fifty Pioneers Of Modern Photography.* New York: Metropolitan Museum of Art, 1978.

Era Of Exploration: The Rise Of Landscape Photography In The American West, 1860-1885. New York: Metropolitan Museum Of Art, 1975.

Newhall, Beaumont. *The History Of Photography From 1838 To The Present Day.* New York: Museum of Modern Art, 1964.

Ovenden, Graham. *A Victorian Album.* New York: DaCapo Press, 1975.

Pollack, Peter. *The Picture History of Photography: From the Earliest Beginnings to the Present Day.* Rev. ed. New York: Museum of Modern Art, 1969.

Scharf, Aaron. *Art and Photography.* Baltimore: Penguin, 1969.

Pioneers of Photography. New York: Abrams, 1976.

Szarkowski, John. *Looking at Photographs: 100 Pictures From the Collections of the Museum of Modern Art, 1976.*

Taft, Robert. *Photography and the American Scene: A Social History, 1839-1899.* Rev. ed. New York: Dover, 1964.

Welling, William. *Photography In America: The Formative Years: 1839-1900.* New York: Crowell, 1978.

Witkin, Lee, and Barbara London. *The Photograph Collector's Guide.* New York: New York Graphic Society, 1979.

Auction Price Results for 1980-81

This listing of auction price results covers the 1980-81 season for North America, which runs from October through May. There are ten information columns that refer to the specific auction lot. A blank space or an "X" in any column means that the information was not available in the auction catalogue or was unknown.

Our information may differ from auction catalogue descriptions where our researchers found that catalogue information to be inaccurate or incorrect. In addition, last-minute catalogue changes are often announced by the auctioneer just prior to the sale. Prints entered in the catalogue but withdrawn prior to the sale are not listed.

Photographer: The photographer's last name is listed first. When a slash (/) separates two photographers' names, the first name refers to the maker of the negative and the second name refers to the printer, e.g.:

WESTON, EDWARD/ COLE = negative by Edward Weston; print by Cole Weston.

ATGET, E./ ABBOTT, B. = negative by Eugene Atget; printed later by Berenice Abbott.

Today, many well-known photographers employ master printers to produce limited editions from their original negatives, under their personal supervision. While many of these printers are known to us, a complete and accurate listing, applied to the appropriate prints sold at auction, would be impractical and incomplete at this time.

There are some cases where a listing under subject matter is of more importance than the photographer, although the photographer's name, if known, will appear in the next information field. Examples:

AMERICANA
DAGUERREOTYPIST UNKNOWN
FAR EAST
VICTORIANA

Title: If available, the actual title will be entered. Since the auction houses often differ in their catalogue titles or descriptions for the same image, every effort has been made to describe identical images under one accurate and acceptable title.

Albums: Albums of photographs are often excluded unless they are composed of works primarily by one photographer, or works which share common subject matter. Mixed topographical albums containing prints by a large number of photographers would demand lengthy, complicated descriptions and have therefore been omitted here.

Books: Photographic literature has been largely omitted except in the case where original vintage prints have been mounted to the page or bound in, e.g.:

> Emerson, Peter Henry. *Life and Landscape of the Norfolk Broads* (1886)
> Curtis, Edward S. *The North American Indian* (1907-1930)

Photogravures: Photogravures are usually entered only as individual prints or as a complete bound volume. Small groups of mixed photogravures, even by a single photographer, have not been entered owing to the possible wide range of image subject matter, quality, and physical condition.

Edition Size: The edition size, if known, is entered after the letters "ED." For example, "ED:21/50" refers to the twenty-first print from an edition of fifty prints having the same dimensions. Historically, the practice of printing multiple editions from the same negative, in various sizes, is rare. However, the late 1970's has produced a few exceptions. In 1979, for instance, ten negatives of George Hurrell portraits originally made in the 1920's, 30's, and 40's were printed under Hurrell's supervision for limited edition portfolios of three different measurements.

Sometimes planned edition sizes are never completed. In 1975, for example, Minor White planned the "Jupiter Portfolio" to be produced in a limited edition of 100. However, only 70–75 are known to have been produced. Edward Weston is also known to have planned editions of up to 50 prints but often these were never completed.

Bibliographical References: Abbreviations for reference books, with page number, are listed where they are of use in identifying images with similar or undescriptive titles. For instance, Bill Brandt often titles many different images from his female nude series simply as "Nude." Such images need further identification to be of use in this auction record.

Photographer	Abbreviation	Title of Book
Brandt, Bill	Persp of Nudes	*Perspective of Nudes* (1971)
	Shad of Light	*Shadow of Light* (1966)
Boubat, Edouard	Woman	*Woman–Edward Boubat Woman* (1973)
Callahan, Harry	Cal	*Callahan* (1976)
Cartier-Bresson	C-B	*The World of Henri Cartier-Bresson* (1968)
Curtis, Edward S.	N.A.I.	*The North American Indian* (1907–1930)
Frank, Robert	Americans or AM	*The Americans* (1958)
	Frank	*Aperture History of Photography: Robert Frank* (1978)
	Lines	*The Lines of My Hand* (1972)
Kertesz, Andre	Kertesz	*Kertesz* (1972)
Stieglitz (Editor)	Cam Wrk or CW	*Camera Work* (1903–1916)

Additional Abbreviations:

ATT or ATTRIB	attributed to
ED	edition
EX. LAB.	exhibition label
FR	from
LETTER-AUTH	letter of authenticity
PL	plate: original print, once probably bound into a book.
P or PR	print
V	view

This field states the date of of the auction: month/year. **Column 3: Date**

CNY	Christie's East, New York	**Column 4: Auction House**
PNY	Phillips, New York	
PT	Phillips Ward-Price, Toronto	
SLA	Sotheby's, Los Angeles	
SW	Sotheby's, New York	
SW	Swann Galleries, New York	

This number is entered for easy reference to the particular auction catalogue's description, illustration, or pre-auction estimate. **Column 5: Lot Number**

Column 6: Print Type

A	Albumen print
AM	Ambrotype
AS	Albumenized salt print
B	Bromoil, an oil pigment print
C	Calotype, also referred to as talbotypes
CN	Carbon print, also referred to as autotypes
CO	Carbro print; can include multiple pigments
CP	Color print, usually a Type-C print; sometimes a color polaroid print
DT	Dye-transfer print (color)
D	Daguerreotype
F	Fresson print (a special color process)
GB	Gum-bichromate, or just "bichromate," usually formed of water-color dye
MP	Mixed processes; possibly oil paint, watercolor, pencil, or other mediums combined on the surface of the photograph
O	Orotone, image on glass, backed by a gold lacquer; also referred to as a gold-tone; used by Edward S. Curtis
P	Platinum or palladium print; or a combination of the two
PD	Photogenic drawing, similar to the modern-day "photogram; " invented by Talbot
PG	Photogravure

PI	Other pigment process; could include gum-bichromate process
PO	Printing-out paper, often used by Atget (sepia-toned silver prints c. 1900 often closely resemble albumen prints)
PP	Other photomechanical processes such as the collotype, galvanotype, half-tone, or photolithograph
S	Silver print, the standard black and white print as it is commonly known today
SA	Salt print (preceded the albumen print)
T	Tintype
W	Woodburytype, a fine photomechanical printing process

Column 7: Dimensions

Measurements are entered in inches according to image size, not paper size. Height always precedes width. Fractions have been rounded off to the nearest whole figure. For example: 13-3/4″ × 10-1/4″ = 14″ × 10″

CABINET	Cabinet card: usually a 4 × 5-1/2-inch albumen print mounted on the photographer's 4-1/4 × 6-1/2-inch studio card
CDV	Carte-de-visite: usually a 2-1/4 × 3-1/2-inch albumen print mounted on the photographer's 2-1/2 × 4-inch studio card
MAMMOTH	Mammoth print: usually 16 × 20 inches or 15 × 19 inches; the term refers to large landscape prints of the 19th century. If the specific measurements are not stated in the auction catalogue, the term "Mammoth" is usually entered for these large prints.
STEREO	Stereoview, also referred to as a stereograph; sometimes appear in glass positive or daguerreotype form, but usually found as two albumen prints mounted on the photographer's 3-1/2 × 7-inch studio card.
VARIOUS	Various dimensions, probably referring to an album or a portfolio where the prints are of various measurements.
WH-PL	Whole-plate (6-1/2 × 8-1/2 inches)
1/2-PL	Half-plate (4-1/2 × 6-1/2 inches)
1/4-PL	Quarter-plate (3-1/2 × 4-1/4 inches)
4TO	Quarto: page size approximately 9 × 12 inches; often refers to *Camera Work* photogravures.
8VO	Octavo: page size approximately 6 × 9 inches.

Column 8: Negative/Print Dates

The date the negative was made is separated from the date of the print by a slash (/). The print date may be entered simply as a "V" (vintage) or as an "L" (later print, in most cases, one made after the late 1960's). C = circa.

A	Annotations: marks, often on the back of the print (verso) that are often negative numbers or the photographer's notes, as opposed to a more specific title (T) or inscription (I)	**Column 9: Identification Marks/ Condition**
D	Dated	
I	Inscription: usually a brief dedication inscribed by the photographer, or the photographer's own description of the photograph that is more detailed than the title (T)	
IN	Inscribed in the negative; usually a title or negative number that has been scratched into the negative, thus appearing printed in the photograph	
PD	Bearing a mechanically printed description; probably from a book or portfolio edition (this entry usually refers to prints that have been mounted to a page)	
S	Signed by the photographer	
SN	Signed in the negative, not on the surface of the print	
ST	Stamped: bears the photographer's studio stamp, copyright stamp, or blind-stamp; may also refer to a special label affixed to the print or mat	
T	Titled	

Physical Condition: The entry for physical condition is always separated from the identification marks by a slash (/). Physical condition is based only upon our first-hand inspection of each print. A number of prints may be in "excellent" condition relative to the specimens that have usually surfaced; but our grading system does not reflect any leniency toward such examples, regardless of rarity, aesthetic quality, or the importance of the photographer. Many prints would have achieved excellent or mint ratings had it not been for one small but, in our opinion, significant flaw. Such examples were usually lowered by one notch in the grading system. (Note also that some prints offered at auction are framed, making examination of the whole print impossible. In such cases, damage to the edges or corners could go undetected. Also, trimmed prints, while infrequent, are sometimes difficult to spot.)

M	Mint	G	Good	P	Poor
E	Excellent	F	Fair		

An explanation of the criteria upon which physical condition is graded can be found in Chapter 4, "The Falk-Leeds Photography Grading System."

All dollar amounts refer to the auctioneer's *hammer price*. For the actual amount paid, add the standard 10 percent buyer's premium instituted at all of the major houses by 1979.

 All figures are in U.S. dollars, with the exception of Phillips Ward-Price of Toronto (PT), which is in Canadian dollars.

 Any lot that failed to be sold is entered as "BI" (bought-in).

Column 10: Auction Price Result

PHOTOGRAPHER	TITLE OR DESCRIPTION	DATE	AH	LOT#	PT	SIZE	N/P DATES	MARKS/COND.	PRICE
ABBOTT, BERENICE	"CHICKEN MARKET"	2/81	SLA	1	S	10 X 8	1937/V	S,T,D,ST	600
ABBOTT, BERENICE	"EL AT BATTERY"	2/81	SLA	2	S	16 X 20	1930'S/L	S,ST	1,000
ABBOTT, BERENICE	"EL, 2ND & 3RD AVENUE LINES"	2/81	SLA	3	S	10 X 8	1936/V	ST	400
ABBOTT, BERENICE	NEWSSTAND	2/81	SLA	4	S	11 X 14	1930'S/L	S,ST	700
ABBOTT, BERENICE	WAREHOUSE, LOWER MANHATTAN	2/81	SLA	5	S	11 X 14	1936/L	S,ST	450
ABBOTT, BERENICE	"NEW YORK, 5TH AVE. AT 8TH ST."	2/81	SLA	6	S	13 X 11	1930'S/L	S,ST	650
ABBOTT, BERENICE	"NEW YORK BY NIGHT"	2/81	SLA	7	S	13 X 11	1934/L	S,ST	1,300
ABBOTT, BERENICE	PORTRAIT:SOLITA SOLANO	2/81	SLA	8	S	10 X 8	1920'S/L	S,ST	200
ABBOTT, BERENICE	JEAN COCTEAU WITH MASK	2/81	SLA	9	S	11 X 14	1920'S/L	S,ST	450
ABBOTT, BERENICE	TRANSFORMATION OF ENERGY	4/81	PNY	97	S	10 X 13	1958/L	S,ST	BI
ABBOTT, BERENICE	MAGNETIC FIELD	4/81	PNY	98	S	14 X 10	1958/L	S	BI
ABBOTT, BERENICE	SPINNING WRENCH	4/81	PNY	99	S	4 X 20	1958/L	S,ST	BI
ABBOTT, BERENICE	"HANDS OF COCTEAU"	5/81	CNY	136	S	8 X 10	C1926/L	S,T,ST/M	950
ABBOTT, BERENICE	"CANYON" (NEW YORK CITY)	5/81	CNY	137	S	14 X 11	1936/V	S,T/F	1,000
ABBOTT, BERENICE	NEW YORK AT NIGHT (ED: 54/60)	5/81	CNY	138	S	23 X 18	1936/80	S,A,ST/M	3,200
ABBOTT, BERENICE	"NY, 5TH AVE. AT 8TH ST." (ED: 54/60)	5/81	CNY	139	S	18 X 23	1936/80	S,A,ST/M	1,700
ABBOTT, BERENICE	PENNSYLVANIA STATION, NEW YORK	5/81	CNY	140	S	10 X 8	1936/70'S	S,ST	850
ABBOTT, BERENICE	BUTCHER SHOP, NEW YORK	5/81	CNY	141	S	8 X 10	C1936/V	S,ST	380
ABBOTT, BERENICE	DEER	5/81	PNY	100	S	10 X 8	1930'S/L	S,ST	BI
ABBOTT, BERENICE	NEW YORK AT NIGHT	5/81	PNY	101	S	14 X 11	C1935/L	S,ST/M	1,050
ABBOTT, BERENICE	PENNSYLVANIA STATION	5/81	PNY	102	S	10 X 8	C1935/L	S,ST/G	450
ABBOTT, BERENICE	TOWNHOUSE FACADES	5/81	PNY	103	S	8 X 10	C1935/V	S,ST/E	450
ABBOTT, BERENICE	DOORWAY:TREDWELL HOUSE, MANHATTAN	5/81	PNY	104	S	9 X 7	1937/V	T,D,ST/F	150
ABBOTT, BERENICE	VIEW S.W. TO MANHATTAN ON MANH. BRIDGE	5/81	PNY	105	S	8 X 10	1937/V	T,D,ST/G	BI
ABBOTT, BERENICE	WALL STREET, MANHATTAN	5/81	PNY	106	S	10 X 5	1938/V	S,D,T,ST/G	BI
ABBOTT, BERENICE	GEORGE WASHINGTON BRIDGE	5/81	SNY	316	S	19 X 15	1930'S/L	S,ST/E	300
ABBOTT, BERENICE	"PUCK BUILDING"	5/81	SNY	317	S	16 X 7	1931/V	T,D,ST	550
ABBOTT, BERENICE	"NEW YORK BY NIGHT"	5/81	SNY	318	S	13 X 11	1934/50'S	S,I,ST	BI
ABBOTT, BERENICE	"WAREHOUSE, LOWER MANHATTAN"	5/81	SNY	319	S	11 X 14	1936/L	S,ST/F	600
ABBOTT, BERENICE	"AROUND THE CORNER FROM STOCK EXCH."	5/81	SNY	320	S	10 X 8	1940'S/V	S,ST/G	300
ABBOTT, BERENICE	"NEW YORK, 5TH AVE. AT 8TH ST."	5/81	SNY	321	S	11 X 14	1930'S/L	S,ST/G	1,200
ABBOTT, BERENICE	"SHOP AT GREENWICH AVE. & W. 10TH ST."	5/81	SNY	322	S	8 X 10	1930'S/L	S,ST/E	200
ABBOTT, BERENICE	"EXCHANGE PLACE"	5/81	SNY	323	S	14 X 4	1930'S/L	S,ST/M	700
ABBOTT, BERENICE	"NEW YORK BY NIGHT"	5/81	SNY	324	S	14 X 11	1934/L	S,ST/F	950
ABBOTT, BERENICE	SEASCAPE	5/81	SNY	325	S	10 X 13	C1960/V	S,ST/P	400
ABBOTT, BERENICE	PORTRAIT: JAMES JOYCE	5/81	SNY	326	S	9 X 8	1920'S/L	S,T,ST/E	600
ABBOTT, BERENICE	PORTRAIT: JAMES JOYCE	5/81	SNY	326A	S	14 X 10	1920'S/L	S,ST/P	650
ABBOTT, BERENICE	PORTRAIT: JAMES COCTEAU WITH MASK	5/81	SNY	327	S	7 X 5	1927/V	T,ST/P	450
ABBOTT, BERENICE	PORTRAIT: JOHN SLOAN	5/81	SNY	328	S	9 X 8	1930'S/L	S,ST/M	150
ABBOTT, BERENICE	PORTRAIT: EDWARD HOPPER	5/81	SNY	329	S	14 X 11	1930'S/L	S,ST/M	250
ABBOTT, BERENICE	PORTRAIT: EUGENE ATGET	10/80	PT	156	S	13 X 10	C1920/60'S	S	300
ABBOTT, BERENICE	PORTRAIT: JAMES JOYCE	10/80	PT	157	S	14 X 11	1928/L	S	575
ABBOTT, BERENICE	PORTRAIT: MRS. RAYMOND MASSEY	10/80	PT	158	S	13 X 10	1920'S/50'S	S,ST	300
ABBOTT, BERENICE	CENTRE STREET, NEW YORK	10/80	PT	159	S	15 X 19	1930'S/L	S	400
ABBOTT, BERENICE	CHILDREN'S & SOCIETY SUMMER HOMES, NY	10/80	PT	160	S	8 X 10	1936/V	S,T,D ST	BI
ABBOTT, BERENICE	"NEW YORK, 5TH AVE. AT 8TH ST."	10/80	PT	161	S	11 X 13	1936/L	S,ST	600
ABBOTT, BERENICE	AVENUE D AND EAST 10TH ST., MANHATTAN	10/80	PT	162	S	8 X 10	1937/V	S,T,D,ST	375
ABBOTT, BERENICE	"TRANSFORMATION OF ENERGY"	10/80	PT	163	S	11 X 13	1961/L	S	BI
ABBOTT, BERENICE	NEW YORK AT NIGHT	11/80	CNY	385	S	23 X 18	1936/1980	S,ST	BI
ABBOTT, BERENICE	NEW YORK AT NIGHT	11/80	CNY	386	S	13 X 10	1936/1970'S	S,ST	950
ABBOTT, BERENICE	"NEW YORK, 5TH AVE. AT 8TH ST."	11/80	CNY	387	S	18 X 23	1936/1970'S	S,ST	1,100
ABBOTT, BERENICE	TREASURY BUILDING FR. J.P. MORGAN'S...	11/80	CNY	388	S	20 X 16	1930'S/70'S	S,ST	700
ABBOTT, BERENICE	ROTHMAN'S PAWNSHOP	11/80	CNY	389	S	20 X 15	1930'S/70'S	S,ST	500
ABBOTT, BERENICE	PORTRAIT: JOHN SLOAN	11/80	CNY	389A	S	10 X 7	C1932/V	S,ST	BI
ABBOTT, BERENICE	SOUTH STREET SEAPORT	11/80	CNY	390	S	8 X 10	1930'S/70'S	S,ST	BI
ABBOTT, BERENICE	PORTRAIT: JAMES JOYCE	11/80	CNY	391	S	15 X 10	1920'S/70'S	S	700
ABBOTT, BERENICE	EL AT COLUMBUS AVENUE AND BROADWAY	11/80	CNY	392	S	9 X 12	1929/1970'S	ST	320
ABBOTT, BERENICE	"CIGAR STORE INDIAN, UNION SQUARE NYC"	11/80	PNY	289	S	7 X 9	C1935/V	S,T,ST	500
ABBOTT, BERENICE	"BROADWAY & THOMAS ST., MANHATTAN"	11/80	PNY	290	S	8 X 10	1936/V	S,T,ST	450
ABBOTT, BERENICE	"OAK AND NEW THOMAS STREET, N.Y."	11/80	PNY	291	S	6 X 6	1935/V	ST,T,D	700
ABBOTT, BERENICE	"BATTERY PARK"	11/80	PNY	292	S	8 X 10	C1935/V	S,ST	475

PHOTOGRAPHER	TITLE OR DESCRIPTION	DATE	AH	LOT#	PT	SIZE	N/P DATES	MARKS/COND.	PRICE
ABBOTT, BERENICE	"RAILWAY STATION"	11/80	PNY	293	S	5 X 7	1929/V	ST	450
ABBOTT, BERENICE	PORTRAIT: JAMES JOYCE	11/80	SNY	304	S	14 X 10	1920'S/L	S	800
ABBOTT, BERENICE	"NEW YORK, 5TH AVE. AT 8TH ST."	11/80	SNY	305	S	16 X 20	1930'S/L-	S	1,600
ABBOTT, BERENICE	NEW YORK BY NIGHT	11/80	SNY	306	S	13 X 11	1934/L	S,ST	1,800
ABBOTT, BERENICE	"EXCHANGE PLACE"	11/80	SNY	306	S	20 X 5	1930'S/L	S,ST	1,500
ABBOTT, BERENICE	LYRIC THEATRE	11/80	SNY	308	S	15 X 20	1930'S/L	S,ST	1,200
ABBOTT, BERENICE	"NORA JOYCE"	11/80	SW	224	S	10 X 8	1927/C30	ST	BI
ABBOTT, BERENICE	"DJUNA BARNES"	11/80	SW	222	S	9 X 8	1926/L	S,ST	BI
ABBOTT, BERENICE	"MADAME ANDRE SALMON"	11/80	SW	223	S	9 X 7	1926/V	ST	BI
ABBOTT, BERENICE	"RENE CREVEL"	11/80	SW	225	S	9 X 7	1928/V	ST	300
ABBOTT, BERENICE	"SCENE UNDER EL" (HORSE & CART)	11/80	SW	226	S	11 X 11	1935/L		850
ABEE, JAMES	DORA DUBY (10 PRINTS)	4/81	PNY	153	S	10 X 7	1920'S/V	S,ST	250
ADAMS, ANSEL	"COAST AND SURF, TIMBER COVE"	2/81	SLA	11	S	11 X 14	50'S/60'S	S,T,ST	1,500
ADAMS, ANSEL	"ASPENS, NORTHERN NEW MEXICO"	2/81	SLA	12	S	19 X 15	1958/L	S,D,ST	3,200
ADAMS, ANSEL	"SUNRISE, MT. TOM, SIERRA NEV., CAL."	2/81	SLA	13	S	16 X 19	C1948/L	S,I,ST	1,300
ADAMS, ANSEL	"MT. WILLIAMSON FR. MANZANAR, CA."	2/81	SLA	14	S	15 X 19	1944/59-63	S,T,ST	1,700
ADAMS, ANSEL	WINTER SUNRISE:SIERRA NEV...	2/81	SLA	15	S	13 X 20	1944/59-63	S,T,D,ST	6,000
ADAMS, ANSEL	"WHITE GRAVESTONE"	2/81	SLA	16	S	14 X 10	1933/L	S,T,ST	550
ADAMS, ANSEL	"MOONRISE, HERNANDEZ, NEW MEXICO"	2/81	SLA	17	S	15 X 20	1941/L	S,ST,T	6,500
ADAMS, ANSEL	"ANSEL ADAMS, IMAGES, 1923-1974"	2/81	SLA	18	S	12 X 9	1961/L	S	1,200
ADAMS, ANSEL	SAGUARO CACTUS, ARIZONA (1942)	4/81	PNY	9	S	14 X 11	1942/1970'S	S	BI
ADAMS, ANSEL	MAROON BELLS, NEAR ASPEN, COLORADO	4/81	PNY	10	S	16 X 20	1951/1974	S,ST,T	1,100
ADAMS, ANSEL	WHITE POST & SPANDREL, COLUMBIA, CA.	4/81	PNY	11	S	19 X 14	1953/1970'S	S,ST,T	500
ADAMS, ANSEL	GOTARDO PIAZZONI (ED: 110)	4/81	SW	286	S	16 X 20	C1932/L	S,A,ST	BI
ADAMS, ANSEL	MOONRISE, HERNANDEX, NEW MEXICO	4/81	SW	287	S	11 X 14	C1941/L	S,ST,T	BI
ADAMS, ANSEL	MOONRISE, HERNANDEZ, NEW MEXICO	5/81	CNY	170	S	15 X 19	1941/70'S	S,ST,T/M	BI
ADAMS, ANSEL	CLEARING WINTER STORM, YOSEMITE PARK	5/81	CNY	171	S	16 X 19	1944/70'S	S,ST,T/M	7,500
ADAMS, ANSEL	ALFRED STIEGLITZ AT AMERICAN PLACE, NY	5/81	PNY	259	S	11 X 8	1935/L	S,T,D,ST/G	550
ADAMS, ANSEL	"TREE AND CLIFFS, SIERRA NEVADA, CAL"	5/81	SNY	410	S	6 X 8	C1929/V	S/M	400
ADAMS, ANSEL	PUEBLO WOMAN, NEW MEXICO	5/81	SNY	411	S	9 X 6	1929/30	S,D,I/M	750
ADAMS, ANSEL	"SHRUBS IN SNOW, YOSEMITE VALLEY, CAL"	5/81	SNY	412	S	15 X 19	C1931/V	S,D,ST/F-G	900
ADAMS, ANSEL	TREES AGAINST CLOUDY SKY, YOSEMITE, CA	5/81	SNY	413	S	4 X 5	C1934/V	S/M	1,200
ADAMS, ANSEL	"WASHINGTON COLUMN, YOSEMITE VALLEY"	5/81	SNY	414	S	6 X 9	1936/V	S/E	1,600
ADAMS, ANSEL	"YOSEMITE & RANGE OF LIGHT"(ED: 39/50)	5/81	SNY	415	S	13 X 19	1936/L	S,A/M	BI
ADAMS, ANSEL	"APPROACHING STORM NEAR FLAGSTAFF, AZ"	5/81	SNY	416	S	10 X 15	C1938/V	S,ST/M	1,000
ADAMS, ANSEL	"INDIAN PROPERTY NEAR PALM SPRINGS"	5/81	SNY	417	S	19 X 15	C1935/39	S,D,ST/M	800
ADAMS, ANSEL	"SAND DUNES-SUNRISE, DEATH VALLEY, CA"	5/81	SNY	418	S	19 X 15	C1948/L	S,ST/M	4,000
ADAMS, ANSEL	"ALDERS" (ED: 110)	5/81	SNY	419	S	16 X 19	C1949/L	S,ST	1,200
ADAMS, ANSEL	"MOONRISE, HERANDEZ, NEW MEXICO"	5/81	SNY	420	S	39 X 56	1941/74	S/E	BI
ADAMS, ANSEL	"SIESTA LAKE, YOSEMITE, CA" (ED: 260)	5/81	SNY	421	S	8 X 10	C1958/V	S,PD/E	950
ADAMS, ANSEL	PORTFOLIO: 18 PARMELIAN PRINTS	11/80	CNY	541	S	8 X 6	1927/V	S,PD	BI
ADAMS, ANSEL	MONOLITH, FACE OF HALF DOME (ED: 50)	11/80	CNY	542	S	8 X 6	1927/77	S	BI
ADAMS, ANSEL	MOUNT WATKINS	11/80	CNY	542B	S	6 X 8	1927/77	S	BI
ADAMS, ANSEL	MOUNT BREWER, SOUTHERN SIERRA (ED: 50)	11/80	CNY	542A	S	6 X 8	1927/77	S	BI
ADAMS, ANSEL	PORTFOLIO: 12 PR/TAOS PUEBLO-ED:68/108	11/80	CNY	543	S	9 X 6	1930/V	S	BI
ADAMS, ANSEL	ALFRED STIEGLITZ, NY (ED: 11/50)	11/80	CNY	543B	S	7 X 5	1938/48	S,ST,A	1,200
ADAMS, ANSEL	"JOSE CLEMENTE, OROZCO, NEW YORK"	11/80	CNY	543A	S	10 X 13	1933/78	S,ST,T,D	BI
ADAMS, ANSEL	MOONRISE, HERNANDEZ, NEW MEXICO	11/80	CNY	544	S	15 X 19	1941/70'S	S,ST,T	BI
ADAMS, ANSEL	"WOMAN BEHIND SCREEN DOOR, CALIF."	11/80	CNY	545	S	20 X 15	1939/70	S,A,ST,T	2,500
ADAMS, ANSEL	ANTELOPE HOUSE RUIN, ARIZONA	11/80	CNY	545A	S	19 X 16	1942/74	S,A,ST	2,500
ADAMS, ANSEL	TETON NATIONAL PARK	11/80	CNY	546	S	8 X 9	C1960/V	S,T	1,100
ADAMS, ANSEL	WINTER SUNRISE, SIERRA NEVADA, CALIF	11/80	CNY	547	S	17 X 23	1944/70'S	S,ST,T	BI
ADAMS, ANSEL	"CLEARING WINTER STORM, YOSEMITE, CA."	11/80	CNY	548	S	16 X 19	1944/78	S,ST,T	BI
ADAMS, ANSEL	PINNACLES, CALIF. (ED: 17/110)	11/80	CNY	549	S	16 X 19	1945/70	S,A,ST	800
ADAMS, ANSEL	"SAND DUNES, OCEANO, CALIFORNIA"	11/80	CNY	550	S	19 X 15	C1950/70'S	S,ST,T	BI
ADAMS, ANSEL	WHITE BRANCHES, MONO LAKE, CALIFORNIA	11/80	CNY	551	S	20 X 15	1950/L	S,A,ST	3,800
ADAMS, ANSEL	"MT. WILLIAMSON, SIERRA NEVADA, CALIF"	11/80	CNY	551A	S	15 X 19	1944/70'S	S,ST,T	BI
ADAMS, ANSEL	"CHARLES SHEELER, SAN FRANCISCO"	11/80	CNY	552B	S	12 X 9	1956/78	S,ST,T,D	BI
ADAMS, ANSEL	HALF DOME, BLOWING SNOW, YOSEMITE, CA.	11/80	CNY	552	S	16 X 20	C1955/76	S,A,ST	BI
ADAMS, ANSEL	"AT TIMBER COVE, SMALL PINE TREE"	11/80	CNY	552A	S	20 X 16	1955/60	S,ST,T	BI
ADAMS, ANSEL	ALDERS, PRAIRIE CREEK	11/80	CNY	553	S	15 X 19	1958/60'S	S,ST	BI

PHOTOGRAPHER	TITLE OR DESCRIPTION	DATE	AH	LOT#	PT	SIZE	N/P DATES	MARKS/COND.	PRICE
ADAMS, ANSEL	"ASPENS, NORTHERN NEW MEXICO"	11/80	CNY	554	S	15 X 20	1959/78	S,ST,T	BI
ADAMS, ANSEL	TREE, STUMP & MIST, N. CASCADES, WASH.	11/80	CNY	555	S	16 X 19	1958/76	S,A,ST	BI
ADAMS, ANSEL	PINE BRANCHES, DETAIL	11/80	CNY	556	S	15 X 19	1960'S/V	S,ST,T	800
ADAMS, ANSEL	PORTFOLIO V: 10 PRINTS	11/80	CNY	557	S	20 X 16	1936-60/70	S,A,ST,T	BI
ADAMS, ANSEL	PORTFOLIO VI: 10 PRS., ED: 100	11/80	CNY	558	S	20 X 16	1932-53/74	S,A,ST,T	BI
ADAMS, ANSEL	"JUNIPER, CLIFFS & RIVER",BOOK, ED: 50	11/80	CNY	559A	S	16 X 19	C1936/79	S	BI
ADAMS, ANSEL	"ICE ON ELLORY LAKE" & BOOK, ED: 35/50	11/80	CNY	559	S	19 X 16	C1959/79	S	3,800
ADAMS, ANSEL	CROSS COUNTRY SKIERS, YOSEMITE PARK	11/80	PNY	264	S	6 X 8	C1931/V	S	325
ADAMS, ANSEL	"TIMBERLINE PINE"	11/80	SNY	417	S	8 X 5	1927-28/V	S,T	BI
ADAMS, ANSEL	"FROZEN LAKE AND CLIFF, KAWEH GAP"	11/80	SNY	418	S	11 X 13	1927/L	S,ST,T	3,800
ADAMS, ANSEL	AUSTIN, MARY (FOLIO, 12 PR, ED:82/108)	11/80	SNY	419A	S	VARIOUS	1930/V	S,ST	12,000
ADAMS, ANSEL	"LEAVES, MILLKS COLLEGE, CALIFORNIA"	11/80	SNY	419	S	10 X 13	1933/L	S,T,ST	950
ADAMS, ANSEL	"SNOW ON ROOF, YOSEMITE NATIONAL PARK"	11/80	SNY	420	S	8 X 10	1936/L	S,T,D,ST	750
ADAMS, ANSEL	CLEARING WINTER STORM, YOS. VAL., CA."	11/80	SNY	421	S	16 X 19	1944/L	S,T,D,ST	5,000
ADAMS, ANSEL	STEHEKIN RIVER FOREST, NORTH. CASCADES	11/80	SNY	422	S	48 X 38	1958/C1960	S	BI
ADAMS, ANSEL	"REFUGIO BEACH, CALIFORNIA"	11/80	SNY	423	S	11 X 14	1938/L	S,T,ST	1,800
ADAMS, ANSEL	"AUTUMN, YOSEMITE VALLEY"	11/80	SNY	424	S	15 X 19	1939/1960'S	S,T,ST	BI
ADAMS, ANSEL	"THE TETONS & THE SNAKE RIVER,..."	11/80	SNY	425	S	15 X 19	1942/L	S,T,D,ST	BI
ADAMS, ANSEL	"MOONRISE, HERNANDEZ, NEW MEXICO"	11/80	SNY	426	S	15 X 20	1941/L	S,T,D,ST	7,000
ADAMS, ANSEL	"MOONRISE, HERNANDEZ, NEW MEXICO"	11/80	SNY	427	S	11 X 14	1941/1960'S	S,T,ST	BI
ADAMS, ANSEL	"MT. WILLIAMSON, SIERRA NEVADA..."	11/80	SNY	428	S	16 X 19	1944/L	S,T,D,ST	4,000
ADAMS, ANSEL	PORTRAIT: JOSE CLEMENTE OROZCO	11/80	SNY	428A	S	6 X 6	1933/V	S	1,600
ADAMS, ANSEL	PORTRAIT: EDWARD WESTON	11/80	SNY	429	S	8 X 6	1950/V	S,T,ST	700
ADAMS, ANSEL	"MT. MCKINLEY AND WONDER LAKE, ALASKA"	11/80	SNY	430	S	16 X 19	1947/C1955	S,T,D,I,ST	BI
ADAMS, ANSEL	"WINTER SUNRISE-SIERRA NEVADA, CA..."	11/80	SNY	431	S	20 X 26	1944/C1962	S,D,T,ST	BI
ADAMS, ANSEL	"WINTER SUNRISE-SIERRA NEVADA, CA..."	11/80	SNY	432	S	15 X 20	1944/L	S,T,D,ST	5,000
ADAMS, ANSEL	"ASPENS, NORTHERN NEW MEXICO"	11/80	SNY	433	S	19 X 15	1958/L	S,T,D,ST	3,800
ADAMS, ANSEL	"MOON AND HALF DOME, YOS. NAT. PK..."	11/80	SNY	435	S	19 X 15	1960/L	S,T,D,ST	BI
ADAMS, ANSEL	STREAM, SEA, CLOUDS, RODEO LAGOON,...	11/80	SNY	436	S	20 X 15	1962/L	S,T,D,ST	BI
ADAMS, ANSEL	"THE BLACK SUN, TUNGSTEN HILLS,..."	11/80	SNY	437	S	14 X 19	1939/L	S,I,ST	3,400
ADAMS, ANSEL	PINNACLES, ALABAMA HILLS, OWENS VALLEY	11/80	SNY	438	S	16 X 19	1945/L	S,I,ST	850
ADAMS, ANSEL	"PORTFOLIO V" (TEN PHOTOS)	11/80	SNY	439	S	15 X 19	1970/V	S,I,ST	BI
ADAMS, ANSEL	"FRESH SNOW"	11/80	SNY	440	S	16 X 19	C1947/L	S,ST	2,200
ADAMS, ANSEL	"ANSEL ADAMS:PORTFOLIO VI" (10 PHOTOS)	11/80	SNY	441	S	16 X 20	1974/V	S,ST	BI
ADAMS, ANSEL	"ANSEL ADAMS:PORTFOLIO VII" 12 PHOTOS	11/80	SNY	442	S	16 X 20	1976/V	S,ST,I	BI
ADAMS, ANSEL	"INTERIOR OF TUMACACORI MISSION,..."	11/80	SNY	443	S	20 X 15	C1952/L	S,I,ST	500
ADAMS, ANSEL	"CEMETERY STATUE AND OIL DERRICKS"	11/80	SNY	444	S	15 X 18	1939/L	S,I,ST	950
ADAMS, ANSEL	"GERRY SHARPE, OURAY, COLORADO"	11/80	SNY	445	S	22 X 15	1958/L	S,I,ST	650
ADAMSON, ROBERT	ARCHITECTURAL STUDY	5/81	PNY	2	C	6 X 8	1843/V	S/F	BI
ALBIN-GUILLOT, LAURE	WOMAN'S HEAD	11/80	PNY	114	CP	12 X 10	1920'S/V	S	BI
ALBOK, JOHN	"FROM WORLD'S FAIR GARDEN"	11/80	SW	228	S	11 X 11	1930'S/V	S,T	BI
ALBOK, JOHN	"HARLEM AT CHRISTMASTIME"	11/80	SW	229	S	11 X 14	1935/V	S	250
ALBOK, JOHN	"SHINE PLEASE!"	11/80	SW	231	S	8 X 10	1930'S/V	S,T	150
ALENIUS, EDWARD	PETS (CATS)	4/81	PNY	70	S	10 X 12	1940'S/V	S,T	BI
ALENIUS, EDWARD	WINTER NIGHT, CENTRAL PARK	4/81	PNY	71	S	12 X 10	1940'S/V	S,T	150
ALENIUS, EDWARD	BROOKLYN BRIDGE, NEW YORK	5/81	PNY	97	S	13 X 10	1932/V		BI
ALENIUS, EDWARD	111 JOHN STREET, NEW YORK	5/81	PNY	98	S	16 X 12	1936/V		250
ALENIUS, EDWARD	"COLORFUL ROSES" (TRI-COLOR BROMOIL)	5/81	PNY	246	B	10 X 10	1933/V		575
ALINARI, L. AND G.	PALAZZO PUBBLICO IN SIENA	4/81	SW	289	A	17 X 23	1860'S	IN,ST	350
ALINARI, L. AND G.	ARCH OF CONSTANTINE IN ROME	4/81	SW	288	A	17 X 23	1860'S	IN,ST	350
ALINARI, L. AND G.	FLORENCE (VIEW FROM HILLS; OVAL)	5/81	PNY	42	A	12 X 17	C1860'S/V	ST,IN/F	100
ALINARI, L. AND G.	ITALIAN CATHEDRALS (2 PRINTS)	11/80	CNY	66	A	23 X 17	1870'S/V	ST	250
ALLEN, ALBERT ARTHUR	ARRANGEMENTS OF NUDE MODELS (2 PR)	5/81	SNY	540	S	7 X 9	C1923/V		150
ALLEN, FRANCES & MARY	4 PORTRAITS...	5/81	PNY	79	P	VARIOUS	C1890/V	T,ST	175
ALLEN, FRANCES & MARY	4 LANDSCAPES...	5/81	PNY	80	P	VARIOUS	C1890/V	T	175
ALTOBELLI, GIOACHINO	COLONNA FOCA, ROMA	5/81	PNY	40	A	14 X 10	1860'S/V	IN	400
AMERICANA	PORTRAIT: DR. DAVID CAMDEN DELEON	4/81	SW	235	D	1/4 PL	1848/V	T,D	600
AMERICANA	ALBUM: YALE CLASS OF 1866	4/81	SW	439	A	VARIOUS	1866/V	I	280
AMERICANA	MODEL SHIP BUILDER, BOSTON AREA	4/81	SW	498	A	8 X 10	1880'S/V	/E	110
AMERICANA	ABE LINCOLN-COPY OF BUTLER'S AMBROTYPE	5/81	SNY	111	P	4 X 3	1860/80'S	/G	175
AMERICANA	JOHN POPE (PAINTER)BY MASURY & SILSBEE	11/80	CNY	97	SA	8 X 6	C1855.V	ST	BI

59

PHOTOGRAPHER	TITLE OR DESCRIPTION	DATE	AH	LOT#	PT	SIZE	N/P DATES	MARKS/COND.	PRICE
AMERICANA	LINCOLN LYING IN STATE (BY T. SWEENY)	11/80	CNY	131	A	8 X 9	1865/V	PD,T	550
AMERICANA	GEL'L GRANT'S FINAL DAYS (33 PRINTS)	11/80	CNY	133	A	9 X 11	1886/V	IN,PD	BI
AMERICANA	BOSTON POLICE CRIMINAL ALBUM-340 CDV'S	11/80	SNY	97	A	CDV	1861-91/V	I	1,600
AMERICANA	MARK TWAIN	11/80	SW	399	S	6 X 4	1920'S?/V	A	40
AMSON, MARCEL	"LE CINEMA"	5/81	PNY	128	S	12 X 9	1930'S/V	S	BI
ANNAN, THOMAS	CLOSE, NO. 148 HIGH STREET	5/81	PNY	13	CN	11 X 9	1877/V	T	300
ANNAN, THOMAS	"TRONGATE, FROM THE TRON STEEPLE"	11/80	CNY	46	CN	11 X 15	1878/V	T	BI
ANNAN, THOMAS	"CLOSES, NOS. 97 AND 103 SALTMARKET"	11/80	CNY	47	CN	11 X 9	1878/V	T	220
ANNAN, THOMAS	"CLOSE NO. 37 HIGH STREET"	11/80	CNY	48	CN	11 X 9	1878/V	T	220
ANTHONY, EDWARD	"NEW YORK CITY" (6 STEREOGRAPHS)	11/80	SW	386	A		1860'S/V		170
ANTHONY, EDWARD	PHOTO STUDIO &... (4 STEREOGRAPHS)	11/80	SW	390	A		C1870'S/V		340
APEIRON WORKSHOP	PORTFOLIO:18 PR-ED:16/40-VARIOUS PHTGR	5/81	SNY	522	S	VARIOUS	VARIOUS/76	S/M	1,800
ARBUS, DIANE	FEMALE IMPERSONATORS' DRESSING ROOM-NY	5/81	PNY	116	S	9 X 6	1958/L	T,D	BI
ARBUS, DIANE	FEMALE IMPERSONATORS BACKSTAGE, NYC	5/81	PNY	117	S	9 X 6	1962/L	ST,T,D	275
ARBUS, DIANE	XMAS TREE IN LIVING ROOM, LEVITTOWN,NJ	5/81	CNY	210	S	10 X 9	1963/V	S/F	BI
ARBUS, DIANE	"A WOMAN IN A BIRD MASK, NYC"	5/81	SNY	502	S	11 X 10	1967/V	/P	2,600
ARBUS, DIANE	"CHILD W/A TOYHAND GRENADE, NYC"	5/81	SNY	503	S	15 X 15	1962/L	ST	1,200
ARBUS, DIANE	"FAMILY ON LAWN, WESTCHESTER" ED: 50	5/81	SNY	504			1968/L	ST/G	550
ARBUS, DIANE	NO. 4	10/80	PT	238	S	14 X 14	1971/70'S	T,D	310
ARBUS, DIANE	"BOY WITH A STRAW HAT WAITING..."	11/80	SNY	507	S	15 X 15	1967/V	S,I	4,750
ARBUS, DIANE	2 YOUNG WOMEN, WASH. SQ. PARK, NYC	11/80	CNY	566	S	10 X 10	1965/67	S,T,D,ST	3,200
ARBUS, DIANE	"TRIPLETS IN BEDROOM, NJ" (ED: 27/75)	11/80	CNY	567	S	15 X 15	1963/70'S	T,A	350
ARBUS, DIANE	"MAN & WIFE AT NUDIST CAMP" (ED:34/50)	11/80	CNY	568	S	14 X 15	1963/70'S	ST,T,A	400
ASMAN, ROBERT	"URBAN TREES" (6 PRINTS, ED: 25)	5/81	PNY	342	S	12 X 17	1980/V	S,T,D	BI
ATGET, E./ABBOTT, B.	BEDROOM	2/81	SLA	30	S	9 X 8	E1900'S/L	ST	150
ATGET, E./ABBOTT, B.	RUE MOUFFETARD	5/81	PNY	124	S	9 X 7	C1900/50'S	ST/M	125
ATGET, E./ABBOTT, B.	VIEWS/PARIS (3 PR. PRINTED BY ABBOTT)	11/80	CNY	273	S	9 X 7	1900'S/50'S	ST	140
ATGET, E./ABBOTT, B.	VIEWS/PARIS (3 PR. PRINTED BY ABBOTT)	11/80	CNY	274	S	9 X 7	1900'S/50'S	ST	220
ATGET, E./ABBOTT, B.	PORTFOLIO: 20 PRINTS (ED: 37/100)	11/80	PNY	41	S	9 X 7	E1900'S/56	A	2,200
ATGET, EUGENE	"POTERNE DES PEUPLIERS"	2/81	SLA	31	PO	6 X 9	E. 1900'S/V	T,ST	BI
ATGET, EUGENE	"GENTILLY-VIEILLE FERME VOITURE"	2/81	SLA	32	PO	7 X 9	C1920/V	T	BI
ATGET, EUGENE	"MONTMARTRE, MAISON DE MUSETTE..."	2/81	SLA	33	PO	7 X 9	E. 1900'S/V	IN,T,ST	1,200
ATGET, EUGENE	"HOTEL 18-SIECLE SURE LE JARDIN..."	2/81	SLA	34	PO	7 X 9	E. 1900'S/V	IN,T	700
ATGET, EUGENE	LES TUILERIES	4/81	SW	291	S	7 X 9	C1910/V	A	1,300
ATGET, EUGENE	ST. JULIEN LE PAUVRE	4/81	SW	292	S	9 X 7	C1910/V	ST,A	550
ATGET, EUGENE	"QUAI D'ANJOU"	5/81	CNY	78	A	7 X 9	C1924/V	ST,T,IN/M	3,600
ATGET, EUGENE	"RUE PRETOUVILLIERS, MATIN TEMPS"	5/81	CNY	80	A	7 X 9	C1924/V	ST,T,IN/M	3,200
ATGET, EUGENE	ROSERIE	5/81	CNY	81	PO	8 X 7	C1910/V	ST/M	2,600
ATGET, EUGENE	"QUAI BOURBON"	5/81	CNY	79	A	7 X 9	C1924/V	ST,T,IN/M	2,800
ATGET, EUGENE	"JARDIN DES PLANTES"	5/81	CNY	82	PO	7 X 9	C1910/V	T,A/P	1,500
ATGET, EUGENE	"BOUCHERIE AUX HALLES"	5/81	PNY	119	PO	9 X 7	C1910/V	ST,T,A/G	BI
ATGET, EUGENE	HOTEL DE NEVERS, 18 RUE SEGUIER	5/81	PNY	120	PO	7 X 8	C1910/V	T,A/G	1,400
ATGET, EUGENE	HOTEL LIANCOURT	5/81	PNY	121	PO	9 X 7	C1910/V	T,A/G	BI
ATGET, EUGENE	SCULPTURE	5/81	PNY	122	PO	7 X 5	C1910/V	T,A/E	BI
ATGET, EUGENE	TREES	5/81	PNY	123	PO	8 X 7	C1910/V	T,A/P	500
ATGET, EUGENE	16TH CENTURY STONE FRIEZE	5/81	SNY	138	PO	9 X 7	1921/V	A,T,D,ST/E	BI
ATGET, EUGENE	"LES TUILERIES-CASSANDRE IMPLORANT..."	5/81	SNY	139	PO	9 X 7	C1900/V	T,A/G	1,000
ATGET, EUGENE	"HOTEL DE LA CHANCELLERU D'ORLEANS..."	10/80	PT	63	A	7 X 9	C1910/V	T,A	BI
ATGET, EUGENE	"ANNEY HOTEL DU DUE DE NOIRMOUTIERS.."	10/80	PT	64	A	7 X 9	C1910/V	T,A	1,500
ATGET, EUGENE	ALONG A CANAL	10/80	PT	65	A	7 X 9	C1910/V	A	850
ATGET, EUGENE	COIN DE RUE FERDINAND DUVAL	11/80	CNY	267	PO	7 X 9	C1910/V	IN,S?	1,800
ATGET, EUGENE	PONTOISE, ANCIEN HOTEL DU TRIBUNAL	11/80	CNY	268A	PO	9 X 7	C1910/V	T	BI
ATGET, EUGENE	COIN RUE MOFFETARD	11/80	CNY	268	PO	7 X 9	C1910/V	ST,T	2,500
ATGET, EUGENE	VERSAILLES-VASE PAR BALLIN	11/80	CNY	269	PO	8 X 7	C1910/V	T	2,000
ATGET, EUGENE	83 RUE CHARLOT	11/80	CNY	270	PO	9 X 7	C1910/V	A	BI
ATGET, EUGENE	60 RUE DE TURENNE	11/80	CNY	271	PO	9 X 7	C1910/V	A	BI
ATGET, EUGENE	57 RUE DE VARENN	11/80	CNY	272	PO	9 X 7	C1910/V	A	BI
ATGET, EUGENE	"BOULEVARD DE STRASBOURG"	11/80	SNY	151	PO	9 X 6	E 1900'S/V	T,ST	1,600
ATGET, EUGENE	"SCEAUX-PORTE"	11/80	SNY	152	PO	9 X 7	E. 1900'S/V	T,ST	BI
ATGET, EUGENE	VERSAILLES, BOS. DE L'ARC DE TRIOMPHE	11/80	SNY	153	PO	9 X 7	E. 1900'S/V	T	1,500
ATGET, EUGENE	HOTEL CHERUSEAU, RUE ST LOUIS EN L'ILE	11/80	SNY	154	PO	9 X 7	E. 1900'S/V	IN,T	1,000

PHOTOGRAPHER	TITLE OR DESCRIPTION	DATE	AH	LOT#	PT	SIZE	N/P DATES	MARKS/COND.	PRICE
AUBRY, CHARLES	FLORAL WREATH	5/81	SNY	100	A	19 X 16	1860'S/V	ST/G	1,500
AUERBACH, ELLEN	DAS EI DES COLUMBUS, BERLIN	11/80	PNY	32	S	9 X 8	1930/V	S,T,D	BI
AUNUTIS, NEWTON	"L'UN CHOISI"	11/80	PNY	121	S	10 X 8	C1930/V	S,T	BI
AUTOMOBILES	ALBUM: GRAMM MOTOR TRUCK CO.	4/81	SW	412	S	8 X 10	C1915/V	T	250
AVEDON, RICHARD	ELSIE DANIELS IN A TURBAN (ED: 34/75)	2/81	SLA	35	S	14 X 18	1949/1970'S	S,ST,T	800
AVEDON, RICHARD	PORTRAIT: BUSTER KEATON (ED: 35)	2/81	SLA	36	S	20 X 24	1952/1970	S.O	BI
AVEDON, RICHARD	PORTRAIT: JIMMY DURANTE (ED: 35)	2/81	SLA	37	SS	24 X 20	1953/1970	S,I	1,700
AVEDON, RICHARD	PORTRAIT: BARBARA STREISAND	2/81	SLA	38	S	15 X 15	1965/V	S,D	750
AVEDON, RICHARD	ANDY WARHOL, ARTIST, N.Y.C. (ED: 3/10)	2/81	SLA	39	S	61 X 49	1969/1975	S,T,ST	4,000
AVEDON, RICHARD	DORIAN LEIGH, COAT BY DIOR (ED: 75)	4/81	PNY	187	S	18 X 14	1949/1978	S,A,ST	BI
AVEDON, RICHARD	MARLENE DIETRICH	4/81	PNY	188	S	11 X 10	1940'S/V		500
AVEDON, RICHARD	PORTRAIT: TRUMAN CAPOTE (ED: 17/50)	5/81	SNY	513	S	10 X 8	1974/75	S,ST/F	500
AVEDON, RICHARD	DORIAN LEIGH, SCHIAPARELLI RHINESTONES	11/80	CNY	615	S	14 X 18	1949/78	S,ST	BI
AVEDON, RICHARD	ELSIE DANIELS IN TURBAN (ED: 14/75)	11/80	CNY	616	S	14 X 18	1948/70'S	S,ST	BI
AVEDON, RICHARD	DOVIMA W/ELEPHANTS, PARIS (ED: 50)	11/80	CNY	616A	S	50 X 40	1955/70'S	S,ST	3,500
AVEDON, RICHARD	IGOR STRAVINSKY, COMPOSER, NY	11/80	CNY	617	S	10 X 24	1969/75	S,ST	1,200
AVEDON, RICHARD	D. LEIGH, DRESSED BY PIGUET (ED: 34/75)	11/80	SNY	504	S	14 X 18	1949/1970'S	S,I,ST	1,300
AVEDON, RICHARD	D. LEIGH IN A DIOR COAT (ED: 34/75)	11/80	SNY	505	S	18 X 14	1949/1970'S	S,ST	BI
AVEDON, RICHARD	ANDY WARHOL, ARTIST, NYC (ED: 3/10)	11/80	SNY	506	S	61 X 49	1969/1975	S,T,ST	BI
AVERY, SID	CONTACT SHEET:JAMES DEAN IN "GIANT"	2/81	SLA	40	S	14 X 12	1955/V	S,D,ST,T	300
BABBITT, PLATT D.	NIAGARA FALLS	5/81	CNY	44	D	1/2 PL.	C1853/V	/E	1,300
BACH, LAURENCE	PACO'S DREAM BOOK #1	5/81	PNY	336	S	24 X 20	1977/V	S	350
BACH, LAURENCE	PACO'S DREAM BOOK #23	5/81	PNY	337	S	24 X 20	1977/V	S	BI
BACHRACH, ERNEST A.	PORTRAIT: MARY ASTOR	2/81	SLA	41	S	13 X 11	C1931/V	PD	250
BALDUS, EDOUARD-DENIS	VIEW OF THE PONT-NEUF & ILE DE LA CITE	4/81	SW	293	A	8 X 11	C1855/V	ST	200
BALDUS, EDOUARD-DENIS	"VIEW DE PARIS EN PHOTOGRAPHIE"	5/81	CNY	32	A	11 X 8	C1853-55/V	ST,T/G	BI
BALDUS, EDOUARD-DENIS	L'ABBAY AUX DAMES, CAEN	5/81	CNY	33	A	13 X 17	C1855/V	IN/F	BI
BALDUS, EDOUARD-DENIS	HOTEL DE VILLE, PARIS	11/80	CNY	59	A	8 X 11	C1860/V	ST	BI
BALL, RAYMOND	ADVERTISEMENT (LEGS)	4/81	PNY	195	S	14 X 11	1950'S/V	ST	BI
BALL, RAYMOND	STUDY OF A COMB	5/81	SNY	393	S	9 X 8	1940'S/V	/E	350
BALL, RAYMOND	HAMILTON WATCH ADVERTISEMENT	11/80	PNY	213	S	9 X 7	1930'S/V		100
BALL, RAYMOND	FLORAL STILL LIFE	11/80	PNY	214	S	9 X 7	1930'S/V		BI
BARKER, GEORGE	NIAGARA FALLS	5/81	CNY	53	A	21 X 17	1880'S/V	/E	1,200
BARKER, GEORGE	"NIAGARA FALLS, CAVE OF THE WINDS"	10/80	PT	45	A	13 X 17	1860'S/V		600
BARKOVITCH	DORA DUBY (4 PRINTS)	4/81	PNY	156	S	8 X 6	1920'S/V	S	BI
BARNARD, GEORGE N.	ALBUM: SHERMAN'S CAMPAIGN (61 PRINTS)	4/81	SW	26	A	16 X 21	1866/V	PD/P	4,000
BARNARD, GEORGE N.	INTERIOR VIEW OF FORT SUMPTER	5/81	PNY	70	A	10 X 14	1866/V	PD	BI
BARNARD, GEORGE N.	COLUMBIA FROM THE CAPITOL	5/81	PNY	71	A	10 X 14	1866/V	PD	BI
BARNARD, GEORGE N.	OSWEGO, NEW YORK	11/80	CNY	96	D	1/6 PL	1848-53/V		BI
BARNBAUM, BRUCE	"BASIN MOUNTAIN; APPROACHING STORM"	11/80	CNY	605	S	14 X 19	1973/V	S,D,T,ST	BI
BARNBAUM, BRUCE	"SCULPTURED WALL, BUCKSKIN GULCH"	11/80	CNY	606	S	19 X 15	1978/V	S,T,D,ST	BI
BARNBAUM, BRUCE	"BASIN MOUNTAIN, APPROACHING STORM"	2/81	SLA	42	S	15 X 19	1973/V	S,D,T,ST	400
BARNBAUM, BRUCE	"SCULPTURED WALL, BUSKSKIN GULCH"	2/81	SLA	43	S	20 X 16	1978/V	S,D,T,ST	200
BARNBAUM, BRUCE	"MT. CLARENCE KING"	2/81	SLA	44	S	16 X 19	1976/V	S,D,T,ST	350
BARNBAUM, BRUCE	BASIN MOUNTAIN, APPROACHING STORM	5/81	PNY	325	S	16 X 19	1973/V	S,D,T,ST	BI
BARRY, D.F.	INDIAN PORTRAITS (2 PHOTOS)	2/81	SLA	46	A	6 X 5	1880'S/V	T,ST	150
BARRY, D.F.	PORTRAIT: CHIEF GALL	2/81	SLA	46	A	14 X 7	C1890/V	ST,I	350
BARRY, D.F.	PORTRAIT: CHIEF RAIN-IN-THE-FACE	2/81	SLA	45	A	14 X 7	C1890/V	ST,I	275
BASSETT, C.	ROUEN CATHEDRAL	11/80	CNY	60	A	11 X 8	C1860/V	A	BI
BAYARD, HIPPOLYTE	"EGLISE DE ST. PIERRE A LOUVIERS"	5/81	SNY	95	SA	8 X 10	1851/V	T,PD/E	BI
BAYER, HERBERT	WALL HANGINGS (ED: 22/40)	11/80	CNY	331	S	10 X 13	1936/1950'S	S,D	BI
BAYER, HERBERT	ASSEMBLAGE (ED: 22/40)	11/80	PNY	53	S	10 X 13	1936/69	S,D,A	BI
BAYER, HERBERT	COLLAGE (ED: 24/40)	11/80	PNY	54	S	13 X 10	1932/69	S,D,A	BI
BAYER, HERBERT	PROFILEN FACE (ED: 17/40)	11/80	PNY	55	S	12 X 11	1929/69	S,D,A	450
BAYER, HERBERT	"GOOD NIGHT, MARIE"	2/81	SLA	48	S	13 X 10	1932/L	S,D,T,ST	500
BAYER, HERBERT	"SPRACHE DES BRIEFES"	2/81	SLA	49	S	13 X 11	1931/L	S,D,T,ST	300
BEALS, JESSIE TARBOX	PORTRAIT: JOHN BURROUGHS	2/81	SLA	50	S	9 X 7	E. 1900'S/V	I,S,T	125
BEATO, A.	EGYPTIAN RUINS	5/81	SNY	107	A	10 X 14	1880'S/V	SN/E	150
BEATO, FELIX	EGYPT (48 PRINTS)	5/81	PNY	56	A	8 X 10	1860'S/V	S/E	900
BEATON, CECIL	PORTRAIT: GRETA GARBO	2/81	SLA	52	S	9 X 11	1946/V	ST	300

PHOTOGRAPHER	TITLE OR DESCRIPTION	DATE	AH	LOT#	PT	SIZE	N/P DATES	MARKS/COND.	PRICE
BEATON, CECIL	PORTRAIT OF A LADY	2/81	SLA	53	S	9 X 7	1951/V	S,ST	275
BEATON, CECIL	PORTRAIT: GEORGE PLATT LYNES	4/81	PNY	148	S	9 X 7	C1940/V		600
BEATON, CECIL	A WOUNDED GURKHA	4/81	PNY	149	S	12 X 10	1944/V	ST,I	BI
BEATON, CECIL	MRS. HARRISON WILLIAMS	4/81	PNY	175	S	10 X 8	1937/V	ST	BI
BEATON, CECIL	CARMEL SNOW	4/81	PNY	176	S	10 X 6	C1939/V	ST	BI
BEATON, CECIL	SURREALIST PORTRAIT: CHARLES H. FORD	5/81	SNY	262	S	10 X 8	1930'S/V	S,ST/F	350
BEATON, CECIL	MARY TAYLOR	11/80	CNY	435	S	10 X 9	1930'S/V	ST	BI
BEATON, CECIL	GRETA GARBO	11/80	CNY	436	S	18 X 16	C1950/V	S,ST	BI
BEATON, CECIL	DAVID HOCKNEY	11/80	CNY	437	S	18 X 13	1970'S/V	S,ST	300
BEATON, CECIL	EVENING DRESS	11/80	SNY	801	S	10 X 8	1930'S/V	ST	150
BEATON, CECIL	LEE MILLER AND MARIAN MOOREHOUSE...	11/80	SNY	802	S	10 X 6	L.1920'S/V	ST,A	450
BEATON, CECIL	FASHION: PROFILE WITH PERMANENT WAVE	11/80	SNY	803	S	10 X 8	E. 1930'S/V	ST,A	275
BEATON, CECIL	M. TAYLOR IN SPOTTED DRESS...	11/80	SNY	804	S	9 X 6	1930'S/V		225
BEATON, CECIL	FASHION: HANDKERCHIEF SKIRTED DRESS	11/80	SNY	805	S	9 X 6	C1930/V		175
BEATON, CECIL	THE HAT BOX-FASHION STUDY	11/80	SNY	806	S	10 X 8	1936/V	I,A,D	150
BEATON, CECIL	EVENING CAPES-FASHION STUDY	11/80	SNY	807	S	8 X 10	1937/V	ST	350
BEATON, CECIL	THE BOUQUET-FASHION STUDY	11/80	SNY	808	S	8 X 9	1930'S/V	ST	175
BEATON, CECIL	"MADAME VIONNET"	11/80	SNY	809	S	10 X 9	1953/V	ST,T	125
BEATON, CECIL	FASHION: THROUGH FRAME AND VEIL	11/80	SNY	810	S	10 X 8	1938/V	ST,A	325
BEATON, CECIL	"MOCK PUPPET THEATRE FASHION STUDY"	11/80	SNY	811	S	8 X 10	1939/V	ST,I	175
BEATON, CECIL	FASHION STUDY	11/80	SNY	812	S	7 X 10	1939/V	ST,I,D	125
BEATON, CECIL	"THE NEW REALITY" (MODEL SEWING)	11/80	SNY	813	S	10 X 8	1946/V	ST,T	150
BEATON, CECIL	FASHION STUDY AGAINST CUTOUT BACKDROP	11/80	SNY	814	S	10 X 8	1949/V	S,ST,D	225
BEATON, CECIL	CHARLES JAMES EVENING DRESSES	11/80	SNY	815	S	8 X 10	1948/V	ST	2,100
BEATON, CECIL	"CHARLES JAMES"	11/80	SNY	816	S	10 X 8	1936/V	ST,T	425
BEATON, CECIL	"MRS. CHARLES JAMES"	11/80	SNY	817	S	6 X 6	1955/V	ST,T	175
BEATON, CECIL	EVENING DRESSES	11/80	SNY	818	S	9 X 7	1951/V		200
BEATON, CECIL	"MARIANA VAN RENSSELAER IN A C.J. HAT"	11/80	SNY	819	S	10 X 8	1930/V	ST	300
BEATON, CECIL	"CHANEL"	11/80	SNY	820	S	10 X 8	1935/V	ST,T,I	175
BEATON, CECIL	DOVIMA MODELLING A CHANEL DRESS	11/80	SNY	821	S	8 X 8	1950'S/V	ST,A	125
BEATON, CECIL	"BALENCIAGA"	11/80	SNY	822	S	10 X 8	1962/V	ST,T	100
BEATON, CECIL	SUMMER IDYLL-FASHION STUDY	11/80	SNY	823	S	8 X 7	1939/V	ST,A	150
BEATON, CECIL	SCHIAPARELLI COAT	11/80	SNY	824	S	8 X 7	1939/V	ST,A	150
BEATON, CECIL	FASHION:BEFORE PAINTED BACKDROP	11/80	SNY	825	S	10 X 8	C1950/V	ST,S	150
BEATON, CECIL	FIFTIES BEACH FASHIONS	11/80	SNY	826	S	10 X 8	1950'S/V		300
BEATON, CECIL	AMERICAN FASHION	11/80	SNY	827	S	10 X 9	1958/V	ST,T	275
BEATON, CECIL	FASHION STUDY-DIOR DRESS	11/80	SNY	828	S	10 X 8	1949/V	ST,D	325
BEATON, CECIL	"EARLY SELF PORTRAIT"	11/80	SNY	841	S	9 X 6	1920/V	ST,T	200
BEATON, CECIL	SELF PORTRAIT WITH STUDIO CAMERA	11/80	SNY	842	S	10 X 8	1951/V	ST,D	275
BEATON, CECIL	SELF PORTRAIT WITH ANITA LOOS, CALIF.	11/80	SNY	843	S	10 X 5	1931/V		125
BEATON, CECIL	SELF-PORTRAIT IN 18TH CENTURY COSTUME	11/80	SNY	844	S	11 X 7	1923/V	ST	275
BEATON, CECIL	NORMA SHEARER	11/80	SNY	845	S	9 X 7	1930/V		325
BEATON, CECIL	"KAREN ORLEY"	11/80	SNY	846	S	10 X 8	C1930/V	ST,T	125
BEATON, CECIL	"GERTRUDE LAWRENCE"	11/80	SNY	847	S	7 X 5	1930/V	T	300
BEATON, CECIL	MARLENE DIETRICH	11/80	SNY	848	S	8 X 8	1930/V		550
BEATON, CECIL	"ALICE WHITE"	11/80	SNY	849	S	9 X 7	1931/V	T	175
BEATON, CECIL	"GARY COOPER"	11/80	SNY	850	S	11 X 9	C1931/V	T,ST	1,500
BEATON, CECIL	"CAROLE LOMBARD"	11/80	SNY	851	S	10 X 8	1931/V	ST,T	300
BEATON, CECIL	"BUSTER KEATON"	11/80	SNY	852	S	9 X 7	1931/V	ST,T	250
BEATON, CECIL	"DOLERES DEL RIO"	11/80	SNY	853	S	9 X 7	1931/V	ST,T	375
BEATON, CECIL	"ANNA MAY WONG"	11/80	SNY	854	S	11 X 8	1930'S/V	ST,T,A	525
BEATON, CECIL	"LAURENCE OLIVIER"	11/80	SNY	855	S	10 X 8	1930'S/V	ST,T	225
BEATON, CECIL	"JOHNNIE WEISMULLER-TARZAN"	11/80	SNY	856	S	9 X 7	1931/V	ST,T	2,100
BEATON, CECIL	"ELSA MAXWELL"	11/80	SNY	857	S	10 X 8	1930'S/V	ST,T	225
BEATON, CECIL	"MARX BROS"	11/80	SNY	858	S	10 X 8	1930'S/V	ST,T	300
BEATON, CECIL	"MERLE OBERON"	11/80	SNY	860	S	10 X 8	1934/V	S,ST,T	350
BEATON, CECIL	"KATHERINE HEPBURN"	11/80	SNY	861	S	10 X 8	1934/V	S,ST,T,A	1,400
BEATON, CECIL	"GARBO"	11/80	SNY	862	S	10 X 10	1946/V	ST,T	650
BEATON, CECIL	"GRETA GARBO"	11/80	SNY	863	S	18 X 15	1945/V	S,ST,T	600
BEATON, CECIL	PORTRAIT: PROFILE OF GARBO	11/80	SNY	864	S	9 X 7	1946/V	ST,A	650
BEATON, CECIL	"CAROL REED"	11/80	SNY	865	S	8 X 8	1940/V	ST,T	175

PHOTOGRAPHER	TITLE OR DESCRIPTION	DATE	AH	LOT#	PT	SIZE	N/P DATES	MARKS/COND.	PRICE
BEATON, CECIL	"VIVIEN LEIGH"	11/80	SNY	866	S	10 X 8	1940'S/V	ST,T	375
BEATON, CECIL	"TILLY LOSCH"	11/80	SNY	867	S	8 X 8	1934/V	S,ST	225
BEATON, CECIL	"JUDY GARLAND"	11/80	SNY	868	S	10 X 8	1953/V	ST,T,A	150
BEATON, CECIL	"JEANNE MOREAU"	11/80	SNY	869	S	10 X 10	1963/V	ST,T	150
BEATON, CECIL	"HERMIONE GINGOLD"	11/80	SNY	870	S	9 X 9	1956/V	ST,T	150
BEATON, CECIL	FRANK SINATRA,SAMMY DAVIS,DEAN MARTIN	11/80	SNY	871	S	14 X 11	1956/V	T	225
BEATON, CECIL	"GRACE KELLY"	11/80	SNY	872	S	7 X 7	1954/V	ST,T	175
BEATON, CECIL	"JOAN CRAWFORD"	11/80	SNY	873	S	14 X 14	1956/V	ST,T	250
BEATON, CECIL	CONTACT SHEET PORTRAITS-MARILYN MONROE	11/80	SNY	874	S	10 X 12	1956/V	ST	750
BEATON, CECIL	"MARILYN MONROE"	11/80	SNY	875	S	14 X 11	1956/V	ST,T,A	1,800
BEATON, CECIL	"K. HEPBURN"	11/80	SNY	876	S	9 X 10	1969/V	ST,T	300
BEATON, CECIL	"MARLON BRANDO"	11/80	SNY	877	S	9 X 7	1947/V	ST,T,I	1,100
BEATON, CECIL	AUDREY HEPBURN AS "MY FAIR LADY"	11/80	SNY	878	S	14 X 11	1953/V		375
BEATON, CECIL	"AUDREY HEPBURN"	11/80	SNY	879	S	10 X 10	1950'S/V	ST,T	900
BEATON, CECIL	"MRS. BEATON"	11/80	SNY	883	S	8 X 7	1920'S/V	ST,T	175
BEATON, CECIL	"BABA BEATON"	11/80	SNY	884	S	12 X 8	1925/V		400
BEATON, CECIL	"NANCY BEATON"	11/80	SNY	885	S	8 X 5	1921/V	ST,T	BI
BEATON, CECIL	"BABA BEATON"	11/80	SNY	886	S	10 X 9	1922/V	ST,T	350
BEATON, CECIL	"BABA BEATON, WANDA BAILLIE-HAMILTON"	11/80	SNY	887	S	9 X 7	1928/V	ST,T	325
BEATON, CECIL	"THE DASHWOOD FAMILY"	11/80	SNY	888	S	9 X 7	1926/V	ST,T	200
BEATON, CECIL	"DEBUTANTES OF 1937"	11/80	SNY	889	S	9 X 6	1927/V	ST,A	225
BEATON, CECIL	LADY JERSEY	11/80	SNY	890	S	10 X 8	1929/V	ST,T	125
BEATON, CECIL	"LADY OXFORD"	11/80	SNY	891	S	12 X 6	1927/V	T	BI
BEATON, CECIL	"LADY OXFORD" (BACK VIEW)	11/80	SNY	892	S	12 X 7	1927/V	T	275
BEATON, CECIL	"PAULA GELLIBRAND"	11/80	SNY	893	S	10 X 5	1928/V	T	150
BEATON, CECIL	"THE HON. LADY CLIFFORD..."	11/80	SNY	894	S	10 X 8	1930'S/V	S,T	175
BEATON, CECIL	"GWILI ANDRE"	11/80	SNY	895	S	10 X 8	1931/V	ST,T	400
BEATON, CECIL	"LADY DIANA COOPER"	11/80	SNY	896	S	10 X 8	1932/V	ST,T	175
BEATON, CECIL	"MRS REGINALD FELLOWES"	11/80	SNY	897	S	10 X 7	1931/V	T	1,000
BEATON, CECIL	"SARAH CHURCHILL"	11/80	SNY	898	S	10 X 8	1936/V	S,T,A	225
BEATON, CECIL	PRINCESS PALEY	11/80	SNY	899	S	10 X 8	1936/V	ST,T	275
BEATON, CECIL	"PRINCESS PALEY"	11/80	SNY	900	S	11 X 10	930'S/V	ST,T	150
BEATON, CECIL	"MRS HARRISON WILLIAMS"	11/80	SNY	901	S	10 X 8	1930'S/V	ST,T	225
BEATON, CECIL	"MRS HARRISON WILLIAMS"	11/80	SNY	902	S	10 X 8	1937/V	ST,T	125
BEATON, CECIL	"DUKE OF WINDSOR"	11/80	SNY	903	S	9 X 7	1937/V	ST,T	175
BEATON, CECIL	THE DUCHESS OF WINDSOR	11/80	SNY	904	S	9 X 7	1937/V	ST	BI
BEATON, CECIL	"DUCHESS OF WINDSOR"	11/80	SNY	905	S	10 X 7	1939/V	ST,T	225
BEATON, CECIL	"LORD BERNERS (ASHCOMBE)"	11/80	SNY	906	S	8 X 10	1937/V	ST,T	475
BEATON, CECIL	"LADY MAUD CARNEGIE"	11/80	SNY	907	S	10 X 10	1940/V	ST,T,I	100
BEATON, CECIL	"LADY MENDL"	11/80	SNY	908	S	10 X 10		ST,T	250
BEATON, CECIL	"VICOMTESSE DE NOAILLES"	11/80	SNY	909	S	10 X 11	1940'S/V	ST,T	175
BEATON, CECIL	"CONTESSA ROMANONES"	11/80	SNY	910	S	8 X 8	1958/V	T	100
BEATON, CECIL	"THE WYNDHAM SISTERS"	11/80	SNY	911	S	12 X 10	1950/V	T,A	300
BEATON, CECIL	"LADY C. PAGET"	11/80	SNY	912	S	10 X 10	C1940/V	ST,T	165
BEATON, CECIL	"NIJINSKA"	11/80	SNY	915	S	10 X 8	1930'S/V	ST,T	200
BEATON, CECIL	"NUREYEV"	11/80	SNY	916	S	10 X 10	1963/V	ST,T	700
BEATON, CECIL	SERGE LIFAR	11/80	SNY	917	S	9 X 7	1938/V		225
BEATON, CECIL	"MARKOVA"	11/80	SNY	918	S	8 X 7	1950/V	ST,T	175
BEATON, CECIL	DANILOVA	11/80	SNY	919	S	10 X 8	1937/V		175
BEATON, CECIL	MARGOT FONTEYN IN COSTUME	11/80	SNY	920	S	10 X 8	1960'S/V	ST,T	350
BEATON, CECIL	"BESTIGUI HOUSE"	11/80	SNY	921	S	6 X 6	1941/V	ST,T	375
BEATON, CECIL	"FLOWERS"	11/80	SNY	922	S	10 X 8		T	1,200
BEATON, CECIL	"10 DOWNING STREET"	11/80	SNY	923	S	10 X 10	1940/V	T	150
BEATON, CECIL	BARONESS PHILIPPE DE ROTHSCHILD HOUSE	11/80	SNY	924	S	10 X 8	1953/V	ST,T	150
BEATON, CECIL	"WINDOW DRESSINGS"	11/80	SNY	925	S	10 X 10	1937/V	S,T,A	275
BEATON, CECIL	NEW YORK STREET DOUBLE IMAGE	11/80	SNY	926	S	10 X 7	1937/V	ST,T,S	275
BEATON, CECIL	MRS SHEVLIN SMITH AGAINST NY AT NIGHT	11/80	SNY	927	S	10 X 8	1936/V	T,S	500
BEATON, CECIL	"NEW YORK" (BATHING SUIT PAGEANT)	11/80	SNY	928	S	9 X 10	1940/V	T	400
BEATON, CECIL	NEW YORK STREET SCENE	11/80	SNY	929	S	8 X 9	1937/V	S,T	200
BEATON, CECIL	CANDY STORE	11/80	SNY	930	S	9 X 10	1937/V	S,A	175
BEATON, CECIL	"NEW YORK", STREET SCENE	11/80	SNY	931	S	9 X 9	1937/V	ST,T	400

PHOTOGRAPHER	TITLE OR DESCRIPTION	DATE	AH	LOT#	PT	SIZE	N/P DATES	MARKS/COND.	PRICE
BEATON, CECIL	"NEW YORK", PHONE BOOTHS	11/80	SNY	932	S	9 X 10	1937/V	ST,T	450
BEATON, CECIL	"CARL VAN VECHTEN"	11/80	SNY	933	S	8 X 7	1930'S/V	T	125
BEATON, CECIL	"WILLIAM WALTON - COMPOSER"	11/80	SNY	934	S	9 X 7	1926/V	T	BI
BEATON, CECIL	EDITH SITWELL TAKING TEA IN BED	11/80	SNY	935	S	10 X 8	1927/V	ST,T	425
BEATON, CECIL	"EDITH SITWELL"	11/80	SNY	936	S	12 X 9	1927/V	S,ST,T	1,300
BEATON, CECIL	EDITH SITWELL PLAYING THE HARP	11/80	SNY	937	S	9 X 7	1927/V	ST,I	500
BEATON, CECIL	"NANCY CUNARD"	11/80	SNY	938	S	10 X 6	1927/V	ST,T	850
BEATON, CECIL	SACHEVERELL SITWELL	11/80	SNY	939	S	8-DIAM	1927/V		225
BEATON, CECIL	"ALDOUS HUXLEY"	11/80	SNY	940	S	10 X 7	C1935/V	T	450
BEATON, CECIL	"SALVADOR DALI AND GALA"	11/80	SNY	941	S	9 X 8	1930'S/V	ST,T	400
BEATON, CECIL	"PICASSO"	11/80	SNY	942	S	14 X 14	1933/V	ST,T,A	1,300
BEATON, CECIL	"COCTEAU"	11/80	SNY	943	S	7 X 6	1945/V	ST,T	370
BEATON, CECIL	"JEAN COCTEAU"	11/80	SNY	944	S	9 X 6	1930'S/V	ST,T,A	700
BEATON, CECIL	GERTRUDE STEIN AND ALICE B. TOKLAS	11/80	SNY	945	S	9 X 9	1930'S/V		750
BEATON, CECIL	"RAOUL DUFY"	11/80	SNY	946	S	7 X 7	1945/V	ST,T	150
BEATON, CECIL	"REX WHISTLER"	11/80	SNY	947	S	7 X 9	1936/V	T	100
BEATON, CECIL	TCHELITCHEW PAINTING PETER WATSON	11/80	SNY	948	S	10 X 8	1930'S	ST	475
BEATON, CECIL	CHRISTIAN BERARD AT WORK ON A PORTRAIT	11/80	SNY	949	S	10 X 9	1937/V	ST	500
BEATON, CECIL	"COLETTE"	11/80	SNY	950	S	8 X 6	1930/V	T	500
BEATON, CECIL	"COLETTE 1953"	11/80	SNY	951	S	10 X 8	1953/V	ST,T,A	650
BEATON, CECIL	"OSCAR KOKOSCHKA"	11/80	SNY	952	S	8 X 6	1940'S/V	ST,T	125
BEATON, CECIL	"NOEL COWARD"	11/80	SNY	953	S	8 X 6	1942/V	ST,T	250
BEATON, CECIL	"PICASSO"	11/80	SNY	954	S	6 X 6	1945/V	ST,T,A	400
BEATON, CECIL	"MIRO"	11/80	SNY	955	S	11 X 7	1950'S/V	ST,T	200
BEATON, CECIL	CHARLES HENRI FORD	11/80	SNY	956	S	8 X 10	1930'S/V		650
BEATON, CECIL	"IRVING PENN"	11/80	SNY	957	S	7 X 8	1950/V	ST,T	BI
BEATON, CECIL	"HENRY MOORE"	11/80	SNY	958	S	10 X 10	1954/V	ST,T	225
BEATON, CECIL	"TRUMAN CAPOTE"	11/80	SNY	959	S	8 X 8	1950/V	ST,T	200
BEATON, CECIL	"COLE PORTER"	11/80	SNY	960	S	7 X 6	1953/V	ST,T,A	450
BEATON, CECIL	"STRAVINSKY"	11/80	SNY	961	S	10 X 8	1956/V	T	125
BEATON, CECIL	"PROF B. BERENSON IN HIS GARDEN-ITALY"	11/80	SNY	962	S	10 X 10	1957/V	ST,T	600
BEATON, CECIL	"GEORGIA O'KEEFE"	11/80	SNY	963	S	9 X 10	1966/V	ST,T	325
BEATON, CECIL	"W.H. AUDEN"	11/80	SNY	964	S	7 X 8	1967/V	ST,T,I,A	275
BEATON, CECIL	"LONDON BOMB DAMAGE: ST. PAUL'S CATH"	11/80	SNY	965	S	8 X 8	1940/V	ST,I	500
BEATON, CECIL	"BOMB VICTIM"	11/80	SNY	966	S	8 X 8	1940/V	ST,T,A	800
BEATON, CECIL	EVACUATED CHILDREN DURING A BLACKOUT	11/80	SNY	967	S	8 X 8	1940/V	I	400
BEATON, CECIL	"WAR ORPHANS DURING BOMBING OF LONDON"	11/80	SNY	968	S	9 X 10	1940/V	ST,T	650
BEATON, CECIL	"SAILOR OFF DUTY"	11/80	SNY	969	S	8 X 10	1944/V	ST,T	125
BEATON, CECIL	"SIR WINSTON CHURCHILL, 10 DOWNING ST"	11/80	SNY	970	S	10 X 10	1940/V	ST,T	375
BEATON, CECIL	WAR WRECKAGE-REMAINS OF TANK	11/80	SNY	971	S	8 X 8	1942/V		600
BEATON, CECIL	SANDSTORM IN THE LIBYAN DESERT	11/80	SNY	972	S	8 X 8	1942/V		425
BEATON, CECIL	BOMBED FIRE STATION, TOBRUK	11/80	SNY	973	S	8 X 8	1942/V		200
BEATON, CECIL	GENERAL CHARLES DE GAULLE	11/80	SNY	974	S	9 X 10	1941/V	ST	375
BEATON, CECIL	GENERAL DWIGHT D. EISENHOWER	11/80	SNY	975	S	8 X 8	1943/V	ST	175
BEATON, CECIL	"IN THE LIBYAN DESERT"	11/80	SNY	976	S	10 X 9	1942/V		150
BEATON, CECIL	"BATTLE OF BRITAIN PILOT"	11/80	SNY	977	S	9 X 10	1941/V	ST,T	225
BEATON, CECIL	"SPAIN" (CHURCH INTERIOR)	11/80	SNY	978	S	8 X 8	1960/V	ST,T	300
BEATON, CECIL	ENGLAND (FAT MAN)	11/80	SNY	979	S	8 X 8	1954/V	ST	150
BEATON, CECIL	"OULED NAILS IN A MOROCCAN BROTHEL"	11/80	SNY	980	S	10 X 9	1937/V	ST,T,D	500
BEATON, CECIL	CHINESE MILITARY POLICE	11/80	SNY	981	S	10 X 10	1945/V	ST	325
BEATON, CECIL	"BANGKOK FLOUR FACTORY"	11/80	SNY	982	S	10 X 10	1957/V	ST	275
BEATON, CECIL	"MOROCCO" (MALE NUDE)	11/80	SNY	983	S	10 X 10	1958/V	ST,I	900
BEATON, CECIL	BARBARA HUTTON IN TANGIER	11/80	SNY	984	S	10 X 10	1961/V		300
BEATON, CECIL	"MAE MURRAY"	11/80	SNY	985	S	10 X 9	1962/V	ST,T	BI
BEATON, CECIL	"MR & MRS ROBERT KENNEDY"	11/80	SNY	986	S	9 X 11	1960'S/V	ST	200
BEATON, CECIL	"CAROLINE KENNEDY"	11/80	SNY	987	S	9 X 8	1960'S/V	ST,T	175
BEATON, CECIL	"PRINCESS LEE RADZIWILL"	11/80	SNY	988	S	10 X 10	1967/V	ST,T	175
BEATON, CECIL	"JOHN LINDSAY"	11/80	SNY	989	S	11 X 10	1966/V	ST,T	100
BEATON, CECIL	"VIVA" (2 PHOTOS)	11/80	SNY	990	S	10 X 8	1969/V	T	200
BEATON, CECIL	"SHRIMPTON" (CONTACT SHEET)	11/80	SNY	991	S	10 X 8	1966/V	ST,T	550
BEATON, CECIL	"TWIGGY" (2 CONTACT SHEETS)	11/80	SNY	992	S	10 X 8	1967/V	T	200

PHOTOGRAPHER	TITLE OR DESCRIPTION	DATE	AH	LOT#	PT	SIZE	N/P DATES	MARKS/COND.	PRICE
BEATON, CECIL	"LORD HAREWOOD"	11/80	SNY	993	S	7 X 10	1968/V	ST,T	BI
BEATON, CECIL	"MRS VREELAND"	11/80	SNY	994	S	10 X 10	1973/V	T,A	175
BEATON, CECIL	"HENRY GLEZALER W/ PAINTING OF HIM..."	11/80	SNY	995	S	10 X 10	1970/V	ST,T,A,D	BI
BEATON, CECIL	DAVID HOCKNEY IN HIS STUDIO	11/80	SNY	996	S	12 X 18	C1970/V	S,ST,T	500
BEATON, CECIL	"DAVID HOCKNEY"	11/80	SNY	997	S	9 X 9	1965/V	ST,T,I	300
BEATON, CECIL	"MICK JAGGER"	11/80	SNY	998	S	8 X 8	1967/V	ST,T	275
BEATON, CECIL	"ELIZABETH TAYLOR (ROTHSCHILD BALL).."	11/80	SNY	999	S	9 X 9	1950'S/V	T	275
BEATON, CECIL	"ALEXANDER QUENNELL"	11/80	SNY	1000	S	8 X 7	1973/V	S,ST,T	550
BEDFORD, FRANCIS	MIDDLE EASTERN VIEWS (48 PRINTS)	10/80	PT	13	A	5 X 4	1866/V	PD	320
BEDFORD, FRANCIS	"VIEW OF THE LLEDR, NORTH WALES"	10/80	PT	22	A	5 X 4	C1880/V	PD	100
BELLMER, HANS	STICK FIGURE	11/80	PNY	104	S	5 X 3	1936/V		700
BELLMER, HANS	MANNEQUIN PARTS	11/80	PNY	105	S	5 X 3	1936/V		750
BELLMER, HANS	POUPEE (HAND-COLORED PRINT)	5/81	SNY	561	S	6 X 7	C1935/V	/G	100
BELLOCQ, E.J./FRIEDLANDER	STORYVILLE PORTRAIT, PL. 1.	10/80	PT	67	S	10 X 8	C1913/70'S	ST	BI
BELLOCQ, E.J./FRIEDLANDER	STORYVILLE PORTRAIT, PL. 14.	10/80	PT	68	S	10 X 8	C1913/70'S	ST	600
BELLOCQ, E.J./FRIEDLANDER	STORYVILLE PORTRAIT, PL. 33.	10/80	PT	69	S	10 X 8	C1913/70'S	ST	260
BELLOCQ, E.J./FRIEDLANDER	STORYVILLE PORTRAITS (2 PRINTS)	5/81	SNY	534	S	8 X 10	1911-13/70	ST/G	750
BENDA, ARTHUR	DORA DUBY (2 PRINTS)	4/81	PNY	154	S	8 X 7	1920'S/V	IN,S	BI
BERNARD, MAURICE	"GRAND GUIGNOL"	11/80	PNY	111	S	12 X 9	C1930/V	S,T	130
BERNHARD, RUTH	PORTFOLIO: 10 PRINTS, ED: 12/15	11/80	CNY	410	S		1935-70/V	S,A,T	1,900
BERNHARD, RUTH	"CLASSIC TORSO"	11/80	CNY	410A	S	10 X 8	1952/V	S,T,D	380
BERNHARD, RUTH	THREE BOYS	11/80	SNY	325	S	7 X 9	1944/V	S,I,ST	250
BERNHARD, RUTH	"HIPS-HORIZONTAL"	11/80	SNY	326	S	10 X 14	1940'S/V	S,T	550
BERNHARD, RUTH	"CLASSIC TORSO"	11/80	SNY	327	S	14 X 11	1952/L	S,T,D	750
BERNHARD, RUTH	"CLASSIC TORSO"	2/81	SLA	54	S	9 X 6	1952/V	S,T,D	500
BERNHARD, RUTH	SHELL STUDY	2/81	SLA	55	S	9 X 8	1943/V	S,D,	350
BERNHARD, RUTH	"IN THE BOX-HORIZONTAL"	2/81	SLA	56	S	7 X 14	1962/L	S,T	650
BERNHARD, RUTH	"CLASSIC TORSO"	5/81	CNY	144	S	13 X 10	1952/L	S,T,D/M	800
BERNHARD, RUTH	"TWO FORMS"	5/81	CNY	145	S	14 X 10	1963/L	S,T,D/G	700
BERNHARD, RUTH	TRIANGLES (ED: 15)	5/81	PNY	302	S	11 X 8	/76	S,T	BI
BERNHARD, RUTH	"SAND DUNE" (ED: 15)	5/81	PNY	303	S	4 X 10	48-70/76	S,T	BI
BERNHARD, RUTH	"CLASSIC TORSO"	5/81	SNY	442	S	14 X 11	1952/L	S,T,D/M	800
BERNHARD, RUTH	"CLASSIC TORSO"	5/81	SNY	572	S	14 X 11	1952/L	S,T,D	750
BERNHARD, RUTH	"CLASSIC TORSO"	5/81	SNY	573	S	14 X 10	1952/L	S,T,D	450
BERNHARDT, SARAH	MISS BERNHARDT IN DRESS AND HAT	4/81	SW	414	S	7 X 5	1909/V	I,ST	550
BIDERMANAS, IZIS	"JARDINS DES TUILERIES, PARIS"	11/80	SNY	404	S	13 X 11	1950/L	S,T,D,I,ST	600
BIDERMANAS, IZIS	"PLACE ST. ANDRE-DES-ARTS"	11/80	SNY	405	S	11 X 9	1950/1972	S,T,D,ST,I	300
BIDERMANAS, IZIS	"ILE DU VERT GALANT, PARIS"	11/80	SNY	406	S	11 X 9	1950/1972	S,T,D,ST,I	BI
BIDERMANAS, IZIS	LE DESERT DE RETZ	4/81	PNY	140	S	14 X 11	1954/1975	S,D,T,ST,I	BI
BIDERMANAS, IZIS	WHITECHAPEL, LONDRES	4/81	PNY	141	S	11 X 9	1954/1977	S,D,T,ST	BI
BIDERMANAS, IZIS	FOIRE DU TRONE-PARIS	4/81	PNY	142	S	14 X 10	1958/L	S,T,D,ST	BI
BIDERMANAS, IZIS	PARADE POUR LA FEMME-CROCODILE	4/81	PNY	143	S	11 X 8	1946/1977	T,D,S,ST	BI
BIDERMANAS, IZIS	RUE BEAUBOURG	5/81	PNY	150	S	9 X 14	1972/L	S,T,D,ST/E	BI
BIDERMANAS, IZIS	"JARDINS DES TUILERIES, PARIS"	5/81	SNY	253	S	13 X 11	1950/L	S,T,D,I,ST/M	550
BIDERMANAS, IZIS	"QUAI DES ORFEVRES"	5/81	SNY	254	S	12 X 10	1942/L	S,T,D,I,ST	950
BING, ILSE	PUDDLE AT SIDEWALK, PARIS	5/81	CNY	107	S	13 X 11	1932/V	S,D	BI
BING, ILSE	CHAIRS IN THE RAIN ALONG THE CHAMPS...	11/80	CNY	317	S	11 X 13	1931/L	S,D	700
BING, ILSE	ILE ST. LOUIS, PARIS	11/80	CNY	318	S	9 X 14	1932/L	S,D	BI
BING, ILSE	"WINDOWS, BRISSAGO, ITALIAN SWITZERLD"	11/80	PNY	170	S	11 X 9	1934/V	S,D,T,ST	200
BING, ILSE	"CHAMNPAGNE BOTTLES"	11/80	PNY	171	S	11 X 9	1933/V	S,ST,D	425
BING, ILSE	"BUM ON PONT DES ARTES, PARIS"	11/80	PNY	172	S	10 X 13	1931/V	S,D	BI
BING, ILSE	"CHRISTA ON BATHTUB" (SOLARIZED)	11/80	PNY	173	S	11 X 9	1934/V	S,D,T	375
BISCHOF, WERNER	"INDIAN FLUTE PLAYER/CUZCO, PERU"	10/80	PT	192	S	14 X 11	1954/V	ST	240
BISCHOF, WERNER	SNOWSTORM, JAPAN	10/80	PT	193	S	11 X 14	1952/V	ST	340
BISSON, FRERES	VANTAIL DE LA PORTE SAINT MARCEL	5/81	PNY	26	A	14 X 10	C1854/V	T,ST,S	500
BISSON, FRERES	TYMPAN DE LA PORTE SAINTE-ANNE (PL 18)	4/81	SW	294	SA	10 X 15	1850'S/V	T,ST	300
BISSON, FRERES	DETAIL D'UNE OGIVE (PLATE 6)	4/81	SW	295	A	10 X 15	1850'S/V	T	190
BISSON, FRERES	FENETRES LATERALES DU BAS COTE (PL 71)	4/81	SW	296	A	9 X 13	1850'S/V	T	300
BLACK, JAMES WALLACE	THE HINKLEY & WILLIAMS WORKS, BOSTON	11/80	CNY	170	A	12 X 17	C1870/V	PD,T	350
BLOSSFELDT, KARL	PORTFOLIO: 12 PRINTS (ED: 21/50)	5/81	SNY	173	S	10 X 7	1900-28/75	ST/M	BI
BLUMENFELD, ERWIN	CORSETS	4/81	PNY	184	S	13 X 10	1940'S/V	ST,S	BI

PHOTOGRAPHER	TITLE OR DESCRIPTION	DATE	AH	LOT#	PT	SIZE	N/P DATES	MARKS/COND.	PRICE
BLUMENFELD, ERWIN	PLAGE A BOLBEC, NORMANDIE	5/81	PNY	296	S	14 X 11	1947/L	T,D,ST	BI
BLUMENFELD, ERWIN	JEAN BERARD, PARIS	11/80	PNY	165	S	12 X 9	1937/V	ST	BI
BLUMENFELD, ERWIN	PORTRAIT: CECIL BEATON (PROFILE)	11/80	SNY	836	S	12 X 9	1938/V		175
BLUMENFELD, ERWIN	"CECIL BEATON"	11/80	SNY	837	S	13 X 10	1940'S/V	T,I	225
BOECKSTYNS, WILLY	WINDOWSILL, STILL LIFE (2 PRINTS)	4/81	PNY	77	S	12 X 9	1950'S/V	S	BI
BOECKSTYNS, WILLY	GLASS AND LEAVES (2 PRINTS)	4/81	PNY	78	S	12 X 9	1950'S/V	S	130
BOISGONTIER, GILBERT	"LOCOMOTIVE"	11/80	PNY	120	S	7 X 9	C1930/V	ST	BI
BONFILS, F. OR SEBAH P.	MIDDLE EASTERN WOMAN & HOOKAH PIPE	5/81	PNY	60	A	9 X 7	1860'S/V	IN	BI
BONFILS, FELIX	TEMPLE AT BALBEK	5/81	SNY	106	A	11 X 15	1870'S/V	SN,IN,T/E	200
BONFILS, FELIX	ALBUM: JERUSALEM & ALGIERS (42 PRINTS)	10/80	PT	15	A	9 X 11	1870'S/V		1,350
BONFILS, FELIX	MIDDLE EAST (16 PRINTS)	10/80	PT	16	A	9 X 12	1870'S/V	SN	180
BONFILS, FELIX	MIDDLE EAST (21 PRINTS)	10/80	PT	18	A	9 X 11	1870'S/V	SN	350
BONFILS, FELIX	7 PHOTOGRAPHS (JERUSALEM, DAMASCUS...)	11/80	SW	243	A	12 X 9	1870'S/V	5=S	325
BONFILS, FELIX	6 PHOTOS (DAMASCUS, MOSQUE, HEBRON...)	11/80	SW	244	A	12 X 15	1870'S/V	SN,IN	800
BONFILS, FELIX	6 PHOTOS (BAALBEK, TEMPLE, MONOLITH..)	11/80	SW	245	A	12 X 15	1870'S/V	SN,IN	750
BONFILS, FELIX	6 PHOTOS (JAFFA, DAMASCUS, NAZARETH..)	11/80	SW	246	A	12 X 15	1870'S/V	SN,IN	700
BONFILS, FELIX	VIEWS OF HOLY LAND (21 PHOTOS)	11/80	SW	247	A	9 X 11	1880'S/V	IN	350
BOUBAT, EDOUARD	LEILA TRANA, LA BRETAGNE	2/81	SLA	58	S	14 X 9	1949/L	S,D,T	375
BOUBAT, EDOUARD	"PARIS, 1942" (CHILD IN PARK)	2/81	SLA	59	S	13 X 10	1942/L	S,T,D,	350
BOUBAT, EDOUARD	"PARIS, 1956" (CHILDREN PLAYING)	2/81	SLA	60	S	13 X 20	1956/L	S,T,D,	600
BOUBAT, EDOUARD	"CYNTHIA, 1925"	2/81	SLA	61	S	13 X 9	1925/L	S,T,D	400
BOUBAT, EDOUARD	LEILA TRANA, LA BRETAGNE	4/81	PNY	145	S	13 X 10	1949/1980	S,T,D	375
BOUBAT, EDOUARD	FRANCE (2 GIRLS ON GRASS)	5/81	PNY	148	S	12 X 11	1949/L	S,T,D/F	225
BOUBAT, EDOUARD	BERNARD, PARIS	5/81	PNY	149	S	10 X 14	1965/L	S,T,D/F	225
BOUBAT, EDOUARD	PARIS (WOMAN, PL. 87)	10/80	PT	123	S	14 X 9	1971/L	S,T,D	BI
BOUBAT, EDOUARD	"ENFANTS DANS LA PREMIERE NEIGE-PARIS"	11/80	CNY	462	S	9 X 14	1955/70'S	S,T	300
BOUCHER, PIERRE	NUDE STUDY	11/80	CNY	434	S	9 X 7	1932/V	ST	BI
BOUGHTON, ALICE	PORTRAIT: TWO WOMEN AND A HARP	5/81	PNY	225	P	15 X 12	C1914/V	S	BI
BOUGHTON, ALICE	DOROTHY, ROSALIND AND CYNTHIA FULLER	5/81	PNY	226	P	8 X 6	C1914/V	S,I,D	250
BOUGHTON, ALICE	MAXIME GORKY	11/80	CNY	245	S	8 X 6	1907/V	S	420
BOUGHTON, ALICE	WALTER HAMPDEN	11/80	SW	248	P?	8 X 6	C1920/V	S	BI
BOURDEAU, ROBERT	"YORKSHIRE, ENGLAND"	10/80	PT	220	A	8 X 10	1975/V	S,T,D	340
BOURDEAU, ROBERT	"YORKSHIRE, ENGLAND"	10/80	PT	221	S	8 X 10	1975/V	S,T,D	BI
BOURDEAU, ROBERT	"CUMBRIA, ENGLAND"	11/80	SNY	519	S	11 X 14	1975/V	S,D,	225
BOURDIN, GUY	THREE WOMEN	11/80	CNY	621	CP	38 X 26	1970'S/V		BI
BOURKE-WHITE, MARGARET	"IRON PUDDLER, STALINGRAD"	2/81	SLA	62	S	14 X 9	1930/V		325
BOURKE-WHITE, MARGARET	SALUTE TO HITLER	4/81	PNY	122	S	8 X 9	C1940/V	ST	BI
BOURKE-WHITE, MARGARET	NAZI RALLY	4/81	PNY	123	S	8 X 9	C1940/V	ST	BI
BOURKE-WHITE, MARGARET	"AUTUMN HARVEST, MORAVIA"	5/81	CNY	142	S	10 X 13	C1938/V	T,A,ST/G	500
BOURKE-WHITE, MARGARET	PROFILE VIEW OF PEASANT OF ROSTOV	5/81	SNY	304	S	13 X 9	1930'S/V	ST,T/F	450
BOURKE-WHITE, MARGARET	LANDSCAPE STUDIES (3 PRINTS)	10/80	PT	194	S	5 X 6	C1950'S/V	ST	220
BOURKE-WHITE, MARGARET	"WOMAN WORKING IN CEMENT FACTORY,RUS."	11/80	PNY	296	S	13 X 9	1930/V		200
BOURKE-WHITE, MARGARET	"LEHIGH, PORTLAND (RAILROAD)	11/80	PNY	297	S	13 X 9	C1931/V		BI
BOURKE-WHITE, MARGARET	USS AKRON (FRAME=METAL OF ZEPPELIN)	11/80	CNY	401A	S	17 X 23	1931/V	S	1,900
BOURKE-WHITE, MARGARET	"LUDLUM STEEL ELECTRIC FURNACE"	11/80	SNY	309	S	13 X 9	1926-28/V	S,I,T,ST	850
BOURKE-WHITE, MARGARET	"IRON PUDDLER, FORD"	11/80	SNY	310	S	13 X 9	1927-28/V	S,T,ST	900
BOURKE-WHITE, MARGARET	"OTIS SMOKE STACKS"	11/80	SNY	311	S	13 X 9	1927-28/V	S,T,ST	850
BOURKE-WHITE, MARGARET	DYNAMO, NIAGRA POWER CO.,	11/80	SNY	312	S	13 X 9	1928/C	T,ST,I	450
BOURKE-WHITE, MARGARET	"OUTSIDE VIEW, FORD, OUR NO. 13."	11/80	SNY	313	S	13 X 9	1927-28/V	S,T,ST	400
BOURKE-WHITE, MARGARET	QUARRIES AT LEHIGH (ARCH. REPR.-1975)	11/80	SNY	314	S	13 X 9	1930'S/V	ST	400
BOURKE-WHITE, MARGARET	RCA SPEAKERS	11/80	SNY	315	S	13 X 9	1930'S/V	ST	550
BOURKE-WHITE, MARGARET	BUNDLES OF WIRE CABLE	11/80	SNY	316	S	14 X 19	1930'S/V		BI
BOURKE-WHITE, MARGARET	"IRON PUDDLER, RUSSIA"	11/80	SNY	318	S	13 X 9	1930/V	S,I,PD	600
BOURKE-WHITE, MARGARET	"IN THE QUARRY, NOVOROSSISK, RUSSIA"	11/80	SNY	319	S	13 X 9	1930/V		BI
BOURKE-WHITE, MARGARET	"IN THE QUARRY, NOVOROSSISK, RUSSIA"	11/80	SNY	320	S	13 X 9	1930/V		BI
BOURKE-WHITE, MARGARET	"POOR PEOPLE GET PASSED BY" (AR. REP.)	11/80	SNY	321	S	5 X 6	1936/V		350
BOURNE, SAMUEL	INDIA (6 PRINTS)	10/80	PT	19	A	9 X 12	1870'S/V	SN,IN	300
BOURNE, SAMUEL	INDIA (3 PRINTS)	10/80	PT	20	A	9 X 12	1870'S/V	SN,IN	BI
BOURNE, SAMUEL	VIEWS OF INDIA (ALBUM OF 69 PRINTS)	11/80	CNY	81	A	12 X 9	C1870/V	S,IN	1,100
BOWDEN, HARRY	PORTRAIT: WILLEM DE KOONING (EX. LAB.)	2/81	SLA	64	S	10 X 8	1946/V		100
BOWDEN, HARRY	PORTRAIT: EDWARD WESTON (EX. LABELS)	2/81	SLA	65	S	7 X 9	1953/V		350

PHOTOGRAPHER	TITLE OR DESCRIPTION	DATE	AH	LOT#	PT	SIZE	N/P DATES	MARKS/COND.	PRICE
BRADY, M (AFTER)	LINCOLN'S 2ND INAUG.(COPY BY C. DODGE)	11/80	CNY	130	S	7 X 10	1865/C1900	ST	200
BRADY, M (AFTER) MEADE, C	LOUIS JACQUES MANDE DAGUERRE	11/80	CNY	98	A	8 X 5	1850'S/V		280
BRADY, MATHEW	PORTRAIT: ABRAHAM LINCOLN	2/81	SLA	67	A	8 X 6	1864/V	I	2,800
BRADY, MATHEW	"WEST POINT: CLASS OF 65" (ALB.100 P.)	11/80	SNY	96	A	4TO	1865/V	ST,T	1,200
BRADY, MATHEW	HENRY CLAY	11/80	CNY	102	SA	19 X 16	1850'S/V		500
BRADY, MATHEW	HENRY CLAY	11/80	CNY	103	SA	17 X 14	C1850/V		500
BRADY, MATHEW	ALBUM: 99 AUTOGRAPHED PORTRAITS	11/80	CNY	106	SA	CABINET	C1860/V	ST	1,500
BRADY, MATHEW	GENERAL LESLIE COOMBS	11/80	CNY	108	SA	9 X 6	1850'S/V	IN	420
BRADY, MATHEW	GEN. BONHAM & HON. BURNETT (2 PRINTS)	11/80	CNY	109	SA	8 X 6	1850'S/V	IN	BI
BRADY, MATHEW	J.C. TEN EYCK & RANDALL (2 PRINTS)	11/80	CNY	111	SA	8 X 6	1850'S/V		BI
BRADY, MATHEW	INCIDENTS OF THE WAR (3 PRINTS)	11/80	CNY	114	A	7 X 9	1862/V	PD,T	250
BRADY, MATHEW	GENERAL R.E. LEE & STAFF (& LETTER)	11/80	CNY	125	A	9 X 7	1865/V	PD,T/M	2,200
BRADY, MATHEW	ABRAHAM LINCOLN	11/80	SW	334	A	11 X 9	1865/V	ST	4,000
BRADY,M. OR GARDNER,A.	MAJOR GENERAL ABNER DOUBLEDAY	11/80	CNY	104	SA	18 X 15	1850'S/V	PD	250
BRADY,M. OR GARDNER,A.	E. M. ARCHIBALD	11/80	CNY	105	SA	18 X 14	1850'S/V	A,ST	250
BRADY,M. OR GARDNER,A.	W. H. RUSSELL	11/80	CNY	106	SA	18 X 14	1850'S/V	A,ST	BI
BRANCUSI, CONSTANTIN	GOLDEN BIRD (SCULPTURE)	11/80	SNY	179	S	9 X 6	C1920/V	ST,I	13,500
BRANDT, BILL	NUDE,MARCH 1952 (SHAD. OF LIGHT P.121)	2/81	SLA	68	S	14 X 12	1952/L	S	1,600
BRANDT, BILL	NUDE (ON PEBBLY BEACH-TORSO)	2/81	SLA	69	S	13 X 12	1950'S/L	S	500
BRANDT, BILL	NUDE (PERSPECTIVE OF NUDES, P. 41)	2/81	SLA	70	S	13 X 11	1950'S/L	S	600
BRANDT, BILL	NUDE (ON PEBBLY BEACH)	2/81	SLA	71	S	14 X 12	1950'S/L	S	700
BRANDT, BILL	NUDE (TORSO W/BREAST)	2/81	SLA	72	S	9 X 8	1950'S/V	ST,I	750
BRANDT, BILL	NUDE WITH MIRROR	2/81	SLA	73	S	14 X 11	1950'S/L	S	700
BRANDT, BILL	NUDE, JUNE 1954"	2/81	SLA	74	S	13 X 11	1954/L	S	650
BRANDT, BILL	"LOTT'S COTTAGE, FLATFORD MILL, SUFF."	2/81	SLA	75	S	11 X 12	1976/V	S	700
BRANDT, BILL	"CHILD W/ NANNY IN HYDE PARK"	2/81	SLA	76	S	13 X 12	1930'S/L	S	400
BRANDT, BILL	NUDE, LONDON (NUDE, PL. 53)	4/81	PNY	146	S	14 X 12	1952/1970'S	S	1,700
BRANDT, BILL	NUDE (PERSP. OF NUDES, P. 65)	4/81	PNY	147	S	14 X 12	1950'S/L	S	BI
BRANDT, BILL	NUDE, MARCH 1952(SHAD. OF LIGHT P.121)	5/81	CNY	150	S	14 X 12	1952/70'S	S/M	1,600
BRANDT, BILL	NUDE, JULY 1953 (NUDES P.23)	5/81	CNY	151	S	14 X 12	1953/70'S	S/G	550
BRANDT, BILL	NUDE (RECLINING)	5/81	CNY	152	S	19 X 16	1955/L	S,D,ST/F	950
BRANDT, BILL	NUDE, JULY 1956(SHAD. OF LIGHT P.133)	5/81	CNY	153	S	14 X 11	1956/70'S	S	480
BRANDT, BILL	RENE MAGRITTE W/"THE GREAT WAR" PIC.	5/81	CNY	154	S	14 X 12	1966/70'S	S/G	650
BRANDT, BILL	"ALLEY OFF EAST INDIA DOCK ROAD"	5/81	PNY	152	S	14 X 12	1930'S/L	S/F-G	650
BRANDT, BILL	"PARLOURMAID PREPARAING A BATH..."	5/81	PNY	153	S	14 X 12	1930'S/L	S/G	600
BRANDT, BILL	RACE-GOERS IN BOWLER HATS	5/81	PNY	154	S	14 X 12	1931/L	S/G	BI
BRANDT, BILL	PORTER AT BILLINGSGATE	5/81	PNY	155	S	14 X 12	1930'S/L	S/E	400
BRANDT, BILL	PARLOURMAIDS READY TO SERVE DINNER	5/81	SNY	263	S	14 X 12	1930'S/L	S/M	850
BRANDT, BILL	"TRAIN LEAVING NEWCASTLE"	5/81	SNY	264	S	14 X 12	1930'S/L	S/M	850
BRANDT, BILL	"YOUNG HOUSEWIFE, BETHNAL GREEN"	5/81	SNY	265	S	14 X 12	1930'S/L	S/G	600
BRANDT, BILL	"A SNICKET IN HALIFAX"	5/81	SNY	266	S	14 X 12	1930'S/L	S/M	800
BRANDT, BILL	"MISTY EVENING IN SHEFFIELD"	5/81	SNY	267	S	13 X 12	1930'S/L	S/E	600
BRANDT, BILL	NUDE, MARCH 1952 (SHAD. OF LIGHTP.121)	5/81	SNY	268	S	14 X 12	1950'S/L	S/G	1,500
BRANDT, BILL	"NUDE NO. 41"	5/81	SNY	269	S	14 X 12	1956/70'S	S	BI
BRANDT, BILL	KNEES ON PEBBLY BEACH	5/81	SNY	270	S	13 X 11	1959/L	S	500
BRANDT, BILL	RENE MAGRITTE W/"THE GREAT WAR" PIC.	5/81	SNY	271	S	14 X 12	1966/L	S/E	500
BRANDT, BILL	TIC-TAC MEN AT ASCOT RACES	10/80	PT	93	S	14 X 12	1930'S/70'S	S	600
BRANDT, BILL	HALIFAX, ENGLAND	10/80	PT	94	S	14 X 12	1930'S/L	S	850
BRANDT, BILL	"ALLEY OFF EAST INDIA DOCK ROAD"	10/80	PT	95	S	14 X 12	1930'S/70'S	S	425
BRANDT, BILL	NUDE	10/80	PT	96	S	14 X 12	1960/70'S	S	650
BRANDT, BILL	NUDE (PERSP. OF NUDES, P. 41)	10/80	PT	97	S	13 X 12	1950'S/L	S	950
BRANDT, BILL	NUDE, MARCH 1952(SHAD. OF LIGHT P.121)	10/80	PT	98	S	14 X 12	1960/L	S	1,500
BRANDT, BILL	"PARLOURMAID PREPARING A BATH ..."	11/80	PNY	183	XS	14 X 12	1930'S/L	S	BI
BRANDT, BILL	"LONDON AT DUSK"	11/80	SW	249	S	14 X 12	1970'S/V	S	250
BRANDT, BILL	"ROYAL GUARD BEHIND BARS"	11/80	SW	250	S	13 X 12	1970'S/V	S	200
BRANDT, BILL	NUDE	11/80	SW	251	S	14 X 12	C1960/70'S	S	BI
BRANDT, BILL	HALIFAX, ENGLAND	11/80	SNY	393	S	14 X 12	1930'S/L	S	600
BRANDT, BILL	MINERS RETURN. TO DAY., SOUTH WALES	11/80	SNY	394	S	14 X 12	1930'S/L	S	800
BRANDT, BILL	NUDE (PERSPECTIVE OF NUDES P. 41)	11/80	SNY	395	S	13 X 11	1950'S/L	S	900
BRANDT, BILL	NUDE, MARCH 1952 (SHAD OF LIGHT P 121)	11/80	SNY	397	S	14 X 12	1952/L	S	1,700
BRANDT, BILL	KNEES ON PEBBLY BEACH	11/80	SNY	398	S	13 X 11	1950'S/L	S	800

PHOTOGRAPHER	TITLE OR DESCRIPTION	DATE	AH	LOT#	PT	SIZE	N/P DATES	MARKS/COND.	PRICE
BRANDT, BILL	KNEES	11/80	SNY	399	S	14 X 11	1950'S/L	S	750
BRANDT, BILL	RACE-GOERS IN BOWLER HATS, PARIS	11/80	SNY	400	S	9 X 7	1950'S/V	S,I	600
BRANDT, BILL	PARLOURMAIDS READY TO SERVE DINNER	11/80	CNY	441	S	14 X 12	1930'S/70'S	S	750
BRANDT, BILL	MINERS RETURNING TO DAYLIGHT, S. WATER	11/80	CNY	442	S	13 X 11	1930'S/70'S	S	700
BRANDT, BILL	COAL-SEARCHERS NEAR HEWORTH	11/80	CNY	443	S	13 X 12	1930'S/70'S	S	600
BRANDT, BILL	CUSTOMERS IN THE CROOKED BILLET	11/80	CNY	444	S	13 X 12	1930'S/70'S	S	BI
BRANDT, BILL	COAL-SEARCHER GOING HOME TO JARROW	11/80	CNY	445	S	13 X 12	1930'S/70'S	S	600
BRANDT, BILL	NUDE	11/80	CNY	446A	S	13 X 11	1950'S/70'S	S	BI
BRANDT, BILL	NUDE	11/80	CNY	446	S	13 X 11	1950'S/70'S	S	420
BRANDT, BILL	NUDE, MARCH 1952(SHAD. OF LIGHT P.121)	11/80	CNY	447	S	13 X 11	1952/70'S	S	1,400
BRANDT, BILL	NUDE	11/80	CNY	448	S	14 X 12	1950'S/70'S	S	BI
BRANDT, BILL	NUDE (FEB 1953, SHAD OF LIGHT, P. 128)	11/80	CNY	449	S	14 X 12	1953/70'S	S	550
BRANDT, BILL	NUDE JULY 1953 (SHAD. OF LIGHT P. 132)	11/80	CNY	450	S	14 X 12	1953/70'S	S	400
BRANDT, BILL	NUDE	11/80	CNY	451	S	14 X 12	1950'S/70'S	S	400
BRANDT, BILL	CUCKMERE RIVER, SUSSEX	11/80	CNY	451A	S	11 X 13	1963/70'S	S	BI
BRANDT, BILL	RENE MAGRITTE W/"THE GREAT WAR" PIC.	11/80	CNY	452	S	13 X 11	1966/70'S	S	500
BRASSAI	"FILLE DE JOIE" (BACK) PARIS	2/81	SLA	77	S	13 X 9	1932/1960'S	S,T,ST	1,400
BRASSAI	A PROSTITUTE PLAYING BILLIARDS	2/81	SLA	78	S	14 X 11	1931-33/L	S,T,ST	1,600
BRASSAI	"FILLE DE JOIE CHEZ "SUZY" (MIRROR)	2/81	SLA	79	S	15 X 11	1932-33/L	S,T,D,ST	1,200
BRASSAI	"AT THE FOLIES-BERGERE"	2/81	SLA	80	S	11 X 9	1932/L	S,ST	1,200
BRASSAI	"GALA SOIREE AT MAXIM'S" (ED:50)	2/81	SLA	81	S	12 X 9	1949/L	S,ST	1,600
BRASSAI	PORTRAIT: PICASSO	2/81	SLA	82	S	9 X 12	C1939/V	ST,I	550
BRASSAI	"CESSPOOL CLEANERS, RUE VISCONTI ..."	5/81	CNY	98	S	9 X 7	1931/V	ST,T/E	850
BRASSAI	TREE GRATE	5/81	CNY	99	S	9 X 7	C1932/V	ST	1,200
BRASSAI	"AMOROUS COUPLE CHEZ 'SUZY'..."	5/81	CNY	100	S	8 X 11	1932/70'S	S,ST,A/M	BI
BRASSAI	"FILLE DE JOIE" (FRONT)PARRI(ED:25/30)	5/81	CNY	101	S	12 X 9	1932/70'S	S,A,T,D,ST/M	BI
BRASSAI	BIJOUX DE MONMARTRE... (ED:2/30)	5/81	CNY	102	S	15 X 12	1932/70'S	S,ST	1,300
BRASSAI	"LE FEMME A MONOCLE, PARIS" (ED:10/40)	5/81	CNY	103	S	12 X 9	1933/70'S	S,A,T,D,ST/E	BI
BRASSAI	"KIKI CHANTANT-MONTPARNASSE"(ED:11/30)	5/81	CNY	104	S	12 X 9	1933/70'S	S,A,T,D,ST/M	BI
BRASSAI	LA PRESENTATION "CHEZ SUZY" - PARIS	5/81	PNY	129	S	14 X 11	1933/L	S,D,T,ST	BI
BRASSAI	COUPLE, MIRRORED ARMOIRE, BROTHEL	5/81	PNY	130	S	11 X 9	C1932/L	S,T,D,ST	BI
BRASSAI	FILLE DE JOIE (BACK) PARIS	5/81	PNY	131	S	14 X 11	1933/L	S,T,D,ST	BI
BRASSAI	"JARDIN EXOTIQUE DE MONACO"	5/81	SNY	205	S	9 X 7	1920'S/V	ST,T/F	475
BRASSAI	"ACCIDENT DANS LA BANLIEU"	5/81	SNY	206	S	7 X 9	1920'S/V	ST,T/P	BI
BRASSAI	"LA SEINE"	5/81	SNY	207	S	7 X 9	1920'S/V	ST,T/P	500
BRASSAI	EIFFEL TOWER AT NIGHT	5/81	SNY	208	S	8 X 5	1920'S/V	ST/P	BI
BRASSAI	"MONASTIC BROTHEL, RUE LE PRINCE"	5/81	SNY	209	S	12 X 9	C1931/L	S,T,D,ST/E	BI
BRASSAI	"AMOROUS COUPLE CHEZ 'SUZY'..."	5/81	SNY	210	S	8 X 11	C1932/L	S,T,D,ST	1,100
BRASSAI	"FILLE DE JOIE CHEZ 'SUZY'..."	5/81	SNY	211	S	15 X 10	1933/L	S,T,D,ST/M	1,200
BRASSAI	"FILLE DE JOIE" (FRONT) PARIS	5/81	SNY	212	S	11 X 9	C1933/L	S,T,D,ST/M	BI
BRASSAI	"UNE FILLE DE JOIE DE MONTMARTRE"	5/81	SNY	213	S	11 X 8	1930'S/V	S,ST/F	1,100
BRASSAI	"TWO HOODLUMS"	5/81	SNY	214	S	12 X 9	C1933/L	S,T,D,ST/M	1,100
BRASSAI	"LA TOILETTE, RUE QUINCAMPOIX"	5/81	SNY	215	S	8 X 11	1932/L	S,T,D,ST/M	1,100
BRASSAI	"KIKI ET SES AMIES"	5/81	SNY	216	S	8 X 11	1933/L	S,T,D,ST/M	BI
BRASSAI	"'PARIS LA NUIT' EN 1932" (ED: 13/150)	5/81	SNY	217	S	12 X 9	1932/L	S,T,D,I,ST/M	BI
BRASSAI	"GALA SOIREE AT MAXIM'S" (ED:50)	5/81	SNY	218	S	12 X 9	1940/73	/M	BI
BRASSAI	MARKET PORTER, LES HALLES (ED: 50)	5/81	SNY	219	S	12 X 9	1939/70'S	/E	800
BRASSAI	PORTRAIT: PICASSO AT RUE DES AUGUSTINS	5/81	SNY	220	S	12 X 10	1939/70'S	/M	1,000
BRASSAI	COUPLE, MIRRORED ARMOIRE, BROTHEL	11/80	CNY	306	S	15 X 11	C1930/70'S	S,ST	800
BRASSAI	"BIJOUX DE MONMARTRE...) (ED:2/30)	11/80	CNY	307	S	12 X 9	C1932/60'S	S,T,ST	1,600
BRASSAI	"KIKI ET SES AMIES"	11/80	CNY	308	S	11 X 15	C1932/60'S	S,T,ST	1,200
BRASSAI	LA RUE QUINCAMPOIX (ED: 4/40)	11/80	CNY	309	S	11 X 9	C1932/70'S	S,S,T,A	BI
BRASSAI	LADIES OF THE NIGHT & CUSTOMER	11/80	CNY	310	S	12 X 9	1930'S/70'S	S,ST	BI
BRASSAI	"GALA SOIREE AT MAXIM'S" (ED:50)	11/80	CNY	311	S	12 X 9	1949/1960'S	S,ST,T,D	1,300
BRASSAI	AU MUSEE DU LOUVRE, APOLLON	11/80	CNY	312	S	9 X 7	C1935/V	S,T,D,ST	BI
BRASSAI	COLLEGUES A MADRID (ED: 17/30)	11/80	CNY	313	S	13 X 9	1952/1960'S	S,T,D,ST	350
BRASSAI	"PIQUE-NIQUE AU BORD DEL ..." (ED. 40)	11/80	PNY	178	S	9 X 13	1937/L	S,A,T,D,ST	BI
BRASSAI	"COUPLE D'AMOUREUX" (PARIS CAFE)	11/80	PNY	179	S	12 X 9	1932/L	ST,S	2,000
BRASSAI	"LE FEMME A MONOCLE, PARIS" (ED:10/40)	11/80	PNY	180	S	11 X 9	1933/L	S,ST	1,400
BRASSAI	"WALL AND TREE"	11/80	PNY	181	S	9 X 10	C1932/V	ST	1,300
BRASSAI	LIGHTING GAS LAMPS/PLACE DE LACONCORDE	11/80	SNY	220	S	12 X 9	C1933/L	S,ST	1,200

PHOTOGRAPHER	TITLE OR DESCRIPTION	DATE	AH	LOT#	PT	SIZE	N/P DATES	MARKS/COND.	PRICE
BRASSAI	GROUP...MEN/BAR OF A BISTRO R. DELAPPE	11/80	SNY	221	S	9 X 12	C1932/L	S,D,ST	BI
BRASSAI	COUPLE, MIRRORED ARMOIRE, BROTHEL	11/80	SNY	222	S	15 X 11	C1932/L	S,ST	1,500
BRASSAI	WOMEN W/SPIT CURLS...BISTRO R.DE LAPPE	11/80	SNY	223	S	9 X 12	C1932/L	S,T,D,ST	BI
BRASSAI	14 JUL., PL. DE LA CONTRESCARPE,...	11/80	SNY	224	S	11 X 9	C1932/L	S,ST	BI
BRASSAI	BIG ALBERT'S GANG, PLACE D'ITALIE	11/80	SNY	225	S	11 X 8	C1931/L	S,ST	900
BRASSAI	PANTHERESS W/BAND,THE HORDE,...	11/80	SNY	226	S	12 X 9	C1932/V	S,T,D,ST	1,700
BRASSAI	CONCHITA W/SAILOR: CAFE...P.D'ITALIE	11/80	SNY	227	S	12 X 9	C1933/L	S,ST	BI
BRASSAI	CLOCHARDS UNDER THE PONT-NEUF	11/80	SNY	228	S	12 X 9	C1932/L	S,ST	1,500
BRASSAI	UNE HIRONDELLE AVEC SON VELO	11/80	SNY	229	S	11 X 9	C1932/L	S,ST	900
BRAVO, MANUEL ALVAREZ	"GOOD REPUTATION SLEEPING"	2/81	SLA	83	S	8 X 10	1930'S/V	S,I	600
BRAVO, MANUEL ALVAREZ	"PORTRAIT OF THE ETERNAL"	2/81	SLA	84	S	9 X 7	1930'S/L	S,I	600
BRAVO, MANUEL ALVAREZ	"EL PERRO VEINTE"	2/81	SLA	85	S	8 X 9	1930'S/L	S,I,T	BI
BRAVO, MANUEL ALVAREZ	"NUDE WITH GLASS"	2/81	SLA	86	S	10 X 7	1938/L	S,I	450
BRAVO, MANUEL ALVAREZ	"INO MAYA DE TULUM"	2/81	SLA	87	S	8 X 10	1930'S/L	S,T	400
BRAVO, MANUEL ALVAREZ	"RUFINO TAMAYO-PINTOR"	2/81	SLA	88	S	10 X 8	C1940/L	S,T	BI
BRAVO, MANUEL ALVAREZ	"15 PHOTOS BY BRAVO" (ED:13/90)	2/81	SLA	89	S	9 X 7	VARIOUS/74	S	2,700
BRAVO, MANUEL ALVAREZ	UN POCO ALEGRE Y GRACIOSA	4/81	PNY	1	S	7 X 10	1942/L	S/E	BI
BRAVO, MANUEL ALVAREZ	MEXICAN CLOWN	5/81	CNY	124	P	9 X 7	1924/V	S,D,A	1,600
BRAVO, MANUEL ALVAREZ	"NINO ORINADO"	5/81	PNY	252	S	10 X 7	1927/L	S,T/E	BI
BRAVO, MANUEL ALVAREZ	"LA HIJA DE LOS DANZANTES"	5/81	PNY	253	S	10 X 7	1933/L	S,T	475
BRAVO, MANUEL ALVAREZ	"SOMEWHAT GAY AND GRACEFUL" (ED: 75)	5/81	PNY	254	S	7 X 10	1942/75	S/M	250
BRAVO, MANUEL ALVAREZ	"IMAGINARY LANDSCAPE" (ED: 75)	5/81	PNY	255	S	11 X 14	?/75	S	350
BRAVO, MANUEL ALVAREZ	THE DAUGHTER OF THE DANCERS	5/81	SNY	376	S	10 X 7	1934/L	S,I/G	500
BRAVO, MANUEL ALVAREZ	"BICYCLES ON SUNDAY"	5/81	SNY	377	S	7 X 9	1968/L	S,I/M	300
BRAVO, MANUEL ALVAREZ	"VIOLIN HUICHOL"	5/81	SNY	378	S	7 X 9	1966/L	S,I/M	BI
BRAVO, MANUEL ALVAREZ	"VENTANA AL CORO"	5/81	SNY	379	S	9 X 7	1930'S/L	S,I/M	300
BRAVO, MANUEL ALVAREZ	"PORTRAIT OF THE ETERNAL"	5/81	SNY	380	S	10 X 8	1930'S/L	S,I/M	650
BRAVO, MANUEL ALVAREZ	"WINDOW ON THE AGAVES"	5/81	SNY	381	S	7 X 9	1976/L	S,I/M	350
BRAVO, MANUEL ALVAREZ	"LA BUENA FAMA DURMIENDO"	5/81	SNY	568	S	7 X 10	1938/L	S,I	850
BRAVO, MANUEL ALVAREZ	PORTRAIT: NIEVIS, DIEGO RIVERA'S MODEL	5/81	SNY	569	S	9 X 9	1943/79	S,T,D	650
BRAVO, MANUEL ALVAREZ	"LA BUENA FAMA DURMIENDO" (ED. 75)	10/80	PT	133	S	7 X 10	1938/75	S	600
BRAVO, MANUEL ALVAREZ	"LA DE LAS BELLAS ARTES" (ED. 75)	10/80	PT	134	S	7 X 10	1933/75	S	BI
BRAVO, MANUEL ALVEREZ	"SA'BANAS" (SHEETS) ED. 75	10/80	PT	135	S	7 X 10	1933/75	S	BI
BRAVO, MANUEL ALVARAZ	"PAISAJE INVENTADO" (ED. 75)	10/80	PT	136	S	11 X 14	C1930'S/75	S	BI
BRAVO, MANUEL ALVAREZ	MEXICO	11/80	CNY	366B	S	9 X 7	C1940/V	S,T	300
BRAVO, MANUEL ALVAREZ	MEXICO WOMAN AT GRAVE	11/80	CNY	366C	S	7 X 10	C1940/V	S	400
BRAVO, MANUEL ALVAREZ	"LOS OBSTACULOS"	11/80	SNY	276	S	8 X 10	1929/L	S,I	BI
BRAVO, MANUEL ALVAREZ	"PUBLIC THIRST"	11/80	SNY	277	S	10 X 8	1934/L	S	450
BRAVO, MANUEL ALVAREZ	BOY NEXT TO DEATH MASK	11/80	SNY	278	S	7 X 10	1930'S/L	S,I	1,000
BRAVO, MANUEL ALVAREZ	"LOS AGACHADOS"	11/80	SNY	279	S	7 X 10	1934/L	S	500
BRAVO, MANUEL ALVAREZ	"SKIFF ON THE SHORE"	11/80	SNY	280	S	7 X 10	1930'S/L	S,I	BI
BRAVO, MANUEL ALVAREZ	BRICKMAKING	11/80	SNY	281	S	8 X 10	1930'S/L	S,I	350
BRAVO, MANUEL ALVAREZ	"ABSENT PORTRAIT"	11/80	SNY	282	S	10 X 7	1945/L	S	300
BRAZIL	2 PRINT PANORAMA OF RAILROAD BRIDGE	11/80	SW	253	A	7 X 19	1860'S/V		160
BREITENBACH, JOSEF	NUDE	11/80	CNY	459	S	13 X 11	1940'S/V	S	BI
BRESLAUER, MARIANNE	"AT THE RIVER'S EDGE, PARIS"	11/80	CNY	101	S	7 X 9	1929/V	S,T,D	400
BRESLAUER, MARIANNE	MAN RAY	5/81	PNY	211	S	9 X 7	1931/V	S,T,D	450
BRIDGEMAN, LADY LUCY	VICTORIA WINDSOR CLIVE	11/80	CNY	27	A	6 X 4	1850'S/V	A	450
BRIDGEMAN, LADY LUCY	PRINCE EDWARD OF SAXE-WEIMAR	11/80	CNY	28	A	5 X 4	1850'S/V	A	BI
BRIDGEMAN, LADY LUCY	ISABEL BRIDGEMAN	11/80	CNY	29	A	6 X 4	1850'S/V	A	BI
BROWN, ERNEST	BUFFALO BONES/SOD HOUSE	10/80	PT	57	S	7 X 10	C1928/V	ST,IN	160
BROWN, ERNEST	3 CANADIAN RIVERS (14 PRINTS)	10/80	PT	59	S	VARIOUS	C1910/V	IN,ST	200
BRUEHL, ANTON	"CLOTHESLINE, NEW YORK"	5/81	CNY	123	P	7 X 9	1924/V	S,T,D,A/G	BI
BRUEHL, ANTON	"THREE CUT-OUT MEN WITH ROOSTER"	5/81	PNY	284	S	13 X 10	1940'S/V	S	BI
BRUEHL, ANTON	LIGHTBULBS	11/80	CNY	333	S	14 X 11	1936/1970'S	S	BI
BRUEHL, ANTON	STILL LIFE	11/80	PNY	199	P	9 X 8	1924/V	S,D	BI
BRUEHL, ANTON	"SKYLIGHT"	11/80	PNY	200	P	9 X 7	1925/V	S,D	1,400
BRUGUIERE, FRANCIS J.	CHAPEL, NEW COLLEGE, OXFORD	11/80	CNY	316	S	4 X 3	1938-39/V	S,T,D	700
BRUGUIERE, FRANCIS J.	"CUT PAPER ABSTRACTION"	11/80	PNY	194	S	9 X 7	C1930/V	S	800
BRUGUIERE, FRANCIS J.	"NEW YORK SKYSCRAPER"	11/80	PNY	192	S	9 X 6	1932/V	ST,D	BI
BRUGUIERE, FRANCIS J.	"FIRE STAIRWELL AND SKYSCRAPER, NY"	11/80	PNY	193	S	9 X 6	1932/V	ST,D	750

69

PHOTOGRAPHER	TITLE OR DESCRIPTION	DATE	AH	LOT#	PT	SIZE	N/P DATES	MARKS/COND.	PRICE
BRUGUIERE, FRANCIS J.	ROSALIND FULLER FROM BEYOND THIS POINT	5/81	CNY	97	S	10 X 8	1929'S/V	A/M	1,300
BRUGUIERE, FRANCIS J.	PANAMA-PACIFIC EXPOSITION	11/80	SNY	146	S	14 X 11	1915/V	S,D	650
BULL, CLARENCE SINCLAIR	GRETA GARBO (4 PORTRAITS)	2/81	SLA	91	S	VARIOUS	1930'S/V	ST	1,100
BULL, CLARENCE SINCLAIR	GRETA GARBO	5/81	CNY	195	S	13 X 10	C1930/V	ST/E	500
BULLOCK, JOHN G.	SAILBOAT	5/81	PNY	215	P	6 X 8	C1900/V	ST/G	300
BULLOCK, JOHN G.	HARBOUR SCENE	5/81	PNY	216	P	5 X 8	C1900/V	/F-G	BI
BULLOCK, JOHN G.	THE SOAP BUBBLE	11/80	CNY	246	P	8 X 6	C1905/V		BI
BULLOCK, WYNN	GRETCHEN RECLINING	2/81	SLA	92	S	9 X 9	1972/V	S,D,I	1,200
BULLOCK, WYNN	"WOMAN'S HANDS"	2/81	SLA	93	S	8 X 10	1956/V	ST,S,T,D,I	1,000
BULLOCK, WYNN	"CHILD & THE UNKNOWN"	2/81	SLA	94	S	10 X 8	1955/V	S,T,D,I	950
BULLOCK, WYNN	"DRIFTWOOD"	2/81	SLA	95	S	8 X 10	1972/V	T,D,ST,I	300
BULLOCK, WYNN	"PT. LOBOS TIDE POOL"	2/81	SLA	96	S	8 X 10	1972/V	ST,S,D,T,I	800
BULLOCK, WYNN	"HALF AN APPLE"	2/81	SLA	97	S	8 X 9	1953/V	S,T,D	BI
BULLOCK, WYNN	"TAIL LIGHT"	2/81	SLA	98	S	6 X 8	1968/V	T,D,ST,I	BI
BULLOCK, WYNN	DRIFTWOOD	4/81	PNY	12	S	7 X 9	1953/V	S,D	1,200
BULLOCK, WYNN	NAVIGATION WITHOUT NUMBERS	5/81	CNY	177	S	7 X 9	1957/L	S/M	2,400
BULLOCK, WYNN	"LET THERE BE LIGHT"	5/81	CNY	178	S	6 X 10	1954/L	S,T/M	3,000
BULLOCK, WYNN	STARK TREE	5/81	CNY	179	S	8 X 9	1956/L	S/M	5,500
BULLOCK, WYNN	CHILD IN FOREST	5/81	CNY	180	S	8 X 10	1956/L	S/M	6,000
BULLOCK, WYNN	LIMPETS AND SAND	5/81	SNY	422	S	10 X 7	1940'S-50/V	S	1,100
BULLOCK, WYNN	NUDE IN FRONT OF FIREPLACE	5/81	SNY	423	S	8 X 10	C1950/V	ST	700
BULLOCK, WYNN	"CHILD AND THE UNKNOWN" (ED: 25)	5/81	SNY	424	S	10 X 8	1955/73	S,ST,T,D,A/M	1,100
BULLOCK, WYNN	THE SHORE	5/81	SNY	425	S	8 X 8	1966/V	S,T,D/M	2,200
BULLOCK, WYNN	"PT. LOBOS TIDE POOLS" (ED: 25)	5/81	SNY	426	S	8 X 10	1972/73	S,ST,T,D,A/E	650
BULLOCK, WYNN	NUDE BEHING SCREEN	5/81	SNY	571	S	10 X 8	1950'S/V	ST	1,200
BULLOCK, WYNN	CHILD IN FOREST	11/80	CNY	523	S	8 X 10	1951/L	S	3,000
BULLOCK, WYNN	OLD CHAIR	11/80	CNY	524	S	10 X 8	1951/L	S	BI
BULLOCK, WYNN	STEFAN	11/80	CNY	525	S	8 X 10	1954/L	S	1,000
BULLOCK, WYNN	"MENDECINO"	11/80	CNY	526	S	8 X 9	1968/V	S,T,D	1,300
BULLOCK, WYNN	DEW DROPS ON IVY	11/80	CNY	527	S	7 X 9	C1966/V	S	BI
BULLOCK, WYNN	COLOR ABSTRACTION	11/80	CNY	528	CP	12 X 16	1964/V	S,D	BI
BULLOCK, WYNN	COLOR ABSTRACTION	11/80	CNY	529	CP	12 X 18	1964/V	S,D,ST	BI
BULLOCK, WYNN	"TREE TRUNK"	11/80	CNY	530	S	7 X 9	1971/V	S,T,D	BI
BULLOCK, WYNN	WOOD	11/80	CNY	531	S	7 X 10	1972/V	S	BI
BULLOCK, WYNN	"TIDE POOL, POINT LOBOS,..."	11/80	SNY	447	S	7 X 9	1950'S/V	S,T,ST	1,200
BULLOCK, WYNN	"BLACK ROCKS, POINT LOBOS"	11/80	SNY	448	S	8 X 10	1950'S/V	S,T,ST	600
BULLOCK, WYNN	"THE CHARRED CHAIR"	11/80	SNY	449	S	10 X 8	1950'S/V	S,T,ST	500
BULLOCK, WYNN	"RAIN ON PALO COLORADO ROAD"	11/80	SNY	450	S	10 X 8	1954/V	S,D,T,ST	1,300
BULLOCK, WYNN	"OLD GRAVEYARD AND WATER TANK"	11/80	SNY	451	S	8 X 10	1954/V	S,D,ST	600
BULLOCK, WYNN	"CAT ON THE KITCHEN STOVE"	11/80	SNY	452	S	10 X 8	1956/V	S,D,T,ST	650
BULLOCK, WYNN	"HORSETAILS AND DEAD LOGS"	11/80	SNY	453	S	10 X 8	1957/V	S,D,T,ST	2,700
BULLOCK, WYNN	"THE PILINGS"	11/80	SNY	454	S	8 X 10	1958/V	S,D,ST	950
BULLOCK, WYNN	"BENEATH THE PIER"	11/80	SNY	455	S	8 X 10	1959/V	S,D,ST	700
BULLOCK, WYNN	"TREES, FLORENCE, OREGON"	11/80	SNY	457	S	7 X 9	1960/V	S,D,T,ST	800
BULLOCK, WYNN	"NAVIGATION WITHOUT NUMBERS"	11/80	SNY	458	S	7 X 9	1957/L	S	2,300
BURKE, JOHN	KASHMIR (4 PHOTOS)	2/81	SLA	100	PP	7 X 9	1869/V	I	175
BURTON, VALERIE C.	"ARLES" (ED: 15)	5/81	PNY	344	S	11 X 10	1980/V	S,T,D	BI
BURTON, VALERIE C.	TORONTO (ED: 15)	5/81	PNY	345	S	9 X 12	1975/78	S,T,D	100
BYERS, ROBERT K.	REEDS IN YOUNG'S RIVER, ASTORIA OREGON	11/80	CNY	593	S	10 X 8		S,D,ST	80
BYERS, ROBERT K.	ROWBOATS AT CHENONCEAUT	11/80	CNY	594	S	11 X 14	1970/V	S,D,ST	90
CADMUS, PAUL	FIDELMA KIRSTEIN	11/80	CNY	332	S	6 X 4	1940/V	S,T,D,I,ST	300
CALLAHAN, HARRY	"ELEANOR"	2/81	SLA	105	S	7 X 10	1948/L	S	700
CALLAHAN, HARRY	"ELEANOR" (NUDE, ATTIC WINDOW)	2/81	SLA	106	S	9 X 13	1948/1970'S	S	650
CALLAHAN, HARRY	"CHICAGO" (TREES)	2/81	SLA	107	S	8 X 10	1950/L	S	750
CALLAHAN, HARRY	"ELEANOR AND BARBARA, CHICAGO"	2/81	SLA	108	S	8 X 10	1953/L	S	650
CALLAHAN, HARRY	"ELEANOR" (ARMS FRAMING HEAD)	2/81	SLA	109	S	8 X 5	C1950/L	S	650
CALLAHAN, HARRY	"ELEANOR, CHICAGO" (HEAD ABOVE WATER)	2/81	SLA	110	S	10 X 9	1953/1970	S	650
CALLAHAN, HARRY	"CHICAGO"	2/81	SLA	111	S	8 X 12	1959/1970'S	S	400
CALLAHAN, HARRY	"PORT HURON"	2/81	SLA	112	S	7 X 7	1954/1970'S	S	650
CALLAHAN, HARRY	"AIX-EN-PROVENCE"	2/81	SLA	113	S	9 X 7	1958/L	S	750

PHOTOGRAPHER	TITLE OR DESCRIPTION	DATE	AH	LOT#	PT	SIZE	N/P DATES	MARKS/COND.	PRICE
CALLAHAN, HARRY	CUT OUT PORTRAITS	2/81	SLA	114	S	8 X 10	1950'S/L	S	450
CALLAHAN, HARRY	"CAPE COD" (VOLLEYBALL NET,VARIANT)	2/81	SLA	115	S	9 X 12	1978/V	S	450
CALLAHAN, HARRY	DETROIT (1941) (LAKESIDE GRASSES)	4/81	PNY	17	S	9 X 12	1941/L	S	600
CALLAHAN, HARRY	ELEANOR (1947)	4/81	PNY	18	S	5 X 3	1947/L	S	750
CALLAHAN, HARRY	ELEANOR, CHICAGO (1954)	4/81	PNY	19	S	7 X 7	1954/L	S	BI
CALLAHAN, HARRY	ELEANOR, PORT HURON (1954)	4/81	PNY	20	S	7 X 7	1954/L	S	900
CALLAHAN, HARRY	SIXTH AVENUE SKYSCRAPERS, NEW YORK	4/81	SW	306	S	9 X 9	1974/V	S,A	550
CALLAHAN, HARRY	"ELEANOR, CHICAGO" (NUDE,TORSO)	5/81	CNY	187	S	8 X 10	1948/64	S,T,D/M	1,600
CALLAHAN, HARRY	"ELEANOR, CHICAGO" (TREE SCENE)	5/81	CNY	188	S	8 X 10	1949/64	S,T,D/M	BI
CALLAHAN, HARRY	"ELEANOR, CHICAGO" (HEAD ABOVE WATER)	5/81	CNY	189	S	10 X 9	1949/70'S	S/M	800
CALLAHAN, HARRY	"CHICAGO" (TREES,WINTER)	5/81	CNY	190	S	8 X 10	C1950/70'S	S/M	750
CALLAHAN, HARRY	ELEANOR, CHICAGO (HEAD ABOVE WATER)	5/81	PNY	309	S	10 X 9	1949/L	S	BI
CALLAHAN, HARRY	"CAPE COD" (BEACH,VOLLEYBALL NET)	5/81	PNY	310	S	10 X 13	1972/L	S	800
CALLAHAN, HARRY	"ELEANOR, CHICAGO" (NUDE, TORSO)	5/81	SNY	450	S	6 X 6	1948/V	S/E	800
CALLAHAN, HARRY	"CHICAGO" (TREES, WINTER)	5/81	SNY	451	S	8 X 10	1950/L	S/M	850
CALLAHAN, HARRY	"ELEANOR, INDIANA"	5/81	SNY	452	S	7 X 7	1948/L	S/M	450
CALLAHAN, HARRY	ELEANOR AND BARBARA	5/81	SNY	453	S	8 X 10	C1953/L	S	650
CALLAHAN, HARRY	AIX-EN-PROVENCE	5/81	SNY	454	S	10 X 12	1957L	S	900
CALLAHAN, HARRY	"DETROIT, 1941" (LAKESIDE GRASSES)	5/81	SNY	455	S	6 X 7	1941/50'S	/E	550
CALLAHAN, HARRY	LANDSCAPE	5/81	SNY	456	S	7 X 8	C1957/V		650
CALLAHAN, HARRY	"AIX-EN-PROVENCE"	5/81	SNY	457	S	8 X 6	1958/V	/G	800
CALLAHAN, HARRY	"DETROIT" (LEAF, CAL. P.29)	10/80	PT	208	S	5 X 7	1942/L	S	BI
CALLAHAN, HARRY	"CHICAGO"	10/80	PT	209	S	7 X 7	1954/L	S	BI
CALLAHAN, HARRY	"ROME" (PARKING LOT)	10/80	PT	210	S	7 X 7	1968/L	S	BI
CALLAHAN, HARRY	HIGHLAND PARK, MI.(3 NEGATIVES ON SHT)	11/80	CNY	571	S	14 X 5	1941/L	S	BI
CALLAHAN, HARRY	MULTIPLE TREES	11/80	CNY	572	S	10 X 9	1949/70'S	S	650
CALLAHAN, HARRY	"ELEANOR,CHICAGO" (HEAD ABOVE WATER)	11/80	CNY	573	S	10 X 9	1949/70'S	S	BI
CALLAHAN, HARRY	CHICAGO (CAL. P.183)	11/80	CNY	574	S	8 X 10	C1950/L	S	600
CALLAHAN, HARRY	ELEANOR, PORT HURON	11/80	CNY	575	S	7 X 7	1954/L	S	750
CALLAHAN, HARRY	MAINE	11/80	CNY	576	S	6 X 6	1962/V	S	600
CALLAHAN, HARRY	CAPE COD	11/80	CNY	577	S	9 X 9	1972/70'S	S	850
CALLAHAN, HARRY	"CAPE COD" (BEACH, VOLLEYBALL NET)	11/80	CNY	578	S	10 X 13	1972/70'S	S	650
CALLAHAN, HARRY	"ELEANOR, INDIANA 1948"	11/80	SNY	465	S	7 X 7	1947/L	S	700
CALLAHAN, HARRY	"ELEANOR,CHICAGO" (HEAD ABOVE WATER)	11/80	SNY	466	S	6 X 6	1949/L	S	650
CALLAHAN, HARRY	"ELEANOR, PORT HURON"	11/80	SNY	467	S	7 X 7	1954/L	S	750
CALLAHAN, HARRY	CHICAGO	11/80	SNY	468	S	10 X 10	C1959/L	S	BI
CALLAHAN, HARRY	CAPE COD	11/80	SNY	469	S	10 X 13	C1972/V	S	550
CALLAHAN, HARRY	"CAPE COD, 1972" (CAL. P.183)	11/80	SNY	470	S	9 X 9	1972/L	S	550
CALLIS, JO ANN	"GIRL IN SHOWER" (ED: 1/15)	11/80	CNY	614	CP	17 X 14	1977/V	S,D,T	BI
CAMERON, JULIA MARGARET	"HATTIE CAMPBELL"&"YOUNG WOMAN"(2 PR.)	2/81	SLA	116	A	VARIOUS	C1867/V	1=S,I 1=ST	600
CAMERON, JULIA MARGARET	"DAPHNE"	5/81	CNY	17	A	14 X 11	1867/V	S,T,D,I,ST/E	3,000
CAMERON, JULIA MARGARET	"THE DREAM"	5/81	CNY	18	A	12 X 10	1871/V	S,T,D,I,ST/E	2,600
CAMERON, JULIA MARGARET	THOMAS CARLYLE	5/81	PNY	9	A	12 X 10	1867/V	X/G	1,800
CAMERON, JULIA MARGARET	BEATRICE, MARY & LA SANTA JULIA (3 P.)	5/81	PNY	10	A	VARIOUS	C1870/V	T,ST	550
CAMERON, JULIA MARGARET	ALFRED TENNYSON,... (3 PRINTS)	5/81	PNY	11	A	VARIOUS	C1870/V	T,ST	500
CAMERON, JULIA MARGARET	PORTRAIT: A YOUNG GIRL	5/81	SNY	89	A	13 X 10	C1870/V	ST/F	500
CAMERON, JULIA MARGARET	"THOMAS CARLYLE"	10/80	PT	3	A	13 X 10	1867/V	S,T	6,000
CAMERON, JULIA MARGARET	"THE TURTLE DOVES"	10/80	PT	4	A	3 X 2	1860'S/V	T	800
CAMERON, JULIA MARGARET	JOSEPH JOACHIM	11/80	CNY	30	A	12 X 10	1868/V	S,D,I/E	1,200
CAMERON, JULIA MARGARET	"REBECCA"	11/80	CNY	31	A	14 X 11	1870/V	S,D,T,I,ST/E	BI
CAMERON, JULIA MARGARET	"THE SUN-TIPPED SYBIL"	11/80	CNY	32	A	14 X 11	C1870/V	S,T,I,ST/E	BI
CAMERON, JULIA MARGARET	HENRY TAYLOR	11/80	CNY	33	A	10 X 8	C1870/V	S,I/G	1,000
CAMERON, JULIA MARGARET	"VIVIEN AND MERLIN"	11/80	CNY	34	A	12 X 11	1874/V	S,D,I,T/G	1,200
CAMERON, JULIA MARGARET	ALFRED LORD TENNYSON, THE DIRTY MONK	11/80	CNY	35	A	10 X 8	C1870/V	S,I/G	900
CAMERON, JULIA MARGARET	"PORTRAIT OF SIR JOHN HERSCHEL"	11/80	SNY	82	A	15 X 12	C1867	T	1,000
CAMUZZI, MAURO	FEMALE NUDE STUDIES (12 PRINTS)	5/81	SNY	538	S	9 X 7	1920'S/V	PD/G-E	BI
CANEVA, GIACOMO (ATTR.)	"PONTE ROTTO"	11/80	CNY	63	SA	7 X 10	1850'S/V	T	400
CANEVA, GIACOMO (ATTR.)	CASTEL SANT'ANGELO & ST. PETER'S	11/80	CNY	69	A	22 X 32	1860'S/80'S		BI
CAPA, ROBERT	NIGHT CLUB, BUDAPEST	4/81	PNY	118	S	14 X 11	C1940/V	ST	BI
CAPA, ROBERT	BURNED OUT BLDGS. ALONG THE DANUBE...	4/81	PNY	119	S	11 X 13	C1940/V	ST	BI
CAPA, ROBERT	SOLDIERS EXERCISING, INDO-CHINA	4/81	PNY	120	S	11 X 14	1940'S/V	ST	BI

71

PHOTOGRAPHER	TITLE OR DESCRIPTION	DATE	AH	LOT#	PT	SIZE	N/P DATES	MARKS/COND.	PRICE
CAPA, ROBERT	DRILL INSTRUCTION, INDO-CHINA	4/81	PNY	121	S	11 X 14	1940'S/V	ST	BI
CAPA, ROBERT	MADRID, LOYALISTS	5/81	CNY	166	S	7 X 9	C1942/V	/G	320
CAPA, ROBERT	CHINA (SOVIET WAR)	11/80	CNY	535A	S	8 X 10	C1946/L	ST	BI
CAPA, ROBERT	CHINA (SOVIET WAR)	11/80	CNY	535	S	8 X 10	C1940/V	ST,A	BI
CAPA, ROBERT	CHINESE PARTISANS	11/80	SNY	219	S	14 X 11	1937/V	I,ST	400
CAPEL-CURE, COL. ALFRED	WELLS CATHEDRAL, THE NORTH PORCH	5/81	CNY	9	A	9 X 11	1857/V	A/E	750
CAPONIGRO, PAUL	JAPANESE TEMPLE (COURTYARD)	2/81	SLA	117	S	10 X 13	1970'S/V	S	750
CAPONIGRO, PAUL	"TREE-NORTHERN CALIFORNIA"	2/81	SLA	118	S	20 X 15	1969/V	S,D,T	BI
CAPONIGRO, PAUL	"BARNACLED ROCK & SEA, NAHANT, MASS."	2/81	SLA	119	S	8 X 10	1970'S/V	S	750
CAPONIGRO, PAUL	RUNNING WHITE DEER,WICKLOW,IRELAND	2/81	SLA	120	S	7 X 19	1967/L	S,D	BI
CAPONIGRO, PAUL	"STONEHENGE"	2/81	SLA	121	S	13 X 19	1970'S/V	S	800
CAPONIGRO, PAUL	STONEHENGE (ED:67)	2/81	SLA	122	S	13 X 10	1970/78	S	450
CAPONIGRO, PAUL	"PORTFOLIO II" (8 PHOTOS; ED:28/100)	2/81	SLA	123	S	VARIOUS	1973/V	S	BI
CAPONIGRO, PAUL	RUNNING WHITE DEER,WICKLOW,IRELAND	5/81	CNY	181	S	7 X 19	1967/70'S	S/M	2,400
CAPONIGRO, PAUL	STONEHENGE	5/81	CNY	182A	S	10 X 16	1967/V	S,I	1,300
CAPONIGRO, PAUL	ICE ON LAKE	5/81	CNY	182	S	8 X 9	1950'S/V	S/M	750
CAPONIGRO, PAUL	ROCK WALL #2, W HARTFORD, CONN.	5/81	PNY	311	S	15 X 18	1959/L	S	900
CAPONIGRO, PAUL	SUNFLOWER	5/81	PNY	312	S	8 X 9	1965/L	S	900
CAPONIGRO, PAUL	RUNNING WHITE DEER,WICKLOW,IRELAND	5/81	PNY	313	S	7 X 19	1967/L	S	1,500
CAPONIGRO, PAUL	WOOD SERIES, REDDING, CONN. (ED: 100)	5/81	PNY	314	S	14 X 19	1968/L	S,A	BI
CAPONIGRO, PAUL	TOFUKUJI TEMPLE, KYOTO,(SAND GARDEN)	5/81	PNY	315	S	13 X 20	1976/V	S,T,D	500
CAPONIGRO, PAUL	STONEHENGE	5/81	PNY	316	S	13 X 19	1977/V	S,T,D	600
CAPONIGRO, PAUL	THISTLE	5/81	SNY	427	S	13 X 11		S/M	550
CAPONIGRO, PAUL	"FUNGUS, IPSWICH, MASS."	5/81	SNY	428	S	13 X 11	1950'S/L	S/M	850
CAPONIGRO, PAUL	PLANTED FIELD	5/81	SNY	429	S	11 X 13	1958/V	S,D	500
CAPONIGRO, PAUL	PETRIFIED LANDSCAPE	5/81	SNY	430	S	9 X 12	1950'S-60/L	S/M	700
CAPONIGRO, PAUL	UNTITLED	5/81	SNY	431	S	8 X 9	1950'S/L	S/M	1,200
CAPONIGRO, PAUL	"REDDING WOODS, CONN."	5/81	SNY	432	S	8 X 11	1970'S/L	S/M	700
CAPONIGRO, PAUL	"WICKLOW, IRELAND" (DEER AT REST)	5/81	SNY	433	S	9 X 13	1967/L	S/E	1,200
CAPONIGRO, PAUL	"PORTFOLIO II" (8 PR, ED: 55/100)	5/81	SNY	434	S	VARIOUS	1973/V	S/M	5,000
CAPONIGRO, PAUL	"REDDING WOODS"	5/81	SNY	435	S	14 X 19	1969/V	S,T,D/F	1,000
CAPONIGRO, PAUL	"WOOD SERIES, REDDING, CONN."(ED. 100)	10/80	PT	214	S	14 X 19	1968/L	S,A	BI
CAPONIGRO, PAUL	"STONEHENGE"	10/80	PT	215	S	14 X 10	C1970/V	S	BI
CAPONIGRO, PAUL	RUNNING WHITE DEER,WICKLOW,IRELAND)	11/80	CNY	590	S	5 X 14	1967/L	S,D	1,900
CAPONIGRO, PAUL	"57"	11/80	CNY	591	S	8 X 9	1957/V	S,T	500
CAPONIGRO, PAUL	RUNNING WHITE DEER,WICKLOW,IRELAND	11/80	SNY	471	S	7 X 19	1967/L	S	2,100
CAPONIGRO, PAUL	SUNFLOWER	11/80	SNY	472	S	8 X 10	1960'S/V	S	500
CAPONIGRO, PAUL	ROCK WALL	11/80	SNY	473	S	8 X 10		S	500
CAPONIGRO, PAUL	"PEBBLE BEACH, CALIFORNIA, 1969"	11/80	SNY	474	S	7 X 9	1969/V	S	450
CAPONIGRO, PAUL	PORTFOLIO II (12 PHOTOS; ED:17/100)	11/80	SNY	475	S	VARIOUS	1973/V	S	7,000
CARJAT, NADAR, ET AL:	GALERIE CONTEMPORAINE(PORTRAITS-8 VOL)	5/81	CNY	41	W	VARIOUS	1880'S/V	/M	BI
CARNEY, JOHN	UNTITLED (DIPTYCH)	11/80	CNY	646	S	6 X 13	1975/V	S,D	BI
CARRA, LUCA	NUDE IN THE SHOWER (ED: 1/3)	5/81	SNY	599	S	6 X 9		S,A	125
CARROLL, LEWIS	DR. ROLLESTON'S LIFE CLASS...	2/81	SLA	124	A	4 X 6	1858/V	I,T,D	400
CARROLL, LEWIS	MISS KITCHIN ON A SOFA	5/81	PNY	8	A	5 X 7	C1860'S/V	IN/E	BI
CARROLL, LEWIS	ALEXANDRA KITCHIN W/ORIENTAL PARASOL	5/81	SNY	87	A	4 X 6	1876/V	I/P	1,500
CARTIER-BRESSON, HENRI	"BRUSSELS" (C-B,P.155)	2/81	SLA	126	S	10 X 14	1932/L	S	1,100
CARTIER-BRESSON, HENRI	"HYERES, FRANCE" (C-B, P.13)	2/81	SLA	127	S	10 X 14	1932/L	S	1,300
CARTIER-BRESSON, HENRI	"ALICANTE, SPAIN"	2/81	SLA	128	S	14 X 10	1933/L	S	1,300
CARTIER-BRESSON, HENRI	"MADRID"	2/81	SLA	129	S	10 X 14	1933/L	S	1,100
CARTIER-BRESSON, HENRI	"TRIESTE, ITALY"	2/81	SLA	130	S	10 X 14	1933/L	S	850
CARTIER-BRESSON, HENRI	"NEW ORLEANS"	2/81	SLA	131	S	10 X 14	1947/L	S	BI
CARTIER-BRESSON, HENRI	SRINAGAR, KASHMIR (C-B, P.77)	2/81	SLA	132	S	10 X 14	1948/L	S	1,500
CARTIER-BRESSON, HENRI	"SRI LANKA"	2/81	SLA	133	S	10 X 14	1949/L	S	900
CARTIER-BRESSON, HENRI	"ASCOT, ENGLAND	2/81	SLA	134	S	14 X 10	1955/L	S	1,100
CARTIER-BRESSON, HENRI	"ILE DE LA CITE"	2/81	SLA	135	S	10 X 14	1952/L	S	1,300
CARTIER-BRESSON, HENRI	"PALAIS-ROYAL, PARIS"	2/81	SLA	136	S	14 X 10	1960/L	S	1,400
CARTIER-BRESSON, HENRI	"SIPHNOS, GREECE" (C-B, P.45)	2/81	SLA	137	S	10 X 14	1961/L	S	1,400
CARTIER-BRESSON, HENRI	"FUNERAL OF A KABUKI ACTOR, JAPAN"	2/81	SLA	138	S	10 X 15	1965/L	S	850
CARTIER-BRESSON, HENRI	"BRIE, FRANCE" (C-B, P.64)	2/81	SLA	139	S	10 X 14	1968/L	S	1,400
CARTIER-BRESSON, HENRI	PORTRAIT: EZRA POUND	2/81	SLA	140	S	14 X 10	1970/L	S	800

PHOTOGRAPHER	TITLE OR DESCRIPTION	DATE	AH	LOT#	PT	SIZE	N/P DATES	MARKS/COND.	PRICE
CARTIER-BRESSON, HENRI	PORTRAIT: CARMEL SNOW & DAVID SELZNICK	2/81	SLA	141	S	10 X 7	1940'S /V	ST,I	250
CARTIER-BRESSON, HENRI	HENRI MATISSE AT HOME, VENCE, FRANCE	4/81	PNY	137	S	9 X 14	1944/L	S	900
CARTIER-BRESSON, HENRI	SRINAGAR, KASHMIR (C-B, P.77)	4/81	PNY	138	S	10 X 14	1948/L	S	1,000
CARTIER-BRESSON, HENRI	CHINA (20 PRINTS)	4/81	PNY	139	S	5 X 7	1949/V	ST	2,200
CARTIER-BRESSON, HENRI	CHRISTIAN BERARD IN HOTEL BED, PARIS	4/81	SW	308	S	9 X 6	1932	S,T	300
CARTIER-BRESSON, HENRI	"CANARIES FOR SALE"	4/81	SW	309	S	9 X 12	1940'S/V	ST,T	350
CARTIER-BRESSON, HENRI	HENRI MATISSE AT HOME, VENCE, FRANCE	4/81	SW	313	S	13 X 19	1944/L	S	1,600
CARTIER-BRESSON, HENRI	PORTRAIT: EZRA POUND	4/81	SW	314	S	20 X 13	1970/L	S	BI
CARTIER-BRESSON, HENRI	HENRI MATISSE AT HOME, VENCE, FRANCE	5/81	CNY	105	S	9 X 14	1944/75	S/M	1,300
CARTIER-BRESSON, HENRI	EZRA POUND	5/81	CNY	106	S	14 X 10	C1955/70'S	S/M	850
CARTIER-BRESSON, HENRI	ALLEE DU PRADO, MARSEILLES	5/81	PNY	133	S	14 X 10	1932/L	S	BI
CARTIER-BRESSON, HENRI	"BEHIND THE GARE SAINT-LAZARE, PARIS"	5/81	PNY	134	S	14 X 10	1932/L	S	1,200
CARTIER-BRESSON, HENRI	SEVILLE, SPAIN (BOY BESIDE ALLEY WALL)	5/81	PNY	135	S	10 X 14	1933/L	S	BI
CARTIER-BRESSON, HENRI	ARENA AT VALENCIA, SPAIN	5/81	PNY	136	S	10 X 14	1933/L	S	1,000
CARTIER-BRESSON, HENRI	CORDOBA, SPAIN (WOMAN)	5/81	PNY	137	S	14 X 10	1933/L	S	700
CARTIER-BRESSON, HENRI	AHMEDABAD, INDIA	5/81	PNY	138	S	13 X 20	1965/L	S	1,800
CARTIER-BRESSON, HENRI	"A DECISIVE MOMENT"	5/81	SNY	238	S	9 X 6	1932/V	S,A/F	1,500
CARTIER-BRESSON, HENRI	"CALLE CUAUHTEMOCZTIN"	5/81	SNY	239	S	10 X 14	1934/L	S	1,100
CARTIER-BRESSON, HENRI	"ALICANTE, SPAIN" (C-B, P.10)	5/81	SNY	240	S	10 X 14	1932/L	S/M	1,100
CARTIER-BRESSON, HENRI	"ALLEE DU PRADO, MARSEILLES"(C-B,P.1)	5/81	SNY	241	S	14 X 10	1932/L	S	950
CARTIER-BRESSON, HENRI	"BRUSSELS" (C-B, P.155)	5/81	SNY	242	S	10 X 14	1932/L	S/M	950
CARTIER-BRESSON, HENRI	"BEHIND THE GARE SAINT-LAZARE, PARIS"	5/81	SNY	243	S	14 X 10	1932/L	S/M	1,400
CARTIER-BRESSON, HENRI	"CHRISTIAN BERARD IN HOTEL BED,PARIS	5/81	SNY	244	S	14 X 9	1932/L	S,ST/M	BI
CARTIER-BRESSON, HENRI	"HENRI MATISSE AT HOME, VENCE, FRANCE	5/81	SNY	245	S	10 X 14	1944/L	S/M	1,700
CARTIER-BRESSON, HENRI	"RUE MOUFFETARD, PARIS"	5/81	SNY	247	S	20 X 13	1954/60'S	S/M	3,400
CARTIER-BRESSON, HENRI	"SIMIANE-LA-ROTONDE, FRANCE"	5/81	SNY	248	S	13 X 19	1970/V	S	2,000
CARTIER-BRESSON, HENRI	"SRINAGAR, KASHMIR" (C-B, P.77)	5/81	SNY	249	S	9 X 14	1948/L	S/M	1,100
CARTIER-BRESSON, HENRI	"SIPHNOS, GREECE" (C-B, P.45)	5/81	SNY	250	S	10 X 14	1961/L	S/M	1,500
CARTIER-BRESSON, HENRI	"FUNERAL OF A KABUKI ACTOR, JAPAN"	5/81	SNY	251	S	10 X 14	1965/L	S/M	BI
CARTIER-BRESSON, HENRI	BRIE, FRANCE (C-B, P.64)	5/81	SNY	252	S	10 X 14	1968/L	S/M	1,100
CARTIER-BRESSON, HENRI	AVENUE DU MAINE, PARIS	10/80	PT	115	S	10 X 14	1932/L	S	1,100
CARTIER-BRESSON, HENRI	ALICANTE, SPAIN (C-B, P.10)	10/80	PT	116	S	10 X 14	1932/L	S	BI
CARTIER-BRESSON, HENRI	AQUILA DEGLI ABRUZZI, ITALY	10/80	PT	117	S	14 X 20	1952/L	S	1,000
CARTIER-BRESSON, HENRI	SEVILLE, SPAIN (C-B, P.9)	10/80	PT	118	S	10 X 14	1933/L	S	1,100
CARTIER-BRESSON, HENRI	GLYNDEBOURNE, ENGLAND	10/80	PT	119	S	14 X 10	1955/L	S	850
CARTIER-BRESSON, HENRI	"ON THE BANKS OF THE MARNE"(C-B,P.145)	10/80	PT	120	S	10 X 14	1938/L	S	1,050
CARTIER-BRESSON, HENRI	"GYMNASTICS AT A REFUGEE CAMP..."	10/80	PT	121	S	10 X 14	1948/L	S	BI
CARTIER-BRESSON, HENRI	BRIE, FRANCE (C-B, P.64)	10/80	PT	122	S	10 X 14	1968/L	S	1,100
CARTIER-BRESSON, HENRI	ALLEE DU PRADO,MARSEILLES (C-B, P.1)	11/80	CNY	296	S	14 X 10	1932/1970'S	S	BI
CARTIER-BRESSON, HENRI	HYERES, FRANCE (C-B, P.13)	11/80	CNY	297	S	10 X 14	1932/1970'S	S	950
CARTIER-BRESSON, HENRI	BRUSSELS (C-B, P.5)	11/80	CNY	298A	S	10 X 14	1932/1970'S	S	900
CARTIER-BRESSON, HENRI	"BEHIND THE GARE SAINT-LAZARE,PARIS"	11/80	CNY	298	S	14 X 10	1932/1970'S	S	1,200
CARTIER-BRESSON, HENRI	MEXICO (TWO PROSTITUTES; C-B, P.4)	11/80	CNY	299	S	10 X 14	1934/1970'S	S	BI
CARTIER-BRESSON, HENRI	HENRI MATISSE	11/80	CNY	300	S	10 X 14	1944/1970'S	S	1,000
CARTIER-BRESSON, HENRI	KASHMIR (C-B, P.112)	11/80	CNY	301	S	9 X 14	1948/1970'S	S	1,000
CARTIER-BRESSON, HENRI	SIPHONOS, GREECE	11/80	CNY	302	S	10 X 14	1955/1970'S	S	1,100
CARTIER-BRESSON, HENRI	NEWS VENDORS NAPPING, MEXICO CITY	11/80	PNY	174	S	7 X 9	1934/V	S	1,300
CARTIER-BRESSON, HENRI	"PARIS" (DOGS COPULATING)	11/80	PNY	175	S	14 X 9	1932/V	S,ST,I	3,000
CARTIER-BRESSON, HENRI	PORTRAIT: ELI	11/80	PNY	176	S	8 X 7	PRE1935/V	S,ST,I	1,100
CARTIER-BRESSON, HENRI	"ON THE BANK OF THE MARNE"	11/80	PNY	177	S	10 X 15	1938/L	S	1,300
CARTIER-BRESSON, HENRI	CARDIGAN ON A CLOTHESLINE	11/80	SNY	206	S	11 X 9	E. 1930'S/V	S,	4,000
CARTIER-BRESSON, HENRI	"BEHIND THE GARE ST.-LAZARE, PARIS"	11/80	SNY	207	S	14 X 10	1932/L	S	1,900
CARTIER-BRESSON, HENRI	"HYERES, FRANCE" (C-B, P.13)	11/80	SNY	208	S	10 X 14	1932/L	S	1,300
CARTIER-BRESSON, HENRI	"BRUSSELS" (C-B, P.155)	11/80	SNY	209	S	10 X 14	1932/L	S	1,300
CARTIER-BRESSON, HENRI	"SEVILLE SPAIN" (C-B, P.90)	11/80	SNY	210	S	10 X 14	1933/L	S	1,400
CARTIER-BRESSON, HENRI	"ON THE BANKS OF THE MARNE" (C-B,P.145)	11/80	SNY	211	S	9 X 14	1938/L	S	1,700
CARTIER-BRESSON, HENRI	"BRIANCON, FRANCE"	11/80	SNY	212	S	14 X 10	1952/L	S	BI
CARTIER-BRESSON, HENRI	"AQUILA DEGLI ABRUZZI, ITALY"	11/80	SNY	213	S	14 X 9	1952/L	S	1,000
CARTIER-BRESSON, HENRI	"AQUILA DEGLI ABRUZZI, ITALY"	11/80	SNY	214	S	9 X 14	1952/L	S	1,000
CARTIER-BRESSON, HENRI	"ATHENS"	11/80	SNY	215	S	14 X 10	1953/L	S	1,500
CARTIER-BRESSON, HENRI	"RUE MOUFFETARD, PARIS"	11/80	SNY	216	S	14 X 10	1954/L	S	1,100

PHOTOGRAPHER	TITLE OR DESCRIPTION	DATE	AH	LOT#	PT	SIZE	N/P DATES	MARKS/COND.	PRICE
CARTIER-BRESSON, HENRI	"SIPHNOS, GREECE" (C-B, P.45)	11/80	SNY	217	S	9 X 14	1961/L	S	1,000
CARTIER-BRESSON, HENRI	"NEWCASTLE-ON-TYNE, ENGLAND"	11/80	SNY	218	S	10 X 14	1978/V	S	850
CARTIER-BRESSON, HENRI	"FITZROY TAVERN IN SOHO"	11/80	SW	259	S	12 X 8	1940'S/V	ST	425
CARTIER-BRESSON, HENRI	"ON RIVER STEAMER, W MINSTER-GREENWCH"	11/80	SW	260	S	12 X 8	C1950/V	ST	475
CHARBONIER, JEAN-PHILIPPE	"L'EXECUTION..." (ED: 3/50)	11/80	CNY	460	S	12 X 16	1944/75	S,A,T	BI
CITROEN, PAUL	REGEN	5/81	PNY	198	S	10 X 7	1930/V	S,T,D/E	425
CITROEN, PAUL	MODELL	5/81	PNY	199	S	11 X 9	1932/V	S,T,D/E	400
CITROEN, PAUL	PORTRAIT: FRANZ OSBORN, PIANIST	11/80	PNY	76	S	9 X 7	1934/V	S,T,D	BI
CITROEN, PAUL	ARBEITER	11/80	PNY	77	S	7 X 9	1930'S/V	S,T	BI
CITROEN, PAUL	WOMAN IN BATH, AMSTERDAM	11/80	PNY	78	S	10 X 7	1930/V	S,T,D	BI
CITROEN, PAUL	STILL LIFE WITH DOG	11/80	PNY	79	S	9 X 7	1933/V	S	BI
CITROEN, PAUL	PORTRAIT: R.G.	11/80	PNY	80	S	9 X 7	1934/V	S	350
CITROEN, PAUL	IM THEATER	11/80	PNY	81	S	16 X 12	1929/59	S.D	700
CLARK, LARRY	TULSA (MAN AND RIFLE BY RIVER)	5/81	PNY	323	S	8 X 12	C1971/V	S	175
CLARK, LARRY	TULSA (COUPLE IN KITCHEN)	5/81	PNY	324	S	12 X 8	C1971/V	S	150
CLAUDET, ANTOINE FRANCOIS	PORTRAIT: A GENTLEMAN	11/80	CNY	1	D	1/2 PL	1851/V	ST/E	BI
CLERGUE, LUCIEN	"NU" (ED: 4/30)	11/80	CNY	623	S	18 X 24	1970/L	S,T,D,ST	120
CLERGUE, LUCIEN	"VIGNES" (ED: 3/30)	11/80	CNY	624	S	24 X 20	1968/L	S,T,D,ST	95
CLERGUE, LUCIEN	"TORO MUERTO" (ED: 8/30)	11/80	CNY	625	S	24 X 20	1966/L	S,T,D,ST	70
CLERGUE, LUCIEN	"NU DE LA MER" (ED: 60)	5/81	PNY	151	S	20 X 16	UNKNOWN	S,ST	225
CLERGUE, LUCIEN	"LES GEANTES" (ED: 5/60)	5/81	SNY	594	S	10 X 14	1978/V	S,T,D,ST/M	250
CLIFFORD, CHARLES	ALCAZAR, SEGOVIA	11/80	CNY	26	A	11 X 16	C1860/V	ST,I	500
CLIFT, WILLIAM	COUNTY COURTHOUSES (6 PR., ED: 16/50)	5/81	CNY	214	S	16 X 13	1976/V	S,T	BI
COBURN, ALVIN LANGDON	"THE DOOR IN THE WALL" (10 PRINTS)	2/81	SLA	143	PG	8 X 6	1911/V		325
COBURN, ALVIN LANGDON	"MEN OF MARK" (33 PRINTS)	2/81	SLA	144	PG	4TO	1913/V		600
COBURN, ALVIN LANGDON	MEN OF MARK (33 PRINTS)	4/81	SW	63	PG	4TO	1913/V		550
COBURN, ALVIN LANGDON	A CANAL IN ROTTERDAM	5/81	CNY	65	PG	12 X 16	1908/V	/M	BI
COBURN, ALVIN LANGDON	THE EAGLE (VORTOGRAPH)	5/81	CNY	66	S	10 X 12	C1917/51	S,T,D/E	4,500
COBURN, ALVIN LANGDON	SIR PHILLIP GIBBS	5/81	PNY	227	P	8 X 6	C1920'S/V	S,A/E	BI
COBURN, ALVIN LANGDON	MEN OF MARK (23 PRINTS)	5/81	PNY	228	PG	8 X 6	1913/V		600
COBURN, ALVIN LANGDON	THE CLOUD, BAVARIA	5/81	SNY	147	PG	14 X 11	C1909/V	/M	850
COBURN, ALVIN LANGDON	LONDON (20 PRINTS)	5/81	PNY	231	PG	VARIOUS	1909/V		1,600
COBURN, ALVIN LANGDON	MEN OF MARK (33 PRINTS)	11/80	CNY	256	PG	VARIOUS	1913/V	S	1,700
COBURN, ALVIN LANGDON	"THE DOOR IN THE WALL..." (10 PRINTS)	11/80	CNY	257	PG	9 X 6	1911/V		500
COLWELL, LARRY	FLOWER STUDY	4/81	PNY	6	S	7 X 9	1950'S/V	ST	100
COLWELL, LARRY	NUDE	4/81	PNY	7	S	10 X 8	1953/V	S,D	200
COMPOSERS AND MUSICIANS	15 CARTES-DE-VISITE'S W/INSTRUMENTS	4/81	SW	442	A	2 X 4	C1880'S/V	SOME T & D	140
CONHEIM, BERNARD	"VERTICALS & CURVES"	10/80	PT	143	S	13 X 10	1920'S/V	S,ST	110
CONSTANT, EUGENE	"TEMPLE OF VESTA...TOWARDS THE TIBER"	5/81	SNY	93	SA	8 X 10	C1848/V	ST,T,A	1,500
COOMBS, F.	PORTRAIT OF A MAN	2/81	SLA	145	D	1/2-P.	C1850/V	ST	300
CORNELIUS, ROBERT	PORTRAIT: UNIDENTIFIED GENTLEMAN	4/81	SW	233	D	1/6 PL	C1840/V	T	750
CORPRON, CARLOTTA M.	"LIGHT FOLLOWS FORM"	5/81	PNY	278	S	9 X 11	C1930/V	S,T/G	325
CRAMER, KONRAD	"PLANT DETAIL"	11/80	PNY	231	S	14 X 9	1930'S/V	S	160
CRESPON, A.	VIEW OF A GARDEN	5/81	PNY	33	A	8 X 10	1860/70'S/V	ST/E	BI
CUNNINGHAM, IMOGEN	"MAGNOLIA BLOSSOM"	2/81	SLA	146	S	11 X 14	1925/L	S,D	750
CUNNINGHAM, IMOGEN	"MY FATHER, MOTHER AND BOSSY"	2/81	SLA	147	S	9 X 12	1923/L	S,D	650
CUNNINGHAM, IMOGEN	"AGAVE DESIGN 2"	2/81	SLA	148	S	10 X 8	1920/L	S,D	900
CUNNINGHAM, IMOGEN	"FALSE HELLEBORE"	2/81	SLA	149	S	7 X 6	1926/1970'S	S,T,D	700
CUNNINGHAM, IMOGEN	PORTRAIT: MISS GOODALE	4/81	SW	322	P	6 X 5	C1916/V	S	550
CUNNINGHAM, IMOGEN	"BRAILLE"	5/81	PNY	250	S	8 X 9	1930/L	/G	225
CUNNINGHAM, IMOGEN	"LEAF PATTERN"	5/81	SNY	273A	S	13 X 10	1928/L	S,D/M	900
CUNNINGHAM, IMOGEN	"ALOE"	5/81	SNY	274	S	9 X 7	1920'S/L	PD,ST/E	400
CUNNINGHAM, IMOGEN	"FALSE HELLEBORE"	5/81	SNY	275	S	12 X 9	1926/V	S,I/F	BI
CUNNINGHAM, IMOGEN	PORTRAIT: MARTHA GRAHAM	5/81	SNY	276	S	8 X 10	1939/L	S,D/M	BI
CUNNINGHAM, IMOGEN	PORTRAIT: WYNN BULLOCK	5/81	SNY	277	S	8 X 8	1966/L	S,D/M	BI
CUNNINGHAM, IMOGEN	PORTRAIT: EDWARD WESTON	5/81	SNY	278	S	7 X 7	1945/L	S,D/M	BI
CUNNINGHAM, IMOGEN	PORTRAIT: BRASSAI	5/81	SNY	279	S	10 X 8	1973/L	S,D	BI
CUNNINGHAM, IMOGEN	PORTRAIT: ALFRED STIEGLITZ	5/81	SNY	280	S	10 X 8	1950/V	I/M	1,500
CUNNINGHAM, IMOGEN	"NAVAJO RUG"	5/81	SNY	281	S	11 X 14	1965/L	S,D/M	600
CUNNINGHAM, IMOGEN	"NUDE ON COUCH"	5/81	SNY	282	S	11 X 14	1968/L	S,D,ST/M	BI
CUNNINGHAM, IMOGEN	CHRISTOPHER	5/81	SNY	283	S	9 X 8	1973/V	T,D,ST/M	200

PHOTOGRAPHER	TITLE OR DESCRIPTION	DATE	AH	LOT#	PT	SIZE	N/P DATES	MARKS/COND.	PRICE
CUNNINGHAM, IMOGEN	"MARTHA GRAHAM"	10/80	PT	131	S	8 X 10	1931/70'S	S,D,ST	550
CUNNINGHAM, IMOGEN	PORTRAIT: LESTER ROWNTREE	10/80	PT	132	S	10 X 7	1972/V	S,T,D	BI
CUNNINGHAM, IMOGEN	TRIANGLES (FEMALE NUDE TORSO)	11/80	CNY	393	S	4 X 3	1928/V	S,D,ST,D	3,200
CUNNINGHAM, IMOGEN	NUDE	11/80	CNY	394	S	6 X 9	1923/1970'S	S,D,ST,T	700
CUNNINGHAM, IMOGEN	FALSE HELLEBORE	11/80	CNY	395	S	9 X 8	1926/1970'S	S,D,ST	750
CUNNINGHAM, IMOGEN	ANNA FREUD	11/80	CNY	396	S	11 X 11	1959/1970'S	S,D,ST,T	BI
CUNNINGHAM, IMOGEN	PAPAVER ORIENTALE	11/80	CNY	397	S	11 X 11	1965/1970'S	S,D,ST,T	420
CUNNINGHAM, IMOGEN	"ROCK WALL ON THE COAST"	11/80	PNY	251	S	11 X 9	C1930/V	S	1,100
CUNNINGHAM, IMOGEN	"SNAKE IN BUCKET"	11/80	PNY	252	S	8 X 10	1929/L	S	250
CUNNINGHAM, IMOGEN	EDWARD WESTON & MARGRETHE MATHER	11/80	PNY	253	S	10 X 7	1923/L	S,D,ST	750
CUNNINGHAM, IMOGEN	"WANDERING JEW"	11/80	SNY	273	S	14 X 11	1930/L	S,D,ST	700
CUNNINGHAM, IMOGEN	PORTRAIT: MORRIS GRAVES	11/80	SNY	274	S	9 X 12	1950/L	S,D,ST	1,000
CUNNINGHAM, IMOGEN	"WOMAN ON A GERMAN TRAIN"	11/80	SNY	275	S	9 X 7	1960/V	S,D,ST,T	250
CURTIS, EDWARD S.	HARRIMAN AK EXP. BOOK: 45 PG BY CURTIS	2/81	SLA	150	PG	VARIOUS	1901/V		300
CURTIS, EDWARD S.	THE N.A. INDIAN (FOLIO 12)	2/81	SLA	151	PG	16 X 11	1907-30/V		2,100
CURTIS, EDWARD S.	THE N. A. INDIAN (FOLIO 14)	2/81	SLA	152	PG	16 X 11	1907-30/V		1,700
CURTIS, EDWARD S.	THE N.A. INDIAN (FOLIO 16)	2/81	SLA	153	PG	16 X 11	1907-30/V		2,100
CURTIS, EDWARD S.	N.A.I.:20 TEXT VOLUMES; ED:270)	2/81	SLA	156	PG	16 X 20	1907-30/V		BI
CURTIS, EDWARD S.	"THE CLAM DIGGER"	2/81	SLA	157	S	14 X 11	C1900/L	IN	450
CURTIS, EDWARD S.	"THE CLAM DIGGER"	2/81	SLA	158	S	10 X 8	C1900/V	S,IN	350
CURTIS, EDWARD S.	"THE THREE CHIEFS" (PIEGAN)	2/81	SLA	159	O	8 X 10	C.1900/V	S	2,500
CURTIS, EDWARD S.	"THE THREE CHIEFS" (PIEGAN)	2/81	SLA	160	S	16 X 21	C.1900/V	S,D,ST	700
CURTIS, EDWARD S.	"THE THREE CHIEFS" (PIEGAN)	2/81	SLA	161	S	12 X 17	C.1900/V	S,D,IN	650
CURTIS, EDWARD S.	"THE VANISHING RACE"	2/81	SLA	162	O	8 X 10	1904/V	S,D,IN	950
CURTIS, EDWARD S.	"THE FISHERMAN"	2/81	SLA	163	P	10 X 8	C.1900'S/V	S	1,400
CURTIS, EDWARD S.	"THE APACHE REAPER"	2/81	SLA	164	S	12 X 16	1906/V	S,ST	700
CURTIS, EDWARD S.	OLD WELL OF ACOMA	2/81	SLA	165	S	14 X 18	E.1900'S/V	S,ST,IN	BI
CURTIS, EDWARD S.	"AN OASIS IN THE BAD LANDS"	2/81	SLA	166	O	7 X 10	C.1900'S/V	S	1,700
CURTIS, EDWARD S.	KALISPEL INDIANS IN CANOES	2/81	SLA	167	S	6 X 8	C1910/V	S,ST,IN	275
CURTIS, EDWARD S.	YUROK FISHERMAN	2/81	SLA	168	S	8 X 6	C.1910'S/V	S	375
CURTIS, EDWARD S.	PORTRAIT OF AN INDIAN)	2/81	SLA	169	S	7 X 6	C.1910'S/V	S	250
CURTIS, EDWARD S.	PORTRAIT OF AN OLD NORTHWEST INDIAN	2/81	SLA	170	S	7 X 6	C.1910'S/V	S	350
CURTIS, EDWARD S.	PORTRAIT: SEATED INDIAN IN A FOREST	2/81	SLA	171	S	6 X 7	C.1910'S/V	S,IN	950
CURTIS, EDWARD S.	SEA NYMPH	2/81	SLA	172	S	10 X 13	1930'S/V	S,IN	950
CURTIS, EDWARD S.	BEFORE THE STORM - APACHE	5/81	CNY	50	O	14 X 17	C1910/V	S,PD/E	6,000
CURTIS, EDWARD S.	PORTRAIT: A NAVAJO	5/81	CNY	51	P	15 X 11	C1903/V	S,IN/M	1,400
CURTIS, EDWARD S.	N.A.I: 45 PRINTS, VARIOUS TRIBES	5/81	CNY	52	PG	16 X 11	1907-30/V	PD	3,000
CURTIS, EDWARD S.	NESJAJA HATALI,NAVAJO MEDICINE MAN	5/81	SNY	123	P	16 X 12	1904/V	IN,S/M	2,700
CURTIS, EDWARD S.	PORTRAIT: AN INDIAN BRAVE, PROFILE	5/81	SNY	124	P	16 X 10	1900'S/V	S/M	1,800
CURTIS, EDWARD S.	PORTRAIT: PRINCESS ANGELINE	5/81	SNY	125	S	7 X 6	C1898/C1930	S/F	750
CURTIS, EDWARD S.	HOPI WATER-CARRIERS	5/81	SNY	126	S	6 X 8	1900'S/V	SN/F	300
CURTIS, EDWARD S.	"CANON DEL MUERTO" (CANYON OF DEATH)	5/81	SNY	127	O	14 X 11	1900'S/V	S,ST/F	850
CURTIS, EDWARD S.	"THE VANISHING RACE"	5/81	SNY	128	O	11 X 14	C1900/V	S/E	2,000
CURTIS, EDWARD S.	"IN THE SHADOW OF THE CLIFFS"	5/81	SNY	129	P	6 X 8	1905/V	S,IN,ST/M	BI
CURTIS, EDWARD S.	"NATURE'S MIRROR: NAVAJO"	5/81	SNY	130	S	8 X 8	1904/V	IN,S,T/M	450
CURTIS, EDWARD S.	"THE SCOUT"	5/81	SNY	131	O	11 X 14	C1900'S/V	S/M	2,800
CURTIS, EDWARD S.	FANTASY STUDY WITH FEMALE NUDE	5/81	SNY	537	S	10 X 8	1920'S/V	S,I,ST/G	850
CURTIS, EDWARD S.	YOUNG SOUTHWEST INDIAN, SEATED	10/80	PT	34	P?	16 X 10	1899/V	S,ST,IN	950
CURTIS, EDWARD S.	"THE THREE CHIEFS" (PIEGAN)	11/80	CNY	155	O	11 X 14	C1907/V	S	2,600
CURTIS, EDWARD S.	PORTRAIT OF AN INDIAN BRAVE	11/80	CNY	162A	P	16 X 10	C1904/V	S/E	1,200
CURTIS, EDWARD S.	"PORTRAIT OF A NEZ PERCE CHIEF"	11/80	SNY	127	S?	15 X 11	1899/V	S	600
CURTIS, EDWARD S.	"THE VANISHING RACE"	11/80	SNY	128	S?	12 X 16	C.1900'S/V	S,IN	950
CURTIS, EDWARD S.	"THE VANISHING RACE"	11/80	SNY	129	O	8 X 10	C.1900'S/V	S,ST	1,500
CURTIS, EDWARD S.	"THE THREE CHIEFS"	11/80	SNY	130	O	13 X 16	1909/V	S,ST	5,000
CURTIS, EDWARD S.	N.A.I.:20 TEXT & 20 FOLIO VOL.(ED:270)	11/80	SNY	131	PG	4TO	1907-30/V	S,I,D,T	73,000
CURTIS, EDWARD S.	"PRAYER TO THE STARS"	11/80	SNY	132	O	14 X 10	C.1900'S/V	S,ST	1,100
CURTIS, EDWARD S.	"CANYON DE CHELLY"	11/80	SNY	133	O	11 X 14	1904/V	S,ST	3,200
CURTIS, EDWARD S.	"THE THREE CHIEFS" (PIEGAN)	11/80	SNY	135	S	13 X 16	C1900/V	S,ST	BI
CURTIS, EDWARD S.	"THE THREE CHIEFS" (PIEGAN)	11/80	SNY	134	O	11 X 14	1909/V	S,ST	3,500
D'ALESSANDRI	"ASSALTO ALLE BARRICATE..DI PORTA PIA"	5/81	SNY	104	A	11 X 15	1870/V	I,S,PD/P	550

PHOTOGRAPHER	TITLE OR DESCRIPTION	DATE	AH	LOT#	PT	SIZE	N/P DATES	MARKS/COND.	PRICE
D'AMORE, ROBERT	WOMAN WITH HAT (ED: 11/200)	4/81	PNY	199	S	15 X 11	1978/V	S,D	BI
D'ORA	DORA DUBY (3 PRINTS)	4/81	PNY	155	S	9 X 7	1920'S/V	ST,IN	BI
DAGUERREOTYPIST, UNKNOWN	SAN FRANCISCO HARBOR	2/81	SLA	22	D	1/4-PL.	1849/V		2,200
DAGUERREOTYPIST, UNKNOWN	PORTRAIT: DOG (SHORT-HAIRED POINTER)	4/81	SW	223	D	1/4 PL	C1850/V	A	250
DAGUERREOTYPIST, UNKNOWN	PORTRAIT: DANIEL WEBSTER	5/81	SNY	110	D	1/4 PL.	1850/V	/G	900
DAGUERREOTYPIST, UNKNOWN	HORACE GREELEY	11/80	CNY	100	D	FULL PL	C1851/V		BI
DATER, JUDY	IMOGEN AND TWINKA AT YOSEMITE	2/81	SLA	173	S	10 X 8	1974/V	S	950
DATER, JUDY	"CHERI"	2/81	SLA	174	S	10 X 13	1972/V	S,T,D	250
DATER, JUDY	"IMOGEN AND TWINKA AT YOSEMITE"	5/81	SNY	526	S	10 X 8	1974/L	S,T,D/M	850
DATER, JUDY	IMOGEN AND TWINKA AT YOSEMITE	5/81	SNY	597	S	10 X 8	1974/V	S,T,D	1,150
DATER, JUDY	"MAUREEN"	5/81	SNY	598	S	13 X 10	1972/V	S,T,D	200
DATER, JUDY	"TWINKA"	10/80	PT	239	S	13 X 10	1970/L	S,T	300
DATER, JUDY	"MOTHER AND DAUGHTERS, BEVERLY HILLS"	10/80	PT	240	S	10 X 8	1972/V	S,T,D	60
DATER, JUDY	"KUNIO, YOSEMITE"	10/80	PT	241	S	12 X 9	1975/V	S,T	BI
DATER, JUDY	"IMOGEN AND TWINKA AT YOSEMITE"	11/80	CNY	602	S	10 X 8	1974/L	S,T,D	650
DATER, JUDY	IMOGEN AND TWINKA AT YOSEMITE	11/80	CNY	520	S	9 X 8	1974/V	S	1,100
DAVANNE, LOUIS-ALPHONSE	LANDSCAPE, THE SOUTH OF FRANCE	5/81	CNY	37	A	12 X 10	1862/V	ST,D/M	BI
DAVANNE, LOUIS-ALPHONSE	HARBOR SCENE	5/81	PNY	29	A	9 X 13	1860'S/V	ST/G	175
DAVANNE, LOUIS-ALPHONSE	"CHENE CENTENAIRE...DES MILELLI"	5/81	SNY	102	A	11 X 15	1870'S/V	ST,T/G	400
DAY, F. HOLLAND/SCHOOL OF	CRUCIFIXION STUDY	5/81	SNY	135	S	9 X 5	1900'S/V	A/P	BI
DE COCK, LILIAN	"EL CAPITAN-WINTER-YOSEMITE VALLEY"	11/80	CNY	600A	S	19 X 14	C1970/V	S,T	200
DE COCK, LILIAN	"AT THE FOOT OF ACOMA, NEW MEXICO"	11/80	CNY	601	S	9 X 11	1970/V	S,T,D,ST	BI
DE DIENES, ANDRE	"SOUVENIR D'UNE AVENTURE MISTERIENE"	11/80	PNY	113	S	10 X 8	1920'S/V	ST,T	130
DE MEYER, BARON	ELIZABETH ARDEN ADVERTISEMENT	4/81	PNY	159	S	10 X 8	1920'S/V		1,000
DE MEYER, BARON	AIDA WITH A CRYSTAL BALL	5/81	CNY	62	P	9 X 7	C1908/V	/E	BI
DE MEYER, BARON	NORTH AFRICAN	5/81	CNY	63	P	9 X 6	C1908/V	/G	BI
DE MEYER, BARON	PORTRAIT: MISS VAN AMELUNGEN	5/81	CNY	64	P	9 X 6	C1908/V	/M	BI
DE MEYER, BARON	DINING ROOM IN THE RUE VANEAU, PARIS	5/81	PNY	232	S	9 X 7	1920'S/C40	/E-G	400
DE MEYER, BARON	RUTH ST. DENIS	5/81	PNY	233	P	9 X 7	C1918/V		300
DE MEYER, BARON	CAMERA WORK (#17, 18 AND 19)	5/81	PNY	235	PG	4TO	1907/V	/M	425
DE MEYER, BARON	PORTRAIT: INA CLAIRE	5/81	SNY	284	S	9 X 6	1920'S/V	S/P	350
DE MEYER, BARON	MISS VAN AMELUNGEN	10/80	SNY	3	P	9 X 6	C1900'S/V		500
DE MEYER, BARON	PORTRAIT OF A LADY	10/80	SNY	5	P	9 X 7	C1900'S/V		250
DE MEYER, BARON	COCO MADRAGGO	10/80	SNY	10	P	9 X 7	C1900'S/V		325
DE MEYER, BARON	GEORGE ARLISS	10/80	SNY	11	S	14 X 11	1900'S/C40	S,T,ST	550
DE MEYER, BARON	COSMO GORDON LENNOX	10/80	SNY	12	P	10 X 7	C1900'S/V		150
DE MEYER, BARON	OLGA DE MEYER	10/80	SNY	13	P	9 X 7	C1900'S/V		550
DE MEYER, BARON	MRS. GINGOLD	10/80	SNY	20	P	17 X 11	C1900'S/V	T	1,000
DE MEYER, BARON	"MRS. LAVERY, LATER LADY LAVERY..."	10/80	SNY	21	S	7 X 9	C1900'S/V	T	425
DE MEYER, BARON	"LE GRAND SALUT"	10/80	SNY	23	P	7 X 9	C1910/V	T,A	425
DE MEYER, BARON	COUNTESS MARGOT ASQUITH (2 PORTRAITS)	10/80	SNY	24	S	17 X 13	C1911/V	T	1,900
DE MEYER, BARON	LI-CHIFU, A CHINESE ACTOR	10/80	SNY	25	P	14 X 11	1911/V		BI
DE MEYER, BARON	LI-CHIFU, A CHINESE ACTOR(2 PORTRAITS)	10/80	SNY	26	P	9 X 6	1911/V	T	400
DE MEYER, BARON	VENICE (GROUP OF 17 VIEWS)	10/80	SNY	28	P	VARIOUS	C1900'S/V		1,000
DE MEYER, BARON	NIJINSKY, LE SPECTRE DE LA ROSE	10/80	SNY	29	P	13 X 10	1911/V	S	12,500
DE MEYER, BARON	FOUNTAIN IN AN ITALIAN GARDEN	10/80	SNY	31	S	19 X 14	?/V		1,100
DE MEYER, BARON	FOUNTAIN AT VILLA D'ESTE, TIVOLI	10/80	SNY	32	S	14 X 11	?/C1940	S,ST	850
DE MEYER, BARON	"VILLA ADRIANA, ROME"	10/80	SNY	33	S	14 X 11	?/40	S,T	800
DE MEYER, BARON	"GUITAR PLAYER, SEVILLE"	10/80	SNY	35	P	14 X 11	1907/V	I,T,	1,700
DE MEYER, BARON	"STILL LIFE" (COPY PRINT OF PG)	10/80	SNY	37	S	10 X 14	C1906/C1940	S	1,600
DE MEYER, BARON	"THE SHADOWS ON WALL CHRYSANTHEMUMS"	10/80	SNY	38	S	19 X 14	C1906/V		6,750
DE MEYER, BARON	PIERRE LOTI	10/80	SNY	39	P	9 X 6	C1900'S/V	T	450
DE MEYER, BARON	"CONSTANTINOPLE, KEEPER OF SULTAN'S.."	10/80	SNY	40	P	9 X 6	C1910/V		475
DE MEYER, BARON	"CONSTANTINOPLE, KEEPER OF SULTAN'S.."	10/80	SNY	43	S	19 X 14	C1910/V		700
DE MEYER, BARON	NORTH AFRICAN	10/80	SNY	44	P	9 X 6	C1911/V		1,000
DE MEYER, BARON	NORTH AFRICAN GIRL (2 PORTRAITS)	10/80	SNY	45	P	9 X 6	C1911/V		400
DE MEYER, BARON	EGYPT, INDIA, CEYLON (50 PHOTOS)	10/80	SNY	49	P	6 X 8	C1900'S/V		1,200
DE MEYER, BARON	EGYPTIAN WITH A FEZ (2 PORTRAITS)	10/80	SNY	50	P	9 X 6	C1911/V		400
DE MEYER, BARON	INDIA AND CEYLON (90 PHOTOS)	10/80	SNY	51	P	6 X 8	C1900'S/V	A	4,500
DE MEYER, BARON	JAPAN (96 PHOTOS)	10/80	SNY	52	P	6 X 8	C1900'S/V	A	5,250
DE MEYER, BARON	ALFRED STIEGLITZ	10/80	SNY	63	P	9 X 7	C1920/V	T	1,400

PHOTOGRAPHER	TITLE OR DESCRIPTION	DATE	AH	LOT#	PT	SIZE	N/P DATES	MARKS/COND.	PRICE
DE MEYER, BARON	ALFRED STIEGLITZ	10/80	SNY	64	P	9 X 7	C1920/V	T	1,100
DE MEYER, BARON	CAMERA WORK 40 (14 PLATES)	10/80	SNY	65	PG	4TO	1912/V		1,400
DE MEYER, BARON	"THE CUP"	10/80	SNY	66	S	17 X 13	C1900'S/V	I	1,900
DE MEYER, BARON	"THE SILVER CAP"	10/80	SNY	67	S	14 X 8	1908/C40	S,T,D,ST	450
DE MEYER, BARON	MARCHESA LUISA CASATI	10/80	SNY	68	S	14 X 11	1912/C40	S,T,ST	1,700
DE MEYER, BARON	MARCHESA LUISA CASATI	10/80	SNY	69	P	9 X 6	1912/V	T	2,300
DE MEYER, BARON	"AIDA, A MAID OF TANGIER" (CAM WRK 40)	10/80	SNY	71	P	9 X 7	C1911/V		4,750
DE MEYER, BARON	AIDA WITH A CRYSTAL BALL	10/80	SNY	73	P	9 X 7	C1911/V		950
DE MEYER, BARON	"FROM SHORES OF THE BOSPHORUS" (CW 40)	10/80	SNY	74	S	14 X 9	C1900'S/C40	S,ST	1,200
DE MEYER, BARON	"A STREET IN CHINA" (PHOTO OF CW 40)	10/80	SNY	75	S	14 X 9	C1911/40	S,ST	325
DE MEYER, BARON	"WINDOWS ON THE BOSPHORUS" (CAM WRK 40)	10/80	SNY	76	S	14 X 19	C1910/V		800
DE MEYER, BARON	PORTRAIT: OLD WOMAN	10/80	SNY	78	S	18 X 14	C1900'S/V		500
DE MEYER, BARON	PORTRAIT: OLD WOMAN	10/80	SNY	79	S	18 X 14	C1900'S/V		125
DE MEYER, BARON	"MRS. BROWN OF PICCADILLY"	10/80	SNY	81	S	19 X 15	C1900'S/V		175
DE MEYER, BARON	PORTRAIT: PEASANT WOMAN	10/80	SNY	82	S	18 X 15	C1900'S/V		1,300
DE MEYER, BARON	"THE BALLOON MAN" (CAM WRK 40/PL. XII)	10/80	SNY	83	S	19 X 15	C1900'S/V		1,700
DE MEYER, BARON	"STILL LIFE-DIRECT FROM NATURE" (CW 40)	10/80	SNY	84	S	14 X 11	C1911/C40	S,T	2,300
DE MEYER, BARON	"FOUNTAIN OF SATURN, VERSAILLES" (CW40)	10/80	SNY	85	S	14 X 11	C1900'S/C40	S,ST	1,100
DE MEYER, BARON	"THE GARDENS OF VERSAILLES"	10/80	SNY	86	S	14 X 11	C1900'S/C40	S,T	1,600
DE MEYER, BARON	STILL LIFE	10/80	SNY	87	S	8 X 6	C1908/V		2,300
DE MEYER, BARON	MRS. RITA DE ACOSTA LYDIG	10/80	SNY	89	P	8 X 9	1913/V	T/E	1,500
DE MEYER, BARON	MRS. RITA DE ACOSTA LYDIG	10/80	SNY	90	S	14 X 11	1913/C40	S,T,ST/E	850
DE MEYER, BARON	BILLIE BURKE (2 PORTRAITS)	10/80	SNY	95	S	10 X 8	C1917/V	T	150
DE MEYER, BARON	MRS. HOWARD CUSHING	10/80	SNY	96	S	10 X 8	C1914/V	T	750
DE MEYER, BARON	MRS. JACK GARDNER OF BOSTON (3 PHOTOS)	10/80	SNY	97	P	8 X 6	C1915/V	T	600
DE MEYER, BARON	INTERIOR STUDIES (7 PHOTOS)	10/80	SNY	99	P	10 X 7	C1916/V	T	600
DE MEYER, BARON	"MRS. LILY HAVEMEYER"	10/80	SNY	101	P	10 X 8	1917/V	T	60
DE MEYER, BARON	RUTH ST. DENIS (2 PORTRAITS)	10/80	SNY	102	P	10 X 6	1918/V		425
DE MEYER, BARON	YVETTE GUILBERT	10/80	SNY	106	S	18 X 15	1919/V		250
DE MEYER, BARON	MRS. IRENE CASTLE	10/80	SNY	107	S	18 X 14	1919/V	S,T,A	1,600
DE MEYER, BARON	LILLIAN GISH	10/80	SNY	109	S	17 X 13	1919/V		1,200
DE MEYER, BARON	MISS NATICA NAST (2 PORTRAITS)	10/80	SNY	110	S	10 X 8	1920/V	A	275
DE MEYER, BARON	JOHN BARRYMORE	10/80	SNY	111	S	15 X 11	1918/V	S,T,D	2,500
DE MEYER, BARON	MARY PICKFORD	10/80	SNY	112	S	18 X 14	1920/V	S,T,D	1,200
DE MEYER, BARON	COMTE ETIENNE DE BEAUMONT	10/80	SNY	114	S	9 X 7	1920'S/V		900
DE MEYER, BARON	CECILE SOREL	10/80	SNY	115	S	18 X 14	C1920'S/V	S,T	500
DE MEYER, BARON	JOSEPHINE BAKER	10/80	SNY	116	S	16 X 15	C1923/V		2,200
DE MEYER, BARON	GABRIELLE 'COCO' CHANEL	10/80	SNY	118	S	14 X 11	1920'S/C40	S,T,ST	700
DE MEYER, BARON	DUCHESSE MARIA DE GRAMONT-RUSPOLI	10/80	SNY	121	S	19 X 15	1920'S/V		1,300
DE MEYER, BARON	ELSIE DE WOLFE, LADY MENDL	10/80	SNY	122	P	8 X 9	1920'S/V	T,I	750
DE MEYER, BARON	"DINING ROOM IN THE RUE VANEAU, PARIS"	10/80	SNY	123	S	14 X 11	1920'S/C40	S,T,ST	500
DE MEYER, BARON	CLAUDE MONET	10/80	SNY	124	S	9 X 7	1921/V	T	1,500
DE MEYER, BARON	MRS. J. ASTOR, LADY RIBBLESDALE (2)	10/80	SNY	125	P	9 X 7	C1920'S/V	T	950
DE MEYER, BARON	LADY EDEN	10/80	SNY	126	P	9 X 7	C1920'S/V	T	100
DE MEYER, BARON	MRS. J. J. ASTOR-DICK	10/80	SNY	127	S	9 X 7	C1920'S/V		375
DE MEYER, BARON	MRS. HARRY PAYNE WHITNEY	10/80	SNY	128	P	9 X 5	C1920/V	T	900
DE MEYER, BARON	MRS. JAY COOGAN	10/80	SNY	129	S	15 X 12	1922/V		1,400
DE MEYER, BARON	ELEONORA DUSE	10/80	SNY	131	P	11 X 6	1922/V		550
DE MEYER, BARON	ROSES	10/80	SNY	132	P	19 X 15	1923/V		750
DE MEYER, BARON	"MARYLAND," CAP FERRAT-A.M. FRANCE	10/80	SNY	133	S	14 X 11	1925/C40	S,T,ST	1,400
DE MEYER, BARON	BERTHE	10/80	SNY	134	S	19 X 14	1926/V		450
DE MEYER, BARON	STILL LIFE WITH GRAPES	10/80	SNY	135	S	18 X 14	1926/V		2,700
DE MEYER, BARON	MISS ROSAMOND PINCHOT	10/80	SNY	136	S	18 X 14	1927/V		500
DE MEYER, BARON	"NILE GREEN SATIN FOR SUMMER"	10/80	SNY	137	S	18 X 14	1927/V		2,300
DE MEYER, BARON	"A NEW BEIGE WALL FABRIC FROM RODIER"	10/80	SNY	138	S	18 X 14	1927/V		3,000
DE MEYER, BARON	MULTIPLE PORTRAIT OF A MODEL	10/80	SNY	139	S	18 X 14	1928		500
DE MEYER, BARON	LILIES	10/80	SNY	140	S	14 X 11	1928/C40	S,ST	2,000
DE MEYER, BARON	"BARONESS DE MEYER IN NEW REBOUX HAT"	10/80	SNY	141	S	7 X 7	1929/V		6,000
DE MEYER, BARON	MLLE. DE ARMINJA	10/80	SNY	142	S	14 X 11	1929/C40	S,T	1,300
DE MEYER, BARON	PORTRAIT: DAISY FELLOWES	10/80	SNY	143	S	14 X 11	1920'S/C40	S,T,ST	2,100
DE MEYER, BARON	"HELEN KELLY, FLORA"	10/80	SNY	144	S	9 X 7	1920'S/V	T	250

PHOTOGRAPHER	TITLE OR DESCRIPTION	DATE	AH	LOT#	PT	SIZE	N/P DATES	MARKS/COND.	PRICE
DE MEYER, BARON	ELIZABETH ARDEN, THE WAX HEAD	10/80	SNY	145	S	14 X 11	1920'S/C40	S,ST	5,000
DE MEYER, BARON	ELIZABETH ARDEN, LA JOIE D'ELIZABETH	10/80	SNY	146	S	14 X 11	1920'S/C40	S,ST	1,700
DE MEYER, BARON	ELIZABETH ARDEN, L'AMOUR D'ELIZABETH	10/80	SNY	147	S	14 X 7	1920'S/C40	S	1,800
DE MEYER, BARON	MRS. EDWARD G. ROBINSON (2 PORTRAITS)	10/80	SNY	149	S	9 X 8	1940'S/V	A	250
DE MEYER, BARON	ELSIE DE WOLFE, LADY MENDL	10/80	SNY	150	S	14 X 11	C1940/V	S,I,ST	400
DE MEYER, BARON	ELSA MAXWELL	10/80	SNY	151	S	14 X 11	C1940/V	S,ST	1,100
DE MEYER, BARON	ELSA MAXWELL	10/80	SNY	152	S	14 X 11	C1940/V	S,T,ST	20
DE MEYER, BARON	HEDDA HOPPER (3 PORTRAITS)	10/80	SNY	153	S	14 X 11	1940'S/V	S,T,ST	500
DE MEYER, BARON	ANITA LOUISE	10/80	SNY	154	S	14 X 11	C1940/V	S,T,ST	250
DE MEYER, BARON	ERNEST DE MEYER	10/80	SNY	155	S	14 X 11	1940'S/V	S,T,ST	300
DE MEYER, BARON	ERNEST DE MEYER	10/80	SNY	156	S	10 X 8	1940'S/V	1=S	750
DE MEYER, BARON	HELEN GAHAGAN-DOUGLAS	10/80	SNY	157	S	14 X 11	C1940/V	S,T	450
DE MEYER, BARON	MRS. PHILIP LEWISOHN	10/80	SNY	158	P	9 X 7	1930'S/V	T	50
DE MEYER, BARON	GLADY'S PEABODY (PAIR OF PORTRAITS)	10/80	SNY	159	S	10 X 8	1940'S/V	ST	150
DE MEYER, BARON	MRS. AND MRS. ROB WAGNER	10/80	SNY	160	S	14 X 11	C1940/V	S,T,ST	175
DE MEYER, BARON	JOSEF VON STERNBERG	10/80	SNY	161	S	VARIOUS		S,T	400
DE MEYER, BARON	LADY RIPON	11/80	SNY	831	P	9 X 7	C1910/V		300
DELANO, JACK	WIFE OF FSA FARMER	4/81	PNY	109	S	10 X 7	C1940/V		BI
DELANO, JACK	OLD WOMAN	4/81	PNY	110	S	7 X 10	1942/V	S,D	BI
DELANO, JACK	FARM FAMILY	4/81	PNY	111	S	10 X 13	1942/V	S,D	250
DELANO, JACK	CHICAGO & NORTHWESTERN RR. YARDS	4/81	PNY	112	S	10 C 13	1942/V	S,ST	250
DELARDI, ALFRED A.	"THE TRUMPETEER"	5/81	PNY	243	S	12 X 10	1934/V	S,ST	250
DELONGRE, FRED	HAND STUDY	11/80	PNY	119	S	12 X 9	C1935/V	S,T	120
DENIS, EUGENE	BRUGES AND VIEILLE (2 PRINTS)	4/81	PNY	79	B	11 X 8	1940'S/V	S,T,D	60
DENIS, EUGENE	ABBAYE AND GAND (2 PRINTS)	4/81	PNY	80	B	9 X 7	1940'S/V	S,T,D	80
DERUJINSKY, GLEB (ATTRIB)	CARMEL SNOW (3 PRINTS)	4/81	PNY	191	S	VARIOUS	C1950/V		BI
DISRAELI, ROBERT	"SUBWAY INTERLUDE"	5/81	PNY	271	S	7 X 5	1934/V	ST,T	350
DISRAELI, ROBERT	SURREALIST STILL LIFE W/MAN RAY LIPS	5/81	PNY	272	S	9 X 7	1934/V	S	200
DISRAELI, ROBERT	"THE SHADOW"	5/81	PNY	273	S	14 X 11	1938/V	S,T,ST	300
DOISNEAU, ROBERT	"L'INFORMATION SCOLAIRE"	2/81	SLA	175	S	9 X 14	1956/1977	I,T,D,S	600
DOISNEAU, ROBERT	"L'AMOUR EN TRIPORTEUR"	2/81	SLA	176	S	11 X 9	1950/1977	S,T,D	550
DOISNEAU, ROBERT	"REGARD OBLIQUE"	2/81	SLA	177	S	10 X 12	1950'S/L	S,T	600
DOISNEAU, ROBERT	"L'INNOCENT"	2/81	SLA	178	S	12 X 10	1949/1977	S,T,D	500
DOISNEAU, ROBERT	L'ACCORDEONISTE AU BOUILLON TIQUETONNE	2/81	SLA	179	S	11 X 10	1950'S/L	S,T	350
DOISNEAU, ROBERT	"L'ENFER"	2/81	SLA	180	S	11 X 10	1952/1977	T,D	375
DOISNEAU, ROBERT	LE GARDE ET LES BALLONS	4/81	PNY	144	S	9 X 12	1946/1977	S,T,D	BI
DOISNEAU, ROBERT	LA STRICTE INTIMITE	5/81	PNY	143	S	14 X 11	1946/74	S,T,D/E	300
DOISNEAU, ROBERT	"MONSIEUR BARRE'S MERRY-GO-ROUND"	5/81	PNY	144	S	12 X 10	1955/81	S,T,D	500
DOISNEAU, ROBERT	MARIAGE POITEVIN (WEDDING RIBBON)	5/81	PNY	145	S	11 X 10	1951/77	S,T,D	350
DOISNEAU, ROBERT	L'INNOCENT	5/81	PNY	146	S	11 X 10	1950'S/L	S,T,A	325
DOISNEAU, ROBERT	PORTFOLIO ED:8/100, 15 PR	5/81	SNY	259	S	10 X 12	1940-70/L	S/M	5,240
DOISNEAU, ROBERT	"BISTROT NOIR ET BLANC"	11/80	CNY	461	S	10 X 12	1948/76	S,T,D,A	BI
DOISNEAU, ROBERT	"LE CLAIRON DU DIMANCHE"	11/80	CNY	461A	S	13 X 11	1972/V	S	90
DOISNEAU, ROBERT	"MADEMOISELLE INCONNUE"	11/80	SNY	401	S	10 X 10	1940'S/V	T,ST	600
DOISNEAU, ROBERT	"LE BAR DE MONSIEUR JEAN"	11/80	SNY	402	S	10 X 14	C1950/1974	S,T,I	BI
DOISNEAU, ROBERT	"LE JARDIN DE LA CONCIERGE"	11/80	SNY	403	S	11 X 14	C1950/1974	S,T,I	BI
DOVIZIELLI, PIETRO	"THE CASCATE DELLE FERRIERE, TIVOLI"	5/81	CNY	39	SA	12 X 16	1850'S/V	ST,T/M	1,700
DRAHOMIR, JOSEPH RUZICKA	"PENNSYLVANIA STATION"	11/80	PNY	123	S	14 X 11	1930'S/V	S,T	550
DRAHOMIR, JOSEPH RUZICKA	"VENICE"	11/80	PNY	124	S	14 X 11	1924/V	S,D	225
DRTIKOL, FRANTISEK	PORTRAIT OF A WOMAN	11/80	PNY	125	MP	5 X 7	C1920/V	S	BI
DRTIKOL, FRANTISEK	NUDE BOY WITH WOMAN	11/80	PNY	126	S	10 X 8	1923/24/V	S,D	BI
DU CAMP, MAXIME	PALAIS DE KARNAK...	11/80		52	SA	7 X 9	1851/V	T,S	475
DU CAMP, MAXIME	"ISAMBOUL, COLOSSE ORIENTAL DU SPEOS"	11/80	CNY	50	SA	9 X 6	1851/52	PD,T/G	BI
DU CAMP, MAXIME	"RIVE ORIENTALE DU NIL, NUBIE"	11/80	CNY	51	SA	7 X 8	C1855/V	PD	BI
DU CAMP, MAXIME	"MOSQUEE DU KHALIFE HAAKEM", (CAIRO)	11/80	SNY	92	SA	8 X 6	C1851/V	T,IN	BI
DUMAS, NORA	NUDE BATHER	5/81	SNY	544	S	16 X 12	C1935/V	ST	600
DUMAS, NORA	3 FIGURES ON THE BANKS OF A RIVER	5/81	SNY	545	S	15 X 11	1933/V	S,D,I,ST	250
DUMAS, NORA	FEMALE NUDE WASHING	5/81	SNY	546	S	13 X 11	1935/V	S,D,I,ST	BI
EAGLE, ARNOLD	TENEMENT	5/81	PNY	111	S	10 X 13	1940'S/V	ST/G	BI
EAKINS, THOMAS	ELIZA COWPERTHWAITE	5/81	CNY	54	A	4 X 3	C1885/V	I/G	700

PHOTOGRAPHER	TITLE OR DESCRIPTION	DATE	AH	LOT#	PT	SIZE	N/P DATES	MARKS/COND.	PRICE
EAKINS, THOMAS	PORTRAIT: ELLA CROMWELL	5/81	SNY	121	A	3 X 2	1885-90/V	/F	500
EAKINS, THOMAS	EAKINS' RELATIVES WADING IN A CREEK	11/80	CNY	180A	A	3 X 5	1883/V	I/F	1,000
EAKINS, THOMAS	PORTRAIT OF MARGARET EAKINS WITH HARRY	11/80	SNY	102	A	3 X 3	1880/V	I	1,000
EAKINS, THOMAS	PORTRAIT OF WALT WHITMAN	11/80	SNY	103	P	6 X 4	1891/V	I	2,800
EAKINS, THOMAS	PORTRAIT OF F.E.CROWELL & HER SON T.	11/80	SNY	104	P	4 X 3	1883/V	I	BI
EASTMAN, SETH & KING, H.	SETH EASTMAN AT DIGHTON DOCK	11/80	CNY	101	D	1/2 PL	1853/V	ST	12,000
EDGERTON, HAROLD	"TENNIS SERVE"	2/81	SLA	181	S	12 X 10	1977/V	S	275
EDGERTON, HAROLD	"SWIRLS & EDDIES OF A TENNIS STROKE"	2/81	SLA	182	S	9 X 12	1939/L	S	275
EDGERTON, HAROLD	"SHOCK WAVES FROM IMPACT"	2/81	SLA	183	S	10 X 11	C1965/L	S	BI
EDGERTON, HAROLD	"VORTEX AT A FAN BLADE TIP"	2/81	SLA	184	DT	14 X 9	C1973/L	S	BI
EDGERTON, HAROLD	RUNNERS 1940	4/81	PNY	61	S	19 X 23	1940/C1970	S	BI
EDGERTON, HAROLD	BOWLING PINS (CIRCA 1950)	4/81	PNY	62	S	23 X 19	C1950/C1970	S	350
EDGERTON, HAROLD	TENNIS PLAYER (MULTIPLE EXPOSURE)	5/81	CNY	168	S	19 X 23	C1954/L	S/E	750
EDGERTON, HAROLD	TRICK DANCERS	5/81	CNY	169	S	23 X 19	1950'S/V	S/G	BI
EDGERTON, HAROLD	FEMALE FINCHES FIGHTING	5/81	SNY	333	S	18 X 15	1930'S/70'S	S/G	350
EDGERTON, HAROLD	WHITE PIGEON RELEASED	5/81	SNY	334	S	18 X 14	1947/70'S	S	400
EDGERTON, HAROLD	BULLET THROUGH APPLE	5/81	SNY	335	DT	10 X 12	C1964/70'S	S	400
EDGERTON, HAROLD	BULLET THROUGH PLAYING CARD	5/81	SNY	336	S	14 X 19	C1964/70'S	S	500
EDGERTON, HAROLD	SPLASH OF MILK DROP	5/81	SNY	337	DT	14 X 11	1957/70'S	S	250
EDGERTON, HAROLD	FOOTBALL PLACEMENT KICK (ED: 7/60)	11/80	CNY	430	S	12 X 10	1934/77	S,A	400
EDGERTON, HAROLD	ACTION AT THE RODEO (ED: 7/60)	11/80	CNY	431	S	12 X 10	1940/77	S,A	BI
EDGERTON, HAROLD	POLE VAULTER, DAVID TORK (ED: 7/60)	11/80	CNY	432	DT	14 X 11	1964/77	S,A	BI
EDGERTON, HAROLD	THE H BOMB	11/80	CNY	433A	S	17 X 13	C1950/70'S	S	350
EDGERTON, HAROLD	SPLASH OF MILK DROP	11/80	CNY	433	DT	10 X 8	1957/70'S	S,T	200
EDGERTON, HAROLD	SPLASH OF MILK DROP (ED: 7/60)	11/80	SNY	477	DT	14 X 11	C1957/77	S	600
EDGERTON, HAROLD	CUTTING THE PLAYING CARD...(ED:7/60)	11/80	SNY	478	DT	11 X 14	C1964/77	S	650
EDGERTON, HAROLD	BULLET THROUGH THE APPLE (ED:7/60)	11/80	SNY	479	DT	10 X 12	C1964/77	S	700
EDGERTON, HAROLD	GOLF (ED: 7/60)	11/80	SNY	480	S	10 X 10	C1957/77	S	250
EGGLESTON, WILLIAM	JAMAICA, PORTICO	2/81	SLA	185	CP	10 X 15	1970'S/V	S	275
EGGLESTON, WILLIAM	JAMAICA, ORCHIDS	2/81	SLA	186	CP	11 X 16	1970'S/V	S	125
EGGLESTON, WILLIAM	JAMAICA, FRUIT TREE	2/81	SLA	187	CP	11 X 16	1970'S/V	S	125
EGGLESTON, WILLIAM	"ORCHIDS FROM BELOW"	11/80	SW	273	CP	14 X 17	C1978/V	S,A	BI
EGGLESTON, WILLIAM	"BOUGAINVILLAEA"	11/80	SW	275	CP	14 X 17	C1978/V	S,A	BI
EGGLESTON, WILLIAM	"FLOWERING BOUGAINVILLAEA TREE"	11/80	SW	276	CP	14 X 17	C1978/V	S,A	130
EICKEMEYER, JR. RUDOLF	GIRL AND DOLL (GLASS POSITIVE)	11/80	CNY	200A		14 X 11	1899/V	IN	BI
EISENSTAEDT, ALFRED	"NUER STORKMAN & "SEA FOAM" (ED:99)	11/80	CNY	415A	S	13 X 10	1936/V	S,ST,I	350
EISENSTAEDT, ALFRED	LANDSCAPE, OREGON	11/80	CNY	415B	S	13 X 9	1937/V	S,ST,I	450
ELISOFON AND HAAS	"NUER STORKMAN & "SEA FOAM" (ED:99)	11/80	SNY	378	S	19 X 12	47;63/70'S	S	450
ELISOFON, ELIOT	FASHION MODELS WITH TRAINER	4/81	PNY	194	S	10 X 13	1950'S/V	ST	350
ELISOFON, ELIOT	GYPSY FORTUNE TELLER	5/81	PNY	265	S	4 X 3	1920'S/V	S	275
EMERSON, PETER HENRY	"SNIPE SHOOTING"	2/81	SLA	188	S	7 X 11	1886/C1910		425
EMERSON, PETER HENRY	LIFE & LANDSCAPE ON NORFOLK BROADS 40P	5/81	CNY	20	P	VARIOUS	1886/V	T/F-E	24,000
EMERSON, PETER HENRY	A SAILING MARCH AT HORNING	5/81	PNY	18	P	9 X 11	1886/V	X/E	700
EMERSON, PETER HENRY	WATER LILIES	5/81	PNY	19	P	5 X 11	1886/V	X/E	BI
EMERSON, PETER HENRY	THE RIVER BURE AT COLTISHALL	5/81	PNY	20	P	9 X 11	1886/V	X/E	800
EMERSON, PETER HENRY	EVENING	5/81	PNY	21	P	7 X 11	1886/V	X/E	700
EMERSON, PETER HENRY	THE AUTUMN MORNING	5/81	PNY	22	P	7 X 11	1886/V	X/E	500
EMERSON, PETER HENRY	THE FRING OF THE MARSH	5/81	PNY	23	P	7 X 11	1886/V	X/E	575
EMERSON, PETER HENRY	"COMING HOME FORM THE MARSHES"	5/81	SNY	90	P	8 X 11	1886/V	/G	1,000
EMERSON, PETER HENRY	"THE FIRST FROST"	5/81	SNY	91	P	8 X 11	1886/V	/M	850
EMERSON, PETER HENRY	"RICKING THE REED"	5/81	SNY	92	P	9 X 11	1886/V	/E	1,200
EMERSON, PETER HENRY	"RICKING THE REED"	10/80	PT	24	P	9 X 11	1886/V		1,100
EMERSON, PETER HENRY	"A BROADMAN'S COTTGE"	10/80	PT	25	P	9 X 11	1886/V		1,600
EMERSON, PETER HENRY	"COMING HOME FROM THE MARSHES"	10/80	PT	26	P	8 X 11	1886/V		1,000
EMERSON, PETER HENRY	"A RUSHY SHORE"	10/80	PT	27	P	8 X 11	1886/V		1,800
EMERSON, PETER HENRY	PICTURES OF EAST ANGLIAN LIFE:5 PRINTS	10/80	PT	28	PG	VARIOUS	1888/V		475
EMERSON, PETER HENRY	WILD LIFE ON A TIDAL WATER: 12 PRINTS	10/80	PT	29	PG	VARIOUS	1890/V		725
EMERSON, PETER HENRY	POLING THE MARSH HAY	11/80	CNY	181	P	9 X 12	1886/V		BI
EMERSON, PETER HENRY	CANTLEY: WHERRIES WAITING...	11/80	CNY	182	P	7 X 11	1886/V	T/E	2,500
EMERSON, PETER HENRY	SETTING THE BOW-NET (IN BOAT)	11/80	CNY	183	P	6 X 11	1886/V	T/E	1,800
EMERSON, PETER HENRY	SETTING-UP THE BOW-NET (ON SHORE)	11/80	CNY	184	P	11 X 9	1886/V	T/E	1,500

79

PHOTOGRAPHER	TITLE OR DESCRIPTION	DATE	AH	LOT#	PT	SIZE	N/P DATES	MARKS/COND.	PRICE
EMERSON, PETER HENRY	THE VILLAGE OF HORNING	11/80	CNY	185	P	9 X 7	1886/V	T/E	1,500
EMERSON, PETER HENRY	AN EEL-CATCHER'S HOME	11/80	CNY	186	P	9 X 11	1886/V		1,500
EMERSON, PETER HENRY	THE FRINGE OF THE MARSH	11/80	CNY	187	P	7 X 11	1886/V	T/E	BI
EMERSON, PETER HENRY	GUNNER WORKING UP TO FOWL	11/80	CNY	188	P	8 X 11	1886/V	T/E	1,500
EMERSON, PETER HENRY	QUANTING THE GLADDON	11/80	CNY	189	P	9 X 12	1886/V		BI
EMERSON, PETER HENRY	A MARSH FARM	11/80	CNY	190	P	8 X 11	1886/V		BI
EMERSON, PETER HENRY	"SNIPE SHOOTING"	11/80	SNY	83	P	8 X 11	1886/V		1,400
EMERSON, PETER HENRY	"THE FIRST FROST"	11/80	SNY	84	P	9 X 11	1886/V		1,100
EMERSON, PETER HENRY	"QUANTING THE MARSH HAY"	11/80	SNY	85	P	8 X 11	1886/V		800
EMERSON, PETER HENRY	"THE GLADDON CUTTERS RETURN"	11/80	SNY	86	P	9 X 11	1886/V		800
EMERSON, PETER HENRY	"A RUINED WATERMILL"	11/80	SNY	87	P	11 X 9	1886/V		600
ENGEL, MORRIS	CONEY ISLAND	5/81	PNY	112	S	14 X 11	1947/V	S,T,D/G	BI
ENGEL, MORRIS	BROOKLYN HORSE AUCTION	5/81	PNY	113	S	10 X 13	1947/V	S,T,D/F	250
ERNST, MAX & CREVEL, RENE	MR. KNIIFE, MISS FORK (19 PHOTOGRAMS)	2/81	SLA	189	S	8VO	1931/V	S	3,000
EROTIC STUDIES	FRENCH ALBUM: 80 PR, SOME ATTR. FRERES	11/80	CNY	61	A	VARIOUS	1880'S/V		3,800
ERWITT, ELLIOTT	PARIS (MASKS)	4/81	PNY	85	S	8 X 12	1949/L	S	275
ERWITT, ELLIOTT	NEW YORK	4/81	PNY	87	S	9 X 14	1946/L	S	375
ERWITT, ELLIOTT	COLORADO (ERWITT P. 40)	4/81	PNY	88	S	8 X 12	1955/L	S	275
ERWITT, ELLIOTT	NEW YORK (MOTHER, BABY & CAT)	4/81	PNY	89	S	15 X 22	1953/L	S	BI
ERWITT, ELLIOTT	NEW YORK	5/81	PNY	114	S	8 X 12	1953/L	S,ST,T,D/M	BI
ERWITT, ELLIOTT	"NEW YORK" (BABY AND MOTHER ON BED)	5/81	PNY	115	S	15 X 22	1953/L	S/M	400
ERWITT, ELLIOTT	LAS VEGAS	5/81	PNY	319	S	15 X 22	1957/L	S	475
ERWITT, ELLIOTT	THE GOURDS	11/80	CNY	582	S	12 X 8	1970'S/V		320
ERWITT, ELLIOTT	SLOT MACHINE COWBOY	11/80	CNY	583	S	11 X 16	1970'S/V		220
ERWITT, ELLIOTT	UNTITLED #3	11/80	CNY	584	S	8 X 12	1970'S/V	S,ST	260
EUGENE, FRANK	OLD GENTLEMAN, SEATED, WITH BOOKS	11/80	CNY	245A	P	7 X 5	C1900/V	S	1,500
EUGENE, FRANK	LADIES CLUB	5/81	SNY	152	P	6 X 8	1900'S/V	/P	BI
EVANS, FREDERICK H.	"RYE FROM WINCHELSEA"	2/81	SLA	191	P	6 X 8	1915/V	PD,S,D	1,200
EVANS, FREDERICK H.	BOURGES CATHEDRAL, THE WEST FRONT	5/81	CNY	21	P	10 X 8	C1900/V	ST/M	500
EVANS, FREDERICK H.	DETAIL OF LE PALAIS DE JUSTICE, ROUEN	5/81	CNY	22	P	8 X 10	1906/V	ST/E	480
EVANS, FREDERICK H.	WINCHESTER CATHEDRAL, DOORWAY IN ALTAR	5/81	CNY	23	P	5 X 4	C1900/V	ST/M	700
EVANS, FREDERICK H.	LINCOLN, CATHEDRAL, THE WEST SIDE PORT	5/81	CNY	24	P	7 X 5	C1900/V	ST/M	480
EVANS, FREDERICK H.	"CHATEAU MEILLANT"	10/80	PT	62	P	5 X 4	C1905/V	S,T	280
EVANS, FREDERICK H.	BOURGES CATHEDRAL-HEIGHT AND LIGHT	11/80	CNY	192	P		C1900/V	ST/E	2,500
EVANS, FREDERICK H.	CHATEAU	11/80	CNY	193	P	5 X 4	C1900/V	S,T	400
EVANS, FREDERICK H.	ANGERS:PREFECTURE:SCREEN OF ARCHES...	11/80	CNY	194	P	10 X 8	C1900/V	S,T,ST/E	BI
EVANS, FREDERICK H.	WINCHESTER CATHEDRAL,...CEILING	11/80	CNY	195	P	3 X 5	C1900/V	ST	500
EVANS, WALKER	BRIDGE STUDY, MANHATTAN	2/81	SLA	192	S	6 X 9	C1929/V	S	800
EVANS, WALKER	"FRESH & SMOKED" (ROAD SIGN)	2/81	SLA	193	S	4 X 7	1930'S/V	S,ST	400
EVANS, WALKER	"FRAME HOUSES IN VIRGINIA"	2/81	SLA	194	S	6 X 5	1936/V	S,ST,I	800
EVANS, WALKER	HELIKER HOUSE, CRANBERRY ISLAND, MAINE	2/81	SLA	195	S	13 X 9	1969/V	S,ST	375
EVANS, WALKER	"WELLFLEET, MASS."	2/81	SLA	196	S	6 X 5	1931/L	S,I	300
EVANS, WALKER	"STUDIO PORTRAITS,BIRMINGHAM, ALABAMA"	2/81	SLA	197	S	13 X 10	1936/L	S	950
EVANS, WALKER	"JOE'S AUTO GRAVEYARD"	2/81	SLA	198	S	5 X 7	1936/L	S,I	650
EVANS, WALKER	BATTLEFIELD MONUMENT, VICKSBURG, MISS.	2/81	SLA	199	S	10 X 8	1936/L	ST	BI
EVANS, WALKER	CHILDREN IN PLAYGROUND, CHICAGO	4/81	PNY	100	S	7 X 9	1946/V	ST	800
EVANS, WALKER	BUILDING, CHICAGO	4/81	PNY	101	S	9 X 11	1946/V	ST	BI
EVANS, WALKER	WOMAN ON STREET, CHICAGO	4/81	PNY	102	S	10 X 10	1946/V	ST	800
EVANS, WALKER	BOY AND STATUE, CHICAGO	4/81	PNY	103	S	9 X 5	1946/V	ST	300
EVANS, WALKER	MAIN STREET, SARATOGA SPRINGS, N.Y.	4/81	SW	331	S	7 X 6	1931/V	S	1,300
EVANS, WALKER	LICENSE PHOTO STUDIO, NEW YORK	4/81	SW	332	S	5 X 4	1934/V	ST	650
EVANS, WALKER	FLOYD BURROUGH'S BEDROOM, ALABAMA	4/81	SW	333	S	7 X 9	1936/V	ST	500
EVANS, WALKER	SELF PORTRAIT, PARIS (HAND ON CHIN)	5/81	CNY	125	S	3 X 2	C1927/V	/E	2,400
EVANS, WALKER	ARCHITECTURAL CADENCE	5/81	CNY	126	S	2 X 2	C1929/V	/E	BI
EVANS, WALKER	ARCHITECTURAL CADENCE	5/81	CNY	127	S	4 X 2	C1929/V	ST/M	1,200
EVANS, WALKER	ROCKEFELLER CENTER CONSTRUCTION	5/81	CNY	128	S	6 X 9	C1929/V	ST/F	BI
EVANS, WALKER	"DOORWAY, NEW YORK CITY"	5/81	CNY	129	S	6 X 3	1938/V	S,D,T,ST/M	1,000
EVANS, WALKER	WOMAN BATHER ON BILLBOARD	5/81	PNY	267	S	8 X 6	C1937/L	ST/E	500
EVANS, WALKER	"WOMAN AND CHILDREN, HAVANA"	5/81	SNY	306	S	2 X 4	1932/V	/G	350
EVANS, WALKER	"WATERFRONT POOLROOM, NEW YORK"	5/81	SNY	307	S	8 X 10	1933/L	ST/E	750
EVANS, WALKER	"OCEAN GROVE, NEW JERSEY"	5/81	SNY	308	S	6 X 8	1933/V	S,D/E	800

PHOTOGRAPHER	TITLE OR DESCRIPTION	DATE	AH	LOT#	PT	SIZE	N/P DATES	MARKS/COND.	PRICE
EVANS, WALKER	"FLOYD BURROUGHS, HALE COUNTY, ALA."	5/81	SNY	309	S		1936/L	ST/E	850
EVANS, WALKER	SARATOGA SPRINGS, NEW YORK (ED: 19/75)	5/81	SNY	310	S	22 X 17	1938/L	ST,A/G	850
EVANS, WALKER	SUBWAY PORTRAIT OF TWO NUNS	5/81	SNY	311	S	5 X 8	C1941/V	/E	BI
EVANS, WALKER	SUBWAY PORTRAIT	5/81	SNY	312	S	5 X 7	1941/V	ST/G	350
EVANS, WALKER	"CHICAGO"	5/81	SNY	313	S	7 X 9	1947/V	S/G	800
EVANS, WALKER	"MARY FRANK'S BED, NEW YORK"	5/81	SNY	314	S	10 X 11	1959/V	ST/F	450
EVANS, WALKER	MISSISSPPI RIVER BOAT, VICKSBURG	10/80	PT	151	S	4 X 5	1935/V	ST,T,D	320
EVANS, WALKER	SELF PORTRAIT, PARIS (PROFILE, SHADOW)	11/80	CNY	373	S	3 X 2	1927/V		2,800
EVANS, WALKER	ARCHITECTURAL CADENCE	11/80	CNY	374	S	9 X 7	C1929/V	ST	BI
EVANS, WALKER	ARCHITECTURAL CADENCE MONTAGE	11/80	CNY	375	S	3 X 3	C1929/V	ST	1,000
EVANS, WALKER	ARCHITECTURAL CADENCE (STAIRWAY)	11/80	CNY	376	S	9 X 6	C1929/V	ST	800
EVANS, WALKER	NEW YORK MILK COUNTER	11/80	CNY	377	S	5 X 8	C1930/V	ST	600
EVANS, WALKER	PINE STREET, NEW YORK	11/80	CNY	378	S	6 X 10	1929/V	ST	BI
EVANS, WALKER	WESTCHESTER FARMHOUSE	11/80	CNY	379A	S	5 X 7	1931/L	S,D,ST	750
EVANS, WALKER	HOTEL SARATOGA	11/80	CNY	379	S	8 X 6	1933/V	S,D	550
EVANS, WALKER	GEORGE'S PLACE	11/80	CNY	380	S	8 X 10	C1935/L		400
EVANS, WALKER	ALLIE MAE BURRUGHS, WIFE...	11/80	CNY	381	S	10 X 8	1936/L	ST	BI
EVANS, WALKER	SUBWAY PORTRAIT	11/80	CNY	382	S	5 X 8	C1941/V	ST	BI
EVANS, WALKER	PORTFOLIO: 15 PRINTS (ED: 1/75)	11/80	CNY	383	S	VARIOUS	1930'S/74	S/M	7,000
EVANS, WALKER	BRIDGE STUDY, MANHATTAN	11/80	PNY	188	S	2 X 2	C1929/V	ST	2,800
EVANS, WALKER	CHILD'S GRAVE, HALE COUNTY, ALABAMA	11/80	PNY	282	S	8 X 10	1936/L	S,D	BI
EVANS, WALKER	"STUDIO PORTRAITS" BIRMINGHAM,AL	11/80	PNY	283	S	9 X 7	1936/V	S,ST	1,800
EVANS, WALKER	"HOTEL PORCH" SARATOGA SPRINGS, NY	11/80	PNY	284	S	6 X 6	1930/V	ST	BI
EVANS, WALKER	"SHOESHINE STAND" (SOUTHEASTERN U.S.)	11/80	PNY	285	S	6 X 6	1936/V	ST	600
EVANS, WALKER	OUTDOOR STILL-LIFE	11/80	PNY	286	S	5 X 3	1930'S/V	S	600
EVANS, WALKER	"DAMAGED" (EXHIBITION LABEL)	11/80	PNY	287	S	7 X 9	1930'S/V	S	1,100
EVANS, WALKER	"VIEW OF OSSINING, NEW YORK"	11/80	PNY	288	S	4 X 8	1930/V	ST	650
EVANS, WALKER	"WOMAN AND CHILD, HAVANA"	11/80	SNY	294	S	3 X 4	1932/V	ST	500
EVANS, WALKER	"DOCKWORKER, HAVANA"	11/80	SNY	295	S	8 X 6	1932/1940'S	ST	850
EVANS, WALKER	"FARMER'S KITCHEN, HALE CTY., ALABAMA"	11/80	SNY	296	S	13 X 8	1936/1941		BI
EVANS, WALKER	"A MINER'S HOME...MORGANTOWN, W. VA."	11/80	SNY	297	S	8 X 10	1935/V	ST	BI
EVANS, WALKER	NEW ORLEANS	11/80	SNY	298	S	10 X 8	1935/V	ST	950
EVANS, WALKER	MAN AND BOY ON STEPS	11/80	SNY	299	S	8 X 6	1930'S/V	S	450
EVANS, WALKER	SUBWAY PORTRAIT	11/80	SNY	300	S	5 X 7	1941/V	ST	450
EVANS, WALKER	"BENNIE SIMMS-SHOE SHINE PARLOR"	11/80	SW	285	S	8 X 10	1930'S/V	ST	BI
EVANS, WALKER	"MAN IN OVERALLS"	11/80	SW	286	S	9 X 4	1930'S/V	ST	850
EVANS, WALKER	"SHARECROPPER FAMILY, HALE CNTY, ALA."	11/80	SW	287	S	8 X 10	1930'S/V	ST	BI
FAMIN, CHARLES	LANDSCAPE WITH FIGURE	11/80	CNY	58	A	10 X 12	1850'S/V	ST,IN	220
FAMIN, CHARLES	RURAL STUDY	5/81	PNY	30	A	8 X 10	C1860'S/V		175
FAR EAST	ALBUM: 103 PR BY BEATO, MILLER, OTHERS	2/81	SLA	51	A	4TO	1870'S/V	IN,I,T	550
FAR EAST	ALBUM: 75 PR BY BEATO, MILLER&THOMSON	5/81	PNY	64	A	VARIOUS	1860'S/V		4,500
FAR EAST	"VIEWS-CHINA, JAPAN" (50 PHOTOS)	5/81	SNY	108	A	8 X 10	1870'S/V	IN,PD/G	BI
FAURER, LOUIS	PORTRAIT: ROBERT FRANK	4/81	PNY	28	S	9 X 6	1949/L	S,D	300
FEHR, GERTRUDE	DEAD FISH ON NEWSPAPER, PARIS	11/80	PNY	100	S	12 X 15	1938/V	S,D,ST	BI
FEININGER, ANDREAS	"ANDREAS FEININGER, N.Y." (12 PHOTOS)	2/81	SLA	201	S	10 X 13	1940-60/70	S,I	900
FEININGER, ANDREAS	SHELL STUDIES (2 PHOTOS)	2/81	SLA	202	S	13 X 10	1940'S/V	S,ST	300
FEININGER, ANDREAS	SHELL STUDIES (2 PHOTOS)	2/81	SLA	203	S	13 X 10	1940'S/V	S,ST	350
FEININGER, ANDREAS	"THREE NUNS"	2/81	SLA	203A	CP	21 X 14	1950'S/V		325
FEININGER, ANDREAS	ON BOARD THE STATEN ISLAND FERRY	4/81	PNY	83	S	14 X 11	C1940/V	ST,I	BI
FEININGER, ANDREAS	MANHATTAN SKYLINE	4/81	PNY	84	S	14 X 11	C1940/V	ST,I	BI
FEININGER, ANDREAS	VIEW FROM TOP OF RCA TOWER	4/81	PNY	85	S	14 X 10	C1940/V	ST,I	BI
FEININGER, ANDREAS	"JEWISH SHOP, LOWER EAST SIDE"	11/80	CNY	466	S	14 X 11	1940'S/V	S,T,A	300
FEININGER, ANDREAS	"BOOT BLACK ON MOOT ST., CORNER CANAL"	11/80	CNY	467	S	14 X 11	1940'S/V	ST,T,A	260
FEININGER, T. LUX	"WORK OF J. SCHMIDT'S SCULPTURE CLASS"	5/81	SNY	172	S	4 X 3	1930'S/V	S,T,ST/F	600
FENTON, ROGER	QUEEN'S HIGHLAND GHILLIES, BALMORAL	5/81	CNY	6	SA	12 X 17	1856/V	IN,A/F	6,000
FENTON, ROGER	A NUBIAN SMOKER AND ATTENDANT	5/81	CNY	7	A	13 X 11	1850'S/V	/G	2,000
FENTON, ROGER	ELY CATHEDRAL	5/81	CNY	8	A	14 X 17	1864/V	/G	650
FENTON, ROGER	THE STAFF AT HEADQUARTERS	5/81	PNY	4	SA	8 X 7	1856/V	S,T,/E	350
FENTON, ROGER	CRIMEA (3 PRINTS)	5/81	PNY	5	SA	8 X 10	1856/V	S,T/P	BI
FENTON, ROGER	DRAWING BY RAPHAEL SANZIO	5/81	PNY	6	SA	14 X 9	1850'S/V	T,S/E	BI

81

PHOTOGRAPHER	TITLE OR DESCRIPTION	DATE	AH	LOT#	PT	SIZE	N/P DATES	MARKS/COND.	PRICE
FENTON, ROGER	"THE DUCHESS OF CAMBRIDGE'S TENT"	5/81	SNY	86	A	10 X 11	1860/V	PD,I/F	BI
FENTON, ROGER	PETERBOROUGH CATHEDRAL	11/80	CNY	15	A	16 X 14	C1857/V	A	BI
FENTON, ROGER	NUBIAN MODEL	11/80	CNY	16	A	14 X 18	1850'S/V	/G	5,700
FENTON, ROGER	"GLYN LLEDS FROM PONT Y PANT (WALES)"	11/80	CNY	17	A	14 X 17	1850'S/V	PD	2,200
FERREZ, MARC	BRAZIL (5 PRINTS)	11/80	CNY	87	A	9 X 7	1860'S/V	T,PD,A	BI
FERREZ, MARC	BRAZIL (2 PRINTS)	11/80	CNY	88	A	7 X 10	1870,75/V		BI
FERREZ, MARC	"JARDIN BOTANIQUE"	11/80	CNY	89	A	10 X 14	C1875/V	IN	600
FERREZ, MARC	"CORCOVADA-DO LARGO DOS LEVES"	11/80	CNY	90	A	14 X 10	C1875/V	IN	600
FERREZ, MARC	BRAZIL (8 PHOTOS)	11/80	SW	256	A	14 X 12	1870'S/V	ST	110
FIEDLER, FRANZ	"MASKS AND CONFETTI"	11/80	PNY	10	S	11 X 9	1927/V	ST	600
FINSLER, HANS	FABRIC	5/81	PNY	187	S	7 X 9	1931/V	ST	450
FINSLER, HANS	TEA SET	5/81	PNY	188	S	9 X 7	1920'S/V	ST,A/G-F	425
FINSLER, HANS	CIGARS	5/81	PNY	189	S	7 X 10	1927/V	D/E	BI
FINSLER, HANS	STUDY FOR A CHOCOLATE FACTORY AD	5/81	SNY	169	S	4 X 8	1930'S/V	/G	500
FINSLER, HANS	PORTRAIT: LASZLO MOHOLY-NAGY	5/81	SNY	170	S	3 X 2	1930'S/V	T/P	BI
FINSLER, HANS	FABRIC	11/80	PNY	29	S	9 X 7	C1931/V	S,ST	600
FINSLER, HANS	SARIZOL DENTIFRICE	11/80	PNY	28	S	9 X 6	C1930/V		350
FLAHERTY, ROBERT JOSEPH	ESKIMO TYPES (6 PRINTS)	11/80	CNY	167	PG	8 X 7	1930'S/V	PD,T	350
FLAHERTY, ROBERT JOSEPH	PORTFOLIO: ESKIMOS (12 PRINTS)	11/80	PNY	301	PG	7 X 9	1920-21/V	PD	950
FLECKENSTEIN, LOUIS	IN THE CONSERVATORY,... (3 PRINTS)	11/80	CNY	336	S	7 X 9	1905-20'S/V	ST,S,I	BI
FLECKENSTEIN, LOUIS	"NEW YORK CITY-NIGHT"	11/80	PNY	226	S	10 X 12	C1930/V	S,T	BI
FLEISCHMANN, TRUDE	1920'S NUDES (3 PRINTS)	5/81	SNY	539	S	VARIOUS	1924/V	S,I,ST	250
FLOWER & PLANT MOTIFS	2 VOLUMES, 254 PLATES	5/81	SNY	137	PP	VARIOUS	C1900/V	PD	175
FONTANA, FRANCO	LANDSCAPE WITH NUDE (ED. 30)	10/80	PT	233	CP	7 X 10	1977/V	S,D,A	260
FORD, CHARLES HENRI	STATUE OF A ROMAN EMPEROR	2/81	SLA	204	S	16 X 16	1954/V	S,D	300
FORD, CHARLES HENRI	WORKERS, PALM BEACH, FLORIDA	5/81	SNY	396	S	8 X 8	1940/V	A,D/F	250
FORTIER	PORCHE DE ST. GERMAIN L'AUXERROIS A P.	5/81	PNY	25	SA		1846/V	PD	BI
FOSTER, GAYLE A.	PARADE SHOWS	4/81	PNY	72	S	16 X 13	1948/V	S,T,ST	50
FOSTER, GAYLE A.	METROPOLITAN MOOD	5/81	PNY	99	S	13 X 10	C1937/V	ST	175
FRANK, ROBERT	"FROM THE BUS" (LINES P.101)	2/81	SLA	205	S	16 X 14	1950'S/L	S,T,ST	550
FRANK, ROBERT	RESTAURANT;RT.1, SC, (AMERICANS P.101)	2/81	SLA	206	S	9 X 13	1955/L	S,D,ST	1,000
FRANK, ROBERT	"YALE COMMENCEMENT" (AMERICANS P.53)	2/81	SLA	207	S	8 X 13	1956/L	S,T,D,ST	850
FRANK, ROBERT	"KINGSTON, N.Y., (PRAYING IN FIELD)"	2/81	SLA	208	S	9 X 13	1953/V	S,T,D	BI
FRANK, ROBERT	AMERICAN LANDSCAPE (MOBILE HOME)	2/81	SLA	209	S	9 X 13	1955/V	S,D	550
FRANK, ROBERT	"RESORT HOTEL, N.Y."	2/81	SLA	210	S	9 X 13	E. 1950'S/V	T,S	BI
FRANK, ROBERT	LONDON, 1951 (ST. CELLIST, LINES P.47)	2/81	SLA	211	S	13 X 9	1951/L	T,D,ST	650
FRANK, ROBERT	"PABLO"	2/81	SLA	212	S	8 X 12	1955/L	S,T,D,ST	500
FRANK, ROBERT	"PORTRAIT: ANNE HARVEY IN PARIS"	2/81	SLA	213	S	10 X 7	1961/V	S,T,D	BI
FRANK, ROBERT	HATS, PERU	4/81	PNY	23	S	9 X 14	1948/V	S,T,D,ST/G	750
FRANK, ROBERT	ST. LOUIS (LINES P. 10)	4/81	PNY	24	S	10 X 10	1948/V	S,T,D,ST	700
FRANK, ROBERT	VALENCIA,SPAIN (FAMILY LYING IN FIELD)	4/81	PNY	25	S	13 X 9	1950/V	S,T,D,ST	BI
FRANK, ROBERT	NEW YORK CITY (FRANK, P.77)	4/81	PNY	26	S	13 X 9	1955/1960'S	S,T,D	BI
FRANK, ROBERT	RANCH MARKET, HOLLYWOOD (AM. P.38)	4/81	PNY	27	S	8 X 12	1956/1968	S,T,D	BI
FRANK, ROBERT	CITY FATHERS - HOBOKEN, N.J.(AM. P.2)	5/81	CNY	159	S	14 X 19	1955/80	S,T,D/G	3,000
FRANK, ROBERT	NEW YORK CITY (AMERICANS P.12)	5/81	CNY	160	S	13 X 9	1955/79	S,T,D,ST/M	850
FRANK, ROBERT	POLITICAL RALLY, CHICAGO (AM. P.58)	5/81	CNY	161	S	12 X 7	1956/L	S,D,ST/M	4,500
FRANK, ROBERT	BLACKFOOT, IDAHO	5/81	CNY	162	S	9 X 13	1955/C60	S,D,ST/M	BI
FRANK, ROBERT	NEWBURGH, NEW YORK (AMERICANS, P. 40)	5/81	CNY	163	S	13 X 9	1955/79	S,D,ST/M	1,100
FRANK, ROBERT	ICE CREAM PARLOR, SAN FERNANDO VLY, CA	5/81	PNY	317	S	9 X 13	1950'/78	S,T,ST,D	BI
FRANK, ROBERT	LONG BEACH, CALIFORNIA	5/81	PNY	318	S	?	1956/80	S,D,ST,T	BI
FRANK, ROBERT	"INDIANAPOLIS" (AMERICANS P. 174)	5/81	SNY	472	S	9 X 13	1956/L	S,D,ST	950
FRANK, ROBERT	"LONDON" (CHILD RUNNING, FRANK P. 9)	5/81	SNY	473	S	9 X 13	1951/L	S,T,D/E	2,400
FRANK, ROBERT	"LONDON" (ROLLS ROYCE)	5/81	SNY	474	S	9 X 13	1950/L	S,T,D/P	700
FRANK, ROBERT	"LONDON" (JUMPING DOG)	5/81	SNY	475	S	8 X 12	1951/L	S,T,D,ST/G-E	700
FRANK, ROBERT	"RODEO, NEW YORK CITY"(AMER., P 40)	5/81	SNY	476	S	12 X 8	1955/L	S,D,I,ST/E	BI
FRANK, ROBERT	"NYC" (PARADE IN RAIN)	5/81	SNY	477	S	7 X 14	1961/L	S,T,D,ST/G	700
FRANK, ROBERT	"PROVINCETOWN" (BEACH, FLAG)	5/81	SNY	478	S	12 X 8	1962/L	S,T,ST/M	850
FRANK, ROBERT	"DAYTONA BEACH"	5/81	SNY	479	S	8 X 12	1961/L	S,T,D,ST/G	BI
FRANK, ROBERT	"BUTTE, MONTANA" (AMERICANS, P. 62)	5/81	SNY	480	S	9 X 13	1956/L	S,T,D,ST/P	BI
FRANK, ROBERT	"MOTORAMA, L.A." (AMERICANS P. 32)	5/81	SNY	481	S	8 X 12	1956/L	S,T,D,ST/G	BI
FRANK, ROBERT	"LONDON" (CHILD RUNNING; FRANK P. 9)	10/80	PT	216	S	10 X 15	1951/L	S,T,D	3,200

PHOTOGRAPHER	TITLE OR DESCRIPTION	DATE	AH	LOT#	PT	SIZE	N/P DATES	MARKS/COND.	PRICE
FRANK, ROBERT	"LONDON" (FRANK P. 11)	10/80	PT	217	S	12 X 18	1951/L	S,T,D	2,800
FRANK, ROBERT	"THE DAY BEFORE ARRIVING IN NEW YORK"	10/80	PT	218	S	5 X 8	1951/L	S,T,D	BI
FRANK, ROBERT	"LONDON" (CHILD RUNNING; FRANK P. 9)	11/80	CNY	504	S	12 X 18	1951/70'S	S,T,D	4,000
FRANK, ROBERT	"PARIS"	11/80	CNY	505	S	9 X 13	1951/76	S,T,D,A	BI
FRANK, ROBERT	"ELIZABETHVILLE, N.C." (AMER., P. 160)	11/80	CNY	506	S	19 X 13	1955/60'S	S,T,D,A,ST	BI
FRANK, ROBERT	"JACK (KEROUAC) IN NYC"	11/80	CNY	507	S	9 X 7	1962/V	S,T,D,ST	900
FRANK, ROBERT	POLITICAL RALLY, CHICAGO (AMER., P.58)	11/80	CNY	508	S	12 X 7	1956/L	S,D,ST	3,800
FRANK, ROBERT	"MOTORAMA, L.A." (AMER., P. 78-79)	11/80	CNY	509	S	8 X 13	1956/60'S	S,T,D,ST,A	BI
FRANK, ROBERT	"U.S. 285, NEW MEXICO" (AMER., P. 47)	11/80	CNY	509A	S	13 X 9	1956/77	S,D,ST,T	950
FRANK, ROBERT	CAR ACCIDENT-U.S. 66, FLAGSTAFF, ARIZ.	11/80	CNY	510	S	8 X 13	1970'S/V	S	BI
FRANK, ROBERT	"RESORT HOTEL, N.Y."	11/80	SNY	379	S	9 X 13	E. 1950'S/V	S,T	BI
FRANK, ROBERT	THREE WOMEN READING NEWSPAPERS	11/80	SNY	380	S	9 X 13	E. 1950'S/V		500
FRANK, ROBERT	"KINGSTON, NY" (PRAYING IN FIELD)	11/80	SNY	381	S	9 X 13	1953/V	S,T,D	BI
FRANK, ROBERT	A TURNPIKE DINER	11/80	SNY	382	S	7 X 12	1950'S/V		950
FRANK, ROBERT	"PALM SPRINGS" (BIKE-TAXI)	11/80	SNY	383	S	9 X 13	1956/V	S,T,D	700
FRANK, ROBERT	"BROOKLYN" (VIEW OF BRIDGE)	11/80	SNY	384	S	13 X 8	1954/V	S,T,D	700
FRANK, ROBERT	AMERICAN LANDSCAPE (MOBILE HOME)	11/80	SNY	385	S	9 X 13	1955/V	S,D	BI
FRANK, ROBERT	"CITY FATHERS-HOBOKEN, N.J."(AM., P.2)	11/80	SNY	386	S	9 X 14	1955/1973	S,T,D,I	1,400
FRANK, ROBERT	"PARADE-HOBOKEN, N.J."ERSEY., P. 13)	11/80	SNY	387	S	9 X 14	1955/1970'S	S,T,D,I	2,800
FRANK, ROBERT	"COVERED CAR, LONG BEACH" (AM., P. 47)	11/80	SNY	388	S	10 X 7	1956/1970'S	S,T,D,	2,100
FRANK, ROBERT	TROLLEY, NEW ORLEANS	11/80	SNY	389	S	12 X 20	1956/1977	S,I,T,D	4,500
FREEMAN, EMMA	"ANCIENT LAW"	5/81	SNY	134	S	14 X 11	1914/V	S,D/G	375
FRERES, BISSON	"MONT BLANC, LA CREVASSE"	2/81	SLA	57	A	14 X 9	1860'S/70'S	T,A	375
FRERES, BISSON	NOTRE DAME CATHEDRAL-REAR VIEW	11/80	SW	241	A	9 X 14	C1858/V	S,ST	300
FRERES, BISSON (ATT.TO)	SAINT-TROPHIME, THE WEST FACADE, ARLES	11/80	SNY	94	A	13 X 18	1860'S/V		BI
FREUND, GISELE	"AU PAYS DES VISAGES"(10 PR, ED:27/36)	5/81	SNY	237	DT	12 X 18	1939/L	S,ST,A	BI
FRIEDLANDER, LEE	FLOWERS (2 PHOTOS)	2/81	SLA	214	S	VARIOUS	1975/V	S,I,ST	300
FRIEDLANDER, LEE	FLOWERS (3 PHOTOS)	2/81	SLA	215	S	VARIOUS	1975/V	S,I,ST	450
FRIEDLANDER, LEE	"NEW YORK STATE"	10/80	PT	227	S	7 X 11	1966/V	S,ST	BI
FRIEDLANDER, LEE	SELF PORTRAIT	10/80	PT	228	S	9 X 6	C1968/V	S,ST	BI
FRIEDLANDER, LEE	"MEMPHIS, TENNESSEE"	10/80	PT	229	S	7 X 11	1973/V	S,ST	275
FRIEDLANDER, LEE	"ALBUQUERQUE"	11/80	CNY	626	S	7 X 10	1972/V	S,T,D,ST	280
FRIEDLANDER, LEE	PORTFOLIO: PHOTOS. OF FLOWERS (15 PR.)	11/80	SNY	514	S	9 X 13	1975/V	S,I,ST	3,500
FRIEDLANDER, LEE	PORTFOLIO: 15 PHOTOGRAPHS	11/80	SNY	515	S	VARIOUS	1973/V	S	3,000
FRIEDMAN, BENNO	UNTITLED (MONOPRINT)	5/81	PNY	331	S	16 X 20	1976/V	S,D	500
FRIEDMAN, BENNO	UNTITLED (MONOPRINT)	5/81	PNY	332	S	16 X 20	1976/V	S,D	BI
FRITH, FRANCIS	UPPER EGYPT... (2 VOL. 37 PL. EACH)	2/81	SLA	216	A	VARIOUS	1850'S/1860		700
FRITH, FRANCIS	"THE TEMPLE OF KOMUMBOO"	5/81	CNY	12	A	16 X 19	C1860/V	T/M	2,000
FRITH, FRANCIS	"THE PYRAMIDS OF SAKKARAH, FROM N.E."	5/81	CNY	13	A	15 X 19	C1860/V	IN,PD/F	BI
FRITH, FRANCIS	"MOUNT SERBAL, FROM THE WADEE FEYRAN"	5/81	CNY	14	A	15 X 19	C1860/V	IN,D,T/E	BI
FRITH, FRANCIS	CAIRO FROM THE CITADEL	5/81	PNY	54	A	16 X 19	C1860/V	T/E	BI
FRITH, FRANCIS	STREET VIEW IN CAIRO	5/81	PNY	55	A	19 X 16	C1860/V	IN,S,T/G	BI
FRITH, FRANCIS	"THE STATUES OF THE PLAIN, THEBES"	5/81	SNY	83	A	MAMMOTH	1858/V	PD/M	1,400
FRITH, FRANCIS	"THE 2ND PYRAMID OF GEEZEH"	5/81	SNY	84	A	MAMMOTH	1858/V	IN,PD/E	1,500
FRITH, FRANCIS	EGYPT & MIDDLE EAST (10 PRINTS)	10/80	PT	12	A	6 X 9	1857/1862	PD	400
FRITH, FRANCIS	"THE HYPAETHRAL TEMPLE, PHILAE"	11/80	CNY	18	A	15 X 19	C1860/V	PD	BI
FRITH, FRANCIS	"THE RAMESEUM OF EL-KURNEH, THEBES"	11/80	CNY	19	A	15 X 19	C1860/V	PD/E	3,500
FRITH, FRANCIS	"THE PYRAMIDS OF SAKKARAH, FROM N.E."	11/80	CNY	20	A	15 X 19	C1860/V	IN,PD/F	BI
FRITH, FRANCIS	"THE PYRAMIDS OF EL-GEEZEH, FROM S.W."	11/80	CNY	21	A	15 X 19	C1860/V	IN,PD/F	BI
FRITH, FRANCIS	SINAI AND PALESTINE (37 PRINTS)	11/80	CNY	22	A	6 X 9	1860/V	S,IN,PD	700
FRITH, FRANCIS	EGYPT AND PALESTINE (39 PRINTS)	11/80	CNY	23	A	6 X 9	C1860/V	S,IN	500
FUHRMANN, ERNST	LEAF AND BUG	11/80	PNY	89	S	9 X 7	C1930/V	A	BI
FUHRMANN, ERNST	PLANT STUDY	11/80	PNY	90	S	7 X 9	C1930/V	A	225
FUHRMANN, ERNST	PLANT STUDY	11/80	PNY	91	S	8 X 7	C1930/V	A	250
FUHRMANN, ERNST	WHEAT	11/80	PNY	92	S	9 X 7	C1930/V		BI
FUHRMANN, ERNST	CACTUS STUDY	11/80	PNY	93	S	7 X 9	C1930/V	A	160
FULTON, HAMISH	"HERMA NESS"	5/81	SNY	273	S	29 X 20	1978	T/M	1,500
FUNKE, JAROMIR	"SNOW SCENE"	11/80	PNY	127	PI	4 X 4	1922/V	S,D	BI
FUNKE, JAROMIR	"LIGHT ABSTRACTION"	11/80	PNY	128	S	7 X 5	1927-29/V		900
FUNKE, JAROMIR	"LIGHT ABSTRACTION"	11/80	PNY	129	S	12 X 9	1927-29/V		BI
FUNKE, JAROMIR	LANDSCAPE	5/81	PNY	158	PI	4 X 7	1922/V	S,D	700

PHOTOGRAPHER	TITLE OR DESCRIPTION	DATE	AH	LOT#	PT	SIZE	N/P DATES	MARKS/COND.	PRICE
FURUKAWA, AKIRA	"STRIKE BOUND"/TREE BRANCHES (2 PRNTS)	10/80	PT	142	B	VARIOUS	C1935/V	1=S,T,ST,2=X	280
FURUKAWA, AKIRA	RAILWORKERS	11/80	CNY	342	B	6 X 8	L1920'S/V	S,T	60
FURUKAWA, AKIRA	STUDY:PAINTERS FR. BELOW,...(3 PRINTS)	11/80	CNY	343	S	12 X 10	C1930/V		240
FURUKAWA, AKIRA	"TRANQUILITY"	11/80	PNY	233	B	11 X 8	1933/V	S,T,D	325
FURUKAWA, AKIRA	PAPER ROLLS	11/80	PNY	234	B	8 X 6	1927/V	I	300
GALLAGHER, BARRETT	PT BOAT, NORTH ATLANTIC, WWII	4/81	PNY	116	S	11 X 10	1944/V	S,D,ST	BI
GARDNER, A. (ATTRIB. TO)	POST MORTEMS (2 PRINTS)	11/80	CNY	123	A	3 X 4	1864/V		BI
GARDNER, A. (ATTRIB. TO)	BRADY'S PHOTO. H'QTRS., PETERSBURG	11/80	CNY	126	A	7 X 9	1865/V	ST	BI
GARDNER, ALEXANDER	PORTRAIT: OGLALA SIOUX	4/81	SW	335	A	6 X 4	1872/V		300
GARDNER, ALEXANDER	PORTRAIT: ABRAHAM LINCOLN (C.D.V.)	4/81	SW	488	A	2 X 4	C1865/V	ST	250
GARDNER, ALEXANDER	ABRAHAM LINCOLN, (COPY PRINT)	11/80	CNY	112	A	10 X 8	1865/80'S	PD	550
GARDNER, ALEXANDER	PRESIDENT LINCOLN, MCCLELLAN AND STAFF	11/80	CNY	113	A	3 X 4	1862/V	PD,ST	BI
GARDNER, ALEXANDER	HAREWOOD GENERAL HOSPITAL (3 PRINTS)	11/80	CNY	116	A	3 X 4	C1862/V		160
GARDNER, ALEXANDER	THE MONITOR	11/80	CNY	117	A	6 X 8	C1863/V		450
GARDNER, ALEXANDER	THE 93RD. REG., N.Y.,... (3 PRINTS)	11/80	CNY	118	A	7 X 9	1863/V		300
GARDNER, ALEXANDER	GENERAL JEFFERSON DAVIS & STAFF (3 P.)	11/80	CNY	119	A	VARIOUS	1863/V		300
GARDNER, ALEXANDER	GENERAL KIRKPATRICK & STAFF (3 PRINTS)	11/80	CNY	120	A	7 X 9	1863/V		380
GARDNER, ALEXANDER	MILITARY OFFICERS (3 PRINTS)	11/80	CNY	121	A	7 X 9	C1863/V		320
GARDNER, ALEXANDER	UNION SUPPLY DEPOT, WASH. (4 PRINTS)	11/80	CNY	124	A	7 X 9	C1863/V		160
GARDNER, ALEXANDER	SKETCH BOOK OF THE WAR (2 VOL;100 PR.)	11/80	SW	87	A	VARIOUS	1864/66	PD	12,500
GARDNER, JAMES	DUNKER CHURCH & THE DEAD...(2 PRINTS)	11/80	CNY	128	A	VARIOUS	1862/V		100
GARNETT, WILLIAM A.	"SAND DUNES, DEATH VALLEY, CALIFORNIA"	2/81	SLA	218	S	11 X 14	1954/L	S,T,D,ST	600
GARNETT, WILLIAM A.	"ANTICLINE & SAN JUAN RIVER GORGE..."	2/81	SLA	219	CP	9 X 14	1967/L	S,D,ST,T,I	BI
GARNETT, WILLIAM A.	"NUDE DUNE, DEATH VALLEY, CAL."	5/81	SNY	441	S	20 X 16	1954/L	S,T,D,ST/M	950
GARNETT, WILLIAM A.	"NUDE DUNE, DEATH VALLEY, CALIFORNIA"	11/80	SNY	446	S	14 X 10	1954/L	S,T,D,ST	700
GARNETT, WILLIAM A.	REFLECTION OF THE SUN, ILLINOIS FARM	11/80	CNY	592	S	16 X 20	1977/L	S,D,ST,I	650
GENTHE, ARNOLD	CHINATOWN, SAN FRANCISCO: 2 CHILDREN	2/81	SLA	220	S	13 X 9	1896-1906/V	S,I	300
GENTHE, ARNOLD	CHINATOWN, SAN FRANCISCO (5 PHOTOS)	2/81	SLA	221	S	VARIOUS	1896-1906/V	S,T,I	450
GENTHE, ARNOLD	CHINATOWN,... (5 STREET SCENES)	2/81	SLA	222	S	VARIOUS	1896-1906/V	S	375
GENTHE, ARNOLD	NUDE STUDY & PORTRAIT: BLANCH YURKA	2/81	SLA	223	S	VARIOUS	1930'S/V	PD	375
GENTHE, ARNOLD	PORTRAIT: ELEANORA DUSE	2/81	SLA	224	S	13 X 10	1924/V		700
GENTHE, ARNOLD	PORTRAIT: JULIA MARLOWE	2/81	SLA	225	S	9 X 7	1905/V	S,I,D	150
GENTHE, ARNOLD	PORTRAIT: IGNACE PADEREWSKI	2/81	SLA	227	S	14 X 10	E. 1900'S/V	I,S	500
GENTHE, ARNOLD	SELF PORTRAIT	2/81	SLA	228	S	9 X 7	C1935/V		400
GENTHE, ARNOLD	"LOAFERS YOUNG AND OLD"	4/81	SW	336	S	9 X 13	C 1905/V	S	550
GENTHE, ARNOLD	EDNA ST. VINCENT MILLAY: STUDY BY POND	4/81	SW	340	S	8 X 10	C1900'S.V	ST,A	400
GENTHE, ARNOLD	THEODORE ROOSEVELT	4/81	SW	341	S	8 X 10	C1900'S/V	ST,A	110
GENTHE, ARNOLD	SARA DELANO ROOSEVELT	4/81	SW	342	S	8 X 10	C1900'S/V	S,ST,A	100
GENTHE, ARNOLD	RUTH ST. DENIS (DRAPED IN FOUNTAIN)	4/81	SW	344	S	8 X 10	C1900'S/V	ST,A	325
GENTHE, ARNOLD	ELEANORA DUSE	5/81	CNY	64A	S	13 X 10	1924/V	S/E	500
GENTHE, ARNOLD	"ANNA PAVLOVA"	5/81	SNY	146	S	13 X 10	1914/V	S/M	750
GENTHE, ARNOLD	"ANNA DUNCAN"	5/81	SNY	147	S	13 X 10	1920'S/F	S,I,ST/F	1,100
GENTHE, ARNOLD	"GREEK DANCER"	5/81	SNY	536	S	13 X 10	1920'S/V	S,I,T	BI
GENTHE, ARNOLD	OLD CHINATOWN, TWO CHILDREN	11/80	CNY	251	S	10 X 8	C1900/V		BI
GENTHE, ARNOLD	PORTRAIT: S. A. CHANLER	11/80	CNY	252	S	10 X 7	C1913/V	S	100
GENTHE, ARNOLD	PORTRAIT: S. A. CHANLER	11/80	CNY	253	S	10 X 5	C1913/V	S	100
GENTHE, ARNOLD	PORTRAIT: S. A. CHANLER	11/80	CNY	254	S	10 X 7	C1913/V	S	100
GENTHE, ARNOLD	PORTRAIT OF A FISHERMAN	11/80	CNY	255	S	10 X 7	1920'S/V	S	BI
GENTHE, ARNOLD	"SAN FRANCISCO, APRIL 18TH 1906"	11/80	SNY	139	S	6 X 10	1906/V		1,800
GENTHE, ARNOLD	"SAN FRAN., EARTHQUAKE AND FIRE 1906"	11/80	SNY	140	S	6 X 10	1906/V		500
GENTHE, ARNOLD	"STEPS THAT LEAD TO NOWHERE"	11/80	SNY	141	S	7 X 9	1906/V		BI
GENTHE, ARNOLD	"PORTRAIT OF ISADORA DUNCAN"	11/80	SNY	144	S	13 X 9	C1916/V	S	450
GENTHE, ARNOLD	DRAPED TORSO	11/80	SNY	145	S	8 X 7	C1920/V	S,I	1,700
GENTHE, ARNOLD	PORTRAIT OF GRETA GARBO	11/80	SNY	145A	S	8 X 6	1920'S/V	S,I	1,000
GENTHE, ARNOLD	"METEORA MONASTERIES, THESSALY"	11/80	SW	293	S	10 X 13	C1930/V	S,T,I	250
GENTHE, ARNOLD	PORTRAIT: A LADY	11/80	SW	294	S	13 X 9	1935/V	S	80
GIACOMELLI, MARIO	"SCANNO"	2/81	SLA	229	S	12 X 16	1962/L	S,ST	650
GIBSON, RALPH	FROM "THE SOMNAMBULIST"	2/81	SLA	230	S	13 X 9	C1970/V	S,T	450
GIBSON, RALPH	NAVEL	5/81	PNY	329	S	8 X 13	1975/V	S,D	300
GIBSON, RALPH	MAN (HEAD PROFILE, CLOSE-UP)	5/81	PNY	330	S	13 X 8	1975/V	S,D	BI

PHOTOGRAPHER	TITLE OR DESCRIPTION	DATE	AH	LOT#	PT	SIZE	N/P DATES	MARKS/COND.	PRICE
GIBSON, RALPH	SHIRT FRONT (ED: 5/25)	5/81	SNY	509	S	13 X 8	1975/V	S,D,A/E	BI
GIBSON, RALPH	THE DOORMAN (ED: 2/25)	5/81	SNY	510	S	18 X 12	1975/V	S,D,A/E	500
GIBSON, RALPH	RECLINING NUDE (ED.24/25)	10/80	PT	245	S	6 X 9	1972/V	S,D,A	BI
GIBSON, RALPH	NAVEL (ED.19/25)	10/80	PT	246	S	12 X 18	1975/V	S,D,A	BI
GIBSON, RALPH	UNTITLED (ED: 25/25)	11/80	CNY	633	S	13 X 8	1975/V	S,D	BI
GIBSON, TOM	"LONDON, ENGLAND"	10/80	PT	225	S	7 X 11	1975/V	S,T,D	150
GIBSON, TOM	"MONTREAL, QUEBEC"	10/80	PT	226	S	7 X 11	1975/V	S,T,D	170
GIDAL, TIM N.	"STREET LAMP, BERLIN"	11/80	PNY	182	S	6 X 4	1929/V	S,T,D,ST	BI
GIDAL, TIM N.	DAMASCUS	5/81	PNY	206	S	10 X 7	1937/L	S,T,D	175
GIDAL, TIM N.	STREET CORNER	5/81	PNY	207	S	11 X 8	1930/L	S,T,D	200
GIGLI, ORMOND	WOMEN IN BLDG. WINDOWS W/ ROLLS ROYCE	5/81	CNY	203	S	14 X 14	1959/L	S,ST/E	420
GILES, WILLIAM	"SNOWY TREES, CONN." (ED: 10/50)	11/80	CNY	607	S	18 X 23	1973/V	S,T,D	400
GILES, WILLIAM	"NUDE BEACH, CA." (ED: 3/50)	11/80	CNY	608	S	18 X 23	1978/V	S,T,D	400
GILPIN, LAURA	"AMARYLLIS"	2/81	SLA	231	P	10 X 8	1930'S/V	S,T,I	BI
GILPIN, LAURA	IRENE YAZZIE, NAVAHO WEAVER	4/81	PNY	3	S	13 X 10	1951/V	S,D,ST	750
GILPIN, LAURA	NEW MEXICO SANTO	4/81	PNY	4	S	7 X 10	1954/V	S,D,ST	BI
GILPIN, LAURA	PORTRAIN: INDIAN	11/80	PNY	261	P	5 X 4	1924/V	S,D	BI
GILPIN, LAURA	"A DEVONSHIRE PATTERN"	11/80	PNY	262	P	4 X 5	1922/V	S,D	BI
GILPIN, LAURA	LILLIAN GISH IN CAMILLE, COLORADO	11/80	PNY	263	S	11 X 10	1932/V	S,D,ST	425
GILPIN, LAURA	"THE RIO GRANDE IN DROUGHT"	11/80	SNY	26	S	8 X 10	1946/V	S,D,T,I,ST	550
GILPIN, LAURA	"LITTLE MEDICINE MAN"	11/80	SNY	259	P	10 X 8	1932/V	S,D,ST	BI
GILPIN, LAURA	"SPRUCE TREE HOUSE, MESA VERDE"	11/80	SNY	260	P	10 X 8	1925/V	I,S,D,T,	850
GILPIN, LAURA	"THE RIO GRANDE YIELDS ITS SURPLUS..."	11/80	SNY	262	S	7 X 13	1947/V	S,D,ST	700
GILPIN, LAURA	"THE RIO GRANDE BEFORE A STORM"	11/80	SNY	263	S	13 X 10	1946/V	S,D,T,I	600
GILPIN, LAURA	"RIO CHAQUITO"	11/80	SNY	264	S	10 X 13	1945/V	S,D,T,I,ST	200
GILPIN, LAURA	"EYES OF THE FOREST"	11/80	SNY	265	S	13 X 10	1950/V	S,D,T,I	450
GILPIN, LAURA	"CHURCH OF SAN LORENZO, PICURIS, N.M."	11/80	SW	295	S	8 X 11	1962/V	ST	350
GILPIN, LAURA	"SIDE ALTAR IN TRAMPAS CHURCH"	11/80	SW	296	S	8 X 10	1960'S?/V	ST	BI
GILPIN, LAURA	"REREDOS. CRISTO REY CHURCH, N. MEX."	11/80	SW	297	S	8 X 10	1960'S?/V	ST	BI
GILPIN, LAURA	"SAN JOSE DE GRACIA, CHURCH @ ...N.M."	11/80	SW	298	S	8 X 10	1960'S?/V	ST	200
GOLDBECK, E.O.	INDOCTRINATION DIV. AIR TRAINING CMD.	4/81	PNY	117	S	16 X 14	1947/V	T	170
GOTTSCHO, SAMUEL	FISK BUILDING	5/81	PNY	92	S	11 X 8	1929/V	ST	BI
GOTTSCHO, SAMUEL	NEW YORK SKYLINE	5/81	PNY	93	S	14 X 17	1931/V	ST	BI
GOWIN, EMMET	ITALY	5/81	PNY	326	S	8 X 10	1973/76	S,T,D,A	250
GOWIN, EMMET	"DANVILLE, VIRGINIA"	10/80	PT	242	S	6 X 7	1968/V	T,D	BI
GOWIN, EMMET	"EDITH AT SCREEN, DANVILLE, VA."	10/80	PT	243	S	8 X 10	1971/V	S,T,D	260
GOWIN, EMMET	"ARTFUL GENEOLOGIES RENDER THEM,...VA"	10/80	PT	244	S	8 X 10	77/V	S,T,D	340
GOWIN, EMMET	"EDITH-DANVILLE, VIRGINIA"	11/80	CNY	636	S	8 X 10	1970/71	S,T,D	220
GRANGER, GERALD	SURREAL STILL LIFE	11/80	CNY	350A	S	16 X 16	C1935/V		BI
GRANGER, GERALD	POURING IRON	11/80	CNY	350B	S	14 X 10	1936/V	S,T,D,ST	BI
GRANGER, GERALD	STILL LIFE	11/80	CNY	350C	S	14 X 10	1930'S/V		160
GRANGER, GERALD	STILL LIFE WITH MATCHES	11/80	CNY	350D	S	10 X 8	C1940/V		BI
GREENE, ALBERT	STILL-LIFE (2 PRINTS)	4/81	PNY	75	S	19 X 15	1950'S/V	S	100
GREENE, ALBERT	LIGHTHOUSE & GOLD. GATE BR. (2 PRINTS)	4/81	PNY	76	S	VARIOUS	1950'S/V	S	350
GREENE, JOHN B.	FELUCCA ON THE NILE	5/81	SNY	96	SA	9 X 12	C1853/V	IN	BI
GREENE, MILTON H.	PORTRAIT: MARLENE DIETRICH	2/81	SLA	232	S	15 X 15	1952/L	S,D,ST	1,200
GREENE, MILTON H.	NELLIE NYAD IN BLACK HAT	2/81	SLA	233	S	16 X 20	1952/L	S,D,ST,A	1,600
GREENE, MILTON H.	MARILYN MONROE (IN BLACK: 1/2 LENGTH)	2/81	SLA	234	S	20 X 16	1953/1978	S,D,ST	600
GREENE, MILTON H.	MARILYN MONROE (IN BLACK, RECLINING)	2/81	SLA	235	S	16 X 20	1953/1979	S,D,ST	850
GREENE, MILTON H.		2/81	SLA	236	DT	14 X 14	1956/1978	S,D,ST	1,000
GREENE, MILTON H.	MARILYN MONROE (2 PORT. ON 1 SHEET)	2/81	SLA	237	DT	8 X 8	C1953/1979	S,D,ST	600
GREENE, MILTON H.	MARILYN MONROE (IN BLACK: 1/2/LENGTH)	4/81	PNY	39	S	20 X 16	1953/1979	S,D	400
GREENE, MILTON H.	MARILYN MONROE (1953)	4/81	PNY	40	S	16 X 20	1953/1980	S,D	BI
GREENE, MILTON H.	MARILYN MONROE (1953)	4/81	PNY	41	S	16 X 20	1953/1979	S,D	400
GREENE, MILTON H.	MARILYN MONROE (IN BLACK, 3 PRINTS)	5/81	CNY	205	S	20 X 16	C1953/78	S,D,ST	950
GREENE, MILTON H.	NELLIE NYAD IN BLACK HAT	5/81	SNY	493	S	16 X 19	1953/80	S,D,ST	1,100
GREENE, MILTON H.	MARILYN MONROE (IN BLACK, BUST)	5/81	SNY	494	S	20 X 16	1953/78	S,D,ST	BI
GREENE, MILTON H.	MARILYN MONROE (IN BLACK, RECLINING)	5/81	SNY	495	S	16 X 20	1953/79	S,D,ST	550
GREENE, MILTON H.	PORTRAIT MARILYN MONROE IN "BUS STOP"	5/81	SNY	496	DT	14 X 14	1956/78	S,D,ST	450
GREENE, MILTON H.	MARILYN MONROE (2 PORT. ON 1 SHEET)	5/81	SNY	497	DT	8 X 8	C1953/78	S,D,ST	400
GREENE, MILTON H.	MARILYN MONROE (ON FLOOR, IN BLACK)	5/81	SNY	498	S	16 X 20	1953/78	S,ST	BI

PHOTOGRAPHER	TITLE OR DESCRIPTION	DATE	AH	LOT#	PT	SIZE	N/P DATES	MARKS/COND.	PRICE
GREENE, MILTON H.	MARILYN MONROE SEATED (IN BLACK)	5/81	SNY	499	S	20 X 16	1953/78	S,ST	400
GREENE, MILTON H.	MARILYN MONROE (IN BLACK, RECLINING)	5/81	SNY	500	S	16 X 20	1953/79	S,ST	850
GREENE, MILTON H.	PORT: "MARILYN" (12 PRS., ED:101/250)	5/81	SNY	501	S	16 X 20	1950/70	S,A,ST	BI
GREENE, MILTON H.	MARILYN MONROE RECLINING	11/80	CNY	564	S	16 X 20	C1960/79	S,D,ST	BI
GREENE, MILTON H.	MARILYN MONROE (IN BLACK: 1/2/LENGTH)	11/80	CNY	565	S	20 X 16	C1953/79	S,D,ST	500
GREENE, MILTON H.	MARILYN MONROE	11/80	CNY	565A	S	20 X 16	C1953/79	S,D,ST	BI
GREENE, MILTON H.	MARILYN MONROE (IN BLACK, RECLINING)	11/80	SNY	350	S	16 X 20	1953/1978	S,D,ST	850
GREENE, MILTON H.	MARILYN MONROE SEATED (IN BLACK)	11/80	SNY	352	S	20 X 16	1953/1978	S,D,ST	800
GRUEN, JOHN	"STILL LIFE WITH GRATERS"	10/80	PT	257	S	17 X 14	C1976/V	S	BI
GUERINET,A.	TWO FLOWER STUDIES (2 PRINTS)	5/81	PNY	31	A	11 X 8	C1860'S/V	S/P	200
GUILLOT, LAURE ALBIN	TWO FEMALE NUDES	5/81	SNY	549	F	8 X 18	C1930/V	S/M	1,100
GUTCH, JOHN W.G.	ARCHITECTURAL STUDY	11/80	CNY	2	SA	6 X 8	1850'S/V		380
GUTEKUNST, FREDERICK	ADMIRAL PEARY	5/81	PNY	78	A	16 X 14	L. 1860'S/V	ST,PD/F	BI
GUTEKUNST, FREDERICK	DR. & LYDIA PARRISH/CHILDREN (2 PRS.)	11/80	CNY	99	SA	8 X 6	C1853/V		160
GUTEKUNST, FREDERICK	PHILADELPHIA AFTER THE FIRE	11/80	CNY	168	A	10 X 8	1870/V	ST,PD	480
GUTEKUNST, FREDERICK	PHILADELPHIA AFTER THE FIRE	11/80	CNY	169	A	10 X 8	1870/V	ST,PD	250
GUTMAN, JOHN	"THE FLEET IS IN, SAN FRANCISCO"	11/80	CNY	414	S	10 X 13	1934/80	S,T,D	BI
GUTMAN, JOHN	"UNEMPLOYED MEN WAITING IN LINE"	11/80	CNY	415	S	11 X 11	1934/80	S,T,D	BI
HAGEMEYER, JOHAN	PORTRAIT: DORNAN JEFFERS	11/80	PNY	259	P	9 X 7	1937/V	S,D,ST	300
HAGEMEYER, JOHAN	FLORAL STUDY	5/81	SNY	371	S	10 X 8	1932/V	S,D,T/G	650
HAHN, BETTY	"LIGHT BLUE MUM"	5/81	SNY	531	MP	20 X 16	1979/V	S,T,D	250
HAHN, BETTY	"BROWN CHRYSANTHEMUMS"	5/81	SNY	532	MP	16 X 20	1978/V	S,T,D	BI
HAJEK-HALKE, HEINZ	"DIE UBLE NACHREDE" (MULTIPLE NEG.)	5/81	SNY	585	S	14 X 12	1932/L	S,I	400
HAJEK-HALKE, HEINZ	"AKT"	5/81	SNY	586	S	14 X 9	1931/L	S,I	250
HAJEK-HALKE, HEINZ	VORSCHLAG... WERBEAUFNAHME (TORSO)	5/81	SNY	587	S	14 X 10	1935/L	S,I	BI
HAJEK-HALKE, HEINZ	"HEIMAT DR MATROSEN"	5/81	SNY	588	S	14 X 10	1931/L	S,I	200
HAJEK-HALKE, HEINZ	FEMALE NUDES SLEEPING	5/81	SNY	589	S	7 X 10	1930'S/L		BI
HALSMAN, PHILIPPE	PORTRAIT: MARILYN MONROE	2/81	SLA	238	S	13 X 8	1952/L	ST	1,000
HALSMAN, PHILIPPE	PORTRAIT: MARC CHAGALL	2/81	SLA	239	S	15 X 11	1935/V	ST	200
HALSMAN, PHILIPPE	PORTRAIT: WINSTON CHURCHILL	2/81	SLA	240	S	14 X 11	1951/V	S,ST	600
HALSMAN, PHILIPPE	CONTACT SHEET OF MARCEL MARCEAU	2/81	SLA	241	S	10 X 8	1957/V	ST	250
HALSMAN, PHILIPPE	ALBERT EINSTEIN (1954)	4/81	PNY	36	S	29 X 16	1954/70'S	S	900
HALSMAN, PHILIPPE	COCTEAU'S DREAM (1950'S)	4/81	PNY	37	S	11 X 14	1950'S/70'S	S,ST	BI
HALSMAN, PHILIPPE	MARILYN MONROE	4/81	PNY	38	S	14 X 8	C1952/V	ST	BI
HALSMAN, PHILIPPE	JANET LEIGH	5/81	CNY	206	S	20 X 16	C1960/V	S,ST/G	BI
HALSMAN, PHILIPPE	MARIAN ANDERSON	5/81	CNY	207	S	19 X 16	C1950/V	S,ST/G	BI
HALSMAN, PHILIPPE	MARILYN MONROE, HOLLYWOOD	5/81	CNY	208	S	14 X 11	1952/L	S,ST/G	750
HALSMAN, PHILIPPE	RUE DES RONIERS, A PROFESSIONAL	5/81	PNY	298	S	10 X 8	1933/V	S,T,D,ST	BI
HALSMAN, PHILIPPE	"DALI ATOMICUS"	5/81	SNY	397	S	10 X 13	1948/70'S	ST/M	750
HALSMAN, PHILIPPE	"DALI'S SKULL" + VARIANT (2 PRINTS)	5/81	SNY	398	S	13 X 10	1951/70'S	ST,T,D,S/M	850
HALSMAN, PHILIPPE	"HENRI MATISSE MAKING CUTOUTS IN BED"	5/81	SNY	399	S	13 X 11	1951/70'S	ST,T,D/G	400
HALSMAN, PHILIPPE	PORTRAIT: JOHN HUSTON	5/81	SNY	400	S	13 X 10	1960'S/V	S,I,ST/F	500
HALSMAN, PHILIPPE	MARILYN MONROE ON A LOS ANGELES STREET	5/81	SNY	401	S	10 X 4	C1952/V	ST,A/F	300
HALSMAN, PHILIPPE	"TRUE MARILYN"	5/81	SNY	402	S	11 X 13	1956/70'S	S,T,D,ST	450
HALSMAN, PHILIPPE	OP ART COMPOSITION (LEG)	5/81	SNY	403	S	23 X 17	1965/V	S,I,ST	BI
HALSMAN, PHILIPPE	JEAN COCTEAU	10/80	PT	178	S	14 X 11	C1950/70'S	ST	BI
HALSMAN, PHILIPPE	MARILYN MONROE WITH BARBELLS	10/80	PT	179	S	11 X 13	1952/70'S	ST	280
HALSMAN, PHILIPPE	DALI ATOMICUS	11/80	CNY	511	S	27 X 35	1948/72	S,I	BI
HALSMAN, PHILIPPE	MARTHA GRAHAM IN "DARK MEADOWS"	11/80	CNY	511A	S	13 X 11	1946/70'S	ST	BI
HALSMAN, PHILIPPE	JEAN COCTEAU	11/80	CNY	512A	S	14 X 11	C1949/V	S,ST	BI
HALSMAN, PHILIPPE	JEAN COCTEAU	11/80	CNY	512	S	3 X 3	1949/V	ST	400
HALSMAN, PHILIPPE	DALI SKULL	11/80	CNY	513	S	5 X 4	1951/V	ST	400
HALSMAN, PHILIPPE	INGRID BERGMAN	11/80	CNY	514A	S	20 X 16	1950'S/V	S,ST	300
HALSMAN, PHILIPPE	"MARILYN MONROE LIFTING BARBELLS"	11/80	CNY	514	S	11 X 14	1952/70'S	S,T,ST	380
HALSMAN, PHILIPPE	SOMERSET MAUGHAM	11/80	CNY	515	S	14 X 11	1953/70'S	ST	BI
HALSMAN, PHILIPPE	DANNY KAYE	11/80	CNY	516	S	14 X 11	1954/70'S	ST	BI
HALSMAN, PHILIPPE	WALTER GROPIUS	11/80	CNY	517	S	14 X 11	1958/70'S	ST	BI
HALSMAN, PHILIPPE	PETER SELLERS	11/80	CNY	518	S	14 X 11	1960'S/V	ST	BI
HALSMAN, PHILIPPE	DAVID MERRICK	11/80	CNY	519	S	14 X 11	1970'S/V	ST	BI
HALSMAN, PHILIPPE	"REFUGEE GIRL, PARIS"	11/80	PNY	300	S	12 X 9	1938/V	ST	325

PHOTOGRAPHER	TITLE OR DESCRIPTION	DATE	AH	LOT#	PT	SIZE	N/P DATES	MARKS/COND.	PRICE
HALSMAN, PHILIPPE	MARILYN MONROE ON A LOS ANGELES STREET	11/80	SNY	353	S	12 X 9	C1952/V	ST,I	900
HALSMAN, PHILIPPE	ADVERTISING MODELS AND ARTISTS	11/80	SNY	354	S	15 X 18	C1956/V	ST	450
HALSMAN, PHILIPPE	WINSTON CHURCHILL	11/80	SW	301	S	14 X 11	1951/C78	ST	BI
HALSMAN, PHILIPPE	ALFRED EISENSTADT (CLOSEUP PORTRAIT)	11/80	SW	302	S	14 X 11	1962/V	S,ST,T	BI
HALSMAN, PHILIPPE	MARTHA GRAHAM	11/80	SW	303	S	14 X 11	1946/70'S	ST,T	130
HALSMAN, PHILIPPE	ANDRE MALRAUX	11/80	SW	304	S	14 X 11	1966/V	ST,T	BI
HALSMAN, PHILIPPE	NELSON A. ROCKEFELLER (PORTRAIT)	11/80	SW	305	S	14 X 11	1963/V	T,ST	BI
HALSMAN, PHILIPPE	DAME EDITH SITWELL	11/80	SW	306	S	14 X 11	1958/70'S	T,ST	BI
HALSMAN, PHILIPPE	WEEGEE	11/80	SW	307	S	14 X 11	1945/70'S		BI
HAMMERSCHMIDT, WILLIAM	EGYPT (6 PRINTS)	10/80	PT	14	A	9 X 12	1870'S/V	SN	280
HANDY, LEVIN C.	GENERAL ULYS. S. GRANT (BRADY & CO.)	11/80	CNY	132	A	CABINET	C1866/V	PD,I	90
HARRINGTON, RICHARD	ESKIMO HOLDING ARC. FOX SKINS (ED.2/6)	10/80	PT	185	S	20 X 16	1951/79	S,T,D,ST,A	300
HARRINGTON, RICHARD	KALAUT WITH SEAL HE HAS SHOT (ED.2/5)	10/80	PT	186	S	20 X 16	1952/79	S,T,D,ST,A	260
HARRIS, EUGENE	PIPER (COVER: FAMILY OF MAN)	4/81	PNY	90	S	4 X 6	C1955/V		100
HARVEY, FRED	INDIANS AT SUNSET	11/80	CNY	166	S	13 X 15	1908/V	ST,D/E	400
HAUSMANN, RAOUL	LANDSCAPE OF SAND AND FOREST	11/80	PNY	102	S	2 X 3	1931/V	ST/E	BI
HAVILAND, PAUL	PORTRAIT: GLADYS GRANGER	5/81	SNY	150	P	10 X 8	1909/V	A/G	400
HAYNES, FRANK JAY	CASTLE GEYSER CONE	5/81	PNY	77	A	17 X 22	C1870'S/V	IN,T	400
HAYNES, FRANK JAY	YELLOWSTONE NAT. PARK (PORT. 12 PR.)	11/80	CNY	172A	A	9 X 7	C1880/V	ST,PD	250
HAYNES, FRANK JAY	"YELLOWSTONE NAT. PARK" (ALBUM 12 P.)	11/80	SNY	118		MAMMOTH	1880'S/V	IN,PD	500
HAYNES, FRANK JAY	"JEFFERSON CANYON, MONTANA"	11/80	SW	309	A	16 X 21	C1880/V		350
HEATH, VERNON	THE BRAVE OLD OAK, BERNHAM BEECHES	5/81	PNY	16	CN	23 X 28	C1880/V	T,ST/G	1,200
HEGGER, FRANK	THOMAS CARLYLE AT GRAIGENPUTTOCK	11/80	CNY	171	A	14 X 11	1874/V	ST,A	BI
HEIDERSBERGER, HEINRICH	INDUSTRIAL DESIGN	11/80	PNY	94	S	9 X 6	1930'S/V	ST	BI
HENLE, FRITZ	PIAZZA SAN MARCO, VENICE	5/81	SNY	255	S	12 X 10	1930/V	S,T,D,ST/G	BI
HENLE, FRITZ	FEMALE NUDE STUDY (SEATED ON ROCKS)	5/81	SNY	256	S	10 X 9	1940'S/V	S/M	450
HENLE, FRITZ	"VEILED NUDE ON ROCKY BEACH" (FEMALE)	5/81	SNY	257	S	12 X 11	1953/V	S,T,D,ST/E	BI
HENLE, FRITZ	FEMALE NUDE WITH CHAIR (TORSO)	5/81	SNY	258	S	13 X 11	1953/V	ST,S/E	BI
HENLE, FRITZ	"TORSO IN THE WINDOW"	5/81	SNY	570	S	8 X 8	1953/V	S,T,D	500
HENLE, FRITZ	"THE GRAVE OF TI, SAKKARA"	11/80	CNY	456	S	4 X 3	1931/V	S,T,D	300
HENLE, FRITZ	"STEELWORKS AT NIGHT"	11/80	CNY	457	S	3 X 5	1938/V	S,T	260
HENLE, FRITZ	"REED IN THE ICE"	11/80	PNY	95	S	3 X 5	1930'S/V	S,T	275
HENLE, FRITZ	RAINY DAY (CROWD WITH UMBRELLAS)	11/80	PNY	96	S	3 X 3	1930'S/V	S,T	475
HENLE, FRITZ	ROME (2 PHOTOS, STREET SCENES)	11/80	SNY	172	S	3 X 3	1930'S/V	S,T	BI
HENNING, ALBERT	FABRIC (ED.8/10	11/80	PNY	30	S	9 X 7	1933/78	S,D,A	BI
HENNING, ALBERT	"MAN ON LADDER" (ED.8/10)	11/80	PNY	31	S	6 X 9	1932/78	S,D,A	BI
HENRI, FLORENCE	"FEMME AUX JACINTHES"	2/81	SLA	244	S	9 X 7	1930/V	ST,I	1,200
HENRI, FLORENCE	"STILL LIFE COMPOSITON"	5/81	SNY	226	S	4 X 3	1931/V	S/G	500
HENRI, FLORENCE	"PORTRAIT COMPOSTION" (SELF)	5/81	SNY	227	S	5 X 3	1930/V	S/G	700
HENRI, FLORENCE	"ADVERTISING PHOTO, 'LA LUNE'"	5/81	SNY	228	S	7 X 5	1929/V	S,D,ST/G	450
HENRI, FLORENCE	"ISLE DE SEINE"	5/81	SNY	229	S	2 X 2	C1935/V	S,T/G	500
HENRI, FLORENCE	PORTRAIT: HANS ARP	5/81	SNY	230	S	5 X 4	1934/V	S/E	300
HENRI, FLORENCE	ROBERT DELAUNAY	5/81	SNY	231	S	5 X 4	1934/V	S/E	350
HENRI, FLORENCE	SWAN (2 PHOTOS)	11/80	SNY	180	S	4 X 3	1928/V	S,D,T	650
HENRI, FLORENCE	"STRUTTURA" (7 PHOTOS)	11/80	SNY	181	S	2 X 2	1937/V	S,T,D	5,250
HENRI, FLORENCE	"PORTRAIT DE FEMME"	11/80	SNY	182	S	4 X 3	1930/V	S	500
HERZEGH, ZOLTAN	FIGURE STUDY #2	11/80	CNY	350E	S	10 X 13	1930'S/V	S,T	180
HERZEGH, ZOLTAN	CLEVELAND, 1930	11/80	CNY	350F	S	13 X 10	1930/V	S,T,D	BI
HERZEGH, ZOLTAN	STUDY NO. 1 (MALE NUDE)	11/80	PNY	229	S	10 X 13	C1930/V	S,T	300
HERZEGH, ZOLTAN	"AN IMPRESSION"	5/81	PNY	245	S	9 X 13	1929/V	S,T	150
HERZEGH, ZOLTAN	TELEPHONE BUILDING (AT NIGHT)	5/81	PNY	244	S	13 X 9	C1938/V	S,T	200
HILL, DAVID & ADAMSON, R.	NEWHAVEN FISHERMEN'S WIVES	4/81	SW	349	C	6 X 7	C1844/V		650
HILL, DAVID & ADAMSON, R.	THOMAS, DUNCA, R.S.A, A.R.A	5/81	CNY	2	C	8 X 6	C1844/V	A	1,700
HILL, DAVID & ADAMSON, R.	ROBERT LISTON, M.D.	5/81	CNY	3	C	9 X 6	C1844/V	ST,A/E	1,300
HILL, DAVID & ADAMSON, R.	JEANIE WILSON, A NEWHAVEN FISHER LASS	5/81	CNY	4	C	8 X 6	C1844/V	/G	1,300
HILL, DAVID & ADAMSON, R.	STUDY OF A TREE, COLINTON WOODS	5/81	CNY	5	C	8 X 6	1847/V	/G	4,500
HILL, DAVID & ADAMSON, R.	KING FISHER, NEWHAVEN	5/81	PNY	1	C	8 X 6	C1845/V	S/F	325
HILL, DAVID & ADAMSON, R.	"DAVID ROBERTS"	10/80	PT	1	CA	8 X 6	1844/V		BI
HILL, DAVID & ADAMSON, R.	"ARCHITECTURAL STUDY"	10/80	PT	2	CA	5 X 8	C1845/V		BI
HILL, DAVID & ADAMSON, R.	FISHERFOLK COTTAGES, NEWHAVEN	11/80	CNY	5	C	6 X 8	C1844/V		BI
HILL, DAVID & ADAMSON, R.	NEWHAVEN FISHERMAN	11/80	CNY	6	C	6 X 5	C1844/V		BI

PHOTOGRAPHER	TITLE OR DESCRIPTION	DATE	AH	LOT#	PT	SIZE	N/P DATES	MARKS/COND.	PRICE
HILL, DAVID & ADAMSON, R.	DR. (ALEXANDER TERTIUS) MONRO	11/80	CNY	7	C	8 X 6	C1845/V	T	BI
HILLERS, JOHN K.	"SAN FRANCISCO MOUNTAINS"	2/81	SLA	247	S	13 X 10	1880'S/V	IN	175
HILLERS, JOHN K.	CANYON DE CHELLY, ARIZONA	2/81	SLA	248		10 X 13	1880'S/V	IN	200
HILLERS, JOHN K.	"WOMAN POLISHING POTTERY"	5/81	CNY	49	A	7 X 9	C1880/V	IN/M	320
HILLERS, JOHN K.	GRAND CANYON, COLORADO RIVER, ARIZONA	11/80	CNY	148	A	13 X 10	C1871/V	IN/E	1,700
HILLERS, JOHN K.	BULLION CREEK, UTAH	11/80	CNY	149	A	13 X 10	C1871/V	IN	400
HILLERS, JOHN K.	DOE RIVER GORGE, TENNESSEE	11/80	CNY	150	A	13 X 10	C1888/V	T,PD,ST	BI
HILLERS, JOHN K.	CAPTAIN OF THE CANYON (GLASS POSITIVE)	11/80	CNY	151		34 X 30	C1904/V	IN	BI
HILLERS, JOHN K. (ATT.TO)	"RUINS OF ANC. TOWER NR. FORT WINGATE"	11/80	SNY	119	A	10 X 13	1880'S/V	T,PD	150
HILLERS, JOHN K. (ATT.TO)	"RAPIDS OF THE YELLOW. ABOVE FALLS"	11/80	SNY	120	A	10 X 13	1880'S/V	IN,PD	200
HILLERS, JOHN K. (ATT.TO)	WESTERN LANDSCAPE	11/80	SNY	121	A	13 X 10	1880'S/V	PD	325
HINE, LEWIS W.	"MESSENGER BOY OF MACKAY TELEGRAPH CO"	4/81	SW	350	S	5 X 7	1900'S/V	A	425
HINE, LEWIS W.	ROW OF TENEMENTS, ELIZABETH ST, NYC	4/81	SW	351	S	5 X 7	1900'S/V	A	180
HINE, LEWIS W.	ANNIE MAIER MAKING PINAFORES IN BSMT	4/81	SW	352	S	5 X 7	1900'S/V	A	240
HINE, LEWIS W.	EAST SIDE MARKET, NEW YORK	5/81	PNY	88	S	11 X 14	1925/V	S,T,D	550
HINE, LEWIS W.	"LOOKING FOR HELP"	5/81	PNY	263	S	8 X 10	1918/V	T,D,A/F	150
HINE, LEWIS W.	CABINET WORK, SCHOOL FOR DEAF MUTES	5/81	PNY	264	S	5 X 7	1917/V	A,T/G	BI
HINE, LEWIS W.	OYSTER SHUCKERS, BILOXI, MISSISIPPI	10/80	PT	145	S	5 X 6	1911/V	IN	180
HINE, LEWIS W.	HOMES OF MILLS WORKERS, GEORGIA	10/80	PT	146	S	4 X 5	1913/V		BI
HINE, LEWIS W.	"NEWSBOYS" (NATIONAL CHILD LABOR COMM)	10/80	PT	147	S	5 X 7	C1911/V	A	320
HINE, LEWIS W.	"CHILDREN CARRYING GARMENTS"	10/80	PT	148	S	5 X 7	C1911/V	A	200
HINE, LEWIS W.	OYSTER SHUCKERS (NAT'L CHILD LBR COM)	10/80	PT	149	S	5 X 7	1911/V	ST,A	200
HINE, LEWIS W.	NEW ENGLAND FARMER	10/80	PT	150	S	5 X 7	1920/V	ST,T,D	200
HINE, LEWIS W.	FAMILY IN TENEMENT, NEW YORK CITY	11/80	CNY	367A	S	11 X 14	1910/1930'S		BI
HINE, LEWIS W.	SPINNER GIRL	11/80	CNY	367	S	11 X 14	C1910/30'S		600
HINE, LEWIS W.	LOOKING FOR LOST BAGGAGE, ELLIS ISLAND	11/80	CNY	368	S	18 X 13	1905/1930'S	ST	500
HINE, LEWIS W.	GLASSBLOWERS	11/80	CNY	369	S	5 X 7	C1910/V		150
HINE, LEWIS W.	INTERIOR OF MILL, FALL RIVER, MASS.	11/80	CNY	370	S	4 X 7	1912/V	D,ST,I	160
HINE, LEWIS W.	A LITTLE "SHAVER", IND. NEWSBOY	11/80	CNY	370A	S	7 X 5	1908/V	ST	BI
HINE, LEWIS W.	SCHOOL HOUSE, KENTUCKY	11/80	CNY	371	S	5 X 7	1930'S/V		100
HINE, LEWIS W.	MECHANIC AND MICROMETER	11/80	CNY	372	S	5 X 7	1920'S/V	ST	BI
HINE, LEWIS W.	"THE EMPIRE STATE BUILDING CONST."	11/80	PNY	294	S	14 X 11	1931/V		850
HINE, LEWIS W.	"MEN AT WORK"	11/80	PNY	295	S	7 X 5	C1931/V	ST	250
HINE, LEWIS W.	"SUMMER ON THE EAST SIDE"	11/80	SW	311	S	8 X 9	C1930/V	S,T	1,300
HINE, LEWIS W.	"SPINNER, WEST TEXAS"	11/80	SW	312	S	5 X 7	C1913/V	A/P	140
HIRO	PORTRAIT: ELIZABETH SCHWARTZKHOFF	11/80	SNY	503	S	10 X 10	1969/V	D,S,I	800
HIRSCHEL-PROTSCH, GUNTHER	OLYPISCHE MEISTERKAKTUS (FOTOMONTAGE)	11/80	PNY	1	S	5 X 3	1929/V	S,T,D	BI
HIRSEKORN, ALICE	PORTRAIT: ALMA HEDIN, BERLIN	11/80	PNY	1656	S	8 X 7	1926/V	T,D	BI
HOCKNEY, DAVID	"THE PINES, FIRE ISLAND" (ED:9/80)	2/81	SLA	249	CP	7 X 10	1973/76	S	325
HOCKNEY, DAVID	"STILL LIFE WITH HATS" (ED.9/80)	2/81	SLA	250	CP	9 X 7	1973/76	S	BI
HOCKNEY, DAVID	"SUR LE MOTIF" (ED.9/80)	2/81	SLA	251	CP	7 X 10	1974/76	S	375
HOCKNEY, DAVID	"MY PARENTS" (ED.9/80)	2/81	SLA	252	CP	10 X 7	1975/76	S	300
HOCKNEY, DAVID	"HOLLYWOOD WINDOW" (ED: 22/80)	5/81	SNY	511	CP	7 X 9	1973/76	S,A/F	225
HOCKNEY, DAVID	"ARLINGTON HOTEL, HOT SPRING, AK"	5/81	SNY	512	CP	7 X 5	1976/V	S,T,D,I/M	350
HOCKNEY, DAVID	HENRY AVOIDING THE SUN (ED.10/80)	11/80	CNY	609	CP	10 X 7	1975/V	S	350
HOCKNEY, DAVID	OCEAN AT MALIBU (ED: 35/80)	11/80	CNY	610	CP	7 X 9	1970'S/L	S	BI
HOCKNEY, DAVID	JEAN IN LUXEMBOURG GARDENS (ED: 35/80)	11/80	CNY	611	CP	10 X 7	1970'S/L	S	BI
HOCKNEY, DAVID	"PRETTY TULIPS"	11/80	SNY	486	CP	10 X 7	1973/V	I	500
HOCKNEY, DAVID	"HOLLYWOOD WINDOW"	11/80	SNY	487	CP	7 X 9	1973/V	I	150
HOCKNEY, DAVID	"JOHN ST. CLAIR SWIMMING"	11/80	SNY	488	CP	7 X 9	1973/V	I	650
HOCKNEY, DAVID	"PINK HOSE"	11/80	SNY	489	CP	7 X 9	1973/V	I	550
HOCKNEY, DAVID	"TIDIED UP BEACH"	11/80	SNY	490	CP	7 X 9	1973/V	I	400
HOEPFFNER, MARTA	"SITZENDER AKT"	5/81	SNY	559	S	9 X 7	1940/V	S,PD	150
HOEPFFNER, MARTA	"SITZENDER AKT"	5/81	SNY	560	S	15 X 11	1940/V	S,PD,ST	150
HOFER, EVELYN	"VIA PIGNOLO, BERGAMO, ITALY"	11/80	CNY	627	S	13 X 10	1977/V	S,D,T	BI
HOPPE, EMIL OTTO	NEW BABYLON (NEW YORK)	11/80	CNY	264	S	19 X 15	1928/V	T,D,ST	BI
HOPPE, EMIL OTTO	BALINESE GIRL	11/80	CNY	265	S	11 X 9	1932/V	S,ST,T,D	BI
HOPPE, EMIL OTTO	SELF PORTRAIT	5/81	CNY	109	S	10 X 10	1910/V	S,T,D/G	900
HOREIS, WILLIAM R.	"WATER PISTOL, LOS ANGELES"	2/81	SLA	253	CA	6 X 8	1968/1975	S,T,D,I,ST	100
HOREIS, WILLIAM R.	"D8 2805"	2/81	SLA	254	CA	4 X 8	1976/1979	S,T,D,I,ST	BI
HOREIS, WILLIAM R.	LATE AFTERNOON	5/81	PNY	338	CO	4 X 9	1979/V	S,T,D	300

PHOTOGRAPHER	TITLE OR DESCRIPTION	DATE	AH	LOT#	PT	SIZE	N/P DATES	MARKS/COND.	PRICE
HOREIS, WILLIAM R.	"PROGRAM"	10/80	PT	260	CA	5 X 7	1979/V	S,T,D	BI
HORST, HORST P.	THE EXHIBITION (FASHION)	4/81	PNY	173	S	11 X 14	1936/1970'S	S	BI
HORST, HORST P.	WHITE SLEEVE (ED: 50)	4/81	PNY	177	S	14 X 11	C1939/70'S	S	BI
HORST, HORST P.	PORTRAIT:CECIL BEATON AND MODELS	4/81	PNY	185	S	11 X 13	1946/V	ST	475
HORST, HORST P.	OYSTER BAY (2 MODELS) (ED: 50)	4/81	PNY	186	S	14 X 11	1948/1970'S	S	600
HORST, HORST P.	FEET (ED: 50)	5/81	PNY	293	S	14 X 11	1930'S/L	S	BI
HORST, HORST P.	BEAUTY (ED: 50)	5/81	PNY	294	S	14 X 11	1930'S/L	S	400
HORST, HORST P.	CORSET (ED: 50)	5/81	PNY	295	S	14 X 11	1939/L	S	550
HORST, HORST P.	TROMPE L'OEIL	5/81	SNY	388	S	14 X 10	C1937/L	/G	BI
HORST, HORST P.	ODALISQUE	5/81	SNY	389	S	10 X 8	1940'S/V	S/F	300
HORST, HORST P.	PORTRAIT: VALENTINA	5/81	SNY	390	S	13 X 11	C1940/70'S	S,T/F	300
HORST, HORST P.	ROBERT PIGUET FASHION MODEL	5/81	SNY	391	S	13 X 10	C1936/50'S	S/P	700
HORST, HORST P.	SEATED MALE NUDE	5/81	SNY	392	S	17 X 16	C1960/V	S	1,600
HORST, HORST P.	GABRIELLE 'COCO' CHANEL	10/80	PNY	119	S	9 X 6	1937/V	I	3,500
HOYNINGEN-HUENE, GEORGE	MISS EVELYN GRIEG, ROBE "LIFS BLANC"..	4/81	PNY	166	S	9 X 11	1931/V	T,D,ST	500
HOYNINGEN-HUENE, GEORGE	CARMEL SNOW	4/81	PNY	178	S	11 X 9	1939/V	ST	BI
HOYNINGEN-HUENE, GEORGE	SEATED MODEL, HEAVILY BACKLIGHTED	4/81	SW	354	S	9 X 7	1933/V	S,ST	200
HOYNINGEN-HUENE, GEORGE	PORTRAIT: INA CLAIRE	5/81	SNY	285	S	10 X 7	1932/V	S,D,I,ST/E	300
HOYNINGEN-HUENE, GEORGE	"LUCIAN LELONG '110' NOCTURNE..."	11/80	CNY	440	S	10 X 8	1932/V	PD,D	260
HOYNINGEN-HUENE, GEORGE	"MALE NUDE ON A PEDESTAL"	11/80	PNY	60		7 X 7	1930'S/V	S?	2,000
HOYNINGEN-HUENE, GEORGE	"COCTEAU"	11/80	SNY	833	S	10 X 8	1930'S/V	T,I	600
HOYNINGEN-HUENE, GEORGE	PORTRAIT: CECIL BEATON (FULL LENGTH)	11/80	SNY	835	S	10 X 7	1930/V	A,D	1,000
HOYNINGEN-HUENE, GEORGE	HORST AND BEATON	11/80	SNY	839	S	14 X 11	1947/V		600
HUGNET, GEORGES	PHOTO-COLLAGE	11/80	PNY	107	S	7 X 9	C1935/V	LETTER-AUTH.	1,300
HUGNET, GEORGES	PHOTO-COLLAGE	11/80	PNY	108	S	9 X 6	C1935/V	LETTER-AUTH.	BI
HUGO, LEOPOLD	"TREES AND CLIFFS" (VARIANT I)	11/80	SW	317	S	8 X 10	1920'S/V	ST	180
HUGO, LEOPOLD	"TREES AND CLIFFS" (VARIANT II)	11/80	SW	318	S	8 X 10	1920'S/V	S	325
HUGO, LEOPOLD	"TREES AND CLIFFS" (VARIANT III)	11/80	SW	319	S	10 X 8	1920'S/V	ST	160
HUGO, LEOPOLD	"STAND OF EUCALYPTUS"	11/80	SW	320	S	11 X 14	1920'S/V	S	260
HUJAR, PETER	PORTRAIT: CANDY DARLING	2/81	SLA	256	S	13 X 13	1973/V	S,T,D	400
HURRELL, GEORGE	RAMON NAVARRO	5/81	CNY	193	S	6 X 5	1930/V	S,D,ST,I/E	9,000
HURRELL, GEORGE	BETTE DAVIS (ED: 198/250)	5/81	CNY	194	S	19 X 16	1970'S/V	S,A	1,900
HURRELL, GEORGE	PORTRAIT: NORMA SHEARER	2/81	SLA	257	S	14 X 11	1949/V	S,D	650
HURRELL, GEORGE	PORTRAIT: GRETA GARBO & JOHN BARRYMORE	2/81	SLA	258	S	19 X 16	1928/1970'S	S	1,300
HURRELL, GEORGE	PORTRAIT: CLARK GABLE	2/81	SLA	259	S	19 X 16	1932/1970'S	S	BI
HURRELL, GEORGE	PORTRAIT: GARY COOPER	2/81	SLA	260	S	19 X 16	1937/1970'S	S	BI
HURRELL, GEORGE	POTRAIT: TYRONE POWER & LORETTA YOUNG	2/81	SLA	261	S	19 X 16	1937/1970'S	S	BI
HURRELL, GEORGE	PORTRAIT: RITA HAYWORTH	2/81	SLA	262	S	19 X 16	1941/1970'S	S	BI
HURRELL, GEORGE	PORTRAIT: JEAN HARLOW (ED: 250)	5/81	SNY	295	S	19 X 16	1934/70'S	S,A/M	900
HURRELL, GEORGE	PORTRAIT: MARLENE DIETRICH (ED: 250)	5/81	SNY	296	S	19 X 16	C1937/70'S	S,A/M	1,500
HURRELL, GEORGE	PORTRAIT: KATHERINE HEPBURN (ED: 250)	5/81	SNY	297	S	19 X 16	1941/70'S	S,A/M	400
HURRELL, GEORGE	"HURRELL" (10 PRINTS, ED: 250)	5/81	SNY	298	S	19 X 16	1920-40'S/L	S,A/M	3,500
HURRELL, GEORGE	BRA ADVERTISEMENT	5/81	SNY	299	S	10 X 12	1940'S/V	S/E	300
HURRELL, GEORGE	MARLENE DIETRICH (ED: 150/250)	11/80	CNY	468	S	15 X 19	C1930/70'S	S,A	1,500
HURRELL, GEORGE	JEAN HARLOWE (ED: 197/250)	11/80	CNY	469	S	19 X 16	C1931/70'S	S,A	1,200
HURRELL, GEORGE	JOHN BARRYMORE & GRETA GARBO/ED197/250	11/80	CNY	470	S	19 X 16	1928/70'S	S,A	1,100
HURRELL, GEORGE	PORTRAIT: CLARK GABLE	11/80	SNY	248	S	19 X 16	1932/1970'S	S	1,100
HURRELL, GEORGE	PORTRAIT: JOAN CRAWFORD	11/80	SNY	249	S	19 X 16	1932/1970'S	S	1,100
HURRELL, GEORGE	PORTRAIT: BETTE DAVIS	11/80	SNY	250	S	19 X 16	1938/1970'S	S	1,100
INCANDELA, GERALD	UNTITLED	11/80	CNY	639	S	24 X 20	1977/V	S,D	BI
INCANDELA, GERALD	OLD NEW YORK	11/80	SNY	516	MP	40 X 60	1978/V	S	2,800
INCANDELA, GERALD	"WIND"	2/81	SLA	263	S	16 X 11	1979/V	S,T,D	500
JACKSON, WILLIAM HENRY	"THE PORTALS-CANON OF THE GRAND RIVER"	2/81	SLA	264	A	MAMMOTH	1880'S/V	T,IN,PD	400
JACKSON, WILLIAM HENRY	"THE CANON OF THE MANCOS"	5/81	SNY	117	A	10 X 13	1874/V	SN,IN,PD/E	1,400
JACKSON, WILLIAM HENRY	"POPOCATEPETL-FROM TLAMACAS MEXICO"	5/81	SNY	118	A	MAMMOTH	1880'S/V	IN/E	1,200
JACKSON, WILLIAM HENRY	"THE CATHEDRAL OF MEXICO"	5/81	SNY	119	A	MAMMOTH	1880'S/V	IN/P	550
JACKSON, WILLIAM HENRY	"YELLOWSTONE LAKE"	11/80	SNY	116	A	10 X 13	C1871/V	IN	500
JACKSON, WILLIAM HENRY	"YELLOWSTONE FALLS"	11/80	SNY	117	A	13 X 10	C1871/V	IN	200
JACOBI, LOTTE	"HEAD OF A DANCER"	2/81	SLA	268	S	8 X 10	C1930/L	S,I	550

PHOTOGRAPHER	TITLE OR DESCRIPTION	DATE	AH	LOT#	PT	SIZE	N/P DATES	MARKS/COND.	PRICE
JACOBI, LOTTE	"PAULINE KONER, PHOTOMONTAGE"	2/81	SLA	269	S	7 X 10	C1937/L	S	350
JACOBI, LOTTE	"HAMBURG, GERMANY"	2/81	SLA	270	S	8 X 10	C1934/L	S	400
JACOBI, LOTTE	FARMWORKERS	2/81	SLA	271	S	4 X 6	1940'S/V	ST	BI
JACOBI, LOTTE	PORTRAIT: ALBERT EINSTEIN	2/81	SLA	272	S	9 X 7	C1938/L	S	800
JACOBI, LOTTE	PORTRAIT: LOTTE LENYA	2/81	SLA	273	S	8 X 9	C1938/L	S	400
JACOBI, LOTTE	PHOTOGENIC	4/81	PNY	56	S	10 X 8	1946-55/V	S	BI
JACOBI, LOTTE	PHOTOGENIC	4/81	PNY	57	S	10 X 8	1946-55/V	S	BI
JACOBI, LOTTE	MARC CHAGALL, NEW YORK (1942)	4/81	PNY	58	S	10 X 8	1942/L	S	BI
JACOBI, LOTTE	LIL DAGOVER, ACTRESS, BERLIN	4/81	PNY	165	S	10 X 8	C1930/L	S	300
JACOBI, LOTTE	PORTRAIT: ALBERT EINSTEIN	5/81	SNY	180	S	10 X 8	C1949/L	S/M	400
JACOBI, LOTTE	PORTRAIT: KARL VALENTIN & L. KARLSTADT	5/81	SNY	181	S	7 X 10	C1930/L	S/M	250
JACOBI, LOTTE	PORTRAIT OF KATHE KOLLWITZ	11/80	SNY	173	S	10 X 7	C1930/L	S	400
JACOBI, LOTTE	"PAULINE KONER"	11/80	SNY	174	S	7 X 10	C1937/L	S	400
JACOBI, LOTTE	PORTRAIT OF LOTTE LENYA	11/80	SNY	175	S	8 X 9	C1938/L	S	400
JACOBI, LOTTE	PORTRAIT OF ALBERT EINSTEIN	11/80	SNY	176	S	10 X 7	C1938/L	S	500
JACOBI, LOTTE	GREMLIN	11/80	SNY	177	S	11 X 8	C1949/L	S,ST	700
JACOBI, LOTTE	PORTRAIT OF MARIANNE MOORE	11/80	SNY	178	S	7 X 5	1958/V	S	200
JACQUE, RENE	SUITCASE ADVERTISEMENT	4/81	PNY	169	S	12 X 9	C1930'S/V	S	BI
JAHAN, PIERRE	LIBERATION	5/81	PNY	140	S	14 X 14	1945/V	S	BI
JAHAN, PIERRE	SENANQUE	5/81	PNY	141	S	12 X 12	1945/V	S,T,D,ST	BI
JAPAN	ALBUM: 50 HAND-COLORED PRINTS	10/80	PT	30	A	8 X 10	1890'S/V	IN	740
JAPAN	ALBUM: 48 PR ATTRIB. TO FARSARI PUB CO	11/80	CNY	95	A	8 X 9	1880'S/V	IN,PD	BI
JOFFE	MODELS (3 PRINTS)	4/81	PNY	164	S	VARIOUS	1930'S/V	S,ST	BI
JOHNSTON, FRANCES B.	"ENTERTAINING FRIENDS BY FIRE PLACE"	5/81	PNY	217	S?	8 X 10	1906/V	S/F	500
JONES, TONY RAY	PORTFOLIO: FIFTEEN PHOTOGRAPHS	10/80	PT	248A	S	8 X 5	1975/V	S,A,ST	BI
JONES, TONY RAY	PORTFOLIO:'41-'72 (15 PRINTS; ED: 125)	2/81	SLA	383	S	5 X 8	1941/72	ST,A	1,200
JONES, TONY RAY	"THE ENGLISH SEEN" (35 EXHIBITION PR.)	5/81	SNY	272	S	7 X 10	1968/V	/M	BI
KAHLEN, WOLF	"BODY HORIZONS"	5/81	SNY	595	S	13 X 11	1980/81	S,T,D,I	175
KAHLEN, WOLF	"BODY HORIZONS"	5/81	SNY	596	S	7 X 10	1980/81	S,T,D	200
KANAGA, CONSUELO	THE BROOKLYN BRIDGE	5/81	PNY	87	S	3 X 4	1924/L		250
KANAGA, CONSUELO	ALFRED STIEGLITZ, LAKE GEORGE, N.Y.	5/81	PNY	277	S	5 X 4	1936/V	S,T,D	300
KANAGA, CONSUELO	"CHILD IN TENNESSEE"	5/81	SNY	407	S	10 X 8	1948/V	S/E	800
KANAGA, CONSUELO	"THE BROOKLYN BRIDGE"	11/80	PNY	190	S	3 X 3	C1925/L		400
KARSH, YOUSUF	GEORGIA O'KEEFFE	2/81	SLA	274	S	20 X 16	1956/L	S,ST,T,D	1,100
KARSH, YOUSUF	PABLO PICASSO	2/81	SLA	275	S	20 X 16	1954/L	S,ST,T,D	1,400
KARSH, YOUSUF	SIR WINSTON CHURCHILL	2/81	SLA	276	S	28 X 21	1941/V	ST,PD	1,200
KARSH, YOUSUF	GEORGE BERNARD SHAW	2/81	SLA	277	S	13 X 10	1943/V	S,I,ST	900
KARSH, YOUSUF	JACQUES COUSTEAU	2/81	SLA	278	S	20 X 16	1972/L	S	BI
KARSH, YOUSUF	GEORGIA O'KEEFFE	5/81	CNY	155	S	24 X 20	1956/70'S	S,ST/M	1,500
KARSH, YOUSUF	WINSTON CHURCHILL	5/81	CNY	156	S	20 X 16	1941/70'S	S,ST	850
KARSH, YOUSUF	PABLO CASALS	5/81	CNY	157	S	20 X 16	1954/70'S	S,ST	1,100
KARSH, YOUSUF	HUMPHREY BOGART	5/81	SNY	483	S	20 X 16	1946/L	S,ST/M	700
KARSH, YOUSUF	ERNEST HEMINGWAY	5/81	SNY	484	S	20 X 16	1957/L	S,ST/M	500
KARSH, YOUSUF	RONALD REAGAN	5/81	SNY	485	S	16 X 18	1980/L	S,ST/M	400
KARSH, YOUSUF	GEORGE BERNARD SHAW	5/81	SNY	486	S	10 X 8	1943/V	S,I,ST/G	600
KARSH, YOUSUF	SIR WINSTON CHURCHILL	5/81	SNY	487	S	8 X 7	1941/L	IN,S,ST/M	450
KARSH, YOUSUF	GEORGIA O'KEEFFE	5/81	SNY	488	S	21 X 16	1956/L	S/G	1,200
KARSH, YOUSUF	WINSTON CHURCHILL	10/80	PT	183	S	11 X 16	1941/79	ST	900
KARSH, YOUSUF	GEORGIA O'KEEFFE	11/80	CNY	520	S	20 X 16	1956/70'S	S,ST	BI
KARSH, YOUSUF	WINSTON CHURCHILL	11/80	CNY	521	S	20 X 16	1941/70'S	S,ST	BI
KARSH, YOUSUF	ERNEST HEMINGWAY	11/80	CNY	522	S	20 X 16	1957/70'S	S,ST	BI
KARSH, YOUSUF	ALEXANDER CALDER	11/80	SNY	339	S	24 X 19	1950'S/V	S,I,PD	1,500
KARSH, YOUSUF	GEORGIA O'KEEFFE	11/80	SNY	340	S	19 X 16	1956/70'S	S,T,D,ST	2,000
KARSH, YOUSUF	PABLO PICASSO	11/80	SNY	341	S	20 X 16	1954/L	S,ST,D,T	1,000
KARSH, YOUSUF	MIRO	11/80	SNY	342	S	13 X 10	1965/70'S	S	500
KARSH, YOUSUF	SIRR WINSTON CHURCHILL	11/80	SNY	343	S	20 X 16	1941/L	S,ST,T,D	800
KARSH, YOUSUF	GEORGE BERNARD SHAW	11/80	SNY	344	S	9 X 7	1943/V	S,ST	500
KARSH, YOUSUF	JEAN SIBELIUS	11/80	SNY	345	S	13 X 10	1949/70'S	S	BI
KARSH, YOUSUF	PABLO CASALS	11/80	SNY	346	S	20 X 15	1954/70'S	S	950
KARSH, YOUSUF	EDWARD STEICHEN	11/80	SNY	347	S	20 X 16	1965/70'S	S	400

PHOTOGRAPHER	TITLE OR DESCRIPTION	DATE	AH	LOT#	PT	SIZE	N/P DATES	MARKS/COND.	PRICE
KARSH, YOUSUF	ERNEST HEMINGWAY	11/80	SNY	348	S	20 X 16	1957/70'S	S	700
KASEBIER, GERTRUDE	AUGUST RODIN IN HIS STUDIO	2/81	SLA	279	P	13 X 10	1905/V	S,ST	2,100
KASEBIER, GERTRUDE	PORTRAIT: JANE & CLARENCE WHITE	2/81	SLA	280	P	8 X 4	C1903/V		350
KASEBIER, GERTRUDE	PORTRAITS: LUCIAN S. KIRTLAND (3)	5/81	CNY	59		VARIOUS	C1912/V	S/G-E	BI
KASEBIER, GERTRUDE	BARON ADOLPH DE MEYER	5/81	PNY	221	P	8 X 6	1903/V	I	400
KASEBIER, GERTRUDE	PORTRAIT: GENTLEMAN SEATED WITH HAT	5/81	PNY	222	P	8 X 6	C1910/V	S	BI
KASEBIER, GERTRUDE	"THE MANGER" (CAMERA WORK, JAN. 1903)	5/81	PNY	237	PG		1903/V	/M	300
KASEBIER, GERTRUDE	"SILHOUETTE"	5/81	SNY	149	P	7 X 6	1900'S/V	S,T,A/E	900
KASEBIER, GERTRUDE	BARON DE MEYER	10/80	SNY	54	S	8 X 6	1903/V	S,D	850
KASEBIER, GERTRUDE	BARON DE MEYER	10/80	SNY	55	P	8 X 6	1903/V	I	200
KASEBIER, GERTRUDE	BARON DE MEYER	10/80	SNY	56	P	6 X 8	1903/V		650
KASEBIER, GERTRUDE	HAPPY DAYS	11/80	CNY	244	P	8 X 6	1902/V	/G	5,500
KASEBIER, GERTRUDE	AUGUSTE RODIN IN HIS STUDIO	11/80	CNY	244A	P	13 X 10	1906/V	S	1,500
KASEBIER, GERTRUDE	SELF PORTRAIT	11/80	CNY	244B	P	6 X 5	C1900/V		450
KASEBIER, GERTRUDE	MOTHER AND HER TWO CHILDREN	11/80	SNY	155	P	8 X 6	C1899/V	S	600
KASEBIER, GERTRUDE	GIRL AT THE DOOR	11/80	SNY	156	P	8 X 6	1904/V	S,D	650
KASEBIER, GERTRUDE	SELF PORTRAIT	11/80	SNY	157	P	8 X 6	C1905/V		1,100
KASEBIER, GERTRUDE	"THE YOUNG AUTOMOBILIST"	11/80	SNY	158	P	8 X 6	C1908/V		1,400
KASEBIER, GERTRUDE	CHILD WITH CUP	11/80	SNY	159	P	8 X 6	C1900/V	S	400
KEETMAN, PETER	PATIO	5/81	PNY	282	S	11 X 16	1950/V	S,D	300
KEETMAN, PETER	GLOVES	5/81	PNY	283	S	9 X 12	1958/V	S,D	BI
KELLOGG, A. L.	TWO QUAILS AND TWO RABBITS	11/80	CNY	337	S	13 X 11	1907/V	ST,S,I	300
KELLOGG, A. L.	TWO BIRDS	11/80	CNY	338	S	14 X 10	1907/V		300
KELLOGG, A. L.	GAME STUDY	5/81	PNY	218	P?	10 X 8	1907/V	S,D,T/E	200
KEPES, GYORGY	ABSTRACT COMPOSITION	11/80	SNY	476	S	14 X 11	1950/V	S,D,	800
KEPES, GYORGY	STILL LIFE	5/81	PNY	281	S	20 X 16	1946/L	S,D	BI
KERTESZ, ANDRE	"COUNTRY ACCIDENT"	2/81	SLA	281	S	8 X 10	1916/L	S	450
KERTESZ, ANDRE	"THE SWING"	2/81	SLA	282	S	10 X 8	1917/L	S	500
KERTESZ, ANDRE	"TRANSPORT"	2/81	SLA	283	S	7 X 10	1918/L	S	800
KERTESZ, ANDRE	ESZTERGOM, HUNGARY (UNDERWATER SWIM.)	2/81	SLA	284	S	9 X 14	1917/L	S,T,D	1,000
KERTESZ, ANDRE	"UNDERWATER SWIMMER" (ED:50)	2/81	SLA	285	S	10 X 8	1919/L	S	275
KERTESZ, ANDRE	WOMAN WITH WATER PAILS	2/81	SLA	286	S	8 X 10	1920'S/L	S	750
KERTESZ, ANDRE	"SATIRIC DANCER" (PARIS)	2/81	SLA	287	S	10 X 8	1926/L	S,T,D	1,600
KERTESZ, ANDRE	"TRIO"	2/81	SLA	288	S	7 X 10	1923/L	S	550
KERTESZ, ANDRE	"LOUIS TIHANYI"	2/81	SLA	289	S	10 X 7	1926/L	S	BI
KERTESZ, ANDRE	"CHEZ MONDRIAN" (PARIS)	2/81	SLA	290	S	14 X 10	1926/L	S,D,I	1,400
KERTESZ, ANDRE	MEUDON	2/81	SLA	291	S	10 X 8	1928/L	S	850
KERTESZ, ANDRE	"BROKEN PLATE"	2/81	SLA	292	S	8 X 10	1929/L	S	600
KERTESZ, ANDRE	"SIDEWALK"	2/81	SLA	293	S	10 X 8	1929/L	S	275
KERTESZ, ANDRE	"ERNEST"	2/81	SLA	294	S	14 X 11	1931/L	S,T,D	800
KERTESZ, ANDRE	CHAGALL AND HIS FAMILY	2/81	SLA	295	S	11 X 15	1933/L	S,D,	750
KERTESZ, ANDRE	"DISTORTION 40"	2/81	SLA	296	S	11 X 14	1933/L	S,T,D	700
KERTESZ, ANDRE	"MELANCHOLY TULIP" (NEW YORK)	2/81	SLA	297	S	10 X 7	1939/L	S,D	1,300
KERTESZ, ANDRE	"WASHINGTON SQUARE" (KERTESZ, P.81)	2/81	SLA	298	S	14 X 10	1954/L	S,D	1,300
KERTESZ, ANDRE	"MARTINIQUE"	2/81	SLA	299	S	8 X 10	1972/L	S,T,D	1,100
KERTESZ, ANDRE	WASHINGTON SQUARE, (WINTER NIGHT)	4/81	PNY	135	S	14 X 9	1954/1970'S	S,D	850
KERTESZ, ANDRE	"WASHINGTON SQUARE" (KERTESZ, P.181)	4/81	PNY	136	S	10 X 7	1954/1970'S	S,D	700
KERTESZ, ANDRE	FORK, PARIS,	4/81	SW	355	S	8 X 10	1928/L	S,D	800
KERTESZ, ANDRE	ROOFTOPS, PARIS	5/81	CNY	88	S	4 X 2	1927/V	S,D/M	BI
KERTESZ, ANDRE	STILL LIFE, CAT WITH MAQUETTE	5/81	CNY	89	S	8 X 6	1927/V	S,D/E	BI
KERTESZ, ANDRE	NEW YORK (ROOFTOPS & QUEENSBOROUGH BR)	5/81	CNY	90	S	14 X 11	1947/V	T,D,S,I/G	1,200
KERTESZ, ANDRE	WASHINGTON SQUARE (BARE TREES,SHADOWS)	5/81	CNY	91	S	10 X 8	1951/V	S,I,D,ST/F	850
KERTESZ, ANDRE	"SATIRIC DANCER" (PARIS)	5/81	CNY	92	S	14 X 12	1926/70'S	S,T,D/M	1,300
KERTESZ, ANDRE	PARIS	5/81	CNY	93	S	11 X 14	1929/70'S	S,T,D/M	750
KERTESZ, ANDRE	"MARTINIQUE"	5/81	CNY	94	S	11 X 14	1972/79	S,T,D/M	1,200
KERTESZ, ANDRE	HUNGARY (LANDSCAPE)	5/81	PNY	183	S	2 X 2	1916/V	S,D/E	1,400
KERTESZ, ANDRE	"AFTER THE BALL"	5/81	PNY	184	S	8 X 10	1926/L	S,T,D	BI
KERTESZ, ANDRE	"SATIRIC DANCER" (PARIS)	5/81	PNY	185	S	14 X 11	1926/70'S	S	BI
KERTESZ, ANDRE	CHEZ MONDRIAN, PARIS	5/81	PNY	186	S	14 X 10	1926/70'S	S,D	BI
KERTESZ, ANDRE	"HUNGARIAN LANDSCAPE, PUSZTA"	5/81	SNY	189	S	10 X 14	1914/C80	S,D/G	650
KERTESZ, ANDRE	"BUDAPEST" (THE LOVERS)	5/81	SNY	190	S	7 X 10	1915/L	S,T,D/G-E	BI

91

PHOTOGRAPHER	TITLE OR DESCRIPTION	DATE	AH	LOT#	PT	SIZE	N/P DATES	MARKS/COND.	PRICE
KERTESZ, ANDRE	"UNDERWATER SWIMMER" (ED: 100)	5/81	SNY	191	S	7 X 10	1917/L	S/F	550
KERTESZ, ANDRE	"BUDAFOK, HUNGARY" (ED: 100)	5/81	SNY	192	S	7 X 10	1919/C80	S/M	BI
KERTESZ, ANDRE	DUNA HARASZTI, HUNGARY (ED: 100)	5/81	SNY	193	S	8 X 10	C1920/C80	S/M	BI
KERTESZ, ANDRE	"TISZA-SZALKA, HUNGARY" (ED: 100)	5/81	SNY	194	S	8 X 10	1924/C80	S/M	650
KERTESZ, ANDRE	"A HUNGARIAN MEMORY"(15 PR, ED:82/100)	5/81	SNY	195	S		1914-21/80	S/M	BI
KERTESZ, ANDRE	"SATIRIC DANCER" (PARIS)	5/81	SNY	196	S	14 X 11	1926/L	S,D/M	1,300
KERTESZ, ANDRE	"ON THE QUAIS, PARIS"	5/81	SNY	197	S	9 X 8	1926/L	S,D/M	650
KERTESZ, ANDRE	"CHAIRS OF PARIS"	5/81	SNY	198	S	16 X 20	1927/L	S,D/M	1,200
KERTESZ, ANDRE	"RAILROAD STATION"	5/81	SNY	199	S	14 X 11	1936/L	S,D/M	700
KERTESZ, ANDRE	"MR. VAJDA"	5/81	SNY	200	S	3 X 3	1930'S/V	S,T,I/E	3,000
KERTESZ, ANDRE	"PUDDLE, SEPTEMBER 17, 1967, NEW YORK"	5/81	SNY	201	S	20 X 13	1967/L	S,D/M	900
KERTESZ, ANDRE	"MARTINIQUE" (ED: 50)	5/81	SNY	202	S	7 X 10	1972/L	S/M	1,100
KERTESZ, ANDRE	FERN STUDY	5/81	SNY	203	S	7 X 9	1930'S/V	ST/F	BI
KERTESZ, ANDRE	"MELANCHOLY TULIP" (NEW YORK)	5/81	SNY	204	S	14 X 10	1939/L	S,D/M	1,300
KERTESZ, ANDRE	ROND POINT OF THE CHAMPS ELYSEE	10/80	PT	106	S	9 X 7	1929/V	ST	1,000
KERTESZ, ANDRE	"PLACE DE LA CONCORDE ON A RAINY DAY"	10/80	PT	107	S	9 X 8	1928/V	ST,S	1,500
KERTESZ, ANDRE	"SATIRIC DANCER" (PARIS)	10/80	PT	108	S	10 X 8	1926/L	S,T,D	950
KERTESZ, ANDRE	CHEZ MONDRIAN, PARIS	10/80	PT	109	S	14 X 10	1926/L	S,T,D	1,500
KERTESZ, ANDRE	MONDRIAN'S GLASSES AND PIPE, PARIS	10/80	PT	110	S	8 X 10	1926/L	S,T,D	BI
KERTESZ, ANDRE	FORK, PARIS	10/80	PT	111	S	8 X 10	1928/L	S,D	700
KERTESZ, ANDRE	"MELONCHOLY TULIP" (NEW YORK)	10/80	PT	112	S	10 X 7	1939/L	S,D	850
KERTESZ, ANDRE	ETRUSEAN BRONZE MIRROR	10/80	PT	113	S	10 X 7	1940'S/V	ST	BI
KERTESZ, ANDRE	MARTINIQUE	10/80	PT	114	S	8 X 10	1972/L	S,T,D	800
KERTESZ, ANDRE	WINDOW DRESSING, PARIS	11/80	CNY	179	S	10 X 8	1925/1970'S	S,D	BI
KERTESZ, ANDRE	HUNGARIAN LANDSCAPE, PUSZTA	11/80	CNY	276	S	10 X 14	1914/1970'S	S,D	BI
KERTESZ, ANDRE	ESZTERGOM, HUNGARY	11/80	CNY	277	S	7 X 10	1917/1970'S	S,T,D	BI
KERTESZ, ANDRE	"CIRCUS" (BUDAPEST)	11/80	CNY	278	S	10 X 8	1920/C1969	S,T,D,ST	650
KERTESZ, ANDRE	"SATIRIC DANCER" (PARIS)	11/80	CNY	281	S	14 X 12	1926/1970'S	S,T,D	900
KERTESZ, ANDRE	ON THE QUAIS, PARIS	11/80	CNY	282	S	14 X 12	1926/1970'S	S,D	580
KERTESZ, ANDRE	MEUDON	11/80	CNY	283	S	14 X 10	1929/1970'S	S,D	900
KERTESZ, ANDRE	PARIS (FROM EIFFEL TOWER)	11/80	CNY	284	S	11 X 14	1929/1970'S	S,T,D	800
KERTESZ, ANDRE	PARIS (KERTESZ, P.100)	11/80	CNY	285	S	11 X 14	1929/1970'S	S,T,D	800
KERTESZ, ANDRE	CARREFOUR	11/80	CNY	286	S	8 X 10	1930/1970'S	S,T,D	700
KERTESZ, ANDRE	DISTORTION #40	11/80	CNY	287	S	11 X 14	1933/1970'S	S,T,D	BI
KERTESZ, ANDRE	DISTORTION #96	11/80	CNY	288	S	10 X 5	1933/1970'S	S,D	BI
KERTESZ, ANDRE	CHAGALL AND HIS FAMILY, PARIS	11/80	CNY	289	S	11 X 14	1933/1970'S	S,D	BI
KERTESZ, ANDRE	NEW YORK	11/80	CNY	290	S	14 X 11	1936/1970'S	S,D	700
KERTESZ, ANDRE	"MELANCHOLY TULIP" (NEW YORK)	11/80	CNY	291	S	14 X 10	1939/V	S,D	1,200
KERTESZ, ANDRE	"WASHINGTON SQARE" (KERTESZ, P.181)	11/80	CNY	292	S	10 X 8	1954/1970'S	S,D,A	700
KERTESZ, ANDRE	WASHINGTON SQUARE	11/80	CNY	293	S	14 X 9	1966/70'S	S,D	950
KERTESZ, ANDRE	MARTINIQUE	11/80	CNY	294	S	11 X 14	1972/1979	S,T,D	1,300
KERTESZ, ANDRE	EGG DISTORTION	11/80	PNY	42	S	9 X 7	1939/V	ST,S,D	BI
KERTESZ, ANDRE	STILL LIFE, PARIS	11/80	PNY	43	S	4 X 3	C1927/V	S,T,	2,600
KERTESZ, ANDRE	EPICERIE, PARIS	11/80	PNY	44	S	3 X 3	1928/V	S,D	BI
KERTESZ, ANDRE	PORTRAIT: SOLANGE	11/80	PNY	45	S	8 X 6	C1930/V	S,ST	BI
KERTESZ, ANDRE	LANDSCAPE, FRANCE	11/80	PNY	46	S	6 X 9	C1930/V	ST	BI
KERTESZ, ANDRE	WALKING IN THE RAIN	11/80	PNY	47	S	2 X 2	1923/V	S,D	1,500
KERTESZ, ANDRE	PARK SCENE, PARIS	11/80	PNY	48	S	2 X 2	1926/V		1,800
KERTESZ, ANDRE	JARDIN DE LUXEMBOUG, PARIS	11/80	PNY	49	S	7 X 9	C1930'S/V	ST	BI
KERTESZ, ANDRE	"VALENTINE HUGO'S APARTMENT"	11/80	PNY	50	S	7 X 9	C1927/V	ST	BI
KERTESZ, ANDRE	"DRUNK ON A BENCH"	11/80	PNY	51	S	7 X 9	PRE1936/V	ST	BI
KERTESZ, ANDRE	"SATIRIC DANCER" (PARIS)	11/80	PNY	52	S	14 X 11	1926/L	S,T,D	BI
KERTESZ, ANDRE	"RIPPLES, HUNGARY,MAY 11,1913" (ED:50)	11/80	SNY	188	S	7 X 7	1913/73	S	600
KERTESZ, ANDRE	"CIRCUS" (BUDAPEST)	11/80	SNY	189	S	14 X 11	1920/L	S,I	1,300
KERTESZ, ANDRE	"MONDRIAN'S GLASSES AND PIPE"	11/80	SNY	190	S	8 X 10	1926/L	S,I	1,100
KERTESZ, ANDRE	"SATIRIC DANCER" (PARIS)	11/80	SNY	191	S	20 X 16	1926/L	S,D	1,600
KERTESZ, ANDRE	"CHEZ MONDRIAN" (PARIS)	11/80	SNY	192	S	20 X 15	1926/L	S,D	2,000
KERTESZ, ANDRE	CLOCHARDS ON THE BANKS OF THE SEINE	11/80	SNY	193A	S	7 X 10	1930'S/V	ST	950
KERTESZ, ANDRE	"CHAIRS OF PARIS"	11/80	SNY	193	S	8 X 9	1927/L	S	900
KERTESZ, ANDRE	"BROKEN BENCH, NEW YORK 1962" (ED:50)	11/80	SNY	194	S	7 X 10	1962/L	S	600
KERTESZ, ANDRE	"PROMENADE, NEW YORK, 1962" (ED:50)	11/80	SNY	195	S	10 X 8	1962/L	S	600

PHOTOGRAPHER	TITLE OR DESCRIPTION	DATE	AH	LOT#	PT	SIZE	N/P DATES	MARKS/COND.	PRICE
KERTESZ, ANDRE	"MARTINIQUE"	11/80	SNY	196	S	11 X 14	1972/L	S,T,D	1,800
KERTESZ, ANDRE	"FORK" (PARIS)	11/80	SNY	197	S	8 X 9	1928/L	S,D	1,100
KERTESZ, ANDRE	"MEUDON"	11/80	SNY	198	S	14 X 10	1928/L	S,D	1,200
KERTESZ, ANDRE	FIRE LADDER, PARIS	11/80	SNY	199	S	9 X 6	1930'S/V	ST	900
KERTESZ, ANDRE	"CARREFOUR"	11/80	SNY	200	S	10 X 14	1930/L	S,D	750
KERTESZ, ANDRE	"ELIZABETH"	11/80	SNY	201	S	10 X 7	1931/L	S	BI
KERTESZ, ANDRE	"DISTORTION #6"	11/80	SNY	202	S	10 X 6	1933/L	S	600
KERTESZ, ANDRE	"MELANCHOLY TULIP" (NEW YORK)	11/80	SNY	203	S	14 X 10	1939/L	S,D	1,400
KERTESZ, ANDRE	DETAIL OF AN ANCIENT BRONZE VESSEL	11/80	SNY	204	S	10 X 8	E. 1940'S/V	ST	250
KERTESZ, ANDRE	"WASHINGTON SQUARE" (KERTESZ, P.181)	11/80	SNY	205	S	10 X 7	1954/L	S,D	850
KESTING, EDMUND	STILL LIFE	5/81	PNY	195	S	17 X 12	C1929/V	ST/F	BI
KESTING, EDMUND	PORTRAIT (MOTHER & CHILD)	5/81	PNY	196	S	6 X 6	C1929/V	ST	BI
KESTING, EDMUND	FEMALE NUDE, SEATED	11/80	PNY	74	S	16 X 11	1928/V		650
KESTING, EDMUND	ADVERTISING STUDY (HAND-COLORED)	11/80	PNY	75	S	13 X 17	1924/V	S	275
KING, B.A.	"TWO ROCKING CHAIRS"	10/80	PT	255	S	9 X 13	70'S/V	S	200
KLEIN, WILLIAM	"MUSEE GREVIN, PARIS"	2/81	SLA	300	S	14 X 17	1963/1980	S,T,D	200
KLEIN, WILLIAM	"PONTE ALEXANDRE III"	2/81	SLA	301	S	12 X 9	1958/1979	S,T,D	175
KLEIN, WILLIAM	"EXPO SURREALISTE"	2/81	SLA	302	S	10 X 14	1950'S/1979	S,T,D	125
KLEIN, WILLIAM	MARMES PONT ALEXANDRE III, PARIS	4/81	PNY	196	S	17 X 14	1959/1980	S,T,D	350
KLEIN, WILLIAM	MUSEE GREVIN, PARIS	4/81	PNY	197	S	14 X 17	1963/1980	S,T,D	BI
KLEIN, WILLIAM	PORTRAIT OF A FASHION MODEL	11/80	SNY	502	S	20 X 16	C1961/1967		1,100
KOCH, H.	SNOW SCENE	11/80	PNY	33	S	11 X 9	C1930'S/V	ST	350
KOLB BROS.	GRAND CANYON OF ARIZONA, EVENING...	2/81	SLA	303	PP	14 X 24	1912/V	D,T	200
KOUDELKA, JOSEF	MAN AND HORSES	5/81	PNY	178	S	9 X 14	/70'S	S	550
KOUDELKA, JOSEF	GYPSY CARAVAN	5/81	PNY	179	S	9 X 14	/70'S	S	BI
KOUDELKA, JOSEF	CHILDREN ON DONKEY	5/81	PNY	180	S	10 X 14	/70'S	S	BI
KRAUSE, GEORGE	GYPSY BOY, PHILDELPHIA	11/80	CNY	499	S	6 X 4	1960/74	S,D	BI
KRAUSE, GEORGE	HAND OF FATIMA, SPAIN	11/80	CNY	500	S	6 X 4	1964/79	S,D	240
KRAUSE, GEORGE	ST. JOHN THE BAPTIST	11/80	CNY	501	S	6 X 4	1968/V		240
KRAUSE, GEORGE	STREET PHOTOGRAPHE, SPAIN	11/80	CNY	502	S	5 X 7	1969/76	S,D	260
KRAUSE, GEORGE	MUMMER, PHILADELPHIA	11/80	CNY	503	S	6 X 4	1972/76	S,D	240
KRIMS, LES	PORTFOLIO:STACK O'WHEAT MURDERS(10 PR)	11/80	CNY	632	S	5 X 7	1971-74/V	S,D,ST	1,500
KROEHLE CH. & KUELNER	COLOMBIAN&PARAGUAYAN INDIANS(2 PRINTS)	11/80	CNY	91	A	7 X 9	C1895/V	IN	BI
KRULL, GERMAINE	FEMALE NUDE, SEATED	5/81	PNY	200	S	8 X 6	C1930/V	ST/G	BI
KRULL, GERMAINE	FEMALE NUDE, RECLINING	5/81	PNY	201	S	5 X 9	C1930/V	ST	BI
KRULL, GERMAINE	FEMALE HEAD STUDY	5/81	PNY	202	S	8 X 6	C1930/V	ST/P	BI
KRULL, GERMAINE	PROTRAIT: JEAN COCTEAU (ED: 12)	5/81	SNY	232	S	9 X 7	1930/76	S,D,I,ST/E	BI
KRULL, GERMAINE	PORTRAIT: ANDRE MALRAUX (ED: 25)	5/81	SNY	233	S	9 X 7	1930/76	S,D,ST/M	BI
KRULL, GERMAINE	"IN FRONT OF A LARGE DEPT. STORE"	5/81	SNY	234	S	7 X 6	1930'S/V	T,ST/F	BI
KRULL, GERMAINE	PARIS STREET SCENE	5/81	SNY	235	S	7 X 6	1930'S/V	ST/BI	BI
KRULL, GERMAINE	MANNEQUINS	5/81	SNY	236	S	7 X 6	1930'S/V	ST/G	BI
KRULL, GERMAINE	FEMALE NUDE STUDY	5/81	SNY	567	S	5 X 9	1940'S/V	ST/G	450
KRULL, GERMAINE	JEAN COCTEAU, PARIS	11/80	CNY	319	S	10 X 7	1930/1970'S	S,ST,A	BI
KRULL, GERMAINE	"RECLINING NUDE" (FEMALE)	11/80	PNY	2	S	5 X 9	C1930/V	ST	800
KRULL, GERMAINE	FEMALE NUDE (HAND BEHIND HEAD)	11/80	PNY	3	S	9 X 7	C1930/V	ST/E	900
KRULL, GERMAINE	NUDE STUDY	11/80	PNY	4	S	7 X 7	C1930/V	ST	750
KRULL, GERMAINE	PORTRAIT: STILL LIFE	11/80	PNY	5	S	9 X 7	C1930/V	ST	BI
KRULL, GERMAINE	"ELEVATOR SHAFT"	11/80	PNY	6	S	9 X 6	C1930/V	ST/E	BI
KRULL, GERMAINE	"CLOCHARD"	11/80	PNY	7	S	9 X 6	C1930/V	ST	BI
KRULL, GERMAINE	"MANNEQUIN AND REFLECTONS"	11/80	PNY	8	S	7 X 6	C1930/V	ST	425
KUHN, HEINRICH	STILL LIFE	11/80	CNY	243	PG	9 X 12	C1910/V		800
KUMLER, KIPTON	"WALL, CABO ST. VINCENTE"	2/81	SLA	304	S	16 X 20	1973/1980	S,T,D	400
KUMLER, KIPTON	"A PORTFOLIO OF PLANTS" 10 PR, ED:6/50	5/81	SNY	530	P	14 X 11	1970'S/V	S	BI
LANDWEBER, VICTOR	"WAX LIPS" (2 PHOTOS)	11/80	CNY	654	S	6 X 4	1978/V	S,T,D	45
LANGE, DOROTHEA	WALKING WOUNDED, OAKLAND, CA.	4/81	PNY	115	S	7 X 8	1954/V		BI
LANGE, DOROTHEA	"MIGRANT MOTHER, NIBOMO, CALIFORNIA"	5/81	CNY	143	S	13 X 11	1936/81	S,T,D,I	400
LANGE, DOROTHEA	"GRAYSON, SAN JOAQUIN VALLEY, CA."	5/81	SNY	303	S	10 X 12	1938/V	S,I,A/G	BI
LANGE, DOROTHEA	PORTRAIT: A WOMAN, SOUTH DAKOTA	10/80	PT	152	S	10 X 12	1939/V		200
LANGE, DOROTHEA	A SHARECROPPER LANDSCAPE	11/80	CNY	398	S	10 X 13	C1935/V	S	900
LANGE, DOROTHEA	MAN ENGAGED IN SELF HELP COOP. DAIRY	11/80	CNY	399	S	8 X 10	1930'S/V	I,ST	BI

PHOTOGRAPHER	TITLE OR DESCRIPTION	DATE	AH	LOT#	PT	SIZE	N/P DATES	MARKS/COND.	PRICE
LANGE, DOROTHEA	DITCHED, STALLED AND STRANDED,...	11/80	CNY	400	S	12 X 11	1935/C1966	ST	170
LANGE, DOROTHEA	MIGRANT MOTHER,...(PRINT BY ROTHSTEIN)	11/80	CNY	401	S	13 X 11	1936/1979	T,D	300
LANGE, DOROTHEA	EX-SLAVE & WIFE, GREEN COUNTY, GA	11/80	PNY	277	S	11 X 14	1937/V	ST,A	275
LANGE, DOROTHEA	"DROUGHT REFUGEES CAMPING, BLYTHE, CA"	11/80	PNY	278	S	11 X 11	1936/V	ST	300
LANGE, DOROTHEA	"KOREAN CHILD" (LETTER OF PROVENANCE)	11/80	SNY	303	S	13 X 11	1958/L		400
LANGE; DELANO; AND, POST	3 F.S.A. PHOTOS (WITH LABELS)	11/80	SNY	302	S	10 X 13	1930'S/V		350
LARTIGUE, JACQUES HENRI	"COUSINE SIMONEL ROUSSEL ..."	2/81	SLA	305	S	10 X 14	1906/L	S	700
LARTIGUE, JACQUES HENRI	"COUSIN BICHONADE IN FLIGHT"	2/81	SLA	306	S	10 X 13	1905/L	S	950
LARTIGUE, JACQUES HENRI	"RICO AND BOUBOUETTE"	2/81	SLA	307	S	9 X 13	E. 1900'S/L	S	450
LARTIGUE, JACQUES HENRI	"MOTHER'S FRIENDS AT ENTRETAT"	2/81	SLA	308	S	10 X 11	E. 1900'S/L	S	700
LARTIGUE, JACQUES HENRI	"READY FOR A DRIVE"	2/81	SLA	309	S	13 X 9	1912/L	S	650
LARTIGUE, JACQUES HENRI	"RACING CAR DRIVER, AUVERGNE"	2/81	SLA	310	S	10 X 10	1913/L	S	600
LARTIGUE, JACQUES HENRI	"TRY-OUTS OF THE NEW DIETRICH"	2/81	SLA	311	S	10 X 14	1905/L	S	700
LARTIGUE, JACQUES HENRI	"EXPERIMENTS WITH AEROPLANES ..."	2/81	SLA	312	S	7 X 14	C1912/L	S	1,100
LARTIGUE, JACQUES HENRI	ALONG THE BOIS DE BOULOGNE	4/81	PNY	151	S	14 X 10	C1906/L	S	600
LARTIGUE, JACQUES HENRI	LARTIGUE'S COUSIN SIMONE ROUSSEL	4/81	SW	356	S	10 X 14	1900'S/L	S	425
LARTIGUE, JACQUES HENRI	"THE BEACH AT VILLERVILLE"	4/81	SW	357	S	10 X 14	1900'S/L	S	425
LARTIGUE, JACQUES HENRI	"COUSIN BICHONADE IN FLIGHT"	5/81	PNY	126	S	10 X 13	1905/L	S/M	1,100
LARTIGUE, JACQUES HENRI	"CHANGING A TIRE"	5/81	PNY	127	S	10 X 14	1912/L	S/M	400
LARTIGUE, JACQUES HENRI	"THE DAY OF THE DRAG RACES AT AUTEUIL"	5/81	SNY	140	S	10 X 13	1910/L	S/M	900
LARTIGUE, JACQUES HENRI	DONKEY-DRAWN RACING CARTS	5/81	SNY	141	S	7 X 14	1900'S/L	S/M	BI
LARTIGUE, JACQUES HENRI	LADY WITH FUR MUFF	5/81	SNY	142	S	13 X 10	1900'S/L	S/M	450
LARTIGUE, JACQUES HENRI	"BIARRITZ"	5/81	SNY	143	S	14 X 10	1905/L	S/E	600
LARTIGUE, JACQUES HENRI	MAN AND BICYCLE-PLANE	5/81	SNY	144	S	10 X 11	1900'S/L	S/M	900
LARTIGUE, JACQUES HENRI	RENEE PERLE RECLINING	5/81	SNY	145	S	10 X 14	1930'S/L	S/F	300
LARTIGUE, JACQUES HENRI	"AUTEUIL"	10/80	PT	103	S	10 X 12	1912/70'S	S	400
LARTIGUE, JACQUES HENRI	"BIBI ON OUR HONEYMOON"	10/80	PT	104	S	14 X 11	1920/70'S	S	350
LARTIGUE, JACQUES HENRI	GROUP PORTRAIT	11/80	SNY	149	CP	7 X 8	E.1900'S/L	S	BI
LARTIGUE, JACQUES HENRI	PORTRAIT OF PABLO PICASSO	11/80	SNY	150	S	10 X 14	1950'S/L	S	BI
LARTIGUE, JACQUES HENRI	"EARLY ATTEMPT AT FLIGHT"	11/80	SW	332	S	12 X 16	1917/70'S	S	550
LARTIGUE/BRASSAI	23 PORTRAITS OF MARCEL VERTES (ARTIST)	11/80	SNY	407	S	9 X 12	1950'S/V	ST	650
LAUGHLIN, CLARENCE JOHN	CHAIR OF THE FALLING STAR	4/81	PNY	63	S	14 X 11	1940/V	S,D,T	325
LAUGHLIN, CLARENCE JOHN	THE SINISTER OLD LADY	4/81	PNY	64	S	13 X 11	1946/V	S,D,T	350
LAUGHLIN, CLARENCE JOHN	JACK-IN-THE-WALL	4/81	PNY	65	S	9 X 8	1955/V	S,D,T,ST	BI
LAUGHLIN, CLARENCE JOHN	"PASSAGE TO NEVER LAND"	5/81	SNY	408	S	11 X 13	1958/78	S,T,D,A,ST	600
LAUGHLIN, CLARENCE JOHN	"GRANDEUR THAT NEVER WAS"	5/81	SNY	409	S	10 X 8	1953/V	S,T,D,ST	300
LAUGHLIN, CLARENCE JOHN	"FIGURE WITH IRON FLAMES"	5/81	SNY	575	S	13 X 11	1940/V	S,T,D,ST	500
LAUGHLIN, CLARENCE JOHN	"THE EYE THAT NEVER SLEEPS"	5/81	SNY	576	S	13 X 9	1946/79	S,T,D	500
LAUGHLIN, CLARENCE JOHN	"THE SECRET OF THE HOUSE"	10/80	PT	205	S	14 X 11	1953/V	S,T,D	BI
LAUGHLIN, CLARENCE JOHN	"THE IRON SHELL"(OLD LA-STATE CAPITOL)	11/80	CNY	532	S	11 X 14	1949/L	S,T,D,ST	850
LAUGHLIN, CLARENCE JOHN	"THE PORTENT IN THE SHADOW"	11/80	CNY	532A	S	14 X 11	1954/V	S,T,D	400
LAUGHLIN, CLARENCE JOHN	"THE ENIGMA OF TRANSITION"	11/80	CNY	532B	S	14 X 11	1961/V	S,T,D,ST	280
LAUGHLIN, CLARENCE JOHN	"ANATOMY OF DISASTER"...	11/80	SNY	390	S	8 X 10	1952/V	S,T,D,ST	500
LAUGHLIN, CLARENCE JOHN	"FIGURE FROM THE UNDERWORLD"	11/80	SNY	391	S	10 X 8	1950/V	S,T,D,ST	300
LAUSCHMANN, JAN	"VORABEND"	11/80	PNY	144	S	11 X 15	1933/V	S,T,D	BI
LAUSCHMANN, JAN	"LIGHT AND SHADOW"	11/80	PNY	145	S	11 X 8	1924/V	S,T,D	BI
LE BLONDEL, A.	POST MORTEM: FATHER SITTING BY CHILD	5/81	CNY	25	D	5 X 7	C1849/V	S/M	15,000
LE GRAY, GUSTAVE	PAYSAGE AU MIDI	5/81	CNY	34	SA	8 X 13	1850'S/V	ST/F	700
LE GRAY, GUSTAVE	THE HARBOR AT SETE	5/81	CNY	35	A	11 X 16	1855/V	/E	6,000
LE GRAY, GUSTAVE	SEASCAPE AT SETE	5/81	CNY	36	A	12 X 16	C1855/V	/F	3,200
LE GRAY, GUSTAVE	SEASCAPE WITH SHIP	5/81	SNY	97	A	12 X 6	C1856/V	ST/F-P	1,500
LE GRAY, GUSTAVE	PORTRAIT: NAPOLEON III	5/81	SNY	98	SA	8 X 6	1862-64/V	ST/E	4,200
LE GRAY, GUSTAVE	BAINS DUMONT	11/80	CNY	57	A	10 X 15	1850'S/V		4,000
LEE, RUSSELL	"MRS. GLENN COOK AND BABY"	5/81	SNY	301	S	10 X 7	1930'S/V	ST,T,A/P	300
LEE, RUSSELL	"OKLAHOMA TENANT FARM FAMILY @ DINNER"	5/81	SNY	302	S	7 X 10	1930'S/V	ST,T/F	250
LEE, RUSSELL	"AT THE COMMUNITY SING, PIE TOWN, NM"	11/80	PNY	279	S	10 X 14	1940/V	ST,A	BI
LEE, RUSSELL	"COMMUNITY CAMP, OKLAHOMA CITY, OKLA."	11/80	PNY	280	S	14 X 10	1939/V	ST	200
LEE, RUSSELL	"THE HANDS OF MRS. OSTERMEYER, IOWA"	11/80	PNY	281	S	10 X 8	C1936/V		300
LEITER, SAUL	"KATHY AND GLORIA"	11/80	CNY	475	S	11 X 10	1948/V	S,T,D	600
LEITER, SAUL	"HALLOWEEN"	11/80	CNY	476	S	13 X 9	1948/V	S,T,D	380
LEMARE, JACQUES	NUDE WITH LADDER	11/80	PNY	115	S	11 X 8	1933/V	ST	350

PHOTOGRAPHER	TITLE OR DESCRIPTION	DATE	AH	LOT#	PT	SIZE	N/P DATES	MARKS/COND.	PRICE
LERNER, NATHAN	"THE SWIMMER"	11/80	CNY	473	S	12 X 8	1935/V	S,T,D	BI
LERNER, NATHAN	"DOLLS"	5/81	PNY	279	S	9 X 10	1936/L	S,T,D	BI
LERNER, NATHAN	"LIGHT BOX EXPERIMENT"	5/81	PNY	280	S	13 X 18	1938/L	S,T,D	BI
LETELLIER, E.	PORTAIL DE CANDEBEC	5/81	PNY	27	A	19 X 15	1869/V	S,T,D,ST	150
LEVICK, EDWIN	SCENES OF N.Y. (TRANSP.) (4 PRINTS)	5/81	PNY	81	S	VARIOUS	1900'S/V	ST	150
LEVICK, EDWIN	SCENES OF N.Y. (AIRPLANES) (4 PRINTS)	5/81	PNY	82	S	6 X 8	1900'S/V	ST	100
LEVICK, EDWIN	SCENES OF N.Y. (WORKERS) (4 PRINTS)	5/81	PNY	83	S	6 X 8	1900'S/V	ST	100
LEVICK, EDWIN	TIMES SQUARE (2 PHOTOS)/NY SKYLINE (1)	11/80	SW	347	S	8 X 10	C1930'S/V	ST	280
LEVICK, EDWIN	VARIOUS SHIPS AND BOATS (3 PHOTOS)	11/80	SW	348	S	8 X 10	C1930'S/V	ST	280
LEYDA, JAY	PORTRAIT: WALKER EVANS	5/81	SNY	305	S	5 X 4	1934/V	S,D/E	BI
LINCOLN, EDWIN HALE	SPREADING DOGBANE (PLANT STUDY)	5/81	PNY	219	P	9 X 7	C1915/V	/E	125
LINCOLN, EDWIN HALE	"WILD FLOWERS IN NEW ENGLAND" (50 PR.)	5/81	SNY	163	P	9 X 7	1904-14/V	PD/M	1,500
LIVICK, STEPHEN	UNTITLED (ED. 6)	10/80	PT	264	CA	18 X 23	1979/V	S,D,A	200
LIVICK, STEPHEN	FERRIS WHEEL	2/81	SLA	313	S	14 X 19	1976/V	S,I,D	400
LIVICK, STEPHEN	STREET SIGN	2/81	SLA	314	S	13 X 19	1976/V	S,I.D	100
LOCHERER, ALOIS (ATT.TO)	PORTRAIT	5/81	PNY	47	SA	7 X 5	C1853/V		BI
LONGWELL, LANGDON H.	MONDAY, WASHDAY & BOATS (2 PRINTS)	11/80	CNY	345	S	7 X 10	1928-30/V	S,T,D,ST	BI
LONGWELL, LANGDON H.	CHURCH YARD	11/80	PNY	236	S	10 X 5	1930'S/V	S,T	275
LOUISE, RUTH HARRIET	PORTRAIT: GRETA GARBO	11/80	SNY	246	S	12 X 9	C1928/V	I,ST	750
LOVING, DON	AQUATIC ARCS	11/80	CNY	349	S	11 X 9	1930'S/V	S,T,I	BI
LOVING, DON	FUGUE (NUDE)	11/80	CNY	350	S	11 X 8	1930'S/V	S,T	320
LUKAS, JAN	ANTI-COMMUNIST MANIFESTATION, PRAGUE	4/81	PNY	125	S	11 X 14	1948/V	S,T,D,ST	BI
LUKAS, JAN	CITIZENS WATCHING FUNERAL CORTEGE...	4/81	PNY	126	S	11 X 12	1948/V	S,T,D,ST	BI
LUKAS, JAN	JEWISH GIRL ON HER WAY TO CONC. CAMP	4/81	SNY	127	S	14 X 11	1942/V	S,T,D,ST	300
LUKAS, JAN	34TH ST., NEW YORK CITY	5/81	PNY	174	S	13 X 9	1964/V	S,T,ST/F	BI
LUKAS, JAN	SUBWAY EXIT-BROADWAY @ WALL ST., NYC	5/81	PNY	175	S	14 X 9	1964/V	S,T,ST	300
LUKAS, JAN	DAS NEUGEBORENE	5/81	PNY	176	S	9 X 9	1947/L	S,T,D	300
LUKAS, JAN	MAN STANDING	5/81	PNY	177	S	9 X 13	1950/L	S,D,A	BI
LUKAS, JAN	"THE BALL"	11/80	PNY	154	S	9 X 7	C1936/V	ST	BI
LUKAS, JAN	"FACE BEHIND A MAGNIFYING LENSE"	11/80	PNY	155	S	7 X 5	C1930/V	ST	150
LUKAS, JAN	"ACCORDIAN PLAYER"	11/80	PNY	156	S	11 X 9	C1936/V	S	BI
LUKAS, JAN	LEGS AND WATER	11/80	PNY	157	S	11 X 9	C1930/V	ST	100
LUMMIS, CHARLES FLETCHER	SELF-PORTRAIT, ON HORSEBACK (CYANOTYPE)	5/81	SNY	122		4 X 4	1890'S/V	/F	500
LYNES, GEORGE PLATT	PORTRAIT: RALPH POMEROY	2/81	SLA	315	S	9 X 8	1940'S/V	ST	250
LYNES, GEORGE PLATT	PORTRAIT: RALPH POMEROY	2/81	SLA	316	S	9 X 7	1940'S/V	ST	250
LYNES, GEORGE PLATT	"BUDDY"	2/81	SLA	317	S	9 X 7	1940'S/V	ST	250
LYNES, GEORGE PLATT	PORTRAIT: THE DANCER FRANCISCO MONCION	2/81	SLA	318	S	10 X 8	1950'S/V	ST	125
LYNES, GEORGE PLATT	PORTRAIT: DANILOVA	2/81	SLA	319	S	10 X 8	1940'S/V	ST	300
LYNES, GEORGE PLATT	CARLOS MC CLENDON, NUDE STUDY	4/81	PNY	47	S	9 X 8	1947/V	ST,T,D	1,200
LYNES, GEORGE PLATT	MALE NUDE WEARING STRAW HAT	4/81	PNY	48	S	9 X 7	C1940/V	ST	500
LYNES, GEORGE PLATT	MALE NUDE ON A SWING	4/81	PNY	49	S	9 X 7	C1940/V	ST	500
LYNES, GEORGE PLATT	P. TCHELITCHEW AND J. TICHENOR	4/81	PNY	50	S	7 X 8	C1940/V	ST	750
LYNES, GEORGE PLATT	P. CADMUS, G. TOOKER AND J. FRENCH	4/81	PNY	51	S	9 X 7	C1940/V	ST	400
LYNES, GEORGE PLATT	FASHION MODEL, VOGUE STUDIO	4/81	PNY	181	S	10 X 8	1940'S/V		BI
LYNES, GEORGE PLATT	2 NUDE STUDIES OF YUL BRYNER	5/81	CNY	146	S	9 X 7	1942/V	ST/E	1,000
LYNES, GEORGE PLATT	STANDING MALE NUDE	5/81	CNY	147	S	10 X 8	1930'S/V	ST/M	BI
LYNES, GEORGE PLATT	TWO MEN, WOUNDED (NUDES)	5/81	CNY	148	S	10 X 8	1930'S/V	/G	480
LYNES, GEORGE PLATT	MALE NUDE	5/81	CNY	149	S	9 X 8	C1940/V	ST/G	700
LYNES, GEORGE PLATT	TWO MALE NUDES	5/81	PNY	290	S	8 X 10	C1940/V	ST	800
LYNES, GEORGE PLATT	W.H. AUDEN	5/81	PNY	291	S	9 X 8	1947/V	ST,T,D	BI
LYNES, GEORGE PLATT	GEORGE TOOKER	5/81	PNY	292	S	9 X 8	C1948/V	ST,D,T	400
LYNES, GEORGE PLATT	CHRISTOPHER ISHERWOOD (WITH MALE NUDE)	5/81	SNY	394	S	9 X 5	1940'S-50/V	T,A	450
LYNES, GEORGE PLATT	"RALPH POMEROY NO. 1"	5/81	SNY	395	S	9 X 8	C1951/V	ST,T	250
LYNES, GEORGE PLATT	PORTRAIT: ELIZABETH LYNES	5/81	SNY	564	S	9 X 8	1945/V	/M	BI
LYNES, GEORGE PLATT	PORTRAIT: ELIZABETH GIBBONS	5/81	SNY	565	S	9 X 8	C1940/V	ST,T,D	500
LYNES, GEORGE PLATT	"ARTHUR LEE'S MODEL..."	5/81	SNY	566	S	9 X 8	1940/V	T,A,D	900
LYNES, GEORGE PLATT	RECLINING MALE NUDE	11/80	CNY	439	S	8 X 10	1930'S/V		450
LYNES, GEORGE PLATT	FEMALE NUDE	11/80	PNY	201	S	9 X 7	C1935/V		1,200
LYNES, GEORGE PLATT	MALE NUDE	11/80	PNY	202	S	9 X 7	C1939/V	ST	700
LYNES, GEORGE PLATT	GLENWAY WESCOTT AND CHARACTERS	11/80	PNY	203	S	9 X 7	C1939/V	ST	600
LYNES, GEORGE PLATT	PAUL CADMUS	11/80	PNY	204	S	9 X 8	C1939/V	ST	600

95

PHOTOGRAPHER	TITLE OR DESCRIPTION	DATE	AH	LOT#	PT	SIZE	N/P DATES	MARKS/COND.	PRICE
LYNES, GEORGE PLATT	SELF-PORTRAIT WITH BILL MILLER	11/80	SNY	329	S	10 X 8	C1951/V		500
LYNES, GEORGE PLATT	"SELF-PORTRAIT"	11/80	SNY	330	S	9 X 8	1940'S/V		250
LYNES, GEORGE PLATT	"RALPH POMEROY NO. 6"	11/80	SNY	331	S	10 X 8	C1951/V		300
LYNES, GEORGE PLATT	"MONROE WHEELER"	11/80	SNY	333	S	9 X 8	C1951/V	ST	450
LYNES, GEORGE PLATT	PORTRAIT: MARIANNE MOORE	11/80	SNY	334	S	9 X 8	1953/V	ST,A	BI
LYNES, GEORGE PLATT	"SWAN LAKE" (2 PHOTOS)	11/80	SNY	832	S	10 X 8	1930'S/V	ST	175
LYNES, GEORGE PLATT	PORTRAIT: CECIL BEATON (FULL LENGTH)	11/80	SNY	840	S	9 X 8	1938/V	ST	175
LYON, DANNY	"CLEARING LAND" (PRISONERS)	2/81	SLA	320	S	9 X 13	1970'S/V	S	300
LYON, DANNY	PRISONERS WITH SHOVELS	2/81	SLA	321	S	9 X 13	1970'S/V	S	275
LYON, DANNY	"UPTOWN"	5/81	PNY	321	S	10 X 10	1965/L	S,T,D	225
LYON, DANNY	"CROSSING THE OHIO, LOUISVILLE"	5/81	SNY	506	S	6 X 9	1966/V	S/F	200
LYON, DANNY	"FIELD MEET, LONG ISLAND, NY"	5/81	SNY	507	S	6 X 9	1964/V	S,I/F	150
LYON, DANNY	"UPTOWN"	5/81	SNY	508	S	9 X 12	1965/L	S,T,D	175
LYON, DANNY	"A WETBACK IN BERNALILLO, NEW MEXICO"	10/80	PT	249	S	9 X 12	1973/V	S,T,D	BI
LYON, DANNY	"THREE CONVICTS, TEXAS"	10/80	PT	250	S	9 X 13	1968/L	S,T,D	BI
LYON, DANNY	"COTTON PICKERS, TEXAS"	11/80	CNY	580	S	12 X 18	1968/80	S,T,D	260
LYON, DANNY	"CROSSING THE OHIO RIVER"	11/80	CNY	581	S	9 X 13	1966/V	S,T,D	170
LYON, DANNY	"UPTOWN"	11/80	SNY	508	S	9 X 13	1965/L	S,T,D	400
LYON, DANNY	PRISONER IN CHAPS	11/80	SNY	509	S	13 X 9	L.1970'S/V	S	200
LYON, DANNY	"OHIO RIVER"	11/80	SNY	510	S	9 X 13	1965/L	S,T,D	200
MAAR, DORA	PORTRAIT: LISE DEHARME	11/80	PNY	103	S	9 X 7	1936/V	S,D	700
MACASKILL, WALLACE R.	"WHEN THE DAWN FLAMES IN THE SKY"	10/80	PT	184	S	4 X 6	C1940/V	S,T	110
MACKENZIE, C.S.	AN INDIAN SQUAW W/BASKET & WOOD...	11/80	CNY	165	O	10 X 8	C1906/V	S,D	200
MACNAUGHTON, WILLIAM E.	A WESTCHESTER LANDSCAPE	11/80	CNY	249	P	7 X 9	C1900/V	ST	120
MACNAUGHTON, WILLIAM E.	PORTRAIT STUDY	11/80	CNY	250	P	7 X 4	C1900/V	ST,S	50
MACPHERSON, ROBERT	BIGA, ARCH OF TITUS, ROMA (BAS RELIEF)	5/81	CNY	15	A	16 X 12	C1858/V	ST/G	260
MACPHERSON, ROBERT	VIEW OF SAINT PETERS, CARACALLA, ...	5/81	CNY	16	A	8 X 16	C1858/V	ST/E	BI
MACPHERSON, ROBERT	THE PIAZZA DI BOCCA DELLA VERITA	5/81	PNY	35	A	9 X 15	C1857/V	ST	250
MACPHERSON, ROBERT	PIAZZA BARBERINI, WINTER	5/81	PNY	36	A	11 X 15	C1850/V	ST/F	400
MACPHERSON, ROBERT	PALANTINE HILL	5/81	PNY	37	A	16 X 11	C1857/V	ST/G	250
MACPHERSON, ROBERT	THE CAPITOL, ROME	5/81	PNY	38	A	12 X 15	C1857/V	ST/G	250
MACPHERSON, ROBERT	ROMAN PORTICO	5/81	PNY	39	A	15 X 10	C1857/V	ST/G	400
MACPHERSON, ROBERT	COLISEUM/META SUDANS & VIA SACRE"	10/80	PT	6	A	10 X 16	C1857/V	ST,A	BI
MACPHERSON, ROBERT	TEMPLE OF MARS ULITOR, FORUM OF NERVA	11/80	CNY	64	A	14 X 12	C1860/V	ST	200
MACPHERSON, ROBERT	ARCH OF CONSTANTINE, ROME	11/80	SNY	88	A	12 X 15	1850'S/V	ST	200
MACPHERSON, ROBERT	BASILICA OF CONSTANTINE, ROME	11/80	SNY	89	A	10 X 15	1850'S/V	ST	125
MACRAE, WENDELL	ROCKEFELLER CENTER	5/81	PNY	107	S	10 X 8	1938/V	ST,T,D/P	BI
MAN, FELIX H.	"FETE ESTIVEDE D'OUTSI"	11/80	PNY	169	S	7 X 8	C1930/V	ST	BI
MANTZ, WERNER	"10 PHOTOGRAPHS" (ED: 8/25)	5/81	SNY	168	S	9 X 7	1920-30/L	S,D,A/M	BI
MANTZ, WERNER	COMMUNION STEPS	11/80	PNY	82	S	11 X 9	1935/V	S,D	1,500
MANTZ, WERNER	FACTORY	11/80	PNY	83	S	15 X 11	1928/V	S,T,D	BI
MANTZ, WERNER	RESTAURANT INTERIOR	11/80	PNY	84	S	9 X 7	1928/V	S,D	900
MANTZ, WERNER	INDUSTRIAL SMOKE STACKS	11/80	PNY	85	S	9 X 7	1936/V	S,D	850
MANTZ, WERNER	DEPARTMENT STORE INTERIOR, KOLN	11/80	PNY	86	S	10 X 7	1929/V	S,D,ST	600
MANTZ, WERNER	APARTMENT BUILDINGS, KOLN	11/80	PNY	87	S	6 X 9	1928/V	S,T,D	BI
MANTZ, WERNER	ELECTROLA, KOLN	11/80	PNY	88	S	6 X 9	1928/V	S,T,D,ST	BI
MAPPLETHORPE, ROBERT	PORTFOLIO:"Y" (13 PRINTS; ED:9/25)	2/81	SLA	323	S	8 X 8	1978/V	S	1,500
MAPPLETHORPE, ROBERT	"ORCHID"&"LILY BUDS" (ED:25)	2/81	SLA	324	S	8 X 8	1977/V	S	400
MAPPLETHORPE, ROBERT	PORTFOLIO:"X" (13 PRINTS; ED:19/25)	5/81	CNY	216	S	8 X 8	1978/V	S,A	BI
MAPPLETHORPE, ROBERT	PORTFOLIO:"Y" (13 PRINTS; ED:18/25)	5/81	CNY	217	S	8 X 8	1978/V	S,A	2,200
MAPPLETHORPE, ROBERT	"LISA LYON, CALIFORNIA" (ED: 1/15)	5/81	SNY	593	S	14 X 14	1980/V	S,D,A,T,ST	600
MAPPLETHORPE, ROBERT	PORTFOLIO:"Y" (13 PRINTS; ED:10/25)	10/80	PT	266	S	8 X 8	1979/V	S,A	1,800
MAPPLETHORPE, ROBERT	PORTFOLIO: "Y" (13 PRINTS, ED: 20/25)	11/80	CNY	643	S	8 X 8	1978/V	S	2,000
MAPPLETHORPE, ROBERT	"LILY IN CLAY VASE" (ED: 3/10)	11/80	CNY	644	S	14 X 14	1979/V	S,D,T,ST	480
MAPPLETHORPE, ROBERT	COWBOY, SAN FRAN.(IN FRAME BY R.MAP.)	11/80	SNY	512	S	15 X 14	C1976/V	S	800
MAPPLETHORPE, ROBERT	"GLADIOLI" (ED:1/10)	11/80	SNY	513	S	14 X 14	1979/V	S,D,ST	500
MARCUS, ELLI	PORTRAIT: LILLI DARVAS-MOLNAR	5/81	SNY	182	S	7 X 9	C1929/V	S,T,ST/P	BI
MARCUS, ELLI	PORTRAIT: JOSEPHINE BAKER	5/81	SNY	183	S	9 X 6	C1937/V	S,T/F	500
MARCUS, ELLI	PORTRAIT: COLETTE JOUVENEL	5/81	SNY	184	S	7 X 9	1938/P	ST,T/P	BI
MAREY, ETIENNE JULES	MAN RUNNING (2 MOTION STUDIES)	5/81	SNY	105	S	2 X 2	C1882/V	/F	3,750

PHOTOGRAPHER	TITLE OR DESCRIPTION	DATE	AH	LOT#	PT	SIZE	N/P DATES	MARKS/COND.	PRICE
MARINO, CAROL	"GILDED LILY #8"	2/81	SLA	325	S	14 X 11	1980/V	S,D,T	200
MARINO, CAROL	"SUNNY BASTILLE DAY #1"	2/81	SLA	326	S	14 X 11	1980/V	S,T,D	100
MARINO, CAROL	"HAPPY BASTILLE DAY #4"	2/81	SLA	327	S	11 X 14	1980/V	S,T,D	BI
MARINO, CAROL	"GILDED LILY NO. 2"	10/80	PT	259	S	14 X 11	1980/V	S,T,D	300
MARVILLE, CHARLES	"PORTAL PRINCIPAL CATHEDRALE D'AMIENS"	5/81	CNY	27	SA	14 X 10	1854/V	T/G	BI
MARVILLE, CHARLES	STUDY OF CLOUDS	5/81	CNY	28	A	6 X 8	1850'S/V	ST/G	BI
MARVILLE, CHARLES	CHARTRES CATHEDRAL	5/81	CNY	29	A	7 X 9	C1854/V	SN/E	BI
MARVILLE, CHARLES	"RUE DES PELERINS"	5/81	CNY	101	A	14 X 11	C1860/V	ST,T/E	2,500
MARVILLE, CHARLES	STREET SCENE, PARIS	11/80	CNY	54	A	11 X 11	C1860/V	ST/E	BI
MARVILLE, CHARLES	RUE DE LA LINGERIE, PARIS	11/80	CNY	55	A	9 X 15	C1860/V	ST/E	BI
MARVILLE, CHARLES (ATTR.)	"LE PONT D'ORTHEZ, BASSES PYRENEES"	11/80	CNY	53	SA	8 X 10	1850'S/V	PD	1,500
MATHER, MARGRETHE	"HAROLD GRIEVE AND HIS WIFE JETTA..."	2/81	SLA	328	P	7 X 9	1930/V	S,D,I	BI
MATHER, MARGRETHE	"LENS SHADOW (EDWARD WESTON)"	5/81	SNY	287	P	10 X 8	1920'S/V	S,T/P	900
MATHER, MARGRETHE	STILL LIFE (POTS & GOURDS ON CHEST)	5/81	SNY	288	P	7 X 9	1928/V	S,D/M	1,000
MATTER, HERBERT	ALEXANDER CALDER WITH WIRE	11/80	CNY	454	S	9 X 8	1935/V	ST	BI
MATTER, HERBERT	ALEXANDER CALDER WITH SHADOW	11/80	CNY	454A	S	10 X 8	1940'S/V	ST	BI
MCBEAN, ANGUS	SURREALISTIC PORTRAIT: DIANA WYNYARD	10/80	PT	176	S	15 X 12	C1940'S/V	S,T	BI
MCBEAN, ANGUS	"SURREAL" (PHOTOMONTAGE)	11/80	PNY	158	S	20 X 16	1938/V	S,T,D	800
MCMURTRY, EDWARD P.	"UP THE STREET"	10/80	PT	138	CO	7 X 5	C1930/V	ST	150
MCMURTRY, EDWARD P.	"HOORN"	10/80	PT	139	CO	6 X 4	1930/V	S,ST	150
MCMURTRY, EDWARD P.	"ROWING"	10/80	PT	140	CO	5 X 7	1931/V	S,ST	210
MCMURTRY, EDWARD P.	WATERGATE, DELFT	10/80	PT	141	CO	5 X 4	1932/V	S,ST	160
MCMURTRY, EDWARD P.	"SHADOW FACES"	11/80	PNY	217	CO	7 X 6	1930/V	S	475
MCMURTRY, EDWARD P.	"UP THE STREET" & "ALONE" (2 PRINTS)	11/80	PNY	218	CO	VARIOUS	1932/V	S	190
MCMURTRY, EDWARD P.	"HARBOR, VLISSINGEN" & "MARTIQUES" (2)	11/80	PNY	219	CO	VARIOUS	C1932/V	S	250
MCPHERSON & OLIVER;OTHERS	LOUISIANA (62 PRINTS: CIVIL WAR)	5/81	SNY	112	A	2 X 4	1860'S/V	/G-E	2,600
MEATYARD, RALPH EUGENE	PORTFOLIO III (10 PHOTOS)	2/81	SLA	329	S	7 X 7	1974/V	ST	450
MEDICAL	X-RAY PHOTO OF A HAND	4/81	SW	491	S	8 X 10	1897/V	A	140
MEYEROWITZ, JOEL	DAIRY LAND (ED: 25)	5/81	PNY	334	CP	8 X 10	1976/77	S,T,D,A	275
MEYEROWITZ, JOEL	BALLSTON BEACH (ED: 25)	5/81	PNY	335	CP	8 X 10	1976/77	S,T,D,A	BI
MEYEROWITZ, JOEL	"PROVINCETOWN, TROMPE L'OEIL INTERIOR"	5/81	SNY	524	S	16 X 20	1977/V	S,T,D	400
MEYEROWITZ, JOEL	PORTFOLIOPBAY SKY PORCH(15 P;ED:17/90)	11/80	SNY	517	CP	8 X 10	1977/1979	8 X 10	BI
MEYERS, WALTER	"HALF WAY DOWN"	11/80	PNY	232	S	13 X 10	C1932/V	S,T	350
MICHALS, DUANE	RENE MAGRITTE	2/81	SLA	330	S	5 X 7	1965/V	S	1,000
MICHALS, DUANE	"THE MOMENTS BEFORE THE TRAGEDY"	2/81	SLA	331	S	4 X 7	1969/L	S	400
MICHALS, DUANE	HOMAGE TO CAVAFY (10 PRINTS, ED: 5/25)	5/81	CNY	213	S	3 X 5	1978/V	S,A	3,000
MICHALS, DUANE	PORTRAIT: ANDY WARHOL (3 PR, ED: 7/25)	5/81	SNY	514	S	4 X 5	1973/V	S,T,D,A	1,300
MICHALS, DUANE	"HOMAGE TO CAVAFY" (10 PR, ED: 12/25)	5/81	SNY	515	S	4 X 5	1978/V	S,A,T	1,500
MICHALS, DUANE	"THINGS ARE QUEER" (9 PR, ED: 10/25)	5/81	SNY	516	S	3 X 5	1970/71	S,T,D,A,ST/G	3,250
MILLER, LEE	ABSTRACT STREET SCENE	11/80	SNY	187	S	12 X 9	1930'S/V	ST	1,700
MISONNE, LEONARD	BRUME	11/80	CNY	339	S	12 X 15	1922/V	S,D,T	60
MISRACH, RICHARD	PLATE FROM "HAWAII" (ED:11/80)	2/81	SLA	332	DT	16 X 19	1978/L	S,D	275
MISRACH, RICHARD	PLATE FROM "HAWAII" (ED:11/50)	2/81	SLA	333	DT	16 X 19	1978/L	S,D	BI
MISRACH, RICHARD	"OCTILLO #1"	11/80	CNY	641	S	15 X 15	1975/V	S,T,D	500
MODEL, LISETTE	"SAILOR AND GIRL, IN SAMMY'S BAR"	2/81	SLA	335	S	20 X 16	1940'S/L	S	500
MODEL, LISETTE	PORTFOLIO:12 PHOTOGRAPHS (ED:III/90)	2/81	SLA	336	S	16 X 20	1977/L	S,ST	2,400
MODEL, LISETTE	WOMAN WITH VEIL, SAN FRANCISCO	4/81	PNY	33	S	20 X 16	C1947/1977	S	BI
MODEL, LISETTE	LITTLE MAN, L. EAST SIDE, N.Y., 1940'S	4/81	PNY	34	S	20 X 16	1940'S/1977	S	450
MODEL, LISETTE	2 WOMEN, FASH. SHOW, HOTEL PIERRE	4/81	PNY	35	S	16 X 20	C1957/1977	S	BI
MODEL, LISETTE	"HERMAPHRODITE" (ED: 75)	5/81	PNY	297	S	20 X 16	1930'S/80	S,ST	250
MODEL, LISETTE	"RELATIONSHIP"	5/81	SNY	491	S	11 X 14	1950'S/V	S/F	500
MODEL, LISETTE	"TWELVE PHOTOGRAPHS" (ED: 46/90)	5/81	SNY	492	S	16 X 20	1940-50'S/L	S,ST,A	BI
MODEL, LISETTE	FRENCH RIVIERA (ED. 50)	11/80	PNY	167	S	19 X 15	1937/L	S,A	250
MODEL, LISETTE	"PROMENADE DES ANGLAIS" (ED. 50)	11/80	PNY	168	S	19 X 15	1937/L	S,A	275
MODOTTI, TINA	YOLANDA MODOTTI	11/80	CNY	366A	P	10 X 7	1925/V	I	650
MODOTTI, TINA	OROZCO PAINTING A MURAL (LABELLED)	11/80	SNY	282A	S	8 X 10	1923/V	ST	1,700
MOHOLY-NAGY, LASZLO	"PHOTOGRAM"	5/81	CNY	95	S	19 X 16	1939/V	S,T,D/F	6,500
MOHOLY-NAGY, LASZLO	"THE HYRDO-CEPHALUS" (ED: 1/15)	5/81	CNY	96	S	9 X 12	1925/V	ST,A,T/M	BI
MOHOLY-NAGY, LASZLO	MOVING LIGHT FORMS (PHOTOGRAM)	11/80	PNY	59	S	36 X 25	1923/V		13,000
MOLE, A. & THOMAS, J. D.	THE HUMAN LIBERTY BELL...	11/80	CNY	372A	B	12 X 10	1918/V	PD,T,D	180
MOON, KARL	PORTRAIT OF AN INDIAN	2/81	SLA	337	S	10 X 7	1908/V	ST	500

PHOTOGRAPHER	TITLE OR DESCRIPTION	DATE	AH	LOT#	PT	SIZE	N/P DATES	MARKS/COND.	PRICE
MOON, KARL	INDIAN WOMAN WITH WATERJUG	5/81	SNY	132	S	13 X 16	1908/V	S,ST/G	550
MOON, KARL	PORTRAIT: YOUNG INDIAN MAN	5/81	SNY	133	S	9 X 8	1907/V	ST/M	500
MOON, KARL	PORTRAIT- YOUNG INDIAN	10/80	PT	39	S	9 X 7	1908/V	ST	BI
MOON, KARL	"THE LAST OF HIS PEOPLE"	11/80	SNY	136	S	14 X 17	1914/V	S,ST,T	1,800
MOORE, HENRY	STUDY OF THREE STANDING FIGURES	11/80	SNY	392	S	9 X 11	1947/V	I	550
MORAN, J. (OR O'SULLIVAN)	DARIEN EXPEDITION (27 PHOTOS)	4/81	SW	362	A	10 X 9	C1874/V	T	12,000
MORATH, INGE	"SOUTH OF MOSCOW" (HORSES, WINTER)	2/81	SLA	338	S	9 X 14	1969/1970'S	S	175
MORATH, INGE	"MRS. NASH"	2/81	SLA	339	S	9 X 14	1970'S/V	S	250
MORGAN, BARBARA	"CORN STALK"	2/81	SLA	340	S	13 X 10	1944/1973	S,T,D,I,ST	300
MORGAN, BARBARA	MARTHA GRAHAM-LETTER TO THE WORLD	4/81	PNY	59	S	15 X 19	1940/V	S,T,ST	1,900
MORGAN, BARBARA	CITY SHELL	4/81	PNY	60	S	19 X 14	C1940/V	S,ST	BI
MORGAN, BARBARA	"LAMENTATION"	5/81	PNY	301	S	15 X 17	C1930/V	S,ST/E	900
MORGAN, BARBARA	MARTHA GRAHAM-LETTER TO THE WORLD	10/80	PT	173	S	11 X 14	1940/80	S,T,D	400
MORGAN, BARBARA	MARTHA GRAHAM-LETTER TO THE WORLD	11/80	CNY	402	S	15 X 19	1940/1980	S,T,D,ST	450
MORGAN, BARBARA	MARTHA GRAHAM-DEEP SONG	11/80	CNY	403	S	15 X 18	1937/V	S,T,ST	BI
MORGAN, BARBARA	AM. DOC., MARTHA GRAHAM-ERIC HAWKINS	11/80	CNY	404	S	15 X 19	1938/V	S,ST,T	BI
MORGAN, BARBARA	SOLSTICE	11/80	CNY	405	S	13 X 9	1942/V	S	BI
MORGAN, BARBARA	"SAMADHI" (LIGHT DRAWING)	11/80	CNY	406A	S	13 X 11	1970'S/V	S,T,D,ST	260
MORGAN, BARBARA	"PURE ENERGY AND NEUROTIC MAN"	11/80	CNY	406	S	14 X 11	1941/V	S,T,D,ST	BI
MORGAN, BARBARA	"SPRING ON MADISON SQUARE"	11/80	CNY	407	S	11 X 13	1980/V	S,T,D,ST	400
MORGAN, BARBARA	"MARTHA GRAHAM-LAMENTATION"	11/80	CNY	408	S	12 X 11	1935/V	S,T,D,A	700
MORGAN, BARBARA	"PREGNANT"	11/80	CNY	409	S	13 X 11	1940/69	S,T,D,ST	320
MORGAN, BARBARA	"SPRING ON MADISON SQUARE" (MONTAGE)	11/80	PNY	195	S	16 X 19	1938/V	S,T	1,200
MORGAN, BARBARA	"HEARST OVER THE PEOPLE" (MONTAGE)	11/80	PNY	196	S	10 X 13	1939/V	S,T,D,ST	BI
MORGAN, BARBARA	MARTHA GRAHAM IN "DEEP SONG"	11/80	PNY	197	S	10 X 12	1939/V	S,T,ST	500
MORGAN, BARBARA	MAY O'DONNELL, WORLD'S FAIR, NEW YORK	11/80	PNY	198	S	13 X 10	1939/V	S,D,ST,T	BI
MORGAN, BARBARA	"MARTHA GRAHAM, WAR THEME"	11/80	SNY	328	S	18 X 26	C1941/V	S,I,T,D,A,ST	850
MORRIS, WRIGHT	STRAIGHT-BACK CHAIR	4/81	PNY	95	S	10 X 8	1947/V	S,T	BI
MORRIS, WRIGHT	ED'S PLACE NEAR NORFOLD, NEBRASKA	4/81	PNY	96	S	8 X 10	1947/V	S	BI
MORRIS, WRIGHT	EROSION	11/80	CNY	416	S	8 X 10	1940'S/70'S	S	300
MORRIS, WRIGHT	FACADE	11/80	CNY	417	S	7 X 9	1940'S/70'S	S	350
MORRIS, WRIGHT	STRAIGHT BACK CHAIR BY DOOR	11/80	CNY	418	S	10 X 8	1940'S/70'S	S	350
MORRIS, WRIGHT	EGGS IN A BUCKET	11/80	CNY	419	S	10 X 8	C1947/70'S	S	BI
MORRIS, WRIGHT	MODEL T IN FRONT OF BARN	11/80	CNY	420	S	10 X 8	1947/70'S	S	350
MORRIS, WRIGHT	A LACE CURTAIN	11/80	SNY	322	S	10 X 8	1947/L	S	275
MORRIS, WRIGHT	ERODED SOIL, NEWAR OXFORD, MISSISSIPPI	11/80	SNY	323	S	7 X 10	C1940/L	S	300
MORRIS, WRIGHT	"MODEL T IN SHED, NEBRASKA"	11/80	SNY	324	S	9 X 7	C1947/L	S	300
MORTENSEN, WILLIAM	PORTRAIT: MILAN MILLER AS HENRY VIII	2/81	SLA	341	B	11 X 14	1930'S/V	IN,S,I,ST	600
MORTENSEN, WILLIAM	"ANITA"	2/81	SLA	342	S	13 X 10	1930/V	S,T,D	500
MORTENSEN, WILLIAM	"SECRETS" (2 PRINTS - BROMOIL TRANS.)	2/81	SLA	343	B	VARIOUS	1930'S/V	S,T	350
MOULIN, F. JACQUES	UNTITLED STUDY	5/81	SNY	99	A	7 X 5	1853/V	/F	BI
MUCCA, ANDRE	FROM THE SERIES GRAND GUIGNOL	11/80	PNY	112	S	10 X 9	C.1930/V	ST,T	BI
MUCHA, ALPHONSE MARIA	MADAME FERKEL	5/81	PNY	156	A	5 X 4	C1900/V	/E	BI
MULLOCK, BENJAMIN R.	BAHIA (3 PRINTS)	11/80	CNY	86	A	7 X 27	1860/V		BI
MUNKACSI, MARTIN	SPECTATORS AT A SPORTS EVENT	2/81	SLA	344	B	12 X 9	1930'S/V	ST,T,I	450
MUNKACSI, MARTIN	THREE CHILDREN BLOWING BUBBLES	2/81	SLA	345	S	9 X 11	1930'S/V	ST,S,D	500
MUNKACSI, MARTIN	TWO MODELS WITH CAR	4/81	PNY	167	S	9 X 12	1930'S/V	ST	BI
MUNKACSI, MARTIN	THREE CHILDREN	4/81	PNY	174	S	12 X 9	1936/V	ST	150
MUNKACSI, MARTIN	COUNT ZICHY, BUDAPEST	5/81	PNY	181	S	6 X 9	C1920/V	ST	400
MUNKACSI, MARTIN	COUNT ZICHY, BUDAPEST	5/81	PNY	182	S	9 X 6	C1920/V	ST,A	BI
MUNKACSI, MARTIN	"FRIEND OF PIGEONS"	5/81	SNY	185	S	12 X 9	1930/V	ST,PD/P	900
MUNKACSI, MARTIN	SWIMMER	5/81	SNY	186	S	12 X 9	1934/F	ST/F	450
MUNKACSI, MARTIN	CATS	5/81	SNY	187	S	9 X 12	1930'S/V	ST/F	300
MUNKACSI, MARTIN	MUSICIANS	5/81	SNY	188	S	12 X 9	1930'S/V	ST/P	BI
MUNKACSI, MARTIN	MAN WITH CAGES	11/80	CNY	457A	A	10 X 8	C1934/V	ST	BI
MUNKACSI, MARTIN	DETAIL OF A BRIDGE	11/80	CNY	458	S	11 X 9	C1947/V	ST	BI
MUNKACSI, MARTIN	"SOMEONE AT BREAKFAST"	11/80	PNY	159	S	12 X 9	1936/V	ST	3,400
MUNKACSI, MARTIN	WOMAN ON BEACH	11/80	PNY	160	S	12 X 9	1930'S/V	ST	BI
MUNKACSI, MARTIN	FASHION MODEL JUMPING	11/80	PNY	161	S	12 X 9	1930'S/V	ST	1,600
MUNKACSI, MARTIN	"CAMEL'S FEEDING"	11/80	PNY	162	S	9 X 12	1920'S/V	ST	600
MUNKACSI, MARTIN	"SCHIFFSENTLADUNG" (FREIGHTER WITH CAR)	11/80	PNY	163	S	9 X 12	1929/V	ST	400

PHOTOGRAPHER	TITLE OR DESCRIPTION	DATE	AH	LOT#	PT	SIZE	N/P DATES	MARKS/COND.	PRICE
MUNKACSI, MARTIN	"STARKSTROM"	11/80	PNY	164	S	9 X 12	1932/V	ST	BI
MUNKACSI, MARTIN	TWO FEMALE BATHERS	11/80	SNY	168	S	9 X 12	C1929/V	ST	550
MUNKACSI, MARTIN	"AN ODD SPARE WHEEL, HOLLAND"	11/80	SNY	169	S	10 X 12	1929/V	ST, I	400
MURAY, NICKOLAS	FEMALE NUDE, RECLINING	2/81	SLA	346	S	8 X 10	1925/V	ST,S,D	500
MURAY, NICKOLAS	FEMALE NUDE, KNEELING	2/81	SLA	347	S	10 X 8	1925/V	ST,S,D	250
MURAY, NICKOLAS	PORTRAIT: GRACE ARSON	2/81	SLA	348	S	10 X 8	1925/V	ST,S,D	300
MURAY, NICKOLAS	PORTRAIT: DANCER (PSBLY ISADORA DUNCAN)	10/80	PT	172	S	9 X 6	1925/V	S,D,ST	150
MURAY, NICKOLAS	"CARLOTA MUABERRY"	11/80	CNY	453	S	10 X 8	1921/V	S,D,T,ST	BI
MURAY, NICKOLAS	THE GREAT ARTIST, BETH BLYTHE	11/80	CNY	453A	S	9 X 7	1924/V	S,D,ST	BI
MURAY, NICKOLAS	EVA LEGALLIENNE (2 PORTRAITS)	11/80	SNY	251	S	9 X 7	1930'S/V	ST	125
MUYBRIDGE, EADWEARD	ANIMAL LOCOMOTION (200 COLLOTYPES)	5/81	CNY	55	PP	14 X 20	1887/V	PD	BI
MUYBRIDGE, EADWEARD	"ANIMAL LOCOMOTION" (28 COLLOTYPES)	5/81	SNY	120	PP	VARIOUS	1887/V	PD	1,300
NADAR (GASPARD TOURNACHON)	PORTRAIT: EUGENE DELACROIX	11/80	SW	345	A	8 X 6	C1860/V		BI
NADAR (GASPARD TOURNACHON)	SARAH BERNHARDT (CABINET CARD)	5/81	PNY	34	A	6 X 4	1880'S/V	ST/F	150
NADAR (GASPARD TOURNACHON)	CHARLES PHILIPON	5/81	CNY	38	A	9 X 7	C1858/V	S,I/E	2,400
NAYA, CARLO	PIAZZA SAN MARCO, VENICE	10/80	PT	7	A	17 X 23	C1869/V	IN	70
NAYA, CARLO	CANAL SCENE, VENICE	4/81	SW	361	A	21 X 17	1860'S/V	ST, IN	80
NEGRETTI & ZAMBRA (ATTR.)	THE CRYSTAL PALACE (2 STEREOVIEWS)	11/80	CNY	8	D	STEREO	1855/V		BI
NEUSUSS, FLORIS MICHAEL	DEATH	5/81	SNY	580	S	11 X 9	1950'S/V	ST	250
NEUSUSS, FLORIS MICHAEL	PHOTOGRAPHER AND MODEL	5/81	SNY	581	S	14 X 9	1972/V	S,D	250
NEUSUSS, FLORIS MICHAEL	NUDE STUDY	5/81	SNY	581A	S	93 X 42	1950'S/V	S	250
NEWBURY, JAMES	NUDE (WOMAN)	11/80	CNY	533	S	9 X 9	C1959/L	S	380
NEWHALL, BEUMONT	"HENRI CARTIER-BRESSON, NEW YORK"	11/80	CNY	474	S	9 X 14	1946/70'S	S,T,D	400
NEWMAN, ARNOLD	PORTRAIT: YASUO KUNIYOSHI	2/81	SLA	350	S	8 X 10	C1941/V	S,I	750
NEWMAN, ARNOLD	PORTRAIT: PABLO PICASSO	2/81	SLA	351	S	19 X 15	1950'S/L	S,I,ST	900
NEWMAN, ARNOLD	PORTRAIT: HENRY GELDZAHLER	2/81	SLA	352	S	14 X 16	1972/V	S,T,D,I,ST	650
NEWMAN, ARNOLD	GRANDMA MOSES	4/81	PNY	42	S	10 X 8	1949/V	S,T,ST	425
NEWMAN, ARNOLD	PORTRAITS: (5 PRINTS - ED: 25)	5/81	PNY	299	S	13 X 10	C1960'S/L	S,T,D,ST	800
NEWMAN, ARNOLD	PORTRAIT: MAX ERNST	5/81	SNY	387	S	13 X 10	1942/L	S,T,D,ST	850
NEWMAN, ARNOLD	"PIET MONDRAIN"	10/80	PT	180	S	10 X 6	1942/L	S,T,D	360
NEWMAN, ARNOLD	EDWARD HOPPER, TRURO, MASS.	10/80	PT	181	S	13 X 10	1960/L	S,T,D	400
NEWMAN, ARNOLD	PORTRAIT: MAX ERNST	11/80	CNY	622	S	10 X 8	1942/V	S,T,D,I	750
NEWMAN, ARNOLD	PORTRAIT: IGOR STRAVINSKY	11/80	SNY	335	S	5 X 10	1946/L	S,T,D,,ST	700
NEWMAN, ARNOLD	PORTRAIT: PIET MONDRIAN	11/80	SNY	336	S	10 X 6	1942/L	S,T,D,ST	400
NEWMAN, ARNOLD	PORTRAIT: ANDREW WYETH	11/80	SNY	337	S	16 X 20	C1948/V	S,A,ST	BI
NEWTON, HELMUT	JENNY KAPITAN IN PENSION DORIAN	2/81	SLA	353	S	17 X 12	1977/V	S,D,ST	600
NEWTON, HELMUT	TWO MODELS IN RUE AUBRIOT, PARIS	2/81	SLA	354	S	13 X 9	1975/V	S,D,ST,I	550
NEWTON, HELMUT	PORTRAIT: XAVIER MOREAUX & GIRLFRIEND	2/81	SLA	355	S	12 X 8	1974/V	S,D,ST,I	450
NEWTON, HELMUT	"SADDLE I, PARIS"	5/81	CNY	209	S	12 X 17	1976/L	S,T,D,ST	650
NINCI, GIUSEPPE (ATTR.)	FORUM ROMANUM (3 PRINTS AS PANORAMA)	11/80	CNY	68	A	24 X 51	1880'S/V		BI
NINCI,C. ET CI.	THE AQUA CLAUDIA	5/81	PNY	41	A	11 X 15	1860'S/V	ST/G	100
NIXON, NICHOLAS	FOUR TEENAGE GIRLS, NEW CANAAN, CONN.	11/80	CNY	638	S	8 X 10	1975/V	S,T	BI
NOHRING, J.	LUBECK, GERMANY (13 PRINTS)	5/81	PNY	49	A	11 X 13	C1871/V	T,D(1)	200
NORTH, KENDA	ELLEN, FRONTAL (ED: 2/5)	11/80	CNY	652	DT	18 X 12	1978/V	S,D	180
NOSKOWIAK, SONIA	"TREES IN BLOOM"	5/81	SNY	372	S	8 X 10	1937/V	S,D,T/G	500
NOSKOWIAK, SONIA	"HANDS"	5/81	SNY	373	S	10 X 7	C1938/V	S,T,ST	500
NOSKOWIAK, SONIA	"CYPRESS-POINT LOBOS, CARMEL, CALIF."	5/81	SNY	374	S	10 X 8	1938/V	S,D,T/V	500
NOSKOWIAK, SONIA	PORTRAIT: MAYNARD DIXON	5/81	SNY	375	S	9 X 8	1937/V	S,T,D	BI
NOTMAN, WILLIAM	ALBUM: CANADA	10/80	PT	48	A	9 X 7	1880'S/V	IN	800
NOTMAN, WILLIAM	VIEWS ALONG THE C.P.R. (10 PRINTS)	10/80	PT	50	A	7 X 9	1880'S/V	IN	240
NOTMAN, WILLIAM	EARL OF ABERDEEN/FAMILY, MONTREAL	10/80	PT	52	A	9 X 7	1895/V	ST	55
NOTMAN, WILLIAM	TRAPPING BEAVER (ADD'L PRINT VERSO)	11/80	CNY	180	A	7 X 9	C1868/V	T,PD/F	BI
NOTMAN, WILLIAM ET ALIA	AMERICA 1890 (113 PRINTS)	11/80	CNY	179	A	VARIOUS	1890/V		800
NUDE STUDIES	4 PRINTS; FEMALE NUDES; ANONYMOUS	5/81	SNY	533	A	VARIOUS	1890'S/V		150
O'SULLIVAN, T. H. (ATTR.)	FORT FISHER, NORTH CAROLINA (5 PRINTS)	11/80	CNY	115	A	4 X 4	C1862/V		BI
O'SULLIVAN, TIMOTHY	"SNOW PEAKS,BULL RUN MINING DIST., NE"	2/81	SLA	357	A	8 X 11	1871/V	PD	200
O'SULLIVAN, TIMOTHY	"SHOSHONE FALLS, SNAKE RIVER, IDAHO"	2/81	SLA	358	A	8 X 11	1874/V	PD	600
O'SULLIVAN, TIMOTHY	CANON OF THE COLORADO RIVER	5/81	PNY	76	A	8 X 11	1873/V	S,T/G	350
O'SULLIVAN, TIMOTHY	ALFRED R. WAUD (2 PRINTS)	11/80	CNY	122	A	4 X 4	C1863/V		90

PHOTOGRAPHER	TITLE OR DESCRIPTION	DATE	AH	LOT#	PT	SIZE	N/P DATES	MARKS/COND.	PRICE
O'SULLIVAN, TIMOTHY	"A HARVEST OF DEATH, JULY 1863"	11/80	CNY	127	A	7 X 9	1865/V	PD,T/G	1,000
O'SULLIVAN, TIMOTHY	NORTH FORK CANON, SIERRA BLANCA...	11/80	CNY	134	A	8 X 11	1873/V	PD,T	BI
O'SULLIVAN, TIMOTHY	NORTH FORK CANON, SIERRA BLANCA...	11/80	CNY	134	A	8 X 11	1873/V	PD,T	BI
O'SULLIVAN, TIMOTHY	"COOLEY'S PARK, AZ"&"CAMP APACHE, AZ"	11/80	CNY	135	A	8 X 11	1873/C	PD,T	300
O'SULLIVAN, TIMOTHY	"SNOW PEAKS, NE" & ALPINE LAKE, CO."	11/80	CNY	136	A	8 X 11	1874/V	PD,T/F	BI
O'SULLIVAN, TIMOTHY	"CONEJOS RIVER" & "CONEJOS CANON"	11/80	CNY	137	A	8 X 11	1874/V	PD,T/F	BI
O'SULLIVAN, TIMOTHY	"CEREUS GIGANTEUS, ARIZONA"	11/80	SNY	114	A	11 X 8	1871/V		350
ODDITIES	"THE NEEDLE MAN"	11/80	PNY	109	S	7 X 9	1920'S/V		275
OEHME, GUSTAVE	3 YOUNG GIRLS, ONE WITH AN OPEN BOOK	5/81	CNY	26	D	1/6 PL.	C1850/V	/G	2,200
ONGANIA, FERDNAND	CALLI E CANALI IN VENEZIA (100 PG'S)	11/80	CNY	72	PG	13 X 9	1891/V		650
OUTERBRIDGE, PAUL JR.	SHOES BY THE FIREPLACE	4/81	PNY	168	P	5 X 3	1930'S/V		BI
OUTERBRIDGE, PAUL JR.	MILK BOTTLE AND EGGS	5/81	CNY	132	S	10 X 7	1922/V	S,I/G	3,200
OUTERBRIDGE, PAUL JR.	COOKIES	5/81	CNY	133	P	8 X 5	C1930/V	/G	1,500
OUTERBRIDGE, PAUL JR.	"ROSES AND CLOUDS"	5/81	CNY	134	CO	15 X 12	C1937/V	T/G	12,000
OUTERBRIDGE, PAUL JR.	SEATED NUDE (HEAD ON KNEE)	5/81	CNY	135	CO	17 X 12	C1937/V	ST/F-G	10,000
OUTERBRIDGE, PAUL JR.	"PERFUME BOTTLES"	5/81	PNY	275	S	4 X 4	C1922/V	ST	BI
OUTERBRIDGE, PAUL JR.	PORTRAIT: A WOMAN (HEAD)	5/81	PNY	276	P	5 X 4	1922/V	S,D	BI
OUTERBRIDGE, PAUL JR.	SEATED NUDE (RED SHOES)	5/81	SNY	562	CO	14 X 10	1936/V	S,D,ST/E	8,250
OUTERBRIDGE, PAUL JR.	NUDE STUDY (ON SAND DUNE)	5/81	SNY	563	CO	17 X 12	1930'S/V	ST	4,750
OUTERBRIDGE, PAUL JR.	NUDE (STANDING IN POSE)	11/80	CNY	334	CO	17 X 9	1930/V	ST	4,200
OUTERBRIDGE, PAUL JR.	STILL LIFE WITH CIGARETTES	11/80	CNY	335	P	4 X 5	1920'S/V		2,200
OUTERBRIDGE, PAUL JR.	STILL LIFE OF GOLF ACCESSORIES	11/80	PNY	56	P	5 X 4	1920'S/V	ST	1,300
OUTERBRIDGE, PAUL JR.	"MANNEQUIN"	11/80	PNY	57	S	9 X 6	C1930/V	ST	3,200
OUTERBRIDGE, PAUL JR.	EGG STILL LIFE	11/80	PNY	58	P	5 X 4	1920'S/V		1,200
OWENS, BILL	SUBURBIA: LIVING ROOM SCENE-CHRISTMAS	11/80	CNY	585	S	9 X 11	1970'S/V	S,T	300
PAJAMA (CADMUS & FRENCH)	P. CADMUS AND M. FRENCH, NANTUCKET	4/81	PNY	52	S	4 X 7	1946/V		160
PAJAMA (CADMUS & FRENCH)	PORTRAIT: EDWARD HOPPER, TRURO, MASS.	4/81	PNY	53	S	5 X 7	1948/V		160
PAJAMA (CADMUS & FRENCH)	MONROE WHEELER, PROVINCETOWN	5/81	PNY	286	S	6 X 7	1947/V		BI
PAJAMA (CADMUS & FRENCH)	JARED FRENCH, PROVINCETOWN	5/81	PNY	287	S	7 X 5	1947/V		BI
PAJAMA (CADMUS & FRENCH)	M. FRENCH, PAUL & FIDELMA CADMUS...	11/80	PNY	205	S	4 X 7	1939/V		275
PAJAMA (CADMUS & FRENCH)	MARGARET FRENCH (HANDS), FIRE ISLAND	11/80	PNY	206	S	4 X 6	C1939/V		BI
PAJAMA (CADMUS & FRENCH)	MARGARET FRENCH & P. CADMUS, FIRE ISL.	11/80	PNY	207	S	6 X 10	C1939/V		225
PAJAMA (CADMUS & FRENCH)	PAUL CADMUS, FIRE ISLAND	11/80	PNY	208	S	4 X 7	1939/V		250
PAJAMA (CADMUS & FRENCH)	FIDLEMA CADMUS (KIRSTEIN)	11/80	PNY	209	S	3 X 5	1937/V		BI
PALFI, MARION	JUVENILE HOME, DETROIT	4/81	PNY	94	S	14 X 11	1949/V	S,T,D,ST	180
PARKER, OLIVIA	"MOONSNAILS"	2/81	SLA	359	S	13 X 11	1978/80	S,T,D,A	400
PARKER, OLIVIA	"MISS APPLETON'S SHOES II"	2/81	SLA	360	CP	5 X 4	1976/80	S,T,D,A	300
PARKER, OLIVIA	"MISS APPLETON'S SHOES"	2/81	SLA	361	CP	7 X 5	1976/79	S,T,D,A	275
PARKER, OLIVIA	"MOONSNAILS"	5/81	SNY	527	S	10 X 8	1978/V	S,D,ST,A/M	400
PARKER, OLIVIA	"TWO FEATHERS"	5/81	SNY	528	S	10 X 8	1980/V	S,D,T,A/M	350
PARKER, OLIVIA	"ROSES"	5/81	SNY	529	S	8 X 10	1980/V	S,D,T,A/M	350
PARKS. J.G.	QUEBEC: 5 PRINTS	10/80	PT	46	A	5 X 7	C1870/V	5=T,3=ST	200
PARRY, ROGER	CAROUSEL HORSE	5/81	SNY	222	S	16 X 12	1929/V	S,A/G	6,500
PARRY, ROGER	STILL LIFE WITH WHITE SHOES	5/81	SNY	223	S	9 X 7	C1930/V	ST/F	1,300
PARRY, ROGER	FEMALE NUDE STUDY (RECLINING)	5/81	SNY	550	S	7 X 9	1930'S/V	IN,PD/E	4,500
PARRY, ROGER	FEMALE NUDE AND CHAIR	11/80	CNY	314	S	9 X 7	C1930/V	ST	2,100
PARRY, ROGER	FEMALE NUDE STUDY (RECLINING)	11/80	PNY	116	S	7 X 9	1931/V	IN,S,D	2,000
PARRY, ROGER	FACE MONTAGE	11/80	PNY	117	S	9 X 7	1931	IN,S,D	1,500
PARSONS, SARA	CELLOPHANE ADVERTISEMENT	11/80	PNY	212	S	7 X 6	C1930/V	ST	200
PENN, IRVING	"SCULPTOR'S MODEL, PARIS" (ED: 14/35)	2/81	SLA	363	P	16 X 12	1951/76	S,T,D,ST	1,800
PENN, IRVING	"TELEGRAPHIST, PARIS" (ED: 22)	2/81	SLA	364	P	19 X 14	1950/76	S,T,D,ST	1,600
PENN, IRVING	"MARCHAND DE CONCOMBRES" (ED: 1/41)	2/81	SLA	365	P	16 X 13	1950/76	S,T,D,ST	1,300
PENN, IRVING	"BUTCHER, LONDON" (ED.:4/38)	2/81	SLA	366	P	20 X 15	1950/67	S,T,D,ST	1,300
PENN, IRVING	"SWEEP, LONDON" (ED.:1/27)	2/81	SLA	367	P	20 X 15	1951/67	S,T,D,ST	1,500
PENN, IRVING	"PLUMBER, NEW YORK" (ED.:4/36)	2/81	SLA	368	P	20 X 15	1951/67	S,T,D,ST,A	1,600
PENN, IRVING	PORTRAIT OF CECIL BEATON (ED.:1/15)	2/81	SLA	369	P	15 X 15	1958/77	S,T,D,ST,A	2,900
PENN, IRVING	"TRUMAN CAPOTE" (ED.:5/20)	2/81	SLA	370	P	16 X 16	1965/76	S,T,D,ST,A	BI
PENN, IRVING	"ROCK GROUPS,SAN FRANCISCO" (ED.:2/50)	2/81	SLA	371	P	19 X 20	1967/74	S,T,D,ST,A	5,250
PENN, IRVING	"NUDE 58" (ED.:4/33)	2/81	SLA	372	P	20 X 20	1950/79	S,T,A,D,ST	BI
PENN, IRVING	"NUDE 151" (ED.:8/38)	2/81	SLA	373	P	19 X 18	1950/76	S,T,D,A,ST	BI

PHOTOGRAPHER	TITLE OR DESCRIPTION	DATE	AH	LOT#	PT	SIZE	N/P DATES	MARKS/COND.	PRICE
PENN, IRVING	"NUBILE BEAUTY OF DIAMARE"(ED.:23/40)	2/81	SLA	374	P	19 X 19	1974/80	S,T,D,A,ST	5,500
PENN, IRVING	"NEPAL WOMEN W/ NOSE RINGS"(ED.13/15)	2/81	SLA	375	P	19 X 20	1974/79	S,T,D,A,ST	BI
PENN, IRVING	"GUEDRAS IN THE WIND" (ED.:9/32)	2/81	SLA	376	P	18 X 18	1971/78	S,T,A,D,ST	BI
PENN, IRVING	PORTRAIT: JEAN COCTEAU (ED: 35)	4/81	PNY	45	P	14 X 13	1949/1979	S,T,D,ST	2,500
PENN, IRVING	BUTCHER, LONDON (ED: 38)	4/81	PNY	46	P	20 X 15	1950/1976	S,T,D,ST	900
PENN, IRVING	WOMAN WITH ROSES (ED: 40)	4/81	PNY	189	P	22 X 16	1950/1968	S,T,D,ST	BI
PENN, IRVING	COCOA DRESS (ED: 50)	4/81	PNY	190	P	19 X 20	1950/1979	S,T,D,ST	BI
PENN, IRVING	2 WOMEN WITH NOSE RINGS, NEPAL (ED:15)	4/81	PNY	198	P	20 X 20	1967/1972	S,T,D,ST	BI
PENN, IRVING	VIONNET DRESS WITH FAN (ED: 37)	4/81	PNY	200	P	21 X 20	1977/1978	S,T,D,ST	3,000
PENN, IRVING	COLETTE, PARIS (ED: 7/50)	5/81	CNY	196	P	20 X 20	1951/76	S,ST,A,D	5,500
PENN, IRVING	ROCK GROUP, SAN FRANCISCO (ED: 28/50)	5/81	CNY	197	P	19 X 20	1967/79	S,T,D,A,ST/M	4,800
PENN, IRVING	"4 UNGGAI, NEW GUINEA" (ED: 16/18)	5/81	CNY	198	P	20 X 20	1970/79	S,ST,T,D,A/E	BI
PENN, IRVING	"TAMBUL WARRIOR-NEW GUINEA"(ED: 20/25)	5/81	CNY	199	P	20 X 19	19070/77	S,T,D,A,ST/M	BI
PENN, IRVING	"MAN IN WHITE,WOMAN IN BLACK" EDROCCO"	5/81	CNY	200	P	22 X 19	1974/78	S,ST,A,T,D/M	BI
PENN, IRVING	ENGA WARRIOR (ED: 8/15)	5/81	CNY	201	P	20 X 19	1970/77	S,D,A,ST/M	2,000
PENN, IRVING	CHILDREN IN TOWN OF GANVIE (ED: 45)	5/81	PNY	300	P	20 X 22	1967/69	S,T,D,ST	BI
PENN, IRVING	AIZO GIRLS OF LAGOON VILLAGE (ED: 45)	5/81	PNY	300	P	20 X 22	1967/69	S,T,D,ST	BI
PENN, IRVING	"MERMAID DRESS" (ED: 3/25)	5/81	SNY	458	P	20 X 20	1950/79	S,T,D,A,ST/M	3,000
PENN, IRVING	"HARLEQUIN DRESS" (ED: 25/30)	5/81	SNY	459	P	21 X 19	1950/79	S,T,D,A,ST/M	BI
PENN, IRVING	FEMALE NUDES (8 PR, ED: 10-26,VARIOUS)	5/81	SNY	460	S	VARIOUS	1950/V	S,ST/M	BI
PENN, IRVING	"GIRL DRINKING (M.J.RUSSELL)"SED:2/25)	5/81	SNY	461	P	20 X 19	1959/77	S,T,D	BI
PENN, IRVING	PORTRAIT: PICASSO	5/81	SNY	462	S	23 X 23	1957/V	ST/E	4,000
PENN, IRVING	PORTRAIT: JOHN MARIN (ED: 27/40)	5/81	SNY	463	P	22 X 16	1948/77	S,T,D,A	BI
PENN, IRVING	"TREE PRUNER, NEW YORK" (ED: 22)	5/81	SNY	464	P	20 X 14	1951/76	S,T,D,A/M	1,300
PENN, IRVING	MAN IN WHITE, WOMAN IN BLACK(ED:12/45)	5/81	SNY	465	P	22 X 19	1974/V	S,T,D,A/M	5,550
PENN, IRVING	"THREE DAHOMEY GIRLS" (ED: 3/35)	5/81	SNY	466	P	20 X 20	1967/72	S,T,D,A/M	2,600
PENN, IRVING	"GUEDRAS IN WIND (MOROCCO)" ED: 25/32	5/81	SNY	467	P	18 X 18	1971/78	S,T,D,A/M	BI
PENN, IRVING	"CUZCO WOMAN WITH HIGH SHOES" ED: 4/20	5/81	SNY	468	P	12 X 11	1978/V	T,D,A/M	BI
PENN, IRVING	"TWISTED PAPER" (ED: 25/69)	5/81	SNY	469	P	30 X 22	1975/V	S,T,D	1,400
PENN, IRVING	"ROCK GROUPS, SAN FRANCISCO" ED: 22/50	5/81	SNY	470	P	19 X 20	1967/74	S,T,D,A,ST	4,250
PENN, IRVING	"HELLS'S ANGELS-SAN FRAN." ED: 27/35	5/81	SNY	471	P	15 X 19	1967/69	S,T,D,A,ST	BI
PENN, IRVING	GYPSY COUPLE & GRANDCHILDREN (ED:4/28)	10/80	PT	187	P	16 X 15	1966/68	S,A,ST	2,600
PENN, IRVING	TWO WOMEN W/NOSE RINGS,NEPAL (ED:5/15)	10/80	PT	188	P	20 X 20	1967/72	S,D,ST,A	2,000
PENN, IRVING	TELEGRAPHISTE, PARIS (ED:12/22)	10/80	PT	189	P	19 X 14	1950/76	S,ST,D,A	BI
PENN, IRVING	BOUCHERS, PARIS (ED:23/33)	10/80	PT	190	P	16 X 13	1951/67	S,D,ST,A	BI
PENN, IRVING	CHIMNEY SWEEP, LONDON (ED:11/27)	10/80	PT	191	P	20 X 15	1950/76	S,D,ST,A	1,800
PENN, IRVING	CLEANING WOMEN, LONDON (ED: 21/32)	11/80	CNY	618	P	17 X 15	1950/76	S,D,A,ST	1,700
PENN, IRVING	SEWER CLEANER, NEW YORK (ED: 32/35)	11/80	CNY	619	P	20 X 15	1951/76	S,D,A,ST	1,000
PENN, IRVING	SPANISH GYPSY FAMILY (ED: 20/28)	11/80	CNY	620	P	15 X 15	1965/71	ST,S,T,D,A	3,000
PENN, IRVING	"NUDE 147" (ED:5/53)	11/80	SNY	492	P	18 X 19	1950/1973	S,T,D,I	2,700
PENN, IRVING	"SCULPTOR'S MODEL, PARIS" (ED:34/35)	11/80	SNY	493	P	16 X 11	1950/1970	S,I,ST	4,000
PENN, IRVING	"TREE PRUNER, NEW YORK" (ED:22)	11/80	SNY	494	P	20 X 14	1951/1976	S,T,D,I	1,000
PENN, IRVING	"BUTCHER, LONDON" (ED:38)	11/80	SNY	495	P	20 X 15	1950/1976	S,T,D,I	BI
PENN, IRVING	PORTRAIT: CECIL BEATON (ED:2/15)	11/80	SNY	496	P	15 X 15	1958/1977	S,T,D,I	4,000
PENN, IRVING	MAN IN WHITE,WOMAN IN BLACK (ED:12/45)	11/80	SNY	497	P	22 X 19	1974/1977	S,T,D,I,ST	9,500
PENN, IRVING	GIRL DRINKING (M.J. RUSSELL)"(ED:3/25)	11/80	SNY	498	P	20 X 19	1959/1977	S,T,D,I	4,500
PENN, IRVING	"TWO GUEDRAS" (ED:26/40)	11/80	SNY	499	P	21 X 17	1971/1978	S,T,D,I,ST	10,000
PENN, IRVING	"FIVE OKAPA, NEW GUINEA" (ED:35)	11/80	SNY	500	P	20 X 20	1974/1978	S,T,D,I	BI
PENN, IRVING	"ENGA WARRIOR" (ED:15)	11/80	SNY	501	PP	20 X 19	1970/1977	S,T,D,I	BI
PENN, IRVING	CECIL BEATON IN MORNING DRESS	11/80	SNY	838	S	10 X 7	C1950/V	ST	1,200
PERCKHAMMER, HEINZ VON	FEMALE NUDES	5/81	SNY	542	S	7 X 9	1930'S/V	S	1,000
PERCKHAMMER, HEINZ VON	FEMALE NUDE ON SAND DUNE	5/81	SNY	543	S	9 X 7	1930'S/V	ST	300
PFAHL, JOHN	"HAYSTACK CONE, FREEPORT MAINE"	10/80	PT	230	CP	7 X 10	1976/V	S,T,D	180
PFAHL, JOHN	"MOUNTAIN & TREE CLEFT, BOULDER, COL."	10/80	PT	231	CP	8 X 10	1977/V	S,T,D	180
PLAUT, FREDERICK	PLAYING CHECKERS, FRANCE	4/81	PNY	91	S	11 X 14	1950'S/1981	S,ST	180
PLAUT, FREDERICK	MARLENE DIETRICH (1950'S)	4/81	PNY	92	S	14 X 11	1950'S/1981	S,ST	100
PLUSCHOW, GUGLIELMO	NUDE GIRL	5/81	PNY	44	A	9 X 6	C1890/V	ST	BI
PLUSCHOW, GUGLIELMO	NUDE STUDY OF A YOUNG WOMAN	5/81	PNY	45	A	9 X 7	C1890/V	ST	BI
PLUSCHOW, GUGLIELMO	TWO NUDE CHILDREN	11/80	CNY	74	A	9 X 7	C1890/V	ST	BI
PLUSCHOW, GUGLIELMO	TWO YOUNG NUDE GIRLS	11/80	CNY	75	A	9 X 7	C1890/V	ST	BI
PLUSCHOW, GUGLIELMO	A YOUNG NUDE COUPLE	11/80	CNY	76	A	9 X 7	C1890/V	ST	300

PHOTOGRAPHER	TITLE OR DESCRIPTION	DATE	AH	LOT#	PT	SIZE	N/P DATES	MARKS/COND.	PRICE
POLLARD, HARRY	PORTRAIT: INDIAN	10/80	PT	60	P	10 X 8	C1910/V	ST	400
PONTI, CARLO	ITALIAN VIEWS (3 PRINTS)	11/80	CNY	65	A	11 X 14	1860'S/V	ST	200
PONTING, HERBERT G.	"ONE OF THE DOG TEAMS"	10/80	PT	72	S	13 X 18	C1910/V	ST,T	110
PORTER, ELIOT	INTIMATE LANDSCAPES(10 PR, ED: 10/250)	5/81	SNY	440	DT	14 X 11	1950-70/L	S/M	250
PORTER, ELIOT	"LAKE POWELL"	11/80	CNY	648	DT	8 X 11	1968/V	ST,T	700
PORTER, ELIOT	BARN SWALLOW IN FLIGHT	11/80	SW	360	CP	18 X 16	C1970/V		BI
PORTER, ELIOT	SWALLOW, GREAT SPRUCE ISLAND, MAINE	11/80	SW	361	CP	18 X 16	C1970/V		130
PORTRAITURE	58 CARTES-DE-VISITE	4/81	SW	424	A	CDV	1860'S/V		300
POTTIER, PHILIPPE	ROBE DE ROCHAS	4/81	PNY	170	S	9 X 7	C1930'S/V	S,T	BI
PREVEL, JEAN	"LE DERNIER SALON DE LA MOTO"	11/80	PNY	122	S	12 X 9	C1930/V	ST,T	130
PRICE, WILLIAM LAKE	"THE FIRST OF SEPTEMBER"	11/80	CNY	9	A	12 X 10	1855/V	PD	BI
PULHAM, PETER ROSE	"CHRISTIAN BERARD"	11/80	CNY	455	S	8 X 8	C1937/V	S,T,D	BI
PULHAM, PETER ROSE	PORTRAIT: PABLO PICASSO	11/80	SNY	230	S	9 X 9	C1936/V		400
PULHAM, PETER ROSE	PORTRAIT: EUGENE BERMAN	11/80	SNY	232	S	8 X 8	1937-39/V	S,I,ST	BI
PULHAM, PETER ROSE	PORTRAIT: SALVADOR DALI	11/80	SNY	231	S	8 X 8	1937-38/V	I	400
QUETIER, E.	ARCHITECTURAL STUDIES (2 PHOTOS)	5/81	SNY	103	A	14 X 18	1870'S/V	ST/P	200
RABINOVITCH, BEN MAGRID	NUDE TORSO	5/81	SNY	541	S	14 X 11	1930'S/V	S	350
RAU, WILLIAM H.	RAILROAD LIVESTOCK CAR (5 PHOTOS)	11/80	SW	365	A?	8 X 10	C1890/V		100
RAUSCHENBERG, ROBERT	"STOP" (ED.:29/50)	2/81	SLA	380	S	12 X 12	1979/V	S,D,A	600
RAUSCHENBERG, ROBERT	PORTFOLIO:RUSCHENBERG (ED.:26/50)	2/81	SLA	381	S	12 X 12	1979/80	S,D,A	4,750
RAUSCHENBERG, ROBERT	"WINDOW" (ED.:29/50)	2/81	SLA	382	S	12 X 12	1979/V	S,D,A	600
RAY, MAN	"PORTRAIT OF BONA"	2/81	SLA	322	S	6 X 4	1930'S/V	S,T,ST	BI
RAY, MAN	GREETINGS, 1959 JULIE AND MAN RAY	4/81	PNY	54	S	3 X 4	1959/V	ST	200
RAY, MAN	KATHERINE DUNHAM	4/81	PNY	182	S	8 X 10	1940'S/50'S	ST,A	BI
RAY, MAN	PORTAIT: AVA GARDNER	4/81	PNY	192	S	10 X 8	1950'S/V	ST,A	BI
RAY, MAN	PORTRAIT: SELMA BROWNER	4/81	PNY	193	S	10 X 8	1950'S/V	ST	BI
RAY, MAN	MONSIEUR J.V.	5/81	CNY	83	S	9 X 7	1922/V	S,A,ST/E	800
RAY, MAN	PEN AND BASKET (RAYOGRAPH)	5/81	CNY	84	S	12 X 9	1924/V	S,D,ST/E	BI
RAY, MAN	ANDRE BRETON	5/81	CNY	85	S	9 X 7	C1930/V	ST,A/E	7,000
RAY, MAN	"CHEZ RENE CHAR L'ISLE SUR SORGUE"	5/81	CNY	86	S	9 X 7	1935/V	I,T,ST,D/M	BI
RAY, MAN	MR. KNIFE AND MRS. FORK (RAYOGRAPH)	5/81	CNY	87	S	12 X 9	1966/V	S,D,T,I/M	4,200
RAY, MAN	PORTRAIT: GERTRUDE STEIN BY PICASSO	5/81	PNY	288	S	8 X 7	1922/V	T,ST,I	275
RAY, MAN	SUNFLOWER	5/81	SNY	224	S	5 X 4	1930'S/V	ST/E	800
RAY, MAN	SURREALIST GROUP PORTRAIT	5/81	SNY	225A	S	8 X 9	1940'S/V	ST/P	600
RAY, MAN	TWO CALLA LILIES	5/81	SNY	225	S	14 X 11	1930/V	ST,S/E	4,500
RAY, MAN	"DEMAIN" (ED: 6/6)	5/81	SNY	552	S	15 X 11	1932/67	S,T,D,A/E	3,750
RAY, MAN	"SEATED NUDE"	5/81	SNY	553	S	12 X 9	1934/V	S,T,D,ST/G-E	6,000
RAY, MAN	FEMALE TORSO IN 2 PARTS (2 PRINTS)	5/81	SNY	554	S	6 X 4	1935/V	S,D,A/E	6,000
RAY, MAN	"JULIET AND MARGARET"	5/81	SNY	555	S	14 X 11	C1941/V	S,ST,T,I/E	5,250
RAY, MAN	"NUE DE DOS"	5/81	SNY	556	S	13 X 10	1930'S/C48	S,ST,A/F	4,750
RAY, MAN	STUDY OF A MANNEQUIN	5/81	SNY	557	S	7 X 6	1938/66	ST	250
RAY, MAN	TILLIE LOSCH (ED. 3)	10/80	PT	177	S	10 X 8	C1950/V	ST	BI
RAY, MAN	EV LA TOUR	11/80	CNY	303	S	12 X 9	1930/V	S,A,ST/M	9,000
RAY, MAN	KIKI AND THE AFRICAN MASK	11/80	CNY	304	S	7 X 9	1930'S/V	ST,A/G	4,200
RAY, MAN	SALVADOR DALI	11/80	CNY	305	S	8 X 7	1932-39/V	S,T,D,I/G	3,000
RAY, MAN	PORTRAIT: VIRGINIA WOOLF	11/80	PNY	61	S	9 X 7	1935/V	ST,I	1,500
RAY, MAN	PORTRAIT: GERTRUDE STEIN	11/80	PNY	62	S	5 X 4	1920'S/V		950
RAY, MAN	PORTRAIT: ILKE CHASE	11/80	PNY	63	S	9 X 7	C1929/V	S,ST	850
RAY, MAN	"HAWAIIAN MASK"	11/80	PNY	64	S	11 X 7	1920'S/V	ST	1,800
RAY, MAN	"ELECTRITE"	11/80	PNY	65	PG	10 X 8	1931/V	SN,T	BI
RAY, MAN	"SHADOWS"	11/80	SNY	183	S	12 X 8	1920/C1972	N,ST	800
RAY, MAN	WOMAN WITH THERMOMETER EARRING	11/80	SNY	184	S	10 X 8	1920/C1972	N,ST	750
RAY, MAN	"NUE DE DOS"	11/80	SNY	185	S	14 X 10	1930'S/1948	S,D,ST	4,750
RAY, MAN	PORTRAIT OF LILLIAN FISCHER	11/80	SNY	186	S	9 X 7	1935/V	S,D,ST	3,500
RAY, MAN	WOMAN IN BLACK BRIEFS AND STOCKINGS	11/80	SW	336	S	12 X 9	1930/V	S,ST	4,000
RAY, MAN	PORTRAIT: WOMAN (NANCY CUNARD?)	11/80	SW	337	S	11 X 9	C1930/V	S	400
RAY, MAN	PORTRAIT: PICASSO (CLOSE FACE STUDY)	11/80	SW	339	S	12 X 9	1932/V	A,ST	BI
RAY, MAN	PORTRAIT: MIRIAM HOPKINS	11/80	SW	340	S	7 X 5	C1950/V	S,ST	225
REED, LEWIS	POTTERY	4/81	PNY	68	S	19 X 15	1940'S/V	S,ST	225

PHOTOGRAPHER	TITLE OR DESCRIPTION	DATE	AH	LOT#	PT	SIZE	N/P DATES	MARKS/COND.	PRICE
REED, LEWIS	POTTERY	4/81	PNY	69	S	16 X 13	1940'S/V	S	140
RENGER-PATZSCH, ALBERT	FLOWERING CACTUS	2/81	SLA	385	S	9 X 7	1930'S/V	ST	600
RENGER-PATZSCH, ALBERT	BRETONISCHE KUSTE AUS DEM BUCH GESTEIN	5/81	CNY	110	S	11 X 15	1965/V	ST/E	1,000
RENGER-PATZSCH, ALBERT	PAULIKIRCHE BRANDENBURG	5/81	CNY	111	S	9 X 6		ST/E	750
RENGER-PATZSCH, ALBERT	"GEHOFT IN SOSA"	5/81	PNY	203	S	7 X 9	C1935/V	T,ST/G-E	350
RENGER-PATZSCH, ALBERT	GARDEN STAIRCASE	5/81	SNY	174	S	9 X 7	1930'S/V	ST/G	400
RENGER-PATZSCH, ALBERT	GESTEIN STRAMPORT UND EROSION	11/80	CNY	327	S	9 X 6	1930'S/V	ST,T	BI
RENGER-PATZSCH, ALBERT	LILY PADS	11/80	CNY	327A	S	7 X 9	1930/V	ST	BI
RENGER-PATZSCH, ALBERT	SHOE VENDOR'S CART	11/80	CNY	328	S	7 X 9	1930/V	ST	BI
RENGER-PATZSCH, ALBERT	ESCHWEILLER BERGWERKS-VEREIN	11/80	CNY	329	S	7 X 9	1930/V	ST,PD	BI
RENGER-PATZSCH, ALBERT	"FENCE"	11/80	PNY	12	S	7 X 9	1929/V	ST	BI
RENGER-PATZSCH, ALBERT	CHURCH INTERIOR	11/80	PNY	13	S	9 X 7	C1930/V	ST	BI
RENGER-PATZSCH, ALBERT	CHURCH INTERIOR	11/80	PNY	14	S	9 X 7	1928/V	ST	400
RENGER-PATZSCH, ALBERT	INDUSTRIAL	11/80	PNY	15	S	9 X 7	?/C1950	ST	400
RENGER-PATZSCH, ALBERT	BOOKBINDER	11/80	PNY	16	S	9 X 7	C1930'S/V	ST	300
RENGER-PATZSCH, ALBERT	PRINTER (SETTING TYPE)	11/80	PNY	17	S	9 X 7	C1930'S/V	ST	BI
RENGER-PATZSCH, ALBERT	STILL LIFE, BIRD'S EGGS AND SHELLS	11/80	PNY	18	S	7 X 9	1926/V	A	BI
RENGER-PATZSCH, ALBERT	FLOWER STUDY	11/80	PNY	19	S	9 X 7	1920'S	ST	350
RENGER-PATZSCH, ALBERT	"YAWNING BABOON" AND "BABOON" (2 PRTS)	11/80	PNY	20	S	9 X 7	C1928/V	T,ST	850
RHODE ISLAND SCH OF DESGN	PORTFOLIO: 1966-67/14 PR. (ED: 7/100)	11/80	CNY	628	S		1966-67/V	T,D	BI
RHODE ISLAND SCH OF DESGN	PORTFOLIO: 1967-68/20 PR. (ED: 9/150)	11/80	CNY	629	S		1967-68/V	S,T,D	BI
RICE, LELAND	"WALL SITE, SPRAY BOOTH" (ED: 42/100)	2/81	SLA	386	CP	18 X 22	1978/V	S,T,D,A	150
RICE, M. P.	GENERAL ULYSEES S. GRANT	11/80	CNY	129	A	15 X 11	C1868/1901	IN,A	350
RICHEE, EUGENE ROBERT	MARLENE DIETRICH (9 PORTRAITS 2 ANON.)	11/80	SNY	247	S	13 X 10	1930'S/V	ST(2)	800
ROBERT, LOUIS-REMY	STILL LIFE (SEVRES PORCELAIN GROUP)	11/80	CNY	56	CN	12 X 10	C1860/V	SN	BI
ROBERT, LOUIS-REMY	"THE GARDEN, ST. CLOUD" (NEGATIVE)	5/81	SNY	94		14 X 11	1850'S/V	/E	BI
ROBERTSON, JAMES	CONSTANTINOPLE AND THE CRIMEA	5/81	PNY	3	SA	10 X 11	1855/V	IN/G	BI
ROBINSON, HENRY PEACH	"HARK! HARK! THE LARK!!"	11/80	CNY	37	A	11 X 15	1882/V	S,T,D	BI
ROBINSON, HENRY PEACH	"A PUZZLING QUESTION"	11/80	CNY	38	A	11 X 15	1881/V	S,T,D	BI
ROBINSON, HENRY PEACH	PORTRAIT GROUP	11/80	CNY	39	A	11 X 15	1881/V	S,T,D	BI
ROMAINE	KING & ROCHE AT THE FOLIES BURLESQUE	4/81	PNY	131	S	10 X 8	C1940/V	S,ST	BI
ROSENBLUM, WALTER	TWO GIRLS BEHIND SCREEN	4/81	PNY	93	S	6 X 5	1940'S/V	S	BI
ROSSLER, JAROSLAV	GIRDERS	11/80	PNY	146	S	10 X 9	1927/V	S,D	750
ROSSLER, JAROSLAV	UNTITLED	11/80	PNY	147	S	9 X 9	C1923/V	S	1,000
ROSSLER, JAROSLAV	"PARIS II" (WOMAN'S EYE)	11/80	PNY	148	S	7 X 7	C1931/V	S,T,ST	500
ROSSLER, JAROSLAV	"PARIS II" (PARTIAL PHOTOMONTAGE)	11/80	PNY	149	S	9 X 9	C1931/V	S,T,D	1,700
ROSSLER, JAROSLAV	"ACCORDIAN PLAYER, PARIS"	11/80	PNY	150	S	12 X 10	1933/V	S,T,D,ST	950
ROSSLER, JAROSLAV	ABSTRACTION	5/81	PNY	159	S	7 X 9	1924/V	S,D/G	BI
ROSSLER, JAROSLAV	"PARIS II"	5/81	PNY	160	S	8 X 6	1928/V	S,T,D/F	600
ROSSLER, JAROSLAV	"CREME DE JOUR"	5/81	PNY	161	S	9 X 9	1931/V	S,D,ST/F	BI
ROSSLER, JAROSLAV	TOOTHBRUSH	5/81	PNY	162	S	10 X 7	1933/V	S,D/F	BI
ROTAN, THURMAN	ST. MARK'S SQUARE, VENICE	4/81	PNY	67	S	7 X 9	1940'S/V	ST,S	300
ROTAN, THURMAN	"SKYSCRAPER, DAILY NEWS BUILDING"	5/81	CNY	130	S	59 X 30	1932/L	S,T,D,ST/E	1,700
ROTAN, THURMAN	FIFTH AVENUE, NEW YORK	5/81	PNY	89	S	4 X 3	1925/V	S,ST	600
ROTAN, THURMAN	CONEY ISLAND, BROOKLYN, NEW YORK	5/81	PNY	90	S	3 X 4	1926/V	S,T,D,ST	375
ROTAN, THURMAN	"SKYSCRAPERS"	5/81	SNY	315	S	11 X 22	1932/70'S	S,T,D,ST	700
ROTAN, THURMAN	PHOTOMONTAGE DAILY NEWS BUILDING	11/80	CNY	471	S	10 X 19	1932/V	S,D,ST	500
ROTAN, THURMAN	"ST. MARK'S SQUARE, VENICE"	11/80	CNY	472	S	7 X 9	1958/V	S,T,D	BI
ROTAN, THURMAN	"DOCK, NEW ORLEANS"	11/80	PNY	184	S	4 X 4	1933/V	S,T,D	325
ROTH, SANFORD H.	PORTRAIT: JAMES DEAN	2/81	SLA	388	S	14 X 11	1955/V	T,D,ST	350
ROTH, SANFORD H.	PORTRAIT: MAURICE UTRILLO	2/81	SLA	389	S	14 X 11	1950'S/V	T,ST	75
ROTH, SANFORD H.	"ZADKINE STUDIO"	2/81	SLA	390	S	9 X 13	1952/V	S,T,D	125
ROTHSTEIN, ARTHUR	"DUST STORM, CIMARRON COUNTY, OKLA."	2/81	SLA	391	S	7 X 7	1936/L	S	400
ROTHSTEIN, ARTHUR	FARM ISOLATED BY FLOODING/SHENANDOAH	2/81	SLA	392	S	8 X 8	1930'S/V	T,ST	225
ROTHSTEIN, ARTHUR	UNEMPLOYED YOUTH, BIRMINGHAM, ALABAMA	4/81	PNY	104	CP	13 X 10	1940/1970'S	S,T,D	BI
ROTHSTEIN, ARTHUR	U.S.ARMY RECRUITS/FORT SLOCUM, N.Y.	4/81	PNY	105	S	10 X 13	1941/1970'S	S,T,D	250
ROTHSTEIN, ARTHUR	MISSISSSIPPI RIVER FLOOD, ST. LOUIS MO	4/81	PNY	106	S	9 X 12	1943/1970'S	S,T,D	275
ROTHSTEIN, ARTHUR	YOUNG COAL MINER, WALES	4/81	PNY	107	S	12 X 9	1947/1970'S	S,T,D	250
ROTHSTEIN, ARTHUR	"DUST STORM, CIMMARON COUNTY, OK."	4/81	SW	367	S	15 X 15	1936/L	S/F	325
ROTHSTEIN, ARTHUR	BOY WITH CHICKEN, HUNGJAO, CHINA	5/81	PNY	270	S	10 X 8	1945/L	S,T,D,ST	275
ROTHSTEIN, ARTHUR	DUST STORM, CIMARRON COUNTY, OKLAHOMA	10/80	PT	153	S	10 X 10	1936/L	S,T,D	650

PHOTOGRAPHER	TITLE OR DESCRIPTION	DATE	AH	LOT#	PT	SIZE	N/P DATES	MARKS/COND.	PRICE
ROTHSTEIN, ARTHUR	RURAL SCHOOL, ALABAMA	10/80	PT	154	S	10 X 13	1938/L	S,T,D	260
ROTHSTEIN, ARTHUR	"VERNON EVANS, MIGRANT TO OREGON"	10/80	PT	155	S	10 X 13	1936/L	S,T,D	260
ROTHSTEIN, ARTHUR	"DUST STORM, CIMARRON COUNTY, OKLA."	11/80	CNY	384	S	15 X 15	1936/1970'S	S,T,D	500
ROTHSTEIN, ARTHUR	INTERIOR, HOTEL DE PARIS, COLORADO	11/80	PNY	273	S	18 X 13	1939/V	S,T,D,ST	350
ROTHSTEIN, ARTHUR	MIGRANT CHILDREN, CALIFORNIA	11/80	PNY	274	S	14 X 11	1938/V	S,T,D	BI
ROTHSTEIN, ARTHUR	GEE'S BEND, ALABAMA	11/80	PNY	275	S	16 X 20	1937/V	S	375
ROTHSTEIN, ARTHUR	WASHINGTON, D.C.	11/80	PNY	276	S	13 X 10	1937/V	S,T,D,ST	375
RUBIN, GENIA	TORSO, HAND AND GLADIOLA	5/81	SNY	590	S	16 X 12		S	175
RUBIN, GENIA	DRAPED NUDE	5/81	SNY	591	S	16 X 12		S	150
RUBIN, GENIA	NUDE	5/81	SNY	592	S	16 X 12		S	100
RUBINSTEIN, EVA	STAIRWAY/DOORWAYS (2 PRINTS, ED: 35)	2/81	SLA	393	S	6 X 8	1975/V	S	400
RUBINSTEIN, EVA	GIRL ON TRAIN-LONDON/SISTERS-ITALY (2)	5/81	PNY	322	S	6 X 8	C1970/L	S	275
RUBINSTEIN, EVA	"BED IN MIRROR"/"MIRROR ON CORNER" (2)	5/81	SNY	525	S	6 X 9	1972/V	S,D,T,ST/M	400
RUBINSTEIN, EVA	NUDE	11/80	CNY	570A	S	6 X 9	1972/V	S,D	180
RUZICKA, DRAHOMIR JOSEPH	PENNSYLVANIA STATION, NEW YORK	5/81	PNY	84	S	14 X 10	1919/V	S,T,ST	500
RUZICKA, DRAHOMIR JOSEPH	PICNIC	5/81	PNY	157	PI	6 X 8	1910/V	D	400
SACHE, JOHN	NYNEE TAL (INDIA)	5/81	CNY	40	A	9 X 11	C1870/V	IN,T/F	BI
SALOMON, DR. ERICH	DISARMAMENT CONFERENCE, GENEVA 1928	5/81	SNY	167	S	5 X 4	1928/V	ST,T,A/G	BI
SALOMON, DR. ERICH	VERHANDLUNGSPAUSE IM PARIS	11/80	CNY	325	S	8 X 10	1930'S/V	ST,T	BI
SALOMON, DR. ERICH	VERHANDLUNGSPAUSE IM PARIS (VARIANT)	11/80	CNY	326	S	8 X 10	1930'S/V	ST,T	300
SALOMON, DR. ERICH	"MADAME VACARESCU ..."	11/80	SNY	167	S	5 X 7	1928/V	ST,I	1,000
SALZMANN, AUGUSTE	JERUSALEM, TOMBEAU DES ROIS DE JUDA	5/81	CNY	31	SA	9 X 13	1854/56	PD/E	1,100
SALZMANN, AUGUSTE	JERUSALEM, VALLEE DE JOSAPHAT	5/81	PNY	53	SA	6 X 9	1855-56/V	S,T	BI
SALZMANN, AUGUSTE	"JERUSALEM, ENCEINTE DU TEMPLE"	11/80	CNY	52	SA	13 X 9	1850'S/V	PD,T	900
SAMARAS, LUCAS	PHOTO TRANSFORMATION (POLAROID)	11/80	CNY	637	CP	2 X 3	1973/V	D	BI
SANDER, AUGUST	GRANDMOTHER WITH CHILD	5/81	CNY	108	S	9 X 6	1913/V	ST,S,D,T/E	BI
SANDER, AUGUST	"INDUSTRIALIST (HERR WEINBRENNER)"	5/81	SNY	164	S	9 X 6	1914/V	S,T,D/M	
SANDER, AUGUST	"DOMESTIC SERVANT" (2 PHOTOS)	5/81	SNY	165	S	4 X 2	1916/V	S,D/G	500
SANDER, AUGUST	TOWN PHILOSOPHERS	5/81	SNY	166	S	11 X 8	1931/V	S,D,T/E	1,200
SANDER, AUGUST	TWO COUPLES	10/80	PT	87	S	9 X 7	1910/L	ST	475
SANDER, AUGUST	"BAUERNMADCHEN" (PEASANT GIRLS)	10/80	PT	88	S	8 X 5	1928/78		130
SANDER, AUGUST	BRICK MASON	10/80	PT	89	S	8 X 5	1920'S/78		150
SANDER, AUGUST	KINDER MIT SCHAF	11/80	CNY	321	S	14 X 11	1920'S/70'S	ST	150
SANDER, AUGUST	"THE HUNTER"	11/80	PNY	66	S	10 X 7	1920/V	ST	BI
SANDER, AUGUST	PORTRAIT: A FAMILY	11/80	PNY	67	S	9 X 11	C1920/V	ST	BI
SANDER, AUGUST	"TRAVELLING CARPENTERS"	11/80	PNY	68	S	7 X 5	C1928/V	T,ST	1,100
SANDER, AUGUST	"APARTMENT HOUSES IN COLOGNE"	11/80	PNY	69	S	9 X 7	C1929/V	T	1,000
SANDER, AUGUST	"CARVINGS ON HOUSE"	11/80	PNY	70	S	9 X 7	C1930'S/V	ST,T	400
SANDER, AUGUST	"CROSS IN HEDGE"	11/80	PNY	71	S	9 X 7	C1930'S/V	T,ST	BI
SANDER, AUGUST	"COLLAGE FOR COLOGNE MARDI GRAS"	11/80	PNY	72	S	7 X 9	1929/V	SN,D	1,300
SANDER, AUGUST	PHOTOGRAPHER AND BROTHER ADOLPH	11/80	SNY	165	S	12 X 9	C1905/V	ST,I,S	1,200
SANDER, AUGUST	BOY IN A SAILOR SUIT	11/80	SNY	166	S	9 X 7	E. 1900'S/V	ST	600
SANDER, AUGUST	"PROF. KORENSKI"	11/80	SW	366	GB	9 X 7	1906/V	S,D	BI
SANDER, AUGUST	"THE ORGAN GRINDER"	11/80	SW	368	S	11 X 8	1937/V	S	1,700
SASGEN, PETER	FEMALE NUDE, STANDING (FRONTAL)	5/81	PNY	339	S	14 X 11	1979/V	S,D,ST	175
SAUDEK, JAN	CHILD WITH ROSE	5/81	SNY	582	S	10 X 9	1970'S/V	S	250
SAUDEK, JAN	"THIS STAR'S MINE"	5/81	SNY	583	S	9 X 9	1978/V	S,T,D	300
SAUDEK, JAN	FEMALE NUDE	5/81	SNY	584	S	9 X 9	1970'S/V	S	150
SAUDEK, JAN	"12 PHASES OF A DYING ROSE" (ED. 50)	10/80	PT	235	S	15 X 11	1975/V	S,A	BI
SAUDEK, JAN	TORSO DRAPED IN WET CLOTH (ED. 50)	10/80	PT	236	S	11 X 11	1975/V	S,D,A	BI
SAUDEK, JAN	"HEY, JOE!" (ED. 50)	10/80	PT	237	CP	11 X 11	1979/V	S,T,D,A	BI
SCAVULLO, FRANCESCO	FEMALE NUDES (2 PHOTOS)	11/80	SNY	501A	CP	13 X 20	1970'S/V	S	250
SCHELL, SHERRIL	PORTRAIT: JOSE CLEMENTE OROZCO	11/80	SNY	232A	S	12 X 8	1932/V	S	300
SCHMIDT, JOOST	FLOWER STUDY	5/81	PNY	194	S	9 X 7	1920'S/V	T?	BI
SCHNEEBERGER, ADOLF	"FILM SPOOLS"	11/80	PNY	151	S	10 X 9	1926/V	ST	BI
SCHNEEBERGER, ADOLF	"THE BEGGAR"	11/80	PNY	152	S	11 X 9	1926/V	S,D,T	350
SCHNEEBERGER, ADOLF	"AT THE WATER MILL"	11/80	PNY	153	S	9 X 10	1926/V	S,D,T	BI
SCHUTZER, PAUL	GENERAL DOUGLAS MACARTHUR	11/80	CNY	534	S	14 X 9	1958/V	ST	BI
SCHUTZER, PAUL	"FREEDOM RIDERS"	11/80	CNY	534A	S	13 X 18	1957/V	S,T,D	200
SEBAH, P.	VIEW OF CONSTANTINOPLE (PANAROMA-8 PR)	11/80	CNY	79	A	11 X102	C1868/V	T	160

PHOTOGRAPHER	TITLE OR DESCRIPTION	DATE	AH	LOT#	PT	SIZE	N/P DATES	MARKS/COND.	PRICE
SEBAH, P.	CITIES & MONUMENTS OF HOLY LAND (6)	11/80	SW	369	A	10 X 14	1870'S/V	SN,IN	300
SEDING, VOLKER	"BROKEN CIRCLE" (ED: 12)	5/81	PNY	340	S	13 X 19	1980/V	S,D,T	350
SEDING, VOLKER	"AERIAL VIEW: NIGHT & DAY..." (ED: 12)	5/81	PNY	341	S	12 X 20	1980/V	S,D,T	300
SEIDENSTUCKER, FRIEDRICH	ROOFTOPS WITH GARGOYLE	11/80	PNY	73	S	7 X 5	1930'S/V	ST	BI
SELIGMANN, HERBERT J.	"CITYSCAPE"	11/80	PNY	189	S	4 X 3	1930'S/V		BI
SHAHN, BEN	"DESTITUTE OZARK MOTHER & CHILD, ARK."	11/80	SNY	301	S	11 X 14	1935/V		550
SHEELER, CHARLES	PORTRAIT: ALDOUS HUXLEY	5/81	SNY	286	S	10 X 8	1927/V	/G	BI
SHEELER, CHARLES	FUNNEL	11/80	CNY	263	S	10 X 8	1927/V	ST	BI
SHEELER, CHARLES	WATERLILY	11/80	SNY	253	S	10 X 8	1981/V	ST,I	8,500
SHEELER, CHARLES	PORTRAIT: MRS. CHARLES SHEELER	11/80	SNY	254	S	8 X 7	1939/V	I	600
SHEELER, CHARLES	BOULDER DAM, COLORADO	11/80	SNY	255	S	6 X 9	1939-40/V	S	2,500
SHEELER, CHARLES	ASSYRIAN RELIEF	11/80	SNY	256	S	8 X 10	1942/V		4,500
SHIGETA, HARRY K.	PORCELAIN	11/80	CNY	344	S	13 X 10	C1930/V	S,T,ST	160
SHORE, STEPHEN	GIVERNY, FRANCE	11/80	CNY	612	CP	16 X 20	1976/V	S,T	400
SHORE, STEPHEN	SCREVEN STREET, GEORGETOWN, S CAROLINA	5/81	PNY	333	CP	8 X 10	1977/V	S,T,D	BI
SINSABAUGH, ART	"AMERICAN LANDSCAPES" (7 PR, ED: 4/10)	5/81	SNY	523	S	8 X 20	1969-70/L	S,T,D,A	3,000
SIPPRELL, CLARA E.	PORTRAIT: ALFRED STIEGLITZ	2/81	SLA	397	S	10 X 7	C1940/L		350
SIPPRELL, CLARA E.	PORTRAIT: ALFRED STIEGLITZ	10/80	PT	182	S	8 X 6	C1940/L		140
SIPPRELL, CLARA E.	MAN SITTING ON A STREET CORNER	11/80	PNY	235	P	9 X 5	C1930/V	S	275
SIPPRELL, CLARA E.	NUN LEAVING A CATHEDRAL	11/80	SNY	164A	P	5 X 4	1917/V	S,D	150
SISKIND, AARON	"ACOLMAN 2"	2/81	SLA	398	S	14 X 18	1955/L	S,T,D	375
SISKIND, AARON	"NEW YORK 288"	2/81	SLA	399	S	9 X 9	1978/V	S,T,D	300
SISKIND, AARON	"CELAYA"	2/81	SLA	400	S	13 X 18	1955/L	S,T,D	375
SISKIND, AARON	"NEW YORK 329"	2/81	SLA	401	S	9 X 9	1978/V	S,T,D	300
SISKIND, AARON	"CALIFORNIA 15"	2/81	SLA	402	S	10 X 9	1978/V	S,T,D	300
SISKIND, AARON	GLOUCESTER 10	4/81	PNY	15	S	8 X 10	1951/V	S,T,D	150
SISKIND, AARON	NEW YORK	4/81	PNY	16	S	10 X 13	1951/L	S,T,D	350
SISKIND, AARON	"FEET 102"	5/81	CNY	191	S	12 X 10	1957/V	S,T,D/E	400
SISKIND, AARON	"ROME 62" (HOMAGE TO FRANZ KLINE)	5/81	CNY	192	S	15 X 15	1973/L	S,T,D/M	550
SISKIND, AARON	"KENTUCKY"	10/80	PT	211	S	18 X 14	1951/L	S,T,D	BI
SISKIND, AARON	"CHICAGO"	10/80	PT	212	S	14 X 18	1960/L	S,T,D	400
SISKIND, AARON	JALAPA	10/80	PT	213	S	8 X 8	1947/74	T,D	160
SISKIND, AARON	"GLOVE GLOUCESTER, MASS."	11/80	CNY	579	S	13 X 10	1944/70'S	S,T,D	650
SKEEN, W.L.H. & CO.	CEYLON (28 PRINTS)	11/80	CNY	82	A	VARIOUS	C1880/V	S,IN	BI
SKEEN, W.L.H. & CO.	SCENES FROM INDIA (5 PRINTS)	5/81	PNY	63	A	10 X 8	1880'S/V	IN,T/G	BI
SMITH, DAVID	SCULPTURE STUDY	11/80	SNY	269	S	7 X 10	1933/V	S,D	2,000
SMITH, W. EUGENE	"SAIPAN, 1944" (ED. 30)	2/81	SLA	403	S	13 X 10	1944/L	S	2,100
SMITH, W. EUGENE	"YOUNG ACTRESS, JEAN SOMEBODY"	2/81	SLA	404	S	14 X 10	1949/V	S,ST,A	800
SMITH, W. EUGENE	"WALES"	2/81	SLA	405	S	7 X 13	1950/L	S	1,500
SMITH, W. EUGENE	"A SPANISH WAKE" (ED. 30)	2/81	SLA	406	S	9 X 13	1951/L	S	BI
SMITH, W. EUGENE	"GUARDIA CIVIL" (SPANISH VILLAGE)	2/81	SLA	407	S	7 X 9	1951/V	S	1,700
SMITH, W. EUGENE	WOMAN CARRYING BREAD (SPANISH VILLAGE)	2/81	SLA	408	S	14 X 8	1951/V	S	1,100
SMITH, W. EUGENE	"SPANISH SPINNER" (ED. 30)	2/81	SLA	409	S	13 X 9	1951/L	S	2,600
SMITH, W. EUGENE	"NURSE MIDWIFE, N. CAROLINA" (ED. 30)	2/81	SLA	410	S	13 X 10	1951/L	S	1,900
SMITH, W. EUGENE	"PORTUGAL"	2/81	SLA	411	S	9 X 13	1954/V	S	750
SMITH, W. EUGENE	"KAMA II" (MINAMATA)	2/81	SLA	412	S	11 X 14	1972/V	ST	BI
SMITH, W. EUGENE	CHARLIE CHAPLIN IN "LIMELIGHT"	2/81	SLA	413	S	11 X 14	1951/V	S	600
SMITH, W. EUGENE	PROP VIOLINS FROM "LIMELIGHT"	2/81	SLA	414	S	11 X 14	1951/V	S	BI
SMITH, W. EUGENE	CHARLIE CHAPLIN & ... IN "LIMELIGHT"	2/81	SLA	415	S	9 X 14	1951/V	S,ST	500
SMITH, W. EUGENE	PORTRAIT: YUL BRYNNER ("THE KING & I")	2/81	SLA	416	S	13 X 11	1951/V	S	475
SMITH, W. EUGENE	MOTHER AND CHILD, SPAIN	4/81	PNY	21	S	13 X 10	C1951/V	S	1,800
SMITH, W. EUGENE	BROKEN WINDOW	4/81	PNY	22	S	17 X 14	1957-58/V		1,500
SMITH, W. EUGENE	GIRL ON STAIRWELL BANISTER, NEW YORK	4/81	SW	369	S	12 X 8	1960'S/V	ST	BI
SMITH, W. EUGENE	CHILD HOLDING ADULT'S HAND AT CRIB	4/81	SW	370	S	7 X 9	C1960/V	A	BI
SMITH, W. EUGENE	G.I. BATHING IN THE RAIN, WW II	5/81	CNY	164	S	13 X 10	1944/V	S,ST/E	1,600
SMITH, W. EUGENE	WOMAN, WALES	5/81	CNY	165	S	13 X 15	1950/L	S	1,600
SMITH, W. EUGENE	HAITI (GIRL CARRYING PAN ON HEAD)	5/81	CNY	165A	S	19 X 13	1958/C60	ST/M	BI
SMITH, W. EUGENE	WELSH MINERS	5/81	PNY	274	S	10 X 13	1950/L	S,T	2,900
SMITH, W. EUGENE	SKULL	5/81	SNY	489	S	7 X 6	1950-60/V	S,ST/E	1,500
SMITH, W. EUGENE	JUANITA DRAWING	5/81	SNY	490	S	15 X 11	1953/V	S,D/G	1,200
SMITH, W. EUGENE	"SCHOOL CHILD, SPANISH VILLAGE"	10/80	PT	206	S	13 X 10	1951/L	S	BI

PHOTOGRAPHER	TITLE OR DESCRIPTION	DATE	AH	LOT#	PT	SIZE	N/P DATES	MARKS/COND.	PRICE
SMITH, W. EUGENE	"THE CARE OF MENTAL PATIENTS, HAITI"	10/80	PT	207	S	8 X 12	1959/L	S,T,D	1,200
SMITH, W. EUGENE	"BREAD, SPANISH VILLAGE"	11/80	CNY	536	S	13 X 10	1951/L	S,T	2,400
SMITH, W. EUGENE	CLASSROOM (SPANISH VILLAGE)	11/80	CNY	537	S	10 X 13	1951/L	S	1,000
SMITH, W. EUGENE	"MAD HANDS-AFRICA"	11/80	CNY	538	S	6 X 8	1954/L	S,T,D	2,200
SMITH, W. EUGENE	GRANDMA MOSES	11/80	CNY	539A	S	13 X 10	C1950/V	S,ST	550
SMITH, W. EUGENE	TOMOKO AND HER MOTHER, MINAMATA	11/80	CNY	540	S	8 X 13	1972/L	S	3,800
SMITH, W. EUGENE	GRAIN HARVEST	11/80	SNY	361	S	13 X 11	1951/V	ST	950
SMITH, W. EUGENE	WOMEN THRESHING WHEAT	11/80	SNY	362	S	14 X 11	1951/V		1,200
SMITH, W. EUGENE	MARKETPLACE	11/80	SNY	363	S	14 X 10	1951/V	ST	1,300
SMITH, W. EUGENE	AFRICAN WORKER	11/80	SNY	364	S	10 X 13	1954/V	ST	1,600
SMITH, W. EUGENE	AFRICAN VILLAGE	11/80	SNY	365	S	8 X 14	1954/V		1,200
SMITH, W. EUGENE	GOATS ON A ROOF	11/80	SNY	366	S	9 X 13	1954/V		1,200
SMITH, W. EUGENE	BALLROOM DANCING (PITTSBURGH)	11/80	SNY	367	S	13 X 9	1955/V	ST	BI
SMITH, W. EUGENE	LOVE (STREET SIGN, PITTSBURGH)	11/80	SNY	368	S	13 X 9	1955/V	S,ST	1,300
SMITH, W. EUGENE	PRIDE STREET (PITTSBURGH)	11/80	SNY	369	S	9 X 6	1955/V	S,T	2,800
SMITH, W. EUGENE	ASSEMBLY LINE (PITTSBURGH)	11/80	SNY	370	S	5 X 11	1955/V	ST	BI
SMITH, W. EUGENE	FLAMING COKE (PITTSBURGH)	11/80	SNY	371	S	7 X 13	1955/V	ST	1,600
SMITH, W. EUGENE	WELSH MINERS	11/80	SNY	372	S	9 X 13	1950/L	S,T,D	3,000
SMITH, W. EUGENE	MOVING DAY (HAITI)	11/80	SNY	373	S	14 X 8	1958/V	S,ST	1,300
SMITH, W. EUGENE	PORTRAIT OF A HAITIAN	11/80	SNY	374	S	19 X 14	1958/V	ST	1,500
SMITH, W. EUGENE	"KAMA II" (MINAMATA)	11/80	SNY	375	S	6 X 8	1972/V	I,ST	500
SMITH, W. EUGENE	"CHISSO-MINAMATA DISEASE"	11/80	SNY	376	S	6 X 9	1972/V	I,ST	400
SMITH, W. EUGENE	HACHIMAN "POOL" (MINAMATA)	11/80	SNY	377	S	6 X 8	1972/V	ST,I	350
SNOWDON (A. A. JONES)	TWO PORTRAITS OF ROBERT LEWIS	4/81	PNY	150	S	12 X 8	1950'S/V	ST	BI
SOLOMON, ROSALIND	DOLL	5/81	PNY	320	S	13 X 9	UNKNOWN	S	125
SOMMER, FREDERICK	"PRINCE ALBERT"	5/81	SNY	404	S	10 X 8	1947/V	S,T,D/M	3,250
SOMMER, FREDERICK	"FURIES"	5/81	SNY	405	S	10 X 8	1946/V	S,T,D/M	4,250
SOMMER, FREDERICK	FOUND PAINTING	5/81	SNY	406	S	5 X 10	1951/V	S,D	3,000
SOMMER, FREDERICK	"IDEE ET ORCHIDEE"	11/80	SNY	458A	S	10 X 8	1949/L	S,T,D,	4,500
SOUGEZ, EMMANUEL	PACKETBOAT 'ILE DE FRANCE' IN PORT	2/81	SLA	417	S	8 X 6	1940'S/V	ST	400
SOUGEZ, EMMANUEL (ATT.TO)	STILL LIFE	11/80	PNY	110	S	8 X 7	C1937/V		700
SOUTHWORTH, A./HAWES, J.	LOUIS KOSSUTH	5/81	CNY	42	D	WH-PL	C1851/V	/E	BI
SOUTHWORTH, A./HAWES, J.	ERASTUS HOPKINS	5/81	CNY	43	D	WH-PL	C1850/V	ST/M	8,000
SPERR, PERCY LOOMIS	SCENES OF NEW YORK (TRANSP.)(4 PRINTS)	5/81	PNY	94	S	VARIOUS	1930'S/V	S,T,ST	350
SPERR, PERCY LOOMIS	SCENES OF NEW YORK (PEOPLE)(4 PRINTS)	5/81	PNY	96	S	8 X 10	C1930'S/V	S,T	150
SPERR, PERCY LOOMIS	SCENES OF N.Y. (ST. SCENES)(4 PRINTS)	5/81	PNY	96	S	10 X 8	C1930'S/V	S,T	100
SPERR, PERCY LOOMIS	BROOKLYN BRIDGE AND SCENES (3 PHOTOS)	11/80	SW	351	S	8 X 10	C1920'S/V	S,T,ST,A	300
SPERR, PERCY LOOMIS	CHEESE VENDOR, PUSHCART,... (3 PHOTOS)	11/80	SW	352	S	8 X 10	C1920'S/V	S,T,ST,A	225
SPERR, PERCY LOOMIS	SEA FOOD, PICKLE STAND,...(3 PHOTOS)	11/80	SW	353	S	8 X 10	C1920'S/V	S,T,ST,A	275
ST. BARBE-WEST, HENRY	STILL LIFE	11/80	CNY	247	P	4 X 6	C1900/V		160
ST. BARBE-WEST, HENRY	THE STREAM	11/80	CNY	248	P	2 X 3	C1900/V		BI
ST. BARBE-WEST, HENRY	ANIMALS (ALBUM-31 PHOTOS @ LONDON ZOO)	5/81	SNY	38	S	VARIOUS	1920'S/V	/E	375
STAMM, PAUL	TWO EKTACOLOR PRS. (#31 & #58)	11/80	CNY	655	S	10 X 12	1970-71/V	S,T,D,ST	BI
STEGMEYER, WERNER	"NEW YORK AVENUE" (PHOTOMONTAGE)	5/81	PNY	118	S	7 X 13	1967/V	S	275
STEICHEN, EDWARD	FASHION PORTRAIT	2/81	SLA	424	S	10 X 8	1940/V	ST	300
STEICHEN, EDWARD	HELEN HAYES IN "COQUETTE"	2/81	SLA	418	S	10 X 8	1924/C.50'S	ST	550
STEICHEN, EDWARD	"CLUB HOLLYWOOD ENSEMBLE"	2/81	SLA	419	S	10 X 8	1931/V		550
STEICHEN, EDWARD	PORTRAIT: GERTRUDE LAWRENCE	2/81	SLA	420	S	10 X 8	1930/V	D,T,ST	400
STEICHEN, EDWARD	PORTRAIT: GRETA GARBO	2/81	SLA	421	S	9 X 7	1928/C50'S	ST,A	BI
STEICHEN, EDWARD	PORTRAIT: WINSTON CHURCHILL, NEW YORK	2/81	SLA	422	S	14 X 11	1932/50'S	ST	1,000
STEICHEN, EDWARD	"ABRAHAM LINCOLN, LIFEMASK"	2/81	SLA	423	S	9 X 7	1935/L	ST	225
STEICHEN, EDWARD	CUTEX ADVERTISEMENT	4/81	PNY	160	S	8 X 10	1929/V	ST	BI
STEICHEN, EDWARD	EXPERIMENT IN NEGATIVE COLOR	4/81	PNY	179	DT	9 X 7	1940/V	ST,A	800
STEICHEN, EDWARD	ZOLLMAN	4/81	PNY	180	S	10 X 8	1940/V	S,T,D,ST	BI
STEICHEN, EDWARD	"THE SPIRAL SHELL"	4/81	SW	371	S	14 X 11	1921/C.50'S	ST,A	BI
STEICHEN, EDWARD	ALFRED STIEGLITZ	5/81	CNY	67	S	9 X 8	C1905/50'S	ST,A/M	1,300
STEICHEN, EDWARD	MR. AND MRS. CARLETON SPRAGUE	5/81	CNY	68	P	7 X5	1906/V	S/G	BI
STEICHEN, EDWARD	THE FLAT-IRON, EVENING (HALFTONE)	5/81	CNY	69	PP	8 X 7	1906/V	/M	550
STEICHEN, EDWARD	TIME SPACE CONTINUUM, FRANCE	5/81	CNY	70	S	14 X 16	1920/C.50'S	A/E	1,800
STEICHEN, EDWARD	WILTED SUNFLOWER	5/81	CNY	71	S	14 X 10	1920/C.50'S	A/G	5,000
STEICHEN, EDWARD	MARTHA GRAHAM, NEW YORK	5/81	CNY	72	S	10 X 8	1931/V	/G	800

PHOTOGRAPHER	TITLE OR DESCRIPTION	DATE	AH	LOT#	PT	SIZE	N/P DATES	MARKS/COND.	PRICE
STEICHEN, EDWARD	VENERABLE TREE TRUNK, CONNECTICUT	5/81	CNY	73	S	17 X 14	1932/C.50'S	ST/M	BI
STEICHEN, EDWARD	RODIN-LE PENSEUR	5/81	PNY	223	S	13 X 16	1902/V	S,D/P	1,000
STEICHEN, EDWARD	ISADORA DUNCAN IN THE PARTHENON	5/81	SNY	290	S	9 X 7	1921/V	ST/P-F	1,700
STEICHEN, EDWARD	PORTRAIT: MYRNA LOY	5/81	SNY	291	S	17 X 14	1935/L	ST,A/M	850
STEICHEN, EDWARD	PORTRAIT: TALLULAH BANKHEAD	5/81	SNY	292	S	8 X 5	1937/V	I/F	450
STEICHEN, EDWARD	PORTRAIT: RAYMOND DITMARS	5/81	SNY	293	S	10 X 8	1930'S/V	A/G	500
STEICHEN, EDWARD	PORTRAIT: WINSTON CHURCHILL	5/81	SNY	294	S	10 X 8	1932/50'S	ST,A	BI
STEICHEN, EDWARD	"DOLOR" (PL. FROM CAMERA WORK 2)	5/81	SNY	535	PG	4TO	1902/V	S,D	550
STEICHEN, EDWARD	SELF PORTRAIT WITH SILK DESIGN	10/80	PT	170	S	10 X 8	C1929/V	T,ST	BI
STEICHEN, EDWARD	NOEL COWARD, NEW YORK	10/80	PT	171	S	10 X 7	1932/V	ST	1000
STEICHEN, EDWARD	DAWN-FLOWERS (CAMERA WORK 2)	11/80	CNY	231	PG	6 X 8	1902/V	S,D	650
STEICHEN, EDWARD	THE POOL (CAMERA WORK 2)	11/80	CNY	232	PG	8 X 6	1901/O3	S,D	500
STEICHEN, EDWARD	RODIN: LE PENSEUR (CAMERA WORK 11)	11/80	CNY	233	PG	6 X 7	1905/V		140
STEICHEN, EDWARD	BARTHOLOME (CAMERA WORK 2)	11/80	CNY	234	PG	8 X 6	1903/V		BI
STEICHEN, EDWARD	MOONLIGHT: THE POND (CAMERA WORK 19)	11/80	CNY	235	PG	6 X 8	1906/V		200
STEICHEN, EDWARD	3-COLOR HALFTONE (CAMERA WORK 15)	11/80	CNY	236	PP	6 X 8	1906/V		120
STEICHEN, EDWARD	PASTORAL - MOONLIGHT (CAMERA WORK 19)	11/80	CNY	236A	MP	6 X 8	1906/V		180
STEICHEN, EDWARD	CYCLAMEN-MRS.PHILIP LYDIG (CM WK 42/43)	11/80	CNY	236B	PG	8 X 6	1913/V		80
STEICHEN, EDWARD	E. GORDON CRAIG (CAMERA WORK 42/43)	11/80	CNY	236C	PG	8 X 6	1913/V		BI
STEICHEN, EDWARD	GRETA GARBO, HOLLYWOOD	11/80	CNY	237	S	10 X 8	1928/V	ST,A	BI
STEICHEN, EDWARD	THE RUSSIAN PUPILS OF ISADORA DUNCAN	11/80	CNY	238	S	10 X 8	1929/V	ST	1,500
STEICHEN, EDWARD	STILL LIFE - AVOCADOS	11/80	CNY	239	S	8 X 10	1930/V	ST,A	5,400
STEICHEN, EDWARD	CHARLES CHAPLIN	11/80	CNY	240	S	10 X 8	1930/V	ST,A/E	BI
STEICHEN, EDWARD	THE MAYPOLE - THE EMPIRE STATE BLDG.	11/80	CNY	241	S	16 X 13	1932/V	S,D,T,A	2,000
STEICHEN, EDWARD	"RODIN, LE PENSEUR"	11/80	SNY	234	S	11 X 13	1902/L	ST,T,D,I	1,800
STEICHEN, EDWARD	"THE TIME AND SPACE CONTINUUM"	11/80	SNY	235	S	8 X 10	C1920/L	ST,T,D,I	900
STEICHEN, EDWARD	PORTRAIT: GRETA GARBO	11/80	SNY	236	S	10 X 8	1928/1940'S	S,I,D	4,000
STEICHEN, EDWARD	PORTRAIT OF A WOMAN	11/80	SNY	237	S	11 X 9	1930'S/V	S	BI
STEICHEN, EDWARD	PORTRAIT: NICKOLAS MURAY	11/80	SNY	238	S	11 X 13	C1930/V	S,ST	BI
STEICHEN, EDWARD	"ST. NICOLAS FIGHTS..., AMEN"	11/80	SNY	239	S	8 X 10	C1930/V	S,ST,T	BI
STEICHEN, EDWARD	PORTRAIT: THOMAS MANN	11/80	SNY	240	S	17 X 14	1934/L	ST,I	500
STEICHEN, EDWARD	PORTRAIT: CARL SANDBURG	11/80	SNY	241	S	13 X 10	1933/V		500
STEICHEN, EDWARD	"SANDBURG AND ROCKS"	11/80	SNY	242	S	9 X 8	1933/V	T,IN	BI
STEICHEN, EDWARD	PORTRAIT: CARL SANDBURG	11/80	SNY	244	S	9 X 8	1933/V	I	BI
STEICHEN, EDWARD	"LOTUS, MT. KISCO, NEW YORK"	11/80	SW	374	S	10 X 8	1915/C31	S,ST	10,500
STEICHEN, EDWARD	JOHN BARRYMORE AS HAMLET	11/80	SW	376	S	17 X 14	1922/30'S	ST	1,200
STEINER, RALPH	"ONE TALKING PICTURE"	2/81	SLA	425	S	8 X 6	C1926/80	S,D	450
STEINER, RALPH	LOLLIPOP SIGNS	2/81	SLA	426	S	5 X 4	1922/80	S,D	275
STEINER, RALPH	BICYCLE	2/81	SLA	427	S	5 X 4	1922/L	S,D	BI
STEINER, RALPH	NEHI SIGN ON ESPOSITO STORE	2/81	SLA	428	S	10 X 8	1929/80	S,D	BI
STEINER, RALPH	FRONT OF OLD FORD	2/81	SLA	429	S	10 X 8	1929/79	S,D	325
STEINER, RALPH	ELECTIC SWITCHES	2/81	SLA	430	S	8 X 10	C1930/80	S,D	300
STEINER, RALPH	SARATOGA COAL CO. (ED. 100)	2/81	SLA	431	S	8 X 10	1929/77	S,N,D	350
STEINER, RALPH	MODEL T	5/81	CNY	131	S	8 X 10	1929/80	S,D/M	500
STEINER, RALPH	CAMEL CIGARETTE BILLBOARD	5/81	PNY	85	P	4 X 5	C1920/1974	S,D/M	450
STEINER, RALPH	POSTER WALL	5/81	PNY	86	P	5 X 4	C1920/1974	S,D/M	500
STEINER, RALPH	ALWAYS	5/81	SNY	330	S	4 X 5	1922/79	S,D,I/G	400
STEINER, RALPH	WALL OF DEMOLISHED BUILDING	5/81	SNY	331	S	5 X 4	1924/80	S,D,I/M	200
STEINER, RALPH	EGGS	5/81	SNY	332	S	8 X 10	1930'S/70'S	S/E	400
STEINER, RALPH	"REHEARSAL"	10/80	PT	164	S	10 X 8	1930'S/50'S	S	500
STEINER, RALPH	TYPEWRITER KEYS	10/80	PT	165	S	8 X 6	1921/79	S	400
STEINER, RALPH	BRIDGE	10/80	PT	166	S	9 X 7	1931/79	S	BI
STEINER, RALPH	"HAM AND EGGS"	10/80	PT	167	S	9 X 7	1934/78	S	BI
STEINER, RALPH	"AMERICAN BAROQUE"	11/80	CNY	421	S	8 X 10	1930/70'S	S	400
STEINER, RALPH	CLOTHESLINE CRISSCROSSING	11/80	CNY	422	S	4 X 5	1925/80	S,D	BI
STEINER, RALPH	WOOLWORTH BUILDING AND OLD POST OFFICE	11/80	CNY	423	S	5 X 4	1923/80	S,D	BI
STEINER, RALPH	SELF PORTRAIT WITH VIEW CAMERA	11/80	CNY	424	S	10 X 8	1929/79	S,D	400
STEINER, RALPH	LEE STRASBERG & MORRIS CARNOVSKY	11/80	CNY	425	S	10 X 8	1929/70'S	S	BI
STEINER, RALPH	SARATOGA COAL	11/80	CNY	426	S	8 X 10	1929/77	S,D	400
STEINER, RALPH	OLD POST OFFICE, NYC	11/80	CNY	427	S	10 X 8	1930/79	S,D	BI
STEINER, RALPH	"AMERICAN BAROQUE"	11/80	SNY	270	S	8 X 10	1929/1979	S,I	600

PHOTOGRAPHER	TITLE OR DESCRIPTION	DATE	AH	LOT#	PT	SIZE	N/P DATES	MARKS/COND.	PRICE
STEINER, RALPH	"TREE AND BARBED WIRE"	11/80	SNY	271	S	10 X 8	1929/1979	S,D	BI
STEINER, RALPH	"SARATOGA COAL COMPANY"	11/80	SNY	272	S	8 X 10	1929/L	S,D,	400
STEINHARDT, ALICE	"RANCHOS DE TAOS" (HAND-COLORED)	5/81	CNY	215	MP	18 X 27	1980/V	S,T,D	800
STEINHARDT, ALICE	"TAOS" (PHOTO MURAL; HAND-COLORED)	11/80	CNY	653	MP	18 X 27	1980/V	S,T,D,A	800
STERN, PHIL	JAMES DEAN	4/81	PNY	43	S	9 X 8	1950'S/V	ST	700
STERN, PHIL	JAMES DEAN	4/81	PNY	44	S	10 X 8	1950'S/V	ST	275
STERN, PHIL	"JAMES DEAN AT GOLDWYN STUDIOS" (2 PR)	5/81	CNY	202	S	10 X 8	1954/L	S,T,ST	350
STERNFELD, JOEL	"MCLEAN, VIRGINIA, DECEMBER 4, 1978"	2/81	SLA	43	DT	14 X 17	1978/80	S,T,D,A	225
STIEGLITZ, ALFRED	"THE STEERAGE" (FROM "291")	2/81	SLA	433	PG	13 X 10	1913/V		2,700
STIEGLITZ, ALFRED	"THE STEERAGE" (FROM "291")	4/81	SW	372	PG	13 X 10	1915/V		2,800
STIEGLITZ, ALFRED	CAMERA WORK #36, OCTOBER 1911	5/81	CNY	56	PG	4TO	1911/V	/M	4,500
STIEGLITZ, ALFRED	"THE STEERAGE" (FROM "291")	5/81	CNY	57	PG	13 X 10	1907/15	/M	2,900
STIEGLITZ, ALFRED	"THE STEERAGE" (FROM "291")	5/81	PNY	236	PG	13 X 11	1907/V	/M	BI
STIEGLITZ, ALFRED	"THE TERMINAL"	5/81	SNY	153	PG	10 X 13	1892/V	S,T,I,D/M	4,750
STIEGLITZ, ALFRED	"THE STEERAGE" (PL. FROM CAMERA WK 36)	5/81	SNY	154	PG	4TO	1911/V	/M	1,300
STIEGLITZ, ALFRED	"GRASSES-LAKE GEORGE"	5/81	SNY	155	S	6 X 8	1933/V	S,T,/E	3,000
STIEGLITZ, ALFRED	THE CANAL, VENICE	10/80	PT	73	PG	8 X 11	1897/V	PD	BI
STIEGLITZ, ALFRED	"THE STEERAGE" (FROM "291")	10/80	PT	74	PG	13 X 10	1907/16		2,100
STIEGLITZ, ALFRED	"THE FERRYBOAT" (FROM CAMERA WORK #36)	10/80	PT	78	PG	4TO	1910/11		320
STIEGLITZ, ALFRED	A BIT OF VENICE	11/80	CNY	206B	PG	7 X 5	1900/V	PD	260
STIEGLITZ, ALFRED	THE HAND OF MAN	11/80	CNY	207	PG	6 X 9	1903/V		450
STIEGLITZ, ALFRED	KATHERINE	11/80	CNY	208	PG	8 X 7	1905/V		120
STIEGLITZ, ALFRED	SPRING	11/80	CNY	209	PG	5 X 6	1905/V		120
STIEGLITZ, ALFRED	PLOUGHING	11/80	CNY	210	PG	8 X 10	1950/V		180
STIEGLITZ, ALFRED	"GOSSIP-KATWYK" AND "SEPTEMBER"	11/80	CNY	211	MP	5 X 8	1905/V		80
STIEGLITZ, ALFRED	SNAPSHOT-FROM MY WINDOW, BERLIN	11/80	CNY	212	PG	8 X 7	1907/V		140
STIEGLITZ, ALFRED	THE AEROPLANE	11/80	CNY	214	PG	6 X 7	1911/V		380
STIEGLITZ, ALFRED	A DIRIGIBLE	11/80	CNY	215	PG	7 X 7	1911/V		400
STIEGLITZ, ALFRED	EXCAVATING - NEW YORK	11/80	CNY	216	PG	5 X 6	1911/V		160
STIEGLITZ, ALFRED	LOWER MANHATTAN	11/80	CNY	217	PG	6 X 8	1911/V		200
STIEGLITZ, ALFRED	THE POOL - DEAL	11/80	CNY	218	PG	5 X 6	1911/V		100
STIEGLITZ, ALFRED	OLD AND NEW NEW YORK	11/80	CNY	219	PG	8 X 6	1911/V		240
STIEGLITZ, ALFRED	TWO TOWERS - NEW YORK	11/80	CNY	220	PG	8 X 6	1911/V		260
STIEGLITZ, ALFRED	A SNAPSHOT; PARIS	11/80	CNY	221	PG	5 X 7	1913/V		200
STIEGLITZ, ALFRED	PORTRAIT - MISS S.R.	11/80	CNY	222	PG	8 X 6	1913/V		100
STIEGLITZ, ALFRED	A SNAPSHOT; PARIS	11/80	CNY	223	PG	5 X 7	1913/V		200
STIEGLITZ, ALFRED	THE ASPHALT PAVER; NEW YORK	11/80	CNY	224	PG	6 X 7	1913/V		200
STIEGLITZ, ALFRED	"THE STEERAGE" (FROM "291")	11/80	CNY	225	PG	13 X 10	1907/1916	X/M	3,200
STIEGLITZ, ALFRED	A VENETIAN BOY	11/80	CNY	226	P	8 X 5	C1887/V	X/G	BI
STIEGLITZ, ALFRED	EXCAVATORS	11/80	CNY	227	P	3 X 4	1893-95/V	X/F	BI
STIEGLITZ, ALFRED	EQUIVALENT, MTNS AND SKY, LAKE GEORGE	11/80	CNY	228	S	9 X 6	1924/V		BI
STIEGLITZ, ALFRED	LAKE GEORGE (LETTER: AUTHENTICATION)	11/80	CNY	229	S	5 X 6	1923/V		BI
STIEGLITZ, ALFRED	PORT: EMMELINE & KATHERINE STIEGLITZ	11/80	SNY	162	P	6 X 4	1898/V	I,D	BI
STIEGLITZ, ALFRED	"THE STEERAGE" (FROM "291")	11/80	SNY	163	PG	13 X 10	1913/V		BI
STIEGLITZ, ALFRED	"THE STEERAGE" (CAMERA WORK 36)	11/80	SNY	164	PG	4TO	1911/V		1,700
STIEGLITZ, ALFRED	PORTRAIT: SARAH RABB	11/80	SW	394	S	8 X 6	1904/V	T	3,200
STIEGLITZ, ALFRED	INSTALLATION OF PICASSO EXHIB-JAN 1915	11/80	SW	395	P	8 X 10	1916/V	T,A	BI
STIEGLITZ, ALFRED (EDITOR)	CAMERA WORK 12	2/81	SLA	104		S	1905/V		1,100
STIEGLITZ, ALFRED (EDITOR)	CAMERA WORK #1-50 & 3 SPECIAL ISSUES	4/81	SW	48	PG	4TO	1900'S/V		BI
STIEGLITZ, ALFRED (EDITOR)	CAMERA WORK (#34/35)	4/81	SW	49	PG	4TO	1911/V	I	300
STIEGLITZ, ALFRED (EDITOR)	CAMERA NOTES (COMPLETE SET OF 24 #'S)	5/81	CNY	55A		4TO	1897-1903/V		5,000
STIEGLITZ, ALFRED (EDITOR)	CAMERA WORK #1-50 & 3 SPECIAL ISSUES	5/81	CNY	55B	PG	4TO	1903-1917/V	/E-M	30,000
STIEGLITZ, ALFRED (EDITOR)	CAMERA WORK #36 (16 SSIEGGLIZ PLATES)	5/81	SNY	17	PG	4TO	1911/V		3,750
STIEGLITZ, ALFRED (EDITOR)	CAMERA WORK 49/50 (11 STRAND PLATES)	5/81	SNY	19	PG	4TO	1917/V		4,000
STIEGLITZ, ALFRED (EDITOR)	CAMERA WORK #1-50 & 3 SPECIAL ISSUES	5/81	SNY	20	PF	4TO	1903-16/V		23,000
STIEGLITZ, ALFRED (EDITOR)	CAMERA WORK #44 OCTOBER 1913	11/80	CNY	206A	PG	4TO	1913/V		BI
STIEGLITZ, ALFRED (EDITOR)	CAMERA WORK (STEICHEN SUPP. APR. 1906)	11/80	CNY	230	PG	4TO	1906/V		500
STIEGLITZ, ALFRED (EDITOR)	CAMERA WORK (#23 JULY 1908)	11/80	CNY	230A	PG	4TO	1906/V		500
STIEGLITZ, ALFRED (EDITOR)	CAMERA WORK 12 (10 PRINTS)	11/80	SNY	14	PG	4TO	1905/V		1,800
STIEGLITZ, ALFRED (EDITOR)	CAMERA WORK 22	11/80	SNY	16	PG	4TO	1908/V		1,100
STIEGLITZ, ALFRED (EDITOR)	CAMERA WORK 30	11/80	SNY	17	PH	4TO	1910/V		400

PHOTOGRAPHER	TITLE OR DESCRIPTION	DATE	AH	LOT#	PT	SIZE	N/P DATES	MARKS/COND.	PRICE
STIEGLITZ, ALFRED(EDITOR)	CAMERA WORK 36	11/80	SNY	18	PG	4TO	1911/V		4,750
STIEGLITZ, ALFRED(EDITOR)	CAMERA WORK (COMPLETE: #1-50 + 3 SP.)	11/80	SW	31	PG	4TO	1903-17/V	1ST VOL.=S/E	42,000
STOCK, DENNIS	PORTRAIT: JAMES DEAN, FAIRMOUNT, IND.	2/81	SLA	434	S	13 X 19	1955/76	S,D,ST	650
STOCK, DENNIS	JAMES DEAN WITH SOW (ED: 19/32)	5/81	SNY	482	S	12 X 8	1955/L	S,A/M	400
STOCK, DENNIS	PORTRAIT: JAMES DEAN TIMES SQ., N.Y.	11/80	SNY	349	S	21 X 14	1955/1976	S,D,ST	750
STOCK, DENNIS	PORTRAIT: JAMES DEAN, TIMES SQUARE	11/80	SNY	349	S	20 X 14	1955/76	S,D,ST	750
STOCKER, ALEX	LIGHT AND COINS	11/80	PNY	98	S	8 X 6	C1930/V	ST	550
STODDARD, SENICA RAY	VIEWS IN THE ADIRONDACKS (7 PHOTOS)	11/80	SW	396	A	7 X 9	1888/V	IN	150
STONE, CAMI	HOUSES, GERMANY	5/81	PNY	212	S	7 X 9	1930'S/V	ST	300
STONE, CAMI	PORTRAIT: ALBERT EINSTEIN	5/81	SNY	179	S	9 X 7	C1930/V	ST/G	350
STONE, CAMI	"CLOWN"	11/80	PNY	11	S	9 X 7	C1930'S/V	ST	BI
STONE, SASHA	FEMALE NUDE (SEATED)	5/81	SNY	547	S	16 X 12	C1940/V	S,ST/G	1,000
STONE, SASHA	FEMALE NUDE (RECLINING)	5/81	SNY	548	S	10 X 8	1930'S/V		BI
STRAND, PAUL	SUSAN THOMNPSON, CAPE SPLIT,ME (ED:58)	4/81	PNY	8	S	8 X 10	1945/1976		700
STRAND, PAUL	BLIND WOMAN, NEW YORK	5/81	CNY	74	S	14 X 11	1916/39	S,A/M	BI
STRAND, PAUL	NEW YORK (WALL STREET)	5/81	CNY	75	PG	5 X 6	1916/V	/M	1,200
STRAND, PAUL	WINDOW OF FISHERMAN'S HOUSE, MEXICO	5/81	CNY	76	S	7 X 4	1934/V	A/F	850
STRAND, PAUL	MEXICO (PORTFOLIO: 20 PRINTS)	5/81	CNY	77	PG	VARIOUS	1940/V	S	5,000
STRAND, PAUL	BOAT AT RIO PAPALOAPAM, VERA CRUX, MEX	5/81	PNY	256	S	5 X 6	1934/V	/E	700
STRAND, PAUL	AKELEY MOTION PICTURE CAMERA (ED:58)	5/81	PNY	257	S	9 X 8	1923/76	ST,A/F	BI
STRAND, PAUL	"CORNER OF PEMBROKE EAST, BRYN MAWR"	5/81	SNY	157	S	9 X 7	C1911/V	S,T/E	125
STRAND, PAUL	"PHOTOGRAPH-NEW YORK" (CAM. WK. 49/50)	5/81	SNY	158	PG		1917/V	/M	BI
STRAND, PAUL	"UNDER THE EL, NEW YORK"	5/81	SNY	159	S	14 X 11	C1940/V	/M	2,500
STRAND, PAUL	BUILDING, PORT KENY, NEW YORK	5/81	SNY	160	S	12 X 10	1916/40	/M	2,500
STRAND, PAUL	MEXICO (PORTFOLIO: 8 PRINTS)	5/81	SNY	161	PG	VARIOUS	1940/V	S	1,100
STRAND, PAUL	"AKELEY MOTION PICTURE CAM."(ED:13/58)	10/80	PT	126	D	9 X 8	1923/76	ST	BI
STRAND, PAUL	"SIDE PORCH, VERMONT" (ED:13/58)	10/80	PT	127	S	10 X 8	1947/76	ST	750
STRAND, PAUL	"IRIS FACING THE WINTER" (ED:13/58)	10/80	PT	128	S	12 X 10	1973/76	ST	800
STRAND, PAUL	THE WHITE FENCE	11/80	CNY	260	PG	7 X 9	1917/V		450
STRAND, PAUL	NEW YORK - MAN IN THE BOWLER HAT	11/80	CNY	261	PG	9 X 7	1917/V		400
STRAND, PAUL	TORSO	11/80	CNY	261A	S	10 X 10	1930/1974	ST	750
STRAND, PAUL	COREA HARBOR, MAINE (DOCUMENTATION)	11/80	CNY	262	S	10 X 8	1945/1970	S,T,D	BI
STRAND, PAUL	"TORSO, TAOS, NEW MEXICO" (ED. 50)	11/80	PNY	260	S	10 X 10	1930/76	A	BI
STRAND, PAUL	"WILLOW PATH-COLGATE"	11/80	SNY	266	MP	7 X 9	1911/V	S,T	900
STRAND, PAUL	"THE LUSETTI FAMILY, LUZZARA, ITALY"	11/80	SNY	267	S	5 X 6	1953/V	S	9,000
STRAND, PAUL	THE GARDEN (PORTFOLIO:6 PRINTS; ED:58)	11/80	SNY	268	S	10 X 8	1957-69/L	ST,S	BI
STRAND, PAUL	"TOWARDS SUGAR HOUSE, E. JAMAICA, VT."	11/80	SW	397	S	9 X 8	C1943/V	S,T	4,600
STRUSS, KARL	LANDSCAPE	2/81	SLA	436	P	5 X 4	1921/V	S,D	400
STRUSS, KARL	"ST. JOHN'S CATHEDRAL, TWILIGHT"	2/81	SLA	437	P	4 X 5	1911/V	S,D,T	250
STRUSS, KARL	"WEST SIDE, NY"	2/81	SLA	438	P	4 X 5	1911/V	S,D,T	300
STRUSS, KARL	"HOTEL PLAZA"	2/81	SLA	439	P	4 X 4	1911/V	D,S,T	500
STRUSS, KARL	WHITE FERRYBOAT OR ON THE RIVER	11/80	CNY	258	P	13 X 10	C1920/V	S,D,ST,T,A	BI
STRUSS, KARL	MONTEREY FIELDS	11/80	CNY	259	P	4 X 5	1921/V	S,D,ST	350
SUDEK, JOSEF	SUNLIGHT IN WOODS	4/81	PNY	128	S	7 X 5	1942-46/V	I,D	BI
SUDEK, JOSEF	TREE & MOLDEA RIVER, PRAGUE (ED: 5/12)	5/81	CNY	183	S	5 X 7	1960'S/V	S,A/M	900
SUDEK, JOSEF	TREES AND FARMHOUSE	5/81	PNY	163	S	3 X 4	C1924/V	S/E	500
SUDEK, JOSEF	TREES AND VILLA	5/81	PNY	164	S	6 X 4	C1944/V	S/E	1,200
SUDEK, JOSEF	PRAGUE (STREET SCENE)	5/81	PNY	165	S	5 X 7	1940'S/V	I,D	500
SUDEK, JOSEF	LANDSCAPE PANORAMA	5/81	PNY	166	S	4 X 12	1968/V	S,D,A	BI
SUDEK, JOSEF	STUDY OF A GLASS	5/81	PNY	167	S	7 X 5	C1968/V	S,A/E	900
SUDEK, JOSEF	"LABYRINTH IN MY ATELIER"	5/81	SNY	260	S	9 X 12	1960/V	S,D	1,600
SUDEK, JOSEF	VIEW FROM SUDEK'S ATELIER WINDOW	5/81	SNY	261	S	7 X 4	C1975/V	I/P	900
SUDEK, JOSEF	TWO CHAIRS	10/80	PT	90	S	5 X 7	1948/V	T,D	750
SUDEK, JOSEF	4 LANDSCAPE STUDIES (LETTER ON VERSO)	10/80	PT	91	S	VARIOUS	1968/V	4=A,1=S,D	BI
SUDEK, JOSEF	PRAGUE (SUNSET)	11/80	CNY	463	S	11 X 9	1940'S/V	S	BI
SUDEK, JOSEF	"TROJA ISLAND" (PANORAMA)	11/80	CNY	463A	S	4 X 11	1940'S/V	T	BI
SUDEK, JOSEF	"PRAGUE"	11/80	CNY	464	S	3 X 6	1968/V	S,D,T	700
SUDEK, JOSEF	GARDEN	11/80	CNY	465	S	8 X 11	1970/V	S	600
SUDEK, JOSEF	LADISLAV SUTNAR CHINA	11/80	PNY	133	S	6 X 9	C1928/V	ST	850
SUDEK, JOSEF	LEAF	11/80	PNY	138	S	9 X 9	1926/V	S,D	950
SUDEK, JOSEF	"IN THE VETERANS HOSPITAL"	11/80	PNY	139	S	9 X 9	C1924/V	S,D	2,000

PHOTOGRAPHER	TITLE OR DESCRIPTION	DATE	AH	LOT#	PT	SIZE	N/P DATES	MARKS/COND.	PRICE
SUDEK, JOSEF	LANDSCAPE	11/80	PNY	140	S	7 X 9	1918/24	S,T,D	900
SUDEK, JOSEF	SNOW SCENE	11/80	PNY	141	S	4 X 3	1918/V	S,D	BI
SUDEK, JOSEF	TREES, PRAGUE	11/80	PNY	142	S	2 X 2	1917/L?	S,D	500
SUDEK, JOSEF	HOUSE AND TREES	11/80	PNY	143	S	2 X 2	1914/L	S	500
SUDEK, JOSEF	STILL LIFE (CLAY POT AND ROOTS)	11/80	SNY	408	S	9 X 11	1956/V	S,D,T,	BI
SUDEK, JOSEF	"EVENING IN MY STUDIO"	11/80	SNY	409	S	9 X 6	1964/V	S,T,D	800
SUDEK, JOSEF	LANDSCAPE PANORAMA	11/80	SNY	410	S	3 X 12		S	1,400
SUDEK, JOSEF	A VIEW FROM SUDEK'S STUDIO WINDOW	11/80	SNY	411	S	7 X 5	1975/V	I	550
SUDEK, JOSEF	WOODED LANDSCAPE	11/80	SNY	412	S			S	BI
SUDEK, JOSEF	TREE BRNCHES	11/80	SNY	413	MP	6 X 4	C1960/V	S	950
SUDEK, JOSEF	PRAGUE CASTLE & THE CHURCH...	11/80	SNY	414	S	7 X 9	C1963/V		500
SUDEK, JOSEF (ATTRIB. TO)	LADISLAV SUTNAR CHINA	11/80	PNY	135	S	9 X 7	C1928/V	ST	650
SUDEK, JOSEF (ATTRIB. TO)	SUTNAR FLATWARE	11/80	PNY	136	S	9 X 7	C1928/V	ST	425
SUDEK, JOSEF (ATTRIB. TO)	SUTNAR FLATWARE	11/80	PNY	137	S	9 X 7	C1928/V	ST	300
SUTCLIFFE, FRANK MEADOW	BOATS IN WHITBY HARBOR (2 PHOTOS)	4/81	SW	373	A	6 X 8	1880'S/V	IN,A	200
SUTCLIFFE, FRANK MEADOW	BOATS, WHTIBY HARBOUR	5/81	PNY	17	A	8 X 6	C1882/V	IN,S	BI
SUTCLIFFE, FRANK MEADOW	THE WATER RATS	11/80	CNY	196	CN	13 X 18	1886/C1890	IN,SN/M	3,000
SUTCLIFFE, FRANK MEADOW	A MOORLAND ROAD	11/80	CNY	197	CN	10 X 12	C1900/V	S,T,I	350
SUTNAR, LADISLAV	SUTNAR EGG CUP	5/81	PNY	173	S	16 X 12	1930/V	S?	BI
SUTNAR, LADISLAV	"TANK A AUTO"	11/80	PNY	131	S	6 X 9	C1927/V	S,T	600
SUTNAR, LADISLAV	"TEA CUPS AND SAUCERS"	11/80	PNY	132	S	15 X 12	C1928/V	S	750
SZEKESSY, KARIN	"ADAM UND EVA" (ED. 100)	2/81	SLA	442	PP	19 X 25	C1970/V	S,A	BI
SZEKESSY, KARIN	"DAGMAR IM WALD" (ED. 50)	2/81	SLA	444	PP	19 X 25	1973/V	S,A	200
SZEKESSY, KARIN	"JUTTA UND JOANNA" (ED. 100)	2/81	SLA	445	PP	26 X 21	C1970/V	S,A	275
TABARD, MAURICE	PAYSAGE	5/81	PNY	142	S	11 X 14	1949/V	S,D,T,ST/P	900
TABARD, MAURICE	PORTRAIT: A MAN	5/81	SNY	221	S	10 X 8	1927/V	S,D,I,ST/F	950
TABARD, MAURICE	MONTAGE: MARY GLORY	11/80	PNY	36	S	9 X 7	1929/V	S,D,ST,T	1,300
TABARD, MAURICE	ROOM INTERIOR	11/80	PNY	37	S	9 X 7	C1930/V	ST	1,100
TABARD, MAURICE	STEPS	11/80	PNY	38	S	10 X 7	1930'S/V	ST	1,000
TABARD, MAURICE	GUITAR SOLARIZATION	11/80	PNY	39	S	9 X 7	C1933/V	ST	1,300
TABARD, MAURICE	GUITAR SOLARIZATION	11/80	PNY	40	S	7 X 5	C1933/V	ST	1,200
TAKAHASHI, HENRY	3 SILVER PRINTS	4/81	PNY	73	S	VARIOUS	1950'S/V	S	100
TAKAHASHI, HENRY	3 SILVER PRINTS	4/81	PNY	74	S	VARIOUS	1950'S/V	S	BI
TALBOT, WILLIAM HENRY FOX	TOMB OF SIR WALTER SCOTT, DRYBURGH ABY	5/81	CNY	1	C	7 X 8	1845/V	/M	3,200
TALBOT, WILLIAM HENRY FOX	"ARTICLES OF CHINA"	5/81	SNY	80	C	5 X 7	1844/V	S/F	700
TALBOT, WILLIAM HENRY FOX	HERIOTS HOSPITAL, EDINBURGH	11/80	CNY	4	C	6 X 8	C1843/V		BI
TALBOT, WILLIAM HENRY FOX	"HERRIOTT'S HOSPITAL, EDINBURGH"	11/80	SNY	79	C	7 X 8	1844/V		BI
TENNESON, JOYCE	"EUGENIA AND PINCUSHION" (ED: 25)	5/81	PNY	343	S	14 X 21	1980/V		BI
TESKE, EDMUND	WHEELCHAIR, CHICAGO	10/80	PT	199	S	8 X 10	1938/50'S	S,T,D	120
TESKE, EDMUND	GIRL IN FRONT OF PIANO	10/80	PT	200	S	8 X 7	1962/V	S	BI
TEYNARD, FELIX	"DANDOUR, VUE GENERALE DES RUINES"	5/81	CNY	30	SA	9 X 12	1853-58/V	A,T/E	BI
THOMSON, JOHN	STREET INCIDENTS (21 PHOTOS)	5/81	CNY	19	W	5 X 4	1881/V	/E	BI
THOMSON, JOHN	OLD FURNITURE	5/81	PNY	14	W	5 X 4	1877-78/V	T	200
THOMSON, JOHN	STREET LIFE IN LONDON (37 PLS., 8 VO.)	5/81	SNY	88	W	8VO	1877/V	S	4,000
THOMSON, JOHN	"STREET LIFE IN LONDON" (36 WOODBURYS)	11/80	CNY	40	W	5 X 4	1878/V	T/E	5,000
THOMSON, JOHN	"AN OLD CLOTHES' SHOP, SEVEN DIALS"	11/80	CNY	41	W	5 X 4	1878/V	PD	BI
THOMSON, JOHN	"THE INDEPENDENT SHOE-BLACK"	11/80	CNY	42	W	5 X 4	1878/V	PD	200
THOMSON, JOHN	"HALFPENNY ICES"	11/80	CNY	43	W	5 X 4	1878/V	PD	BI
THOMSON, JOHN	"MUSH-FAKERS" & GINGER BEER MAKERS	11/80	CNY	44	W	5 X 4	1878/V	PD	BI
THOMSON, JOHN	"THE TEMPERENCE SWEEP"	11/80	CNY	45	W	4 X 2	1878/V	PD	100
TICE, GEORGE A.	"OAK TREE, HOLMDEL, N.J."	2/81	SLA	447	S	15 X 19	1970/80	S,T,D	750
TICE, GEORGE A.	"AQUATIC PLANTS #1, N.J."	2/81	SLA	448	S	8 X 10	1967/V	S,T,D	375
TICE, GEORGE A.	"HORSE & BUGGY, WINTER, LANCASTER, PA"	2/81	SLA	449	S	3 X 10	1961/V	S,T,D	300
TICE, GEORGE A.	"SHAKER INTERIOR, SABBATHDAY LAKE, ME"	2/81	SLA	450	S	9 X 13	1971/V	S,T,D	450
TICE, GEORGE A.	"ROARING FORK RIVER, ASPEN, COLORADO"	2/81	SLA	451	S	19 X 16	1969/80	S,T,D	350
TICE, GEORGE A.	"WHITE CASTLE, RT. #2, RAHWAY N.J."	5/81	SNY	519	S	11 X 13	1973/V	S,T,D/M	400
TICE, GEORGE A.	"PETIT'S MOBIL STATION, NEW JERSEY"	5/81	SNY	520	S	15 X 20	1974/80	S,T,D	950
TICE, GEORGE A.	"STRAND THEATER, KEYPORT, N.J."	5/81	SNY	521	S	8 X 10	1973/L	S,T,D/M	450
TICE, GEORGE A.	"OAK TREE, HOLMDEL, NEW JERSEY"	10/80	PT	222	S	15 X 19	1970/80	S,T,D	600
TICE, GEORGE A.	"ROARING FORK RIVER, ASPEN, COLORADO"	10/80	PT	223	S	13 X 11	1969/80	S,T,D	BI

PHOTOGRAPHER	TITLE OR DESCRIPTION	DATE	AH	LOT#	PT	SIZE	N/P DATES	MARKS/COND.	PRICE
TICE, GEORGE A.	"MOUNT DESERT ISLAND, MAINE"	10/80	PT	224	S	11 X 13	1970/80	S,T,D	350
TICE, GEORGE A.	PETIT'S MOBIL STATION, CHERRY HILL, NJ	11/80	CNY	595	S	15 X 19	1974/76	S,T,D	550
TICE, GEORGE A.	ROARING FORK RIVER, ASPEN, COLORADO	11/80	CNY	596	S	19 X 15	1969/76	S,T,A	550
TICE, GEORGE A.	"TREE #19, CAL."	11/80	CNY	597	S	10 X 8	1965/L	S,T,D	120
TICE, GEORGE A.	COTT BEVERAGE SIGN, PATERSON, NJ	11/80	CNY	598	S	8 X 9	1969/L	S,T,D	150
TICE, GEORGE A.	SHAKER INTERIOR, SABBATHDAY LAKE, ME	11/80	CNY	599	S	7 X 9	1971/L	S,T,D	130
TICE, GEORGE A.	"TWO LIGHTS, CAPE ELIZABETH, ME."	11/80	CNY	600	S	7 X 10	1971/L	S,T,D	130
TICE, GEORGE A.	THE AMISH PORTFOLIO (12 PHOTOS,LETTER)	11/80	SNY	481	S	VARIOUS	1968/V	ST,I	1,900
TICE, GEORGE A.	"OAK TREE, HOLMDEL, N.J."	11/80	SNY	482	S	15 X 19	1970/1980	S,T,D	600
TICE, GEORGE A.	PETIT'S MOBIL STATION, CHERRY HILL, NJ	11/80	SNY	483	S	15 X 20	1974/1980	T,D,S	1,100
TIFFANY, LOUIS COMFORT	FLOWER STUDIES (2 PRINTS)	10/80	PT	70	S	VARIOUS	C1910/V	#1=SN, #2=ST	200
TRAMPUS	ALEXANDRINE & MARCELLE ROSE (2 PRINTS)	4/81	PNY	172	S	8 X 6	1930'S/V	ST	BI
TRESS, ARTHUR	SHADOW #'S 8,10,12,60 (4 PRINTS)	5/81	PNY	327	S	8 X 8	1970'S/V	S,T	275
TRESS, ARTHUR	SHADOW #'S 16,23,24,33 (4 PRINTS)	5/81	PNY	328	S	8 X 8	1970'S/V	S,T	250
TRESS, ARTHUR	"BOB LEET & SHEEP, SF, CAL." (ED: 3/25)	5/81	CNY	211	S	15 X 16	1970'S/L	S,A,T/M	BI
TRESS, ARTHUR	"THE MUSIC LESSON" (ED: 1/25)	5/81	CNY	212	S	16 X 16	1970'S/V	S,T,A	BI
TRESS, ARTHUR	"CLAIRE DE LUNE,BREEZY PT,NY(ED:19/25)	10/80	PT	247	S	10 X 10	C1976/V	S,T,A	160
TRESS, ARTHUR	"FLOOD DREAM" (ED:24/25)	10/80	PT	248	S	10 X 10	1972,V	S,T,A	100
TRESS, ARTHUR	"DRILL FANTASY" (ED: 6/25)	11/80	CNY	586	S	10 X 10	1970'S/L	S,T,A	BI
TRESS, ARTHUR	"TWO MEN" (ED: 3/50)	11/80	CNY	587	S	10 X 10	1970'S/L	S,T,A	90
TRESS, ARTHUR	"GIRLS'S DREAM, CAPE MAY" (ED: 5/25)	11/80	CNY	588	S		1970'S/L	S,T	85
TRESS, ARTHUR	"BOY IN FLOOD DREAM" (ED: 30/50)	11/80	CNY	589	S	10 X 10	1970'S/L	S,T	110
TRIPE, CAPT. LINNEUS	ARCHITECTURAL VIEW IN TRICHONOPOLY	5/81	CNY	10	AS	10 X 15	C1858/V	/G	800
TRIPE, CAPT. LINNEUS	VIEW OF A STREET IN MADURA, INDIA	5/81	CNY	11	AS	11 X 15	C1858/V	ST/E	900
TRUAX, KAREN	PRINT FROM PAINTED WOMAN SERIES	11/80	CNY	650	S	19 X 13	1978/V	S,T	BI
TURNER, BENJAMIN B.	STUDY OF A TREE	11/80	CNY	12	A	12 X 16	1850'S/V		1,300
TURNER, BENJAMIN B.	ARCHITECTURAL STUDY	11/80	CNY	13	A	12 X 16	1850'S/V		1250
TURNER, BENJAMIN B.	LANDSCAPE STUDY	11/80	CNY	14	A	12 X 16	1850'S/V		420
UELSMANN, JERRY N.	"APOCALYPSE II"	2/81	SLA	452	S	11 X 13	1967/V	S,T,D	600
UELSMANN, JERRY N.	"LITTLE HAMBURGER-TREE"	5/81	SNY	517	S	7 X 5	1970/V	S,T,D	300
UELSMANN, JERRY N.	NUDE WOMAN	5/81	SNY	518	S	12 X 9	1972/V	S,D/M	550
UELSMANN, JERRY N.	"EQUIVALENT"	11/80	CNY	630	S	14 X 9	1964/V	S,T,D	320
UELSMANN, JERRY N.	"ALL AMERICAN SUNSET"	11/80	CNY	631	S	7 X 8	1971/V	S,D,T	120
ULMANN, DORIS	PORTRAIT: JOHN JACOB NILES	2/81	SLA	453	P	8 X 6	1930'S/V	S	225
ULMANN, DORIS	STILL LIFE WITH VASE	5/81	SNY	289	P	8 X 6	1930-40'S/V	S/E	700
ULMANN, DORIS	"TWO BLACK WOMEN, DRESSED IN WHITE"	11/80	PNY	298	P	8 X 6	C1930/V		500
ULMANN, DORIS	FISH-CURING SHED CAPE ELIZABETH, MAINE	11/80	PNY	299	P	8 X 6	C1930/V	S	BI
ULMANN, DORIS	JOSE CLEMENTE OROZCO (3 PORTRAITS)	11/80	SNY	245A	P	8 X 6	1929/V	S	800
UMBO (UMBEHR, OTTO)	COUPLE ON GRASS	4/81	PNY	129	S	6 X 8	1940'S/V	ST	375
UMBO (UMBEHR, OTTO)	PORTFOLIO: 10 PHOTOGRAPHIEN (ED:42/50)	11/80	CNY	324	S	11 X 8	1927-30/80	S,ST	BI
UMBO (UMBEHR, OTTO)	"MENJOU EN GROS"	11/80	PNY	9	S	7 X 8	C1929/79	SN,D,A	BI
UYEDA, SHIGEMI	SESAME ON OIL POND, SWIMMERS (2 PR.)	11/80	CNY	341	S	VARIOUS	C1925/V	S,T,D	80
VACHON, JOHN FELIX	ABANDONED FARM HOME, NORTH DAKOTA	4/81	PNY	113	S	6 X 9	1940/V	S,D,T	200
VACHON, JOHN FELIX	BUS DEPOT, WASHINGTON, D.C.	4/81	PNY	114	S	10 X 10	1951/V	S,D,T	BI
VACHON, JOHN FELIX	"STOCKYARDS, OMAHA"	11/80	PNY	272	S	16 X 20	1938/V	AUTHENICATED	BI
VACHON, JOHN FELIX	FOUR F.S.A IMAGES	11/80	CNY	384A	S	7 X 9	1940'S/V	S,T,D,ST	200
VACHON, JOHN FELIX	NORTH AND SOUTH DAKOTA (4 PRINTS)	11/80	CNY	384B	S	7 X 10	C1940/V	S,ST,T,D	200
VALENTINE J. & WILSON, G.	FOUR ALBUMS (357 ALBUMEN PRINTS)	5/81	PNY	12	A	VARIOUS	1870'S/V	IN,T	BI
VAN DER ZEE, JAMES	"EIGHTEEN PHOTOGRAPHS" (ED: 75/75)	5/81	SNY	300	S	VARIOUS	1905-38/L	S,A/M	BI
VAN DER ZEE, JAMES	KATE AND RACHEL (ED: 5/75)	11/80	CNY	428	S	7 X 6	1909/70'S	S,A	120
VAN DER ZEE, JAMES	ATLANTIC CITY (ED: 5/75)	11/80	CNY	429	S	6 X 4	1930/70'S	S,A	BI
VAN DYKE, WILLARD	PORTRAIT: EDWARD WESTON AT CARMEL	2/81	SLA	455	S	10 X 7	1933/L	I	300
VAN DYKE, WILLARD	SONYA NOSKOWIAK PHOTOGRAPHING AT TAOS	2/81	SLA	456	S	7 X 9	C1931/L	S,T,I	400
VAN DYKE, WILLARD	SANCTUARIES, NEW MEXICO	5/81	PNY	251		8 X 10	1937/?	S,T,D/M	175
VAN DYKE, WILLARD	CHAIR AND WINDOW, MONTEREY	11/80	CNY	411	S	10 X 8	C1931/V	S,I,A	BI
VAN DYKE, WILLARD	"BONE AND SKY, I"	11/80	CNY	412	S	9 X 7	C1932/V	S,I,A,D,T	BI
VAN DYKE, WILLARD	"NEHI"	11/80	CNY	413	S	10 X 8	C1931/V	S,T,D,I	BI
VAN DYKE, WILLARD	PORTFOLIO: CALIFORNIA, 10 PR, ED:20/25	11/80	CNY	413A	S		1930-37/77	S,A	BI
VAN VECHTEN, CARL	GERTRUDE STEIN AND ALICE B. TOKLAS	11/80	CNY	320	S	9 X 7	1934/V	ST	200

PHOTOGRAPHER	TITLE OR DESCRIPTION	DATE	AH	LOT#	PT	SIZE	N/P DATES	MARKS/COND.	PRICE
VAN VECHTEN, CARL	PORTRAIT: LINCOLN KIRSTEIN	11/80	PNY	210	S	9 X 7	1939/V	S?,D	BI
VAN VECHTEN, CARL	PORTRAIT: EDNA ST. VINCENT MILLAY	11/80	PNY	211	S	13 X 9	1933/V	ST	BI
VANNERSON, JULIUS	CZH-NA-NIK-KA-GA-HI, THE LONE CHIEF...	11/80	CNY	152	SA	8 X 6	1850'S/V	T	300
VANNERSON, JULIUS	TA-KA-KO-GREY FOX, CHIEF OF SACS...	11/80	CNY	153	SA	8 X 6	1850'S/V	T	250
VANNERSON, JULIUS	O-TA-WA-THE SUCKERFISH (POTTAWOTAMIE)	11/80	CNY	154	SA	8 X 6	1850'S/V	T	380
VICTORIANA	PERSONALITIES-BY ELLIOTT & FRY, 112 PR	11/80	CNY	198	W	6 X 4	C1890/V	X/G	BI
VICTORIANA	FAMILY ALBUM OF 150 CDV'S	4/81	SW	459	A	2 X 4	C1865/V		160
VICTORIANA	ROYALTY (13 CDV'S)	4/81	SW	513	A	2 X 4	C1880'S/V	ST	100
VISHNIAC, ROMAN	"GRANDFATHER AND GRANDDAUGHTER,WARSAW"	10/80	PT	168	S	8 X 10	1937/L	S,T,D	BI
VISHNIAC, ROMAN	"THE SCROLL IS BEING CARRIED"	10/80	PT	169	S	8 X 10	C1937/L	S,T,ST	BI
VISHNIAC, ROMAN	"NEXT YEAR THE BOOK WILL GO TO... BOY"	4/81	SW	378	S	13 X 11	1936/L	S,T	BI
VISHNIAC, ROMAN	CRACOW	4/81	SW	379	S	13 X 10	1937/L	S,T	1,050
VISHNIAC, ROMAN	CARPATHO RUTHENIA	4/81	SW	381	S	10 X 13	1937/L	S,T	BI
VISHNIAC, ROMAN	"THE LAST CHANNUKAH"	4/81	SW	382	S	15 X 16	1938/L	S,T	BI
VISHNIAC, ROMAN	MARC CHAGALL ARRIVING IN NEW YORK	4/81	SW	383	S	13 X 11	1941/L	S,T	BI
VOBECKY, FRANTISEK	THE DANCE	11/80	CNY	322	S	16 X 12	1936/1974	S,D,T	100
VOBECKY, FRANTISEK	THE MOMENT OF MARVEL	11/80	CNY	323	S	11 X 16	1936/1974	S,D,T	100
VON GLOEDEN, WILHELM	TWO NUDE BOYS	11/80	CNY	73	A	9 X 7	C1890/V	ST	550
VON GLOEDEN, WILHELM	AGED PEASANT SPINNING	11/80	SNY	829	A	9 X 7	C1900/V	ST	175
VON GLOEDEN, WILHELM	STUDY OF A YOUNG PEASANT GIRL	11/80	SNY	830	A	9 X 6	C1900/V		150
VON STILLFRIED & KIMBEI	JAPAN (ALBUM OF 100 HAND-COLORED PRS.)	11/80	CNY	93	A	10 X 8	1870'S-90/V		2,200
WAGGAMAN, JOHN	LOUISE NEVELSON	11/80	CNY	495A	S	8 X 9	C1946/V	ST	BI
WALKER, LEWIS	FEDERAL BLDGS. CONSTR.,WASH,DC (2 PR.)	5/81	SNY	113	A	9 X 13	1871,75/V	IN/G	BI
WALKER, TODD	NUDE (PHOTO SILKSCREEN, ED: 2/17)	11/80	CNY	613	MP	10 X 7	1970/V	S,D	100
WALMSLEY BROTHERS	MAN ON A HORSE WITH SHEEP	5/81	PNY	213	CN	7 X 9	C1900/V		275
WARD, JOHN	ASPENS NEAR MAROON LAKE, COLORADO	11/80	CNY	603	S	15 X 20	1974/78	S,ST,T	180
WARD, JOHN	MIST AT OUZEL FALLS, ROCKY MNT PK, CO.	11/80	CNY	604	S	19 X 16	1970/78	S,ST,T	220
WARREN, GEORGE K.	ARCHITECTURAL STUDY	11/80	CNY	95A	SA	6 X 8	1850'S/V	IN	80
WATKINS, CARLETON E.	GALEN CLARK IN FRONT OF GRIZZLY GIANT	2/81	SLA	464	A	MAMMOTH	1866/V	S	BI
WATKINS, CARLETON E.	YOSEMITE VALLEY FROM INSPIRATION POINT	2/81	SLA	465	A	MAMMOTH	1860'S/V		950
WATKINS, CARLETON E.	"AT THE FARALLONES"	2/81	SLA	466	A	MAMMOTH	1860'S/V	T	800
WATKINS, CARLETON E.	"MULTNOMAH FALLS CASCADES"	2/81	SLA	467	A	MAMMOTH	1860'S/V	T	850
WATKINS, CARLETON E.	"CELILO"	2/81	SLA	468	A	MAMMOTH	1860'S/V	T	900
WATKINS, CARLETON E.	"MULTNOMAH FALLS, CASCADES, OREGON"	2/81	SLA	469	A	MAMMOTH	1868/V	T	1,900
WATKINS, CARLETON E.	"VIEW UP YOSEMITE VALLEY ..."	2/81	SLA	470	A	MAMMOTH	1860'S/V	T	750
WATKINS, CARLETON E.	"VIEW FROM SUGAR LOAF ISL., FARALLONS"	5/81	CNY	45	A	16 X 21	1870/V	T/E	BI
WATKINS, CARLETON E.	"WEBER CANON"	5/81	CNY	46	A	16 X 22	1870/V	T/E	BI
WATKINS, CARLETON E.	"MIRROR VIEW OF THE NORTH DOME"	5/81	CNY	47	A	15 X 20	1870/V	T/G	3,000
WATKINS, CARLETON E.	"PULPIT ROCK"	5/81	CNY	48	A	22 X 16	1870/V	T/E	2,500
WATKINS, CARLETON E.	MT. BRODERICK & NEVADA FALL, YOSEMITE	5/81	PNY	72	A	16 X 21	C1866/V	S,T/G	700
WATKINS, CARLETON E.	CAPE HORN, COLUMBIA RIVER, OREGON	5/81	PNY	73	A	16 X 21	1868/V		1,500
WATKINS, CARLETON E.	CASTLE ROCK, COLUMBIA RIVER, OREGON	5/81	PNY	74	A	16 X 21	1868/V	S,T/E	3,500
WATKINS, CARLETON E.	EL CAPITAN & V. FR. GLACIER PT. (2 P.)	5/81	PNY	75	A	8 X 5	C1875/V	IN,T	200
WATKINS, CARLETON E.	"CATHEDRAL ROCKS, YOSEMITE"	5/81	SNY	114	A	MAMMOTH	1866/V	T,D,A/G	1,300
WATKINS, CARLETON E.	"PASSAGE OF THE DALLAS"	5/81	SNY	115	A	MAMMOTH	1860'S/V	T,A/G-E	1,900
WATKINS, CARLETON E.	"MIRROR VIEW OF EL CAPITAN 3600 FT."	5/81	SNY	116	A	MAMMOTH	1866/V	T,D,A/G	2,500
WATKINS, CARLETON E.	SUGAR LOAF ISLANDS & FISHERMAN'S BAY..	11/80	CNY	138	A	16 X 21	C1867/V	T/F	3,800
WATKINS, CARLETON E.	MORRAINES, MT. SHASTA	11/80	CNY	139	A	16 X 21	C1867/V	T	BI
WATKINS, CARLETON E.	WILLIAMSONII, MT. SHASTA	11/80	CNY	140	A	21 X 16	C1867/V	T	BI
WATKINS, CARLETON E.	MT. SHASTA, FROM SHASTA VALLEY	11/80	CNY	141	A	16 X 21	C1867/V	T	3,500
WATKINS, CARLETON E.	STREET VIEW, ACIENDA, NEW ALMADEN	11/80	CNY	142	A	16 X 21	C1868/V	T	BI
WATKINS, CARLETON E.	THE YOSEMITE BOOK (28 PRINTS)	11/80	CNY	143	A	4TO	1868/V	T	BI
WATKINS, CARLETON E.	2 ALBUMS: THURLOW LODGE (60 PRINTS)	11/80	CNY	144	A	16 X 20	C1874/V	T/E	75,000
WATKINS, CARLETON E.	YOSEMITE VALLEY FROM INSPIRATION POINT	11/80	CNY	145	A	8 X 12	C1870/V		500
WATKINS, CARLETON E.	THE VALLEY FR. MARIPOSA TR., YOSEMITE	11/80	CNY	146	A	16 X 20	1880'S/V	IN/F	BI
WATKINS, CARLETON E.	THE CLIFF HOUSE, SAN FRANCISCO	11/80	CNY	147	A	16 X 21	1880-85/V	X/F	BI
WATKINS, CARLETON E.	"GRIZZLY GIANT, MARIPOSA GROVE, CALIF.	11/80	SNY	106	A	MAMMOTH	1864/V	S	1,700
WATKINS, CARLETON E.	"EL CAPITAN 3600 FT. YOSEMITE"	11/80	SNY	107	A	MAMMOTH	1866/V	S,T	700
WATKINS, CARLETON E.	"OUTLINE OF THE CATH. ROCKS, YOSEMITE"	11/80	SNY	108	A	MAMMOTH	C1866/V	S,T	700
WATKINS, CARLETON E.	"POHONO, THE BRIDAL VEIL 900 FT. YOS."	11/80	SNY	109	A	MAMMOTH	C1866/V	S,T	1,900

PHOTOGRAPHER	TITLE OR DESCRIPTION	DATE	AH	LOT#	PT	SIZE	N/P DATES	MARKS/COND.	PRICE
WATKINS, CARLETON E.	THE YOS. VAL./INSP. PT. MARIPOSA TRAIL	11/80	SNY	110	A	MAMMOTH	C1866/V	S,T	1,600
WATKINS, CARLETON E.	TACOYE, THE NORTH DOME 3730 FT. YOS.	11/80	SNY	111	A	MAMMOTH	C1866/V	S,T	900
WEBB, TODD	BABY YUCCA-NEW MEX/BATH, ENG. (2 PRTS)	5/81	PNY	262	S	8 X 10	61/75,75/75	S,T,D	150
WEBB, TODD	THIRD AVENUE, NEW YORK	10/80	PT	195	S	13 X 10	1946/L	S,T,D	180
WEBB, TODD	RUE DE SEINE, PARIS	10/80	PT	196	S	13 X 10	1951/V	S,T,D,ST	180
WEBB, TODD	42ND ST @ VANDERBILT PLACE, NYC	11/80	CNY	496	S	8 X 10	1942/70'S	S,T,D	BI
WEBB, TODD	"LA SALLE ST AT AMSTERDAM, NYC"	11/80	CNY	497	S	8 X 10	1946/70'S	S,T,D	BI
WEBB, TODD	"RUE CHATILLON, PARIS"	11/80	CNY	498	S	14 X 11	1949/70'S	S,T	BI
WEBB, TODD	"PARIS" (PAINTER ON BANKS OF SEINE)	11/80	SW	402	S	14 X 11	1950/V	S,ST	220
WEBB, TODD	"2 WOMEN ON MOTT ST., NY"	11/80	SW	403	S	11 X 14	1948/L	S,T	BI
WEBB, TODD	"PATIO GATE AT GEORGIA O'KEEFFE'S..."	11/80	SW	404	S	8 X 10	1962/V	S,T	110
WEBB, TODD	"ON THE PORTAL @ GEORGIA O'KEEFFE'S.."	11/80	SW	405	S	14 X 11	1960/L	S,T	260
WEBER, AL	SURF, CALIFORNIA (3 PRINTS)	11/80	CNY	649	CP	10 X 8	1970'S/V	S,ST	BI
WEEGEE (ARTHUR FELLIG)	FRANK SINATRA CONCERT (6 AUDIENCE PTS)	2/81	SLA	471	S	13 X 11	1940'S/V	ST	600
WEEGEE (ARTHUR FELLIG)	STRIPPERS (2 PHOTOS)	2/81	SLA	472	S	VARIOUS	1940'S/V	ST	500
WEEGEE (ARTHUR FELLIG)	DISTORTIONS (8 PHOTOS)	2/81	SLA	473	S	VARIOUS	1950'S/V	ST	450
WEEGEE (ARTHUR FELLIG)	"THE CRITIC"	4/81	PNY	29	S	11 X 13	1943/V	ST	1,000
WEEGEE (ARTHUR FELLIG)	EASTER SUNDAY, HARLEM	4/81	PNY	30	S	14 X 11	1940/V	ST	550
WEEGEE (ARTHUR FELLIG)	SUMMER, THE LOWER EAST SIDE	4/81	PNY	31	S	11 X 14	1937/V	ST	550
WEEGEE (ARTHUR FELLIG)	COSTUME PARTY (UNCLE JOE)	4/81	PNY	32	S	10 X 13	C1945/V	ST	350
WEEGEE (ARTHUR FELLIG)	CLOTHING SALESMAN IN FULL DRESS SUIT	4/81	SW	386	S	14 X 11	1940/V	ST	375
WEEGEE (ARTHUR FELLIG)	2 FEMALE ENTERTAINERS AT SAMMY'S	4/81	SW	390	S	14 X 11	1945/V	ST	325
WEEGEE (ARTHUR FELLIG)	BALDING MAN, SEEN FROM BEHIND	4/81	SW	391	S	14 X 11	1950'S/V		400
WEEGEE (ARTHUR FELLIG)	"THE CRITIC" (PRINTED ON LINEN)	5/81	CNY	158	MP	11 X 14	C1960/V	ST/G	1,700
WEEGEE (ARTHUR FELLIG)	NEW YORK (7 PRINTS)	5/81	SNY	382	S	14 X 11	1940'S/V	ST	650
WEEGEE (ARTHUR FELLIG)	NEW YORK (6 PRINTS)	5/81	SNY	383	S	14 X 11	1940'S/V	ST	600
WEEGEE (ARTHUR FELLIG)	NEW YORK (7 PRINTS)	5/81	SNY	384	S	11 X 14	1940'S/V	ST	500
WEEGEE (ARTHUR FELLIG)	THE CLOWN	5/81	SNY	385	S	10 X 14	1940'S/V	ST/G	300
WEEGEE (ARTHUR FELLIG)	"THE CRITIC"	5/81	SNY	386	S	8 X 8	1943/V	ST/P	750
WEEGEE (ARTHUR FELLIG)	DISTORTED NUDE	5/81	SNY	577	S	8 X 7	1950'S/V		150
WEEGEE (ARTHUR FELLIG)	DISTORTED NUDE	5/81	SNY	578	S	9 X 6	1950'S/V		175
WEEGEE (ARTHUR FELLIG)	DISTORTED NUDE	5/81	SNY	579	S	5 X 8	1950'S/V	ST	200
WEEGEE (ARTHUR FELLIG)	"THE CRITIC"	11/80	CNY	489	S	11 X 13	1940'S/V	ST	1,100
WEEGEE (ARTHUR FELLIG)	"NUDE"	11/80	CNY	490	S	9 X 7	C1960/V	S,T,ST	800
WEEGEE (ARTHUR FELLIG)	ASLEEP ON FIRE ESCAPE	11/80	CNY	490A	S	13 X 11	1938/60'S		400
WEEGEE (ARTHUR FELLIG)	ALFRED STIEGLITZ	11/80	CNY	490B	S	11 X 14	1940'S/60'S	ST	260
WEEGEE (ARTHUR FELLIG)	YIDDISH THEATER REHEARSAL	11/80	CNY	490C	S	14 X 11	1943/60'S	ST	BI
WEEGEE (ARTHUR FELLIG)	BOOKED FOR STRANGLING LITTLE GIRL	11/80	CNY	490D	S	10 X 13	1944/60'S	ST	160
WEEGEE (ARTHUR FELLIG)	WOMAN WITH A DASCHUND	11/80	CNY	490E	S	14 X 11	1940'S/60'S	ST	170
WEEGEE (ARTHUR FELLIG)	SLEEPING YOUNG MAN WITH A DINER	11/80	CNY	490F	S	14 X 11	1950'S/60'S	ST	BI
WEEGEE (ARTHUR FELLIG)	TWO DRUNKEN MEN DANCING	11/80	CNY	490G	S	14 X 11	1950'S/60'S	ST	150
WEEGEE (ARTHUR FELLIG)	PORTRAIT: JIMMY DURANTE	11/80	CNY	491	S	10 X 8	1940'S/V	ST	BI
WEEGEE (ARTHUR FELLIG)	PORTRAIT: A LADY	11/80	CNY	492	S	11 X 5	1940'S/V	S,T,ST	850
WEEGEE (ARTHUR FELLIG)	"CONEY ISLAND AT 4 P.M."	11/80	PNY	191	S	10 X 13	1939/V	ST	700
WEEGEE (ARTHUR FELLIG)	"SHORTY, THE BOWERY CHERUB	11/80	SNY	355	S	14 X 11	1943/V	ST	600
WEEGEE (ARTHUR FELLIG)	"THE CRITIC"	11/80	SNY	356	S	10 X 13	1943/V	I,ST	1,800
WEEGEE (ARTHUR FELLIG)	"GOD BLESS AMERICA"	11/80	SNY	357	S	11 X 13	1940'S/V	ST	400
WEEGEE (ARTHUR FELLIG)	"TENEMENT PENTHOUSE"	11/80	SNY	358	S	14 X 11	1940'S/V	ST	200
WEEGEE (ARTHUR FELLIG)	3-D SMOOCH	11/80	SNY	359	S	10 X 13	1940'S/V	ST	400
WEEGEE (ARTHUR FELLIG)	THE ARTIST'S BALL (5 PHOTOS)	11/80	SNY	360	S	VARIOUS	1960'S/V	ST	300
WEEGEE (ARTHUR FELLIG)	"LADY SINGER"	11/80	SW	408	S	11 X 14	1940'S/V	ST	BI
WEEGEE (ARTHUR FELLIG)	"FAT MAN SLEEPING ON FIRE ESCAPE"	11/80	SW	411	S	11 X 14	1940'S/V	ST	180
WEEGEE (ARTHUR FELLIG)	"MUSICIAN CARRYING BASS FIDDLE"	11/80	SW	412	S	14 X 11	1940'S/V	ST	275
WEEGEE (ARTHUR FELLIG)	"MAN DRINKING FROM SHOT GLASS"	11/80	SW	413	S	11 X 14	1940'S/V	ST	170
WEEGEE (ARTHUR FELLIG)	PORTRAIT: ALFRED STIEGLITZ	11/80	SW	414	S	11 X 14	1940'S/V	ST	300
WEEGEE (ARTHUR FELLIG)	"THE CRITIC"	11/80	SW	415	S	13 X 11	C1945/V	ST	1,200
WEEGEE (ARTHUR FELLIG)	MARILYN MONROE (DISTORTION)	11/80	SW	418	S	10 X 8	1950'S/V	S,ST	225
WEINER, DAN	"MAY DAY, 1948"	2/81	SLA	474	S	6 X 9	1948/V	I	200
WELPOTT, JACK	"SABINE, ARLES" (FEMALE NUDE)	2/81	SLA	475	S	13 X 10	1973/V	S,T,D,ST	300
WELPOTT, JACK	"SABINE, ARLES"	2/81	SLA	476	S	12 X 9	1973/V	S,T,D,I	300
WENCKER, V.	PORTRAIT: LISE DEHARME WITH MANNEQUIN	11/80	PNY	106	S	12 X 8	C1936/V	S,I	350

113

PHOTOGRAPHER	TITLE OR DESCRIPTION	DATE	AH	LOT#	PT	SIZE	N/P DATES	MARKS/COND.	PRICE
WESTON, BRETT	FEMALE NUDE (RECLINING TORSO)	2/81	SLA	477	S	10 X 14	1975/V	S,D	550
WESTON, BRETT	METAL ABRASION	2/81	SLA	478	S	8 X 10	1973/V	S,D	350
WESTON, BRETT	TREES	2/81	SLA	479	S	8 X 10	1965/V	S,D	500
WESTON, BRETT	HARBOR, THE NETHERLANDS	2/81	SLA	480	S	8 X 10	1960/V	S,D	650
WESTON, BRETT	TORN WINDOW SCREEN	2/81	SLA	481	S	10 X 8	1975/V	S,D	250
WESTON, BRETT	WHITE SANDS, NEW MEXICO, 1946	4/81	PNY	5	S	8 X 10	1946/1949	S,D	BI
WESTON, BRETT	PORTFOLIO:"WHITE SANDS" (10 PRINTS)	5/81	CNY	172	S	10 X 8	1946/49	S,D	6,000
WESTON, BRETT	PORTFOLIO:"NEW YORK"(12 PRINTS; ED:50)	5/81	CNY	173	S	10 X 8	1940'S/52	S,ST,D,I	8,000
WESTON, BRETT	PORTFOLIO:"FIFTEEN PHOTOGRAPHS"(ED:35)	5/81	CNY	174	S	10 X 8	1934-61/61	S,D	7,500
WESTON, BRETT	PORTFOLIO:"EUROPE"(12 PRINTS; ED:100)	5/81	CNY	175	S	12 X 11	1960-73/73	S,D,ST	8,000
WESTON, BRETT	CANAL, HOLLAND	5/81	CNY	176	S	20 X 15	1971/V	S,D/M	2,200
WESTON, BRETT	CANAL, HOLLAND	5/81	SNY	436	S	14 X 11	1971/V	S,D	1,400
WESTON, BRETT	CENTURY PLANT	5/81	SNY	437	S	11 X 13	1977/V	S,D/M	1,950
WESTON, BRETT	BUILDING FACADE	5/81	SNY	438	S	11 X 11	1973/L	S,D	450
WESTON, BRETT	GOLDEN GATE BRIDGE	5/81	SNY	439	S	8 X 9	1939/V	S,D	125
WESTON, BRETT	"DUNES, BAJA"	10/80	PT	219	S	8 X 10	1968/V	S,D	450
WESTON, BRETT	PORTFOLIO:"FIFTEEN PHOTOGRAPHS"(ED:35)	11/80	CNY	477	S	10 X 8	1934-61/61	S,D,T	5,500
WESTON, BRETT	VINEYARD	11/80	CNY	478	S	8 X 10	1940/V	S,D	BI
WESTON, BRETT	TORN POSTER	11/80	CNY	479	S	13 X 11	1971/V	S,D	240
WESTON, BRETT	ABASTACTION, WALL PAPER	11/80	CNY	480	S	13 X 11	1972/V	S,D	260
WESTON, BRETT	MENDENHALL GLACIER, ALASKA	11/80	CNY	481	S	8 X 9	1973/L	S,D	700
WESTON, BRETT	ST. CHRYSLER	11/80	CNY	482	S	8 X 10	1973/V	S,D	BI
WESTON, BRETT	BROKEN WINDOW	11/80	CNY	483	S	11 X 13	1974/V	S,D	300
WESTON, BRETT	TREES REFLECTION IN WATER	11/80	CNY	484	S	13 X 11	1974/V	S,D	280
WESTON, BRETT	MOSS LANDING	11/80	CNY	485	S	8 X 10	1975/V	S,D	400
WESTON, BRETT	NUDE	11/80	CNY	486	S	8 X 10	1975/V	S,D	400
WESTON, BRETT	KELP, PEBBLE BEACH	11/80	CNY	487	S	10 X 8	1975/V	S,D	350
WESTON, BRETT	SIGN ABSTRACTION	11/80	CNY	488	S	10 X 8	1977/V	S,D	BI
WESTON, BRETT	"CAR DETAIL"	11/80	PNY	265	S	7 X 9	1936/V	S,T,D	BI
WESTON, BRETT	"DUNES"	11/80	PNY	266	S	8 X 10	1936/V	S,D	500
WESTON, BRETT	ROOFTOPS	11/80	SNY	484	S	8 X 10	1960/V	S,D,	600
WESTON, BRETT	REFLECTIONS THROUGH A WINDOW	11/80	SNY	485	S	10 X 8	1954/V	S,D,	350
WESTON, EDWARD	PORTRAIT: WILLIAM ANDREWS CLARK, JR	2/81	SLA	482	P	9 X 8	1921/V	S,D,I	900
WESTON, EDWARD	PORTRAIT: ROBINSON JEFFERS & SONS, CA.	2/81	SLA	483	S	10 X 7	C1929/V	S,I	1,000
WESTON, EDWARD	PORTRAIT: SADAKICHI HARTMANN	2/81	SLA	484	P	10 X 8	C1922/V	S	2,500
WESTON, EDWARD	"KELP" (ED: 50?)	2/81	SLA	485	S	8 X 10	1930/V	S,T,D,A	BI
WESTON, EDWARD	"OAK", MONTEREY	2/81	SLA	486	S	7 X 9	1929/C40'S	S,T,D,A	BI
WESTON, EDWARD	NUDE IN SWEET ALYSSUM	2/81	SLA	487	S	8 X 10	1939/V	S,D	2,900
WESTON, EDWARD	SAND DUNES	2/81	SLA	489	S	8 X 10	1936/V	S,D	10,500
WESTON, EDWARD	"WIND EROSION, DUNES OCEANO"	2/81	SLA	490	S	8 X 10	1936/V	S,D,T	BI
WESTON, EDWARD	"ERODED ROCK"	2/81	SLA	491	S	8 X 10	1942/V	S,D	2,500
WESTON, EDWARD	"DEATH VALLEY"	2/81	SLA	492	S	8 X 10	1937/V	S,D,T,A	1,800
WESTON, EDWARD	"STARFISH" (ED: 50?)	2/81	SLA	493	S	8 X 11	1930'S/V	A	900
WESTON, EDWARD	TINA MODOTTI, GLENDALE	5/81	CNY	114	P	9 X 7	1921/V	/E	9,500
WESTON, EDWARD	TINA MODOTTI, MEXICO	5/81	CNY	115	S	9 X 7	1924/V	S,T,D/E	13,000
WESTON, EDWARD	"DIEGO RIVERA, MEXICO"	5/81	CNY	116	S	7 X 8	1924/V	S,T,D/G-E	2,800
WESTON, EDWARD	BONE (ED: 1/(0?)))	5/81	CNY	117	S	10 X 7	1930/V	S,D,A/M	2,000
WESTON, EDWARD	"DISCARDED GLOVE"	5/81	CNY	118	S	8 X 10	1936/V	S,D,T,I/M	2,000
WESTON, EDWARD	NUDE (SEATED)	5/81	CNY	119	S	4 X 5	1934/V	D,S,A/M	10,000
WESTON, EDWARD	CHURCH DOOR, HORNITOS, CALIF	5/81	CNY	120	S	8 X 10	1940/V	D,S,T,I/M	4,800
WESTON, EDWARD	"ANSEL ADAMS DARKROOM, YOSEMITE"	5/81	CNY	121	S	8 X 10	1938/V	S,D,T/G	1,200
WESTON, EDWARD	ERODED ROCK, POINT LOBOS	5/81	CNY	122	S	8 X 10	1938/V	S,D,A/G	1,200
WESTON, EDWARD	"DEATH VALLEY"	5/81	PNY	249	S	8 X 10	1937/V	S,D,T/G-F	BI
WESTON, EDWARD	"NEIL, MAY 1919"	5/81	SNY	338	P	10 X 8	1919/V	S,T,D/F	BI
WESTON, EDWARD	"JAPANESE FIGHTING MASK"	5/81	SNY	339	P		1921/V	S,T,D/F	8,250
WESTON, EDWARD	"LA PIRAMIDE DEL SOL"	5/81	SNY	340	P	8 X 10	1923/V	S,T,D,I/G	5,500
WESTON, EDWARD	PORTRAIT: MARGRETHE MATHER	5/81	SNY	341	P	6 X 9	1923/V	S,D/M	9,000
WESTON, EDWARD	RESTAURANT SIGN, MEXICO CITY	5/81	SNY	342	S	7 X 9	C1926/V	T/P	BI
WESTON, EDWARD	"JUGUETES"	5/81	SNY	343	S	9 X 7	1926/V	/F	1,200
WESTON, EDWARD	"MEXICAN TOYS"	5/81	SNY	344	P	8 X 10	1924/V	T,D/E	1,400
WESTON, EDWARD	"WOMAN TRIUMPHANT..."	5/81	SNY	345	S	10 X 8	C1926/V	T/F-G	1,200

114

PHOTOGRAPHER	TITLE OR DESCRIPTION	DATE	AH	LOT#	PT	SIZE	N/P DATES	MARKS/COND.	PRICE
WESTON, EDWARD	"ORANGE-BANANAS-AND OLLA"	5/81	SNY	346	S	8 X 9	C1927/V	T/G-E	2,200
WESTON, EDWARD	"BIRD MADE FROM GOURD"	5/81	SNY	347	S	10 X 6	C1926/V	T/P	700
WESTON, EDWARD	"GUADALUPE, MEXICO"	5/81	SNY	348	S	8 X 7	1924/C40	S,T,D	BI
WESTON, EDWARD	"CORRIDOR-DINING ROOM OF DIEGO RIVERA"	5/81	SNY	349	S	8 X 9	C1927/V	T/F	500
WESTON, EDWARD	PORTRAIT: NEIL WESTON	5/81	SNY	350	S	5 X 4	C1946/V	T,A	BI
WESTON, EDWARD	"SHELLS" (ED: 7/(50?))	5/81	SNY	351	S	9 X 7	1927/V	S,T,D,A/E	6,750
WESTON, EDWARD	"EEL RIVER RANCH"	5/81	SNY	352	S	8 X 10	1937/V	S,D,T/P	BI
WESTON, EDWARD	"CHINESE CABBAGE" (ED: 4/(50?))	5/81	SNY	353	S	9 X 8	1931/V	S,D,A/G-E	2,750
WESTON, EDWARD	"NUDE ON SAND"	5/81	SNY	354	S	8 X 10	1936/V	S,D,T/M	12,500
WESTON, EDWARD	SURF, POINT LOBOS	5/81	SNY	355	S	8 X 10	1938/V	S,D,A/E	1,200
WESTON, EDWARD	"WALLS SCRAWLS, HORNITOS, CA."	5/81	SNY	356	S	8 X 10	1940/V	S,D,T/E	1,000
WESTON, EDWARD	"SAND DUNES, OCEANO"	5/81	SNY	357	S	8 X 10	1936/V	S,D,T/M	9,000
WESTON, EDWARD	NUDE ON THE DUNES	5/81	SNY	358	S	8 X 10	1939/V	S,D/E	2,300
WESTON, EDWARD	SAND DUNES	5/81	SNY	359	S	8 X 10	1936/V	S,D	6,000
WESTON, EDWARD	ROW OF SHEDS	5/81	SNY	360	S	8 X 10	1937/V	S,D,I/P	250
WESTON, EDWARD	"WHITE SANDS - NEW MEXICO"	5/81	SNY	365	S	7 X 10	1941/V	S,D,T/G-E	3,000
WESTON, EDWARD	PORTRAIT: ANSEL ADAMS	5/81	SNY	366	S	8 X 10	1943/V	S,D,T/G-E	1,000
WESTON, EDWARD	PORTRAIT: DAVID MCALPIN, NYC (ED: 100)	5/81	SNY	367	S	10 X 8	1941/L	S,D,ST/M	800
WESTON, EDWARD	BRETT	11/80	CNY	351	P	8 X 10	1923/V	S,T,D	3,400
WESTON, EDWARD	CYPRESS - POINT LOBOS (ED: 1/(50?))	11/80	CNY	352	S	10 X 8	1930/V	S,D,T	3,000
WESTON, EDWARD	LETTUCE RANCH, SALINAS	11/80	CNY	353	S	8 X 10	1934/V	D,S,T	3,400
WESTON, EDWARD	STUMP AGAINST SKY (ED: 6/(40?))	11/80	CNY	354	S	10 X 8	1936/V	S,D,T	2,600
WESTON, EDWARD	ALBION - NORTH COAST	11/80	CNY	355	S	10 X 8	1937/V	S,D,T	2,000
WESTON, EDWARD	PETER KRASNOW	11/80	CNY	356	S	10 X 8	1942/V	D	BI
WESTON, EDWARD	"ROCK EROSION, POINT LOBOS"	11/80	PNY	254	S	8 X 10	1938/V	S,T,D	2,400
WESTON, EDWARD	PORTRAIT: RAFAEL SALA	11/80	PNY	255	S	9 X 7	C1926/V	A	BI
WESTON, EDWARD	PORTRAIT: SONYA NOSKOWIAK	11/80	PNY	256	S	4 X 4	1933/V	S,D	750
WESTON, EDWARD	"POTATO CELLAR, LAKE TAHOE"	11/80	PNY	257	S	7 X 10	1937/53	S,D	750
WESTON, EDWARD	ROBINSON JEFFERS AND SONS, CARMEL	11/80	PNY	258	S	10 X 7	C1929/V	S	BI
WESTON, EDWARD	"COSAS DE LA VIDA"	11/80	SNY	284	P	7 X 9	1926/V	S,I,T	2,900
WESTON, EDWARD	CLEMENTE OROZCO	11/80	SNY	284A	P	10 X 10	1930/V	S,D,T,I	2,000
WESTON, EDWARD	FEMALE NUDE (TORSO, ARMS CROSSED)	11/80	SNY	285	P	6 X 7	1925/V	S,D	16,000
WESTON, EDWARD	TREE STUDY (ED:2/(50?))	11/80	SNY	286	S	10 X 8	1929/V	S,I,D,ST	1,600
WESTON, EDWARD	PORTRAIT: ROBINSON JEFFERS	11/80	SNY	287	S	4 X 3	1929/V	S,D	550
WESTON, EDWARD	"DUNES-OCEANO" (EXHIB.LABELS)	11/80	SNY	288	S	8 X 10	1936/V	S,D,T	7,500
WESTON, EDWARD	PORTRAIT: ROBINSON JEFFERS	11/80	SNY	289	S	5 X 4	1933/V	S,T,D	350
WESTON, EDWARD	"BADGER PASS, YOSEMITE"	11/80	SNY	290	S	8 X 10	1938/V	S,D,T	1,200
WESTON, EDWARD	"CEMETERY, NEW ORLEANS"	11/80	SNY	291	S	8 X 10	1941/V	S,D,I	1,700
WESTON, EDWARD	"WM. EDMONDSON-SCULPTOR, NASHVILLE,TN"	11/80	SNY	292	S	8 X 10	1941/V	S,D,T	1,700
WESTON, EDWARD	"NEW MEXICO" (WITH BROCHURE BY WESTON)	11/80	SNY	293	S	8 X 10	1941/V	S,D,T	2,000
WESTON, EDWARD/COLE	"TINA"	2/81	SLA	494	S	9 X 7	1924/L	ST,	275
WESTON, EDWARD/COLE	"NAHUI OLIN"	2/81	SLA	495	S	9 X 7	1924/L	ST	275
WESTON, EDWARD/COLE	"NUDE"	2/81	SLA	496	S	7 X 8	1927/L	ST	550
WESTON, EDWARD/COLE	NUDES (4 PHOTOS)	2/81	SLA	497	S	8 X 10	1936/L	T,I,ST	900
WESTON, EDWARD/COLE	"CLOUD, THE PANAMINTS"	2/81	SLA	498	S	8 X 10	1937/L	ST	175
WESTON, EDWARD/COLE	"CHARIS, LAKE EDIZA"	5/81	SNY	368	S	10 X 8	1937/L	ST/M	350
WESTON, EDWARD/COLE	PEPPER	5/81	SNY	369	S	9 X 7	1930/L	ST/M	BI
WESTON, EDWARD/COLE	"NUDE"	5/81	SNY	370	S	7 X 10	1936/L	ST/M	300
WESTON, EDWARD/COLE	"PEPPER NO. 30"	10/80	PT	124	S	9 X 8	1930/L		280
WESTON, EDWARD/COLE	PEPPER	11/80	CNY	357	S	10 X 8	1929/46-53	ST,T,D,A	BI
WESTON, EDWARD/COLE	RANCHO, SONOMA	11/80	CNY	358	S	8 X 10	1937/46-53	ST,T,D,A	BI
WESTON, EDWARD/COLE	NORTH COAST,...	11/80	CNY	359	S	8 X 10	1937/46-53	ST,T,D,A	BI
WESTON, EDWARD/COLE	MANLEY'S BEACON...	11/80	CNY	360	SD	8 X 10	1938/46-53	T,D,A	400
WESTON, EDWARD/COLE	PORTFOLIO: "DESNUDOS"(12 PR,ED:15/100)	11/80	CNY	361	S	10 X 8	1920-45/72	T,D,ST	2,500
WESTON, EDWARD/COLE	CABBAGE LEAF	11/80	CNY	363	S	8 X 9	1931/1970'S	T,D	260
WESTON, EDWARD/COLE	IVANOS AND BUGATTI	11/80	CNY	364	S	8 X 9	1931/1970'S	ST,T,D	140
WESTON, EDWARD/COLE	ARMCO STEEL, OHIO	11/80	CNY	365	S	10 X 7	1922/1970'S	ST,T,D	220
WESTON, EDWARD/COLE	NUDE	11/80	CNY	366	S	5 X 4	1934/1970'S	T,D	140
WHITE, C.H. (ATTRIB. TO)	HANDS	5/81	PNY	224	P	4 X 5	C1909/V	/M	BI
WHITE, CLARENCE H.	NUDE (WOMAN AND REFLECTION)	5/81	CNY	61	P	10 X 8	1909/V	/E	3,200
WHITE, CLARENCE H.	PORTRAIT STUDY IN BLACK, LETITIA FELIX	5/81	CNY	60	P	7 X 3	1897/V	S,D/G	500

PHOTOGRAPHER	TITLE OR DESCRIPTION	DATE	AH	LOT#	PT	SIZE	N/P DATES	MARKS/COND.	PRICE
WHITE, CLARENCE H.	PORTRAIT: A WOMAN	5/81	PNY	238	PG	6 X 4	C1901/V	S,D	BI
WHITE, CLARENCE H.	DRAPED FIGURE STUDY	5/81	SNY	151	P	10 X 8	1909/V	S,D/F	800
WHITE, CLARENCE H.	DRAPED FIGURE IN THE WOODS	5/81	SNY	535A	P	9 X 6	C1917/V		400
WHITE, CLARENCE H.	BARON DE MEYER	10/80	SNY	61	P	9 X 6	C1920/V	S	550
WHITE, CLARENCE H.	ILLUSTRATION TO: "BENEATH THE WIND"	11/80	CNY	242	PG	8 X 6	1905/V		BI
WHITE, CLARENCE H.	GIFT PORTFOLIO (9 PHOTOS SILV & PLAT)	11/80	SNY	160	S	VARIOUS	1902-09/V	S,ST	24,000
WHITE, CLARENCE H.	PORT: JANE, MAYNARD, AND LEWIS WHITE	11/80	SNY	161	P	7 X 8	C1899/V		900
WHITE, HENRY	THE THAMES AT WEYBRIDGE	5/81	PNY	7	A	7 X 9	C1856/V	S,T/G	BI
WHITE, HENRY	"THE LLEDR BRIDGE NEAR BETTWS Y COED"	5/81	SNY	85	A	8 X 10	1850'S/V	A,T/E	BI
WHITE, HENRY	"RYE"	11/80	CNY	10	A	8 X 10	C1856/V	I,PD	1,800
WHITE, HENRY	"THE DECOY"	11/80	CNY	11	A	8 X 10	C1856/V	I,PD	BI
WHITE, MINOR	"RINGS & ROSES, CEMETERY, PONCE, P.R."	2/81	SLA	500	S	9 X 12	1973/V		1,100
WHITE, MINOR	"NUDE FOOT"	2/81	SLA	501	S	8 X 11	1947/L	S	1,000
WHITE, MINOR	"NUDE, SAN FRANCISCO"	2/81	SLA	502	S	10 X 6	1947/V		BI
WHITE, MINOR	"SAW AND DOOR, CHINA CAMP, CALIFORNIA"	2/81	SLA	503	S	15 X 9	1948/V	A,T,D,ST	500
WHITE, MINOR	NIGHT HARBOR	2/81	SLA	504	S	7 X 9	C1950'S/V		300
WHITE, MINOR	SAN FRANCISCO HARBOR	2/81	SLA	505	S	11 X 11	C1950/V		300
WHITE, MINOR	WESTERN LANDSCAPE	2/81	SLA	506	S	10 X 13	C1950/V		300
WHITE, MINOR	"CAT SKELETON, SAN FRANCISCO"	2/81	SLA	507	S	10 X 7	1953/V		BI
WHITE, MINOR	PLANT AND TREE STUMP	2/81	SLA	508	S	15 X 14	C1950'S/V		700
WHITE, MINOR	"N. UNION STREET, ROCHESTER"	2/81	SLA	509	S	13 X 9	1956/V		350
WHITE, MINOR	"CHRISTMAS ORNAMENT, BATAVIA, N.Y."	2/81	SLA	510	S	9 X 6	1958/V		BI
WHITE, MINOR	"BURNED MIRROR"	2/81	SLA	511	S	12 X 8	1959/V		300
WHITE, MINOR	"LICHEN COVERED ROCKS, UTAH"	2/81	SLA	512	S	13 X 10	1964/V		BI
WHITE, MINOR	"LANDSCAPE WITH BULLET HOLES, UTAH"	2/81	SLA	514	S	8 X 13	1962/V	ST	225
WHITE, MINOR	SONG WITHOUT WORDS, NO. 21	4/81	PNY	13	S	4 X 5	1947/V		1,000
WHITE, MINOR	SONG WITHOUT WORDS, NO. 6	4/81	PNY	14	S	5 X 4	1947/V		850
WHITE, MINOR	SEQUENCE 17 (25 CONTACT PRINTS)	5/81	CNY	184	S	4 X 5	1959-62/V		8,500
WHITE, MINOR	JUPITER PORTFOLIO (12 PR.; ED: 49/75)	5/81	CNY	185	S	9 X 11	1975/V	S	9,000
WHITE, MINOR	"PEELED PAINT ON STORE WINDOW, S.F."	5/81	CNY	186	S	7 X 9	1950/V	S,D,/M	1,100
WHITE, MINOR	EASTER SUNDAY, STONY BROOK PARK, N.Y.	5/81	PNY	304	S	10 X 4	1963/V	D,S	1,000
WHITE, MINOR	CAPE MEARES, OREGON	5/81	PNY	305	S	9 X 7	1967/V	S,T,D	600
WHITE, MINOR	RITUAL STONES, NOTOM, UTAH	5/81	PNY	306	S	12 X 9	1963/76	S	BI
WHITE, MINOR	NAVIGATION MARKERS, NOVA SCOTIA	5/81	PNY	307	S	9 X 11	1970/76	S	BI
WHITE, MINOR	TREE PEONIES	5/81	SNY	443	S	7 X 9	1950'S/V	/G	BI
WHITE, MINOR	TREE AND BROKEN WINDOW	5/81	SNY	444	S	13 X 11	1950'S/V	/E	600
WHITE, MINOR	"TWO BARNS"	5/81	SNY	445	S	11 X 14	1955/V	S,T,D/G-E	2,400
WHITE, MINOR	"WATER PUMP AND WINDOW"	5/81	SNY	446	S	13 X 10	1958/V	A,T,D,ST/G-E	450
WHITE, MINOR	"GONE THE NEXT TO THE LAST ILLUSION"	5/81	SNY	447	S	7 X 9	1950'S/V	T	250
WHITE, MINOR	BICYCLE	5/81	SNY	448	S	10 X 13	1950'S/V	/E	300
WHITE, MINOR	CITY IN THE SNOW	5/81	SNY	449	S	9 X 6	1950'S/V		1,000
WHITE, MINOR	"NUDE FEET"	5/81	SNY	574	S	7 X 10	1947/V	S,T,D/M	1,500
WHITE, MINOR	"PEELED PAINT, ROCHESTER, N.Y."	10/80	PT	201	S	12 X 9	1959/76	S	700
WHITE, MINOR	"RITUAL STONES, NOTOM, UTAH"	10/80	PT	202	S	12 X 9	1963/76	S	BI
WHITE, MINOR	"NAVIGATION MARKERS, NOVA SCOTIA"	10/80	PT	203	S	9 X 11	1970/76	S	BI
WHITE, MINOR	PORTRAIT: JOSEPH A. PRESTO	10/80	PT	204	S	5 X 4	1947/V	S	BI
WHITE, MINOR	"NUDE FEET"	11/80	SNY	459	S	7 X 10	1947/V	I,T,D	1,100
WHITE, MINOR	"PEELED PAINT ON STORM WINDOW,..."	11/80	SNY	460	S	9 X 12	1951/V	S,T,D	800
WHITE, MINOR	WATERFALL	11/80	SNY	461	S	11 X 8	C1968/V	S	600
WHITE, MINOR	"LUBEC, MAINE"	11/80	SNY	462	S	4 X 9	1969/V	S,D,T	400
WHITE, MINOR	"NAVIGATION MARKER, NOVA SCOTIA"	11/80	SNY	463	S	9 X 11	1970/V	S	700
WHITE, MINOR	JUPITER PORTFOLIO (12 PRINTS;ED:53/75)	11/80	SNY	464	S	9 X 12	1975/V	S,T,D	14,000
WHITE, MINOR	"SONG WITHOUT WORDS #13"	11/80	CNY	560	S	5 X 4	1960'S/V	S,T	1,200
WHITE, MINOR	ICE	11/80	CNY	561	S	8 X 10	1958/V	S,D	500
WHITE, MINOR	LOBOS (CALIF.)	11/80	CNY	562	S	7 X 9	1959/V	S,T,D	650
WHITE, MINOR	WINDOWSILL DAYDREAMING	11/80	CNY	563	S	12 X 9	1958/C70	S	1,600
WHITE, MINOR	"LARGE BARN, NAPLES & DANVILE, NY"	11/80	CNY	563A	S	6 X 10	1955/L	S,T,D	750
WICHURA, GERHARD	"WOMAN ON CHRISTMAS MORNING"	11/80	PNY	216	CA	16 X 13	C1938/V		BI
WIDOKIM OF WARSAW	BASILICA	11/80	CNY	62	SA	12 X 9	1858/V	PD	900
WILDING, DOROTHY	TALLULAH BANKHEAD	11/80	CNY	392A	S	4 X 5	C1923/V	S,I	BI
WILLIAMS, J.J.	SOUVENIR OF HAWAII (24 PRINTS & TEXT)	11/80	CNY	172	A	4TO	C1880/V		BI

PHOTOGRAPHER	TITLE OR DESCRIPTION	DATE	AH	LOT#	PT	SIZE	N/P DATES	MARKS/COND.	PRICE
WILLIAMS, T.R.	STILLIFE (GUITAR AND STEREOVIEWER)	2/81	SLA	516	D	4 X 7	1850'S/V		400
WILSON, GEORGE WASHINGTON	VIEWS OF SCOTLAND (72 PRINTS)	11/80	CNY	199	A	4 X 7	C1880/V	IN,SN/F	50
WILSON, LESLIE HAMILTON	WHALE	2/81	SLA	518	P	4 X 6	C1900'S/V		200
WINNINGHAM, GEOFF	"WRESTLING, HOUSTON"	2/81	SLA	521	S	18 X 13	1971/V	S,T,D	75
WINNINGHAM, GEOFF	"WRESTLING, HOUSTON"	11/80	CNY	634	S	12 X 18	1971/V	S,T,D	100
WINNINGHAM, GEOFF	"BALL", HOUSTON	11/80	CNY	635	S	12 X 18	1972/V	S,T,D	BI
WINOGRAND, GARRY	CAR IN A GARAGE	5/81	SNY	505	S	9 X 13	1950'S/V	S/G	200
WIRTZ, DR. PAUL	NEW GUINEA TRIBESMAN (3 PHOTOS)	5/81	SNY	109	S	7 X 5	1915-31/V	IN/F	125
WOLCOTT, MARION POST	BLIZZARD, BRATTLEBORO, VERMONT	4/81	PNY	108	S	10 X 14	1940/V	ST	425
WOLCOTT, MARION POST	"WAITING IN LINE"	4/81	SW	399	S	9 X 13	C1940/V	ST	160
WOLCOTT, MARION POST	LANDSCAPE WITH BOX CARS	4/81	SW	401	S	10 X 13	C1940/V	ST	375
WOLCOTT, MARION POST	"NEGROES FISHING, NEAR MISS. DELTA"	11/80	PNY	267	S	10 X 13	1939/V	S,T,D,ST	BI
WOLCOTT, MARION POST	"OLD NEGRO, WHITTLING, CAMDEN, ALA."	11/80	PNY	268	S	13 X 20	C1939/V	S,T,ST	400
WOLCOTT, MARION POST	"VEGETABLE PICKERS, HOMESTEAD, FLA."	11/80	PNY	269	S	13 X 19	1939/V	S,T,D,ST	BI
WOLCOTT, MARION POST	"MIGRANT PICKER ..., FLORIDA"	11/80	PNY	270	S	7 X 10	1939/V	S,T,D,ST	BI
WOLCOTT, MARION POST	"BRATTLEBORO, VERMONT"	11/80	PNY	271	S	7 X 9	1939/V	S,T,ST	BI
WOLCOTT, MARION POST	"DISCUSSION"	11/80	SW	423	S	12 X 10	1930'S/V	ST	170
WOLCOTT, MARION POST	"FARMER"	11/80	SW	424	S	12 X 10	1930'S/V	ST	BI
WOLCOTT, MARION POST	"FREIGHT TRAIN"	11/80	SW	425	S	12 X 10	1930'S/V	ST	250
WOLCOTT, MARION POST	"WAITING"	11/80	SW	426	S	12 X 10	1930'S/V	ST	260
WOLGENSINGER, MICHAEL	"BURNING CIGARETTE"	11/80	PNY	99	S	9 X 7	C1930/V	ST	100
WORTH, DON	"TREES AND FOG"	2/81	SLA	522	S	16 X 22	1971/L	S,ST	800
WORTH, DON	"SUCCULENT: ECHEVERIA 'MORNING LIGHT'"	2/81	SLA	523	S	16 X 16	1972/L	S,ST	225
WRIGHT, FRANK LLOYD	WILD FLOWERS BOUQUET (2 PANELS)	5/81	SNY	136	PG	2@7 X 3	C1895/V	/M	1,200
WRIGHT, FRANK LLOYD	STUDY OF DRIED WILD FLOWERS (2 PANELS)	11/80	SNY	147	PG	8 X 2	C1895/V		1,000
WRIGHT, FRANK LLOYD	STUDY OF DRIED WILD FLOWERS (2 PANELS)	11/80	SNY	148	PG	8 X 3	C1895/V		1,000
YAVNO, MAX	"KNOCKOUT" (ED. 75)	2/81	SLA	524	S	16 X 19	?/1977	S,A	275
YAVNO, MAX	STOCKING, OLYMPIC BLVD. IN HOLLYWOOD	5/81	CNY	167	S	19 X 16	C1950/70'S	S/G	600
YAVNO, MAX	"KEYBOARD HOUSES"	10/80	PT	197	S	13 X 10	C1947/L	S	280
YAVNO, MAX	"SAN FRANCISCO AT NIGHT"	10/80	PT	198	S	10 X 13	C1947/L	S	BI
YAVNO, MAX	STOCKING-OLYMPIC BLVD. IN HOLLYWOOD	11/80	CNY	493	S	20 X 16	C1950/70'S	S	550
YAVNO, MAX	MUSCLE BEACH, VENICE, CALIFORNIA	11/80	CNY	494	S	8 X 12	C1950/70'S	S	260
YAVNO, MAX	MOVIE PREMIERE AT CARTHAY THEATER	11/80	CNY	495	S	19 X 16	1950/70'S	S	480
ZICHY, COUNT THEODORE	20 CHIAROSCUROS (20 PR, ED: 90/100)	11/80	CNY	438	S	12 X 10	C1930/48	A,S	2,400
ZICHY, COUNT THEODORE	SURREAL PORTRAITS OF LEGS (2 PHOTOS)	2/81	SLA	525	S	9 X 12	1940'S/V	S,A	300
ZICHY, COUNT THEODORE	CHIAROSCURO (LEGS W/SCREWDRIVER)	4/81	PNY	132	S	11 X 8	1948/70'S	S,I	250
ZICHY, COUNT THEODORE	CHIAROSCURO (LEGS CARRYING LEGS)	4/81	PNY	133	S	11 X 9	1948/70'S	S,I	100
ZICHY, COUNT THEODORE	CHIAROSCURO (LEGS ON A PIANO)	4/81	PNY	134	S	8 X 11	1948/70'S	S,I	BI
ZOETMULDER, STEEF	"STATUETTE"	11/80	PNY	97	S	10 X 7	C1930/V	ST	190
ZOETMULDER, STEEF	"DE DUISTERNIS DER NAAMLOOZEN"	5/81	SNY	558	S	10 X 7	C1930/V	ST	100
ZWART, PIET	INTERIOR STUDY	2/81	SLA	526	S	7 X 5	1930'S/V		275
ZWART, PIET	FACTORY STUDY	2/81	SLA	527	S	7 X 5	1930'S/V	ST	BI
ZWART, PIET	GROCERIES IN A BASKET	2/81	SLA	528	S	5 X 7	1930'S/V	ST	500
ZWART, PIET	ELECTRICAL APPARATUS	5/81	CNY	112	S	5 X 7	1930'S/V	ST/G	240
ZWART, PIET	WOOD SHAVINGS	5/81	CNY	113	S	7 X 5	1930'S/V	ST/F-G	BI
ZWART, PIET	MAN WITH CAMERA	5/81	PNY	208	S	5 X 5	1930'S/V	S,ST,A	250
ZWART, PIET	STILL LIFE	5/81	PNY	209	S	7 X 5	1930'S/V	ST	BI
ZWART, PIET	ABSTRACT INTERIOR	5/81	PNY	210	S	7 X 5	1930'S/V	ST	BI
ZWART, PIET	STILL LIFE WITH BASKETS	5/81	SNY	175	S	2 X 3	1930'S/V	ST,I/G	300
ZWART, PIET	STILL LIFE WITH VEGETABLES	5/81	SNY	176	S	5 X 7	1930'S/V	ST/G	300
ZWART, PIET	PORTRAIT: A WOMAN	5/81	SNY	177	S	7 X 5	1930'S/V	S,ST/F	300
ZWART, PIET	CHILD'S SWEATER	5/81	SNY	178	S	5 X 7	1930'S/V	ST/G	BI
ZWART, PIET	STILL LIFE	11/80	PNY	22	S	7 X 5	1930'S/V	S,ST	500
ZWART, PIET	STILL LIFE WITH VEGETABLES	11/80	PNY	23	S	5 X 7	S	ST	BI
ZWART, PIET	"PIPE"	11/80	PNY	24	S	7 X 5	1930'S/V	ST	325
ZWART, PIET	STILL LIFE WITH SWEATER	11/80	PNY	25	S	7 X 5	1930'S/V	ST	300
ZWART, PIET	SHADOW ON WALL	11/80	PNY	26	S	5 X 7	1930'S/V	S	425